# RAPHAEL

## HIS LIFE AND WORKS IN 500 IMAGES

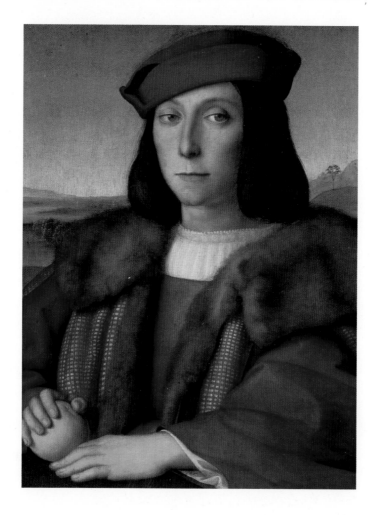

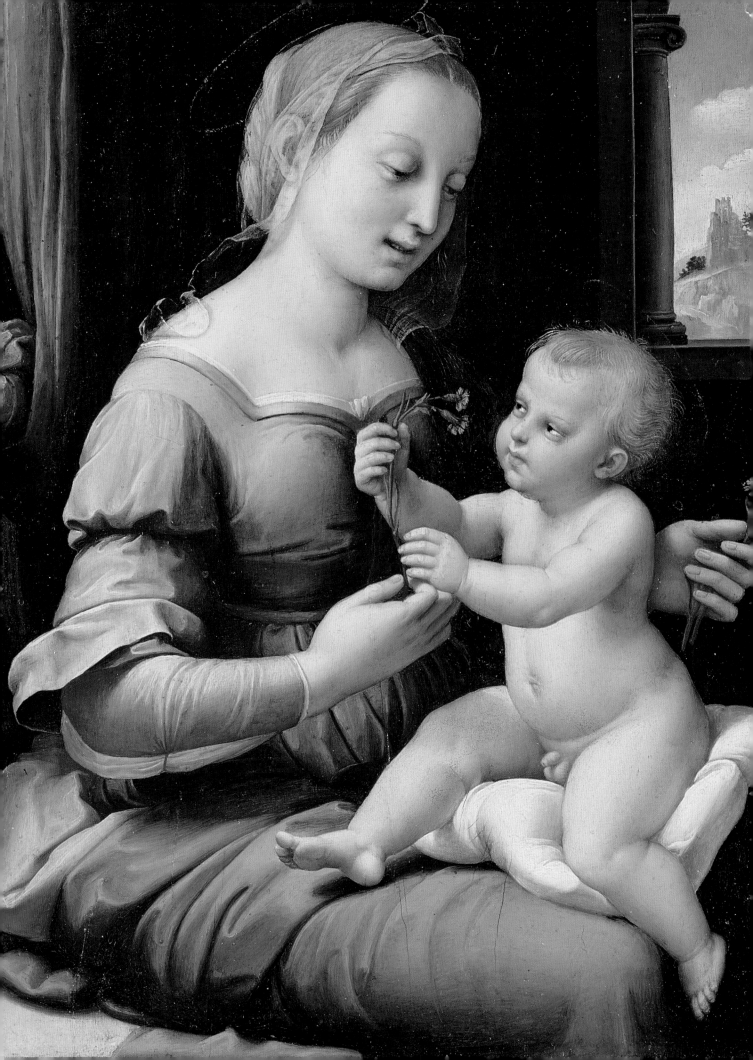

# RAPHAEL

## HIS LIFE AND WORKS IN 500 IMAGES

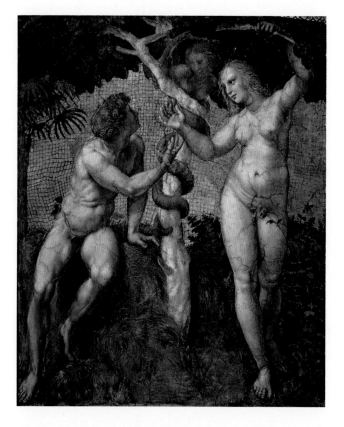

AN ILLUSTRATED STUDY OF THE ARTIST, HIS LIFE AND CONTEXT,
WITH 500 IMAGES AND A GALLERY OF HIS GREATEST PAINTINGS

SUSIE HODGE

LORENZ BOOKS

This edition is published by Lorenz Books, an imprint of Anness Publishing Ltd, Blaby Road, Wigston, Leicestershire LE18 4SE

Email: info@anness.com

Web: www.lorenzbooks.com; www.annesspublishing.com

Anness Publishing has a new picture agency outlet for images for publishing, promotions or advertising. Please visit our website www.practicalpictures.com for more information.

© Anness Publishing Ltd 2013

Publisher: Joanna Lorenz
Project Editor: Anne Hildyard
Designer: Sarah Rock
Production Controller: Mai-Ling Collyer

PUBLISHER'S NOTE

'Although the information in this book is believed to be accurate and true at the time of going to press, neither the author nor the publisher can accept any legal responsibility or liability for any errors or omissions that may be made.

PICTURE ACKNOWLEDGEMENTS
**AKG:** akg-images: 57b, 63tr, 71bl, 80b, 101 (both), 102t, 108m, 128b, 130, 131 (both), 136t, 141b, 146t, 146b, 149t, 150 (both), 153 (both), 163, 165t, 169b, 180t, 188m, 188m, 192t, 204 (both), 207b, 214b, 217m, 224b, 233m; akg/De Agostini Pic. Lib.: 90; akg-images/André Held: 208t, 232b; akg-images/Archives CDA/Guillot 29t; akg-images/Cameraphot: 42l, 71br; akg-images/Erich Lessing: 30br, 35t, 36l, 57tr, 58, 59b, 66r, 77bl, 102b, 103b, 107b, 116b, 136b, 160b, 166t, 171b, 172t, 176m, 182t, 187t, 194t, 207t, 223m, 224t, 225b, 227b, 245t, 248b, 249b; IAM/akg: 191b; akg-images/ Andrea Jemolo: 197b, 229b; akg-images/ Laurent Lecat: 95t; akg-images/MPortfolio/ Electa: 21b, 31, 41t, 83t, 83bl, 98, 108t, 109, 110 (both), 111 (both), 112 (both), 113 (both), 114 (both), 197t; The National Gallery: 2, 123m, 129, 144t, 172b; akg-images/Nimatallah: 91br; akg-images/Pirozzi: 43tl, 65r, 70t, 174t, 183t, 198b, 206t; akg-images/Rabatti-Dominigie: 32l, 32r, 41l, 66l, 67, 125t, 127 (both), 133, 151t, 151m, 177t, 191m, 232t; akg-images/Stefan Drechsel: 77t; akg-images/ullstein bild: 138b; Album/
Oronoz/AKG: 54b, 55t, 69tr, 73b, 83br, 137m, 160t, 214m, 225t; Album/Prisma/AKG: 51tl, 51r, 158t, 159b, 200b.
**Alamy:** © The Art Archive: 104b; © Interfoto: 10, 46t; © David Litschel: 123b.
**Art Archive:** Gemaldegalerie Dresden: 4, 195b; Duomo Florence/Colleciton Dagli Orti: 6r; Carrara Academy Bergamo/Collection Dagli Orti: 7tl; Monastery of the Rabida, Palos, Spain/ Collection Dagli Orti: 13tl; Battistero di San Giovanni, Florence/ Collection Dagli Orti: 16; Galleria degli Uffizi Florence/Collection Dagli Orti: 17t; Chiesa di Santa Zaccaria Venice/Gianni Dagli Orti: 17bl; San Domenico Cagli/Gianni Dagli Orti: 22; San Domenico Cagli/Gianni Dagli Orti: 23t; Museo Civico Città di Castello/Gianni Dagli Orti: 26; Galleria Nazionale delle Marche, Urbino/Mondadori Portfolio/Electa: 28t; National Gallery London; 28b; Mondadori Portfolio/Electa: 29b; Private Collection Italy/Gianni Dagli Orti: 34t, 212b, 213 (both), 236m; Musée du Louvre Paris / Collection Dagli Orti: 35bl; Neil Setchfield: 36; Galleria Brera Milan/Collection Dagli Orti : 39l; National Museum Bucharest/Collection Dagli Orti: 44; Ashmolean Museum: 60l; Musée du Louvre Paris/Gianni Dagli Orti: 89r, 226m; British Museum/Eileen Tweedy:103t; Vatican Museum Rome/Superstock: 106t; Accademia Carrara Bergamo Italy/Collection Dagli Orti: 115t; Galleria degli Uffizi Florence/Collection Dagli Orti: 124t; Gianni Dagli Orti: 34b, 157b, 237 (all); Gemaldegalerie Dresden: 194b; Superstock: 214t; Galleria degli Uffizi Florence/Gianni Dagli Orti: 236b.
**Bridgeman Art Library:** Alte Pinakothek, Munich, Germany: 64tl, 134, 198t, 255; Ancient Art and Architecture Collection Ltd: 91b; Biblioteca Ambrosiana, Milan, Italy: 86t, 88r; Biblioteca Estense Univeritaria, Modena, Italy: 14br; Bridgeman Art Library: 23b; British Museum, London, UK: 242b; © Bristol City Museum and Art Gallery, UK: 95b; Burrell Collection, Glasgow, Scotland: 85br; © Clement Guillaume: 92r; © Devonshire Collection, Chatsworth: 161b, 193b, 194m, 216m, 233b; © Dulwich Picture Gallery, London, UK: 104t; © Collection of the Earl of Pembroke, Wilton House, Wilts: 196t; Edinburgh University Library, Scotland: 94l; Galleria Borghese, Rome, Italy: 5r, 80t, 99, 126b, 139b; Galleria degli Uffizi, Florence, Italy: 1, 33tl, 65l, 69tl, 81r, 100b, 173, 243t, 243m, 244 (both); Galleria dell' Accademia, Venice, Italy: 238; Galleria Nazionale dell'Umbria, Perugia, Italy: 38; Gabinetto dei Disegni e Stampe, Uffizi, Florence, Italy: 41br; 61t, 139t, 165m; Gemaedegalerie Alte Meister, Dresden, Germany: 195t; Guildhall library, City of London: 91tr; Hamburger Kunsthalle, Hamburg, Germany: 100t; Hermitage, St Petersburg, Russia: 247t; Kunsthistorisches Museum, Vienna, Austria: 39b, 58t, 132t, 241b, 242t, 243t, 247b; Louvre, Paris, France: 30bl, 40, 43l, 55b, 69b, 88l, 148 (both), 227t, 231b, 249t; Musee des Augustins, Toulouse, France: 13bl; Musee des Beaux-Arts, Caen, France: 246b; Musee des Beaux-Arts, Orleans, France: 27bl, 246m; Musee Bonnat, Bayonne, France: 89l; Musee des Beaux-Arts, Strasbourg, France: 91tl; Musee Conde, Chantilly, France: 14bl, 38t, 61b, 77br, 154m, 154b, 165b, 178t, 217t, 229m, 235b, 240m, 254; Musee Fragonard, Grasse, France: 68; Musee Ingres, Montauban, France: 250m; Musee d'Orsay, Paris, France: 251 (both); Museum of Fine Arts, Budapest, Hungary: 240t; National Gallery, London, UK: 119, 122 (both), 123t, 146m, 245b; National Gallery of Art, Washington DC, USA: 164b; National Library, St Petersburg,
Russia: 59tl; © Nationalmuseum, Stockholm, Sweden: 20br; Nottingham City Museums and Galleries (Nottingham Castle): 250t; Palais de Longchamp, Marseille, France: 71t; Palazzo Ducale, Urbino, Italy: 82, 143; 144b, 145 (both); Photo © Christie's Images: 57tl; 240b; Pinacoteca di Brera, Milan, Italy: 27br; Pinacoteca Capitolina, Palazzo Conservatori, Rome, Italy: 25b; Pinacoteca Civica, Comune di Jesi, Venice, Italy: 246t; Pinacoteca Nazionale, Bologna, Italy: 192b, 193t; Pinacoteca, Volterra, Italy: 43r; Prado, Madrid, Spain: 149b, 235t; Private Collection: 15, 19b, 23t, 52t, 67b, 70, 92l, 164t, 218m, 234b, 242m; Pushkin Museum, Moscow, Russia: 142t; The Royal Collection © 2011 Her Majesty Queen Elizabeth II: 60r, 72, 142b, 152t, 181t, 199 (both), 217b; Santa Maria del Popolo, Rome, Italy: 78l; Santa Maria Gloriosa dei Frari, Venice, Italy: 243b; San Michele, Carmignano, Prato, Italy: 239, 245m; San Pietro in Vincoli, Rome, Italy: 47r; Santissima Annunziata, Florence, Italy: 27t; Vatican Museums and Galleries, Vatican City, Rome, Italy: 3, 37b, 45t, 45m, 48, 56, 59tr, 157t, 167 (both), 168, 175, 176b, 178b, 200t, 202t, 233t; Victoria & Albert Museum, London, UK: 85t, 209b, 210 (all), 211; Villa Farnesina, Rome Italy: 96; 183b, 185b, 186t, 230m, 230b; Villa Madama, Rome, Italy: 76, 215 (both), 216t, 216b; © Walters Art Museum, Baltimore, USA: 249m; Yale Center for British Art, Paul Mellon Collection, USA: 248t; Yale University Art Gallery, New Haven, CT, USA: 250b.
**Corbis:** © Alinari Archives: 81l, 85bl, 117t, 155b; © Araldo de Luca: 87t, 184b, 218b, 219 (both), 220 (both), 221 (both), 222 (all), 223t, 230t; © Arte & Immagini srl: 30t, 33tl, 73tl, 124b, 137t, 212t; © Peter Barritt/Superstock: 37t; © David Bartruff: 231t; © Bettmann: 87b; © Christophe Bolsvieux: 13mr; © Burstein Collection: 115m, 115b, 177b; © Geoffrey Clements: 120b, 121 (both); © Corbis: 94t, 118t, 181b, 209t; © Laurie Chamberlain: 18t; © Christie's Images: 223b; © Gillian Darley; Edifice: 74t; © Fine Art Photographic Library: 8, 12; © The Gallery Collection: 21t, 229t; © Heritage Images: 19t; © Image Source: 45b; © Andrea Jemolo: 78r; © David Lees: 188b, 189 (both), 190 (both); © Dennis Marsico: 86b, 202b; © Francis G. Mayer: 105t, 120t, 128t, 132b, 135, 137b, 147, 162, 205b; © Massimo Listri: 74b, 75l; 218t; © Murat Taner: 6bl; © Ocean: 73tr; © Doug Pearson/JAI: 20l; © Radius Images: 7t; © Paul Seheult/Eye Ubiquitous: 50, 169t; © Joseph Sohm/Visions of America, 49, 159tr; © Ted Spiegel: 11, 46b, 174b, 179t; 201; © Jim Zuckerman: 53b.
**Superstock:** 5tl, 14t, 39tr, 53t, 64tr, 75r, 107t, 117t, 151b, 152t, 156, 166b, 180b, 182b, 184t, 185t, 186b, 187b, 203t, 206b, 208b, 226t, 226b; The Art Archive: 17br, 118b; De Agostini: 18b, 170b; Universal Images Group: 32r, 35br, 42t, 63b, 106b, 125b, 126t, 138t, 140, 141t, 191t, 196b, 236t; Pixelchrome-Jeremy Woodhouse: 33b; Robert Harding Picture Library: 47t; Hemis.fr: 51ml; National Gallery, London, UK: 7b; Michael Nitzschke/ ima/imagebroker.net: 52b; Peter Barritt: 62, 143t, 228t; Marka: 64b, 79t; Prisma: 93 (both); Image Asset Management Ltd: 154t; Lonely Planet: 155t; Marco Brivio/age fotostock: 158b; Visions of America: 170t; Ron Chapple Photography/ Superfusion: 171t; Travel Library Limited: 176t; Fine Art Images: 179b; Bridgeman Art Library, London: 203b, 228b; Peter Willi: 212m.
**Photo12:** Photo12/Alfredo Dagli Orti: 116t; Photo12/Ann Ronan Picture Library: 24 (both), 25t, 84, 105b, 108b, Photo12/Oronoz: 24, 161t, 205t, 234t, 234m.

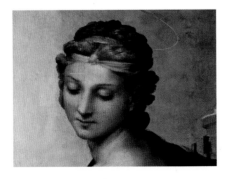

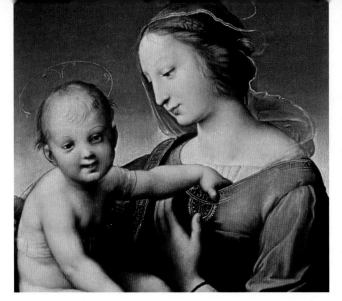
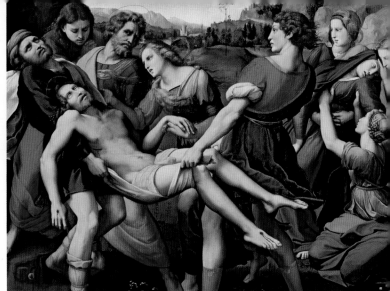

# CONTENTS

# INTRODUCTION

Raphael's art has been revered for over five centuries. Often grouped as part of a venerated trinity with Leonardo and Michelangelo (similarly recognized by just their first name), he is acclaimed as one of the greatest artists of all time – the epitome of purity, taste and refinement.

During his short life, Raphael (1483 –1520) was hugely productive, running an extremely large workshop and becoming the favoured painter and architect at the papal court in Rome. He dominated the Roman art world for the last seven years of his life, diversifying into architecture and archaeology while continuing to create and oversee vast and important painting commissions. For centuries his painting style was considered the height of artistic achievement, accepted by art officials as the embodiment of classical splendour and harmony to which all art students should aspire. In addition – an extremely rare achievement – his work has never been out of fashion. Raphael was revered and followed during his lifetime, and since his untimely death almost 500 years ago he has continued to be admired and emulated.

## EMBODIMENT OF THE RENAISSANCE

Although Raphael (actual name Raffaello Santi) was not a polymath like Leonardo da Vinci (1452–1519) or Michelangelo Buonarroti (1475–1564), his graceful lines, colours and serene yet expressive compositions are often described as superior to Leonardo and Michelangelo's painting styles, perhaps because he learned from them and synthesized several of their techniques and qualities.

By amalgamating others' ideas with his own innovative style, he changed viewers' expectations of art, pioneering a new, more human approach to devotional subjects. The unprecedented tenderness and compassion of his Madonna and Child groups were some of the first paintings that portrayed the subject with such human, lifelike poses, gestures and expressions. With his inherent warmth and sensitivity, he injected life into all his work, from Bible stories, to myths, to portraits.

Raphael was born in Italy during the period that has since been labelled the High Renaissance. Although he would have been aware that he was living during an exciting time of change and progress, he did not have the advantage of historical perspective as we do, and the idea of the Renaissance as a movement had not firmly been formed.

It was not until 30 years after his death that the Italian painter, writer, historian and architect Giorgio Vasari (1511–74) wrote his *Lives of the Most Excellent Painters, Sculptors and Architects*, including a biography of Raphael, stating that art had been reborn in Italy in about 1250 and had progressed through 'childhood' and 'youth' to its 16th-century maturity. Vasari used the word *rinascita*, Italian for rebirth, and declared that excellence in painting required refinement, intelligence and richness of invention, all expressed through skilful technique.

As was usual for his time, Raphael always produced work on commission. Unlike artists from later periods, he never painted purely for pleasure, choosing his own subject; but his interpretation and compositions were all his own. Renaissance artists were taught their craft in busy workshops run

*Below: Luca della Robbia (1400–82) strove for naturalism, which was demonstrated in* La Cantoria, *a marble relief of children and putti dancing.*

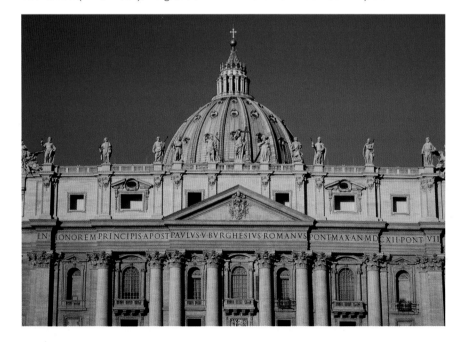

*Left: St Peter's Basilica in Rome remains a testament to the overriding ambitions and ideals of the High Renaissance.*

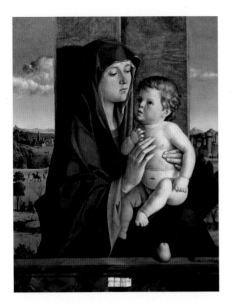

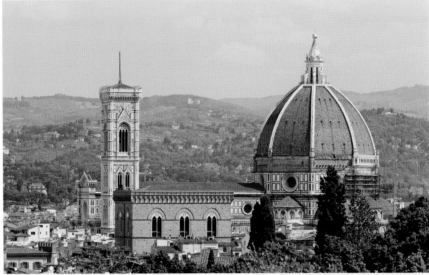

*Above:* The Virgin and Child, 1480–90, *workshop of Giovanni Bellini. Bellini was one of the few artists who portrayed the Virgin and Child as real people.*

*Above right: The Basilica di Santa Maria del Fiore in Florence was completed in 1436 by Brunelleschi. The complex includes the Baptistery and Giotto's Campanile.*

by a master. As well as painting and drawing, apprentices learned to grind and mix pigments, prepare wooden panels, and gild with gold leaf – the practical and essential skills. Once they were proficient, they assisted the master with some of his commissions, often painting backgrounds and minor figures while the master painted the main subjects. When they moved on to become masters themselves, they were commissioned directly and had their own apprentices and assistants to help them. Like architects or goldsmiths, for instance, artists were members of the artisan class.

From early on, Raphael's work was assured and dexterous. His ability to understand and integrate advances made in painting since the time of Giotto di Bondone secured his reputation as a unique artist of exceptional skill.

*Right:* The Madonna and Child, (The Mackintosh Madonna), *c.1509–11, Raphael. Also known as the 'Madonna of the Tower,' the tender moment shared by a mother and child was universally appealing.*

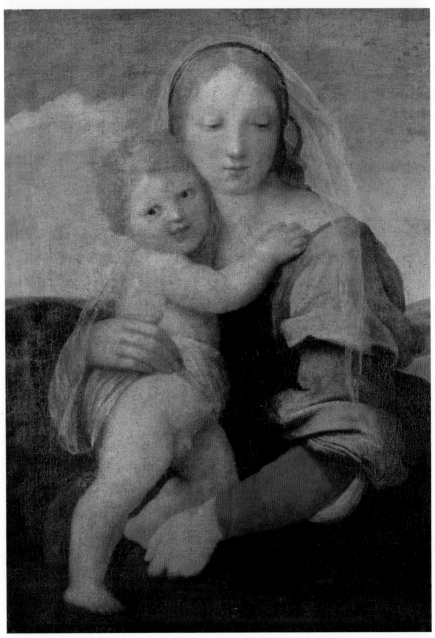

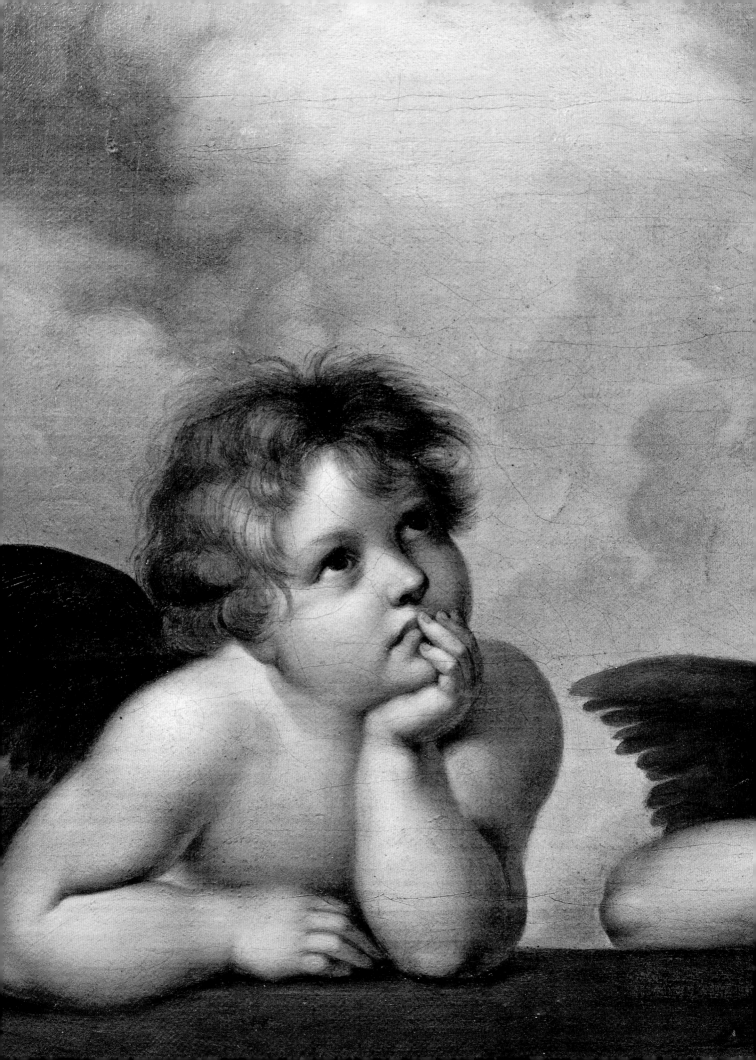

# RAPHAEL: HIS LIFE AND TIMES

For approximately 20 years, Raphael lived and worked as an artist, moving from his birthplace of Urbino to Perugia, to Florence and finally to Rome. Even in his earliest works he outstripped many of his contemporaries, and he soon became noticed. Along with his meticulous attention to detail, he had an unusual capacity to empathize with his subjects and a natural ability for characterization and narrative. His reputation rose with remarkable rapidity and he received prestigious commissions from some of the most powerful patrons in Italy.

*Left:* From The Sistine Madonna, *c.1513–14, showing the characterful cherubs that appear to lean on the bottom of the altar.*

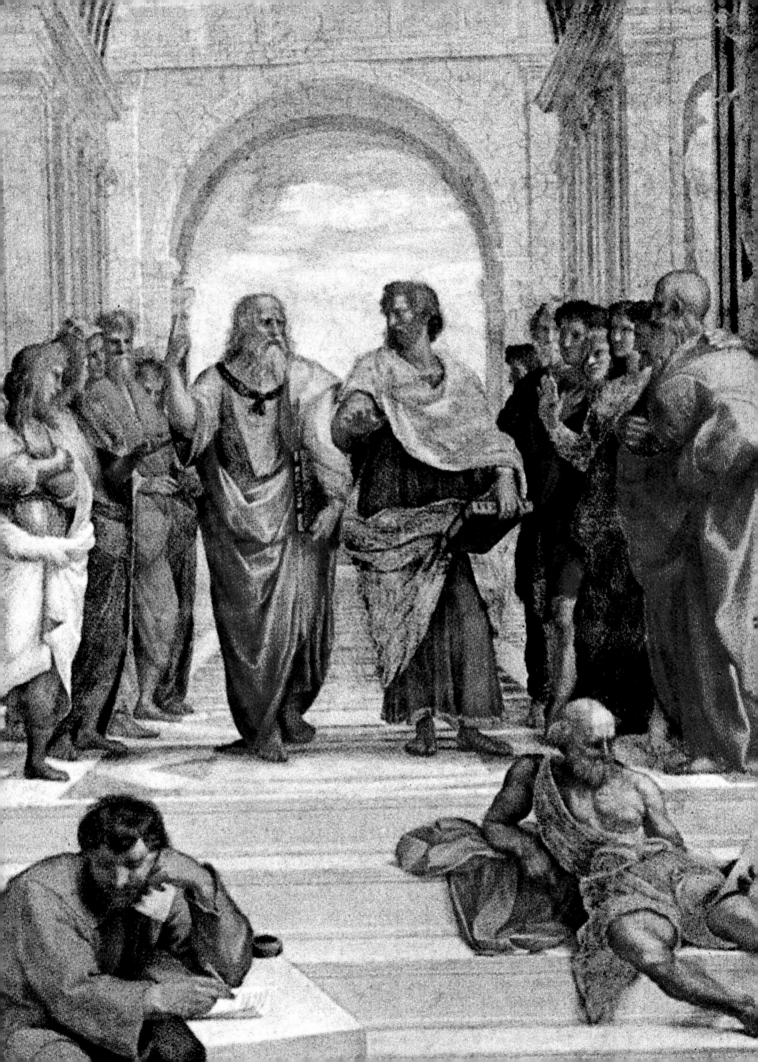

# THE RENAISSANCE

The term Renaissance refers to a rebirth of ideas and accomplishments in art, literature, philosophy, religion, politics and science that occurred from the early 14th to the late 16th century. It describes a cultural movement that began in Florence and then spread to the rest of Europe, manifesting itself variously in different places. Although it encompassed diverse intellectual, social and political changes, the period is best known for its artistic accomplishments and is seen by many as the beginning of the modern era.

*Above: Detail from* The School of Athens, *1509–10, showing the self-portrait that Raphael included in his large and celebrated fresco.*
*Left: Detail from* The School of Athens, *1509–10, one of the most famous Renaissance paintings, painted for Pope Julius II.*

# EUROPE IN THE 15TH CENTURY

Although Raphael was born near the end of the 15th century, in order to understand how and why he developed as such an accomplished artist it helps to explore that century – an exceptionally eventful time that is perceived as bringing a close to the Middle Ages.

The period from 1400 to 1500 has been labelled the Early Renaissance or the Quattrocento in acknowledgement of the vast changes that occurred. It was a century of transition, when great advances were made in trade, travel, art, literature and science. For instance, Christopher Columbus (1451–1506) voyaged to the Americas, modern banking was established and the printing press was invented.

There were also serious conflicts across Europe, such as the Hundred Years War between France and England (1337–1453) and civil wars in England, Italy and France.

## IMPROVED LITERACY

Few inventions have had a greater impact on the world than printing in the 15th century. In 1440, German goldsmith Johannes Gutenberg (c.1398–1468) invented the movable type press, which made it possible to print books inexpensively. In enabling the masses to obtain all kinds of printed material, the structure of society was permanently affected, as literacy became widespread and was no longer a privilege of the wealthy.

The printing press made accessible the works from ancient writers, such as Homer, Plato, Aristotle and Cicero, whose texts had fallen into obscurity. These writings encouraged new notions about humanism, education, art and society.

*Below: The Château de Fougères-sur-Bièvre, a castle in the Loir-et-Cher, France, was rebuilt at the end of the 15th century in the Renaissance style.*

### THE PAPAL SCHISM

For the first time in history, from the 14th century to the 15th, the Roman Catholic Church was split in two in what became called the Papal Schism. In 1378, the King of France elected a French pope and ignored the Italian one. For about 68 years, the two popes both claimed authority over the Catholic Church, causing great confusion and conflict. Eventually, between 1414 and 1418, the Council of Constance restored order. The French pope was deposed and the Roman pope resigned. Once more, a single pope was elected and established in Rome as the supreme authority in the Church.

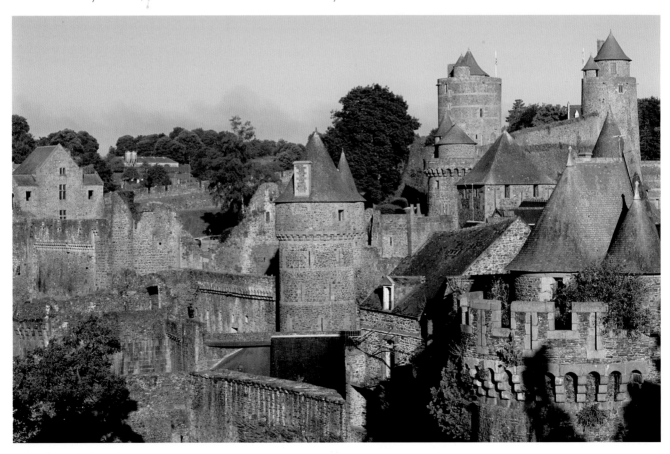

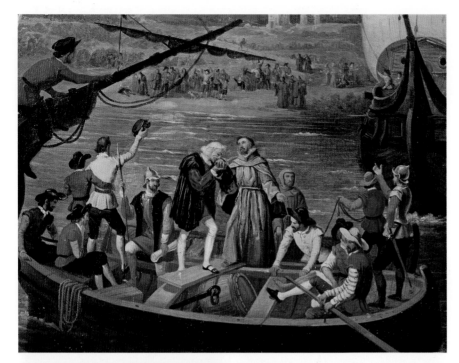

*Left: A 19th-century fresco of Christopher Columbus departing for the New World from Palos, Spain, August 1492, by Antonio Cabral y Aguado Bejarano (1798–1861).*

scientific and mathematical concepts – such as the structure and proportions of the human body – into their work. They also focused on nature and harmony.

## INDEPENDENCE, DISCOVERY AND CONFLICT

The revival of interest in antiquity developed particularly in Italy because of the economic and cultural conditions that existed there. Unlike other European countries, Italian nobles lived among the wealthy merchants and together they formed a patrician ruling class, developing a large export industry. They also amassed great wealth through importing luxury goods from the East. With such wealth, some became money-lenders and bankers, and this prosperous, worldly society gained self-confidence which was reflected in literature and art. Unlike most of Europe, Italy was divided into several city-states, each with its own characteristics, rulers and language. For much of the 15th century, many of these city-states were in conflict with each other as they progressed diversely and at different rates. For instance, as a major port, Venice was particularly influenced by foreign ideas, while Rome adhered to papal preferences.

Meanwhile, other aspects of life were changing. The so-called 'Age of Exploration and Discovery' was under way. For example, during the first half of the century Niccolò de' Conti (c.1395–1469) voyaged to India, South-East Asia and possibly southern China; Columbus first reached the Americas in 1492, an achievement that subsequently led to new trade networks and colonies; John Cabot (c.1450–c.1498) discovered parts of North America in 1497; and between 1497 and 1499 Vasco da Gama (c.1460/9–1524) travelled from Europe to India and back.

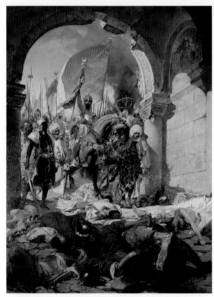

*Above: Painted in 1876, by Benjamin Constant (1845–1902), this illustrates the entry of the Ottoman Turks into Constantinople on 29 May 1453.*

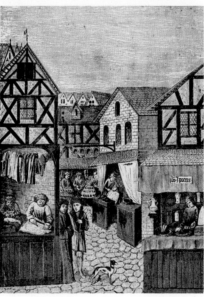

*Above: 15th-century European town buildings were constructed close together and shops were open to the street.*

In 1453, Ottoman Turks captured Constantinople, the capital of the Eastern Roman Empire, forcing western Europeans to find a new trade route. The fall of Constantinople marked the end of the Byzantine Empire, which had lasted for more than a thousand years. It was a massive blow to the Christian world. Many Greek-speaking intellectuals fled, predominantly to Italy, taking with them precious classical

manuscripts that had been part of Byzantine higher education. They helped to spread understanding of the ancient literature, encouraging the revival of classical learning. Soon intellectuals began drawing on ideas they discovered in these writings, and artists and architects reinterpreted the notions, selecting certain aspects and mixing them with elements of their own medieval heritage. For the first time, artists were incorporating

# NEW IDEAS

Although the pursuit of learning of sorts had taken place for many years, by the 15th and 16th centuries this increased appreciably, fuelled by the widespread availability of information, the revival of ancient ideas and scientific and technical advancements. Greater questioning stimulated novel approaches to thought and new ideas were encouraged.

From this cultural revival emerged new patterns of thought, in particular, four new ideas: secularism, humanism, individualism and scepticism.

Secularism described the focus on this world, rather than religion and the next world. Humanism was the focus on humans rather than God. Individualism was an extension of humanism, which encouraged individual accomplishment, and scepticism promoted curiosity and the questioning of authority. The four new ideas led to innovations in a variety of fields.

Among other things, this appreciation of learning and spirit of inquiry initiated a desire for improving the world and the self, contrasting directly with the views of the Church and the attitudes of previous generations, which had been overshadowed for centuries by religious dogmas that insisted on a focus on God's will and the afterlife. Considering the self and life on Earth defied Christian doctrine and eventually changed the structure of society. The idea of a Renaissance man is a retrospective term, describing the aspirations of those who strove to be erudite, enquiring and enterprising.

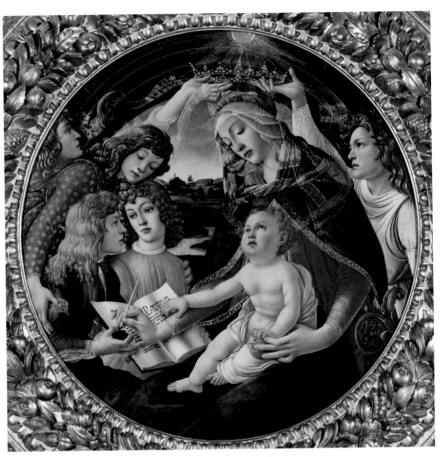

*Above right: Madonna of the Magnificat, Botticelli, 1481; one noticeable change in Renaissance painting was the way artists made holy figures appear human. This sacred image doubles as a portrait of the Medici family.*

*Right: Painted on vellum in the 15th century, a depiction of adults attending lessons – illustrating the fashion for learning at that time.*

*Far right: To make reading accessible, this Bible was commissioned in 1455 by Borso d'Este (1413-71) the first Duke of Ferrara.*

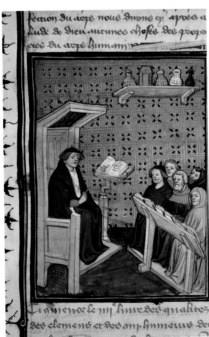

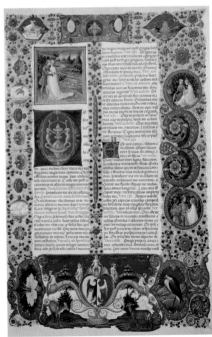

## THE DEVELOPMENT OF HUMANISM

In the late 14th century, the writers Petrarch (1304–74) and Boccaccio (1313–75) announced their admiration for the achievements of the ancient Romans and scorned what they viewed as the subsequent 'Dark Ages'. Combined with their love of nature, their thoughts and opinions stimulated many of the developments in the arts and sciences of the next century. In 1492, the philosopher and astrologer Marsilio Ficino (1433–99) wrote: 'This century, like a golden age, has restored light to the liberal arts, which were almost extinct: grammar, poetry, rhetoric, painting, sculpture, music, architecture… Achieving what had been honoured by the ancients, but almost forgotten since, the age has joined wisdom with eloquence.'

Developing directly from the secular writings of antiquity, humanism focused on the consideration of life in the present and emphasized the importance of independent thought, encouraging a breadth of learning. Unlike Christians, humanists believed that humans are inherently good – not 'born in sin'. Humanism is a late 15th-century word, used to distinguish these intellectuals from previous scholars by these changes in their learning. Slowly, through the writings of humanists, attitudes toward artists changed too. During the Middle Ages, artists had been thought of as craftspeople who did little more than give form to ideas from God. Now, for the first time, individuals were respected for their accomplishments, and the idea of a 'work of art' took shape.

## INFLUENCE OF THE WIDER WORLD

With the invention of the compass and new methods of shipbuilding, European sailors were able to travel farther than had previously been possible, facilitating trade with Arab, African and Indian merchants. Certain European ports became bustling centres. Through these new connections, ideas for art and architecture filtered through from distant cultures. In effect, foreign trade, travel and the printed word motivated ideas of individualism, moderation and reason, which contrasted markedly with the focus on life after death that had prevailed in western Europe for centuries.

Although in many ways the Renaissance was a time of new ideas and huge changes, when Europeans rediscovered their past and simultaneously found their individuality, the term underestimates the complexities of the period. Some of the new ideas included theories on astronomy and mathematics (in 1608 the Dutch invented the telescope); an understanding developed of cultures outside Europe; and theological beliefs were reassessed and new creative approaches developed. It was a time of cultural revival that incorporated and reinterpreted ancient and pagan ideas but also looked to the future with the aim of modernizing the world.

### REPRESENTING NATURE

The idea that art should imitate nature intensified during the Renaissance. Artists trained their apprentices to make close studies from the nude, while some dissected the corpses of criminals in order to learn more about the workings of the human body. Artists of the Early Renaissance slavishly copied aspects of nature, but by the High Renaissance a more holistic approach was taken and entire works of art became more lifelike. Giorgio Vasari declared that art had finally conquered nature itself.

The scientist Vannoccio Biringuccio (1480–c.1539) wrote: 'I am certain that new information always gives birth in men's minds to new discoveries and so to further information.'

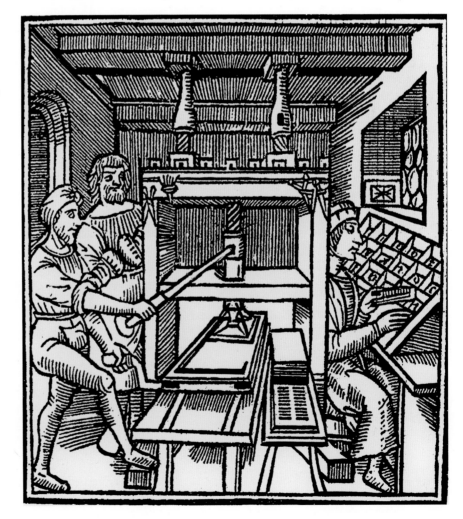

*Right: A German woodcut (a technique developed in the 15th century) of a printing press.*

# RENAISSANCE DEVELOPMENTS

It is argued that the Renaissance began in Italy because of its position in the Mediterranean and the importance of various city-states. Rome was the centre of the Catholic Church; Florence was the centre of banking; and ports such as Naples, Genoa and Venice became busy trade centres, meeting increasing demands for imported goods.

Money was needed for developments during the Renaissance, and was brought to Italy during the 14th century through to the 16th by trade with other countries.

## FLORENCE

The capital of Tuscany, Florence, and one of the most flourishing republics on the Italian peninsula, is usually cited as being the location for the start of the Renaissance. The city already had a prosperous history through banking and wool manufacture, and it became even more influential as the papal bankers were established there. These bankers became the most successful in Europe, and the powerful banking family the Medici first came to prominence under Cosimo de' Medici (1389–1464) in Florence during the early 15th century. By commissioning works from Florence's leading artists, Cosimo encouraged new developments in painting, sculpture and architecture. Because of the economic and cultural conditions in Florence, the city prospered through trade and manufacturing, which led to the establishment of a middle class that valued intellectual and artistic pursuits.

Philosophers and artists soon gathered in Florence, stimulating an environment where art and humanism flourished. As well as commissioning artists, the Medici established the first public library since antiquity in 1437 and inspired other wealthy patrons to pay for the creation of new works of art. Meanwhile, talented artists and thinkers were emerging in other Italian cities such as Venice, which, like Florence, had the economy to support them.

## OIL PAINT

The first use of oil paint in Europe was in the 12th century, in the north of the continent, but it was not until the 15th century that painters from the Netherlands used it more than tempera. Its slow-drying qualities made it suitable for blending gradated tones. The oil allows artists to apply thin layers, or glazes, of transparent paint, resulting in even more glowing colours. As artists travelled, the use of oil painting spread to southern Europe.

## BEYOND ITALY

Renaissance developments were not, however, confined to Italy. In building on their medieval heritage, artists in northern Europe also developed innovative ideas and techniques. North and south of the Alps there was a new interest in naturalism, and certain northern European artists painted the natural world using a system of perspective and realism that had not been attempted before. Several of these artists, for example Jan van Eyck (c.1395–1441) and his brother Hubert (c.1385/90–1426), Rogier van der Weyden (1399/1400–1464) and Albrecht Dürer (1471–1528), became renowned for their clearly coloured, luminous works with rich descriptive detail. This approach spread to France, Spain, England and Italy, and an interchange of ideas was one of the determining factors of Renaissance style. Although the evolution of Italian Renaissance art was a continuous

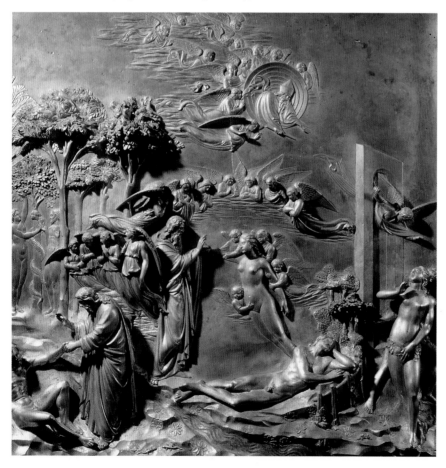

*Left:* The Creation, c.1404–24; Bronze relief panel by Lorenzo Ghiberti for the Gates of Paradise, baptistery of St John, Florence. It is one of the innovative masterpieces of Renaissance Florence.

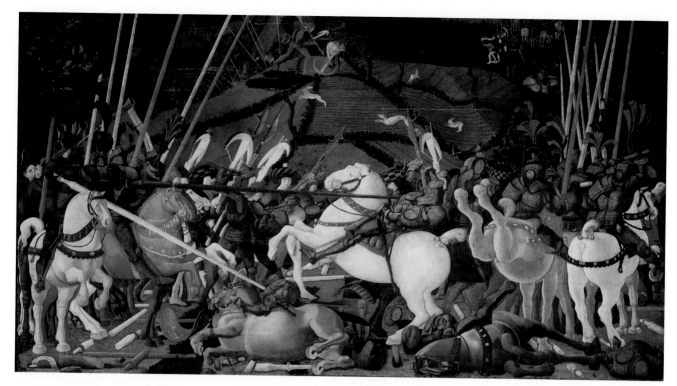

process, it is traditionally divided into Early and High Renaissance, usually starting with Giotto in the early 14th century and spreading from Florence to the rest of Italy and Europe. As it spread, ideas diversified, changed and developed.

As humanity became the centre of all things, a new visual language became necessary to record the shift from the medieval view based on God and heaven, to one that was based on nature. Architects constructed many buildings focusing on Renaissance ideals which contrasted strongly with previous medieval Gothic architecture. Structure was emphasized and the senses lifted by the use of bright colours and classical ornaments. Apart from the visual world, the new ideas and inventions inspired a sense of optimism.

*Above:* The Rout of San Romano, *c.1435–60, by Paolo Uccello; one of three paintings by Uccello as he explored different methods of representing linear perspective.*

*Below:* Adoration of the Magi, *c.1475, by Botticelli, includes four members of the Medici family and an alleged self-portrait.*

*Above:* Detail of Madonna and Child with Four Saints, *1505; the Venetian artist Giovanni Bellini was unique at the time for his acute realism.*

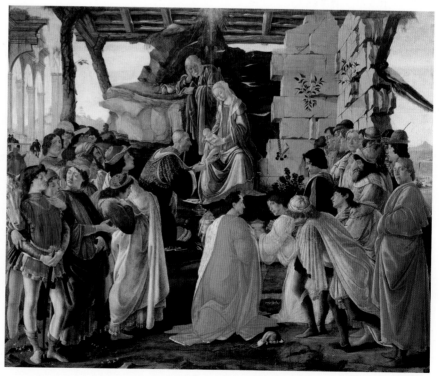

# THE HIGH RENAISSANCE

During the 16th century, cross-cultural exchanges continued within Europe and beyond. Travel increased and new ideas spread even more quickly than before. The period from 1500 to the year of Raphael's death in 1520 is often called the High Renaissance because art reached its highest level of achievement.

In the late 15th and early 16th century, sea travel increased, first among the Portuguese and Spanish and later among the British, French and Dutch.

## NEW COLONIES

Exploration fulfilled the curiosity that the Renaissance had engendered. Ocean voyages to the unknown were considered worth the risks, especially when the travellers discovered entire continents they had not known about and had opportunities to amass riches. But exploration turned to exploitation. After initially befriending the indigenous people of these lands, European explorers started setting up new colonies, creating new trade routes, helping themselves to the riches they found and rounding up the locals to ship them back to Europe as slaves. The name America, first used in 1507,

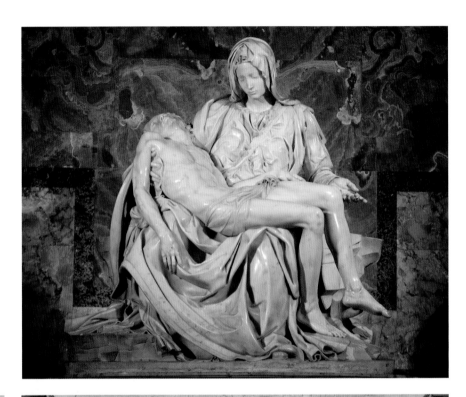

## ROME TAKES OVER

The High Renaissance is a term that describes the culmination of the artistic developments of the Early Renaissance and the surge of creative enterprise and proficiency that occurred at the beginning of the 16th century, when Rome took over from Florence as the main centre for art and ideas. Patrons sponsored artistic activity that was defined by harmony, symmetry and clever interpretations of classical antiquity. Venice and some other parts of Italy continued to produce artists with exceptional creative skills, such as Giovanni Bellini (c.1430–1516), Antonio Allegri da Correggio (1489–1534), Andrea Mantegna (c.1431–1506), Giorgione; (c.1477/8–1510), Titian (born Tiziano Vecellio); c.1488/90–1576) and Jacopo Tintoretto (1518–94).

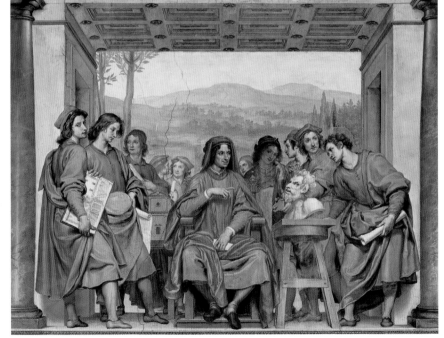

Top: Pietà, c.1498–1500, by Michelangelo. The High Renaissance witnessed an intense search for an ideal representation of the human body.

Above: Lorenzo de' Medici (the Magnificent) pictured with the most important artists of the period. Fresco, 1635, by Ottavio Vannini.

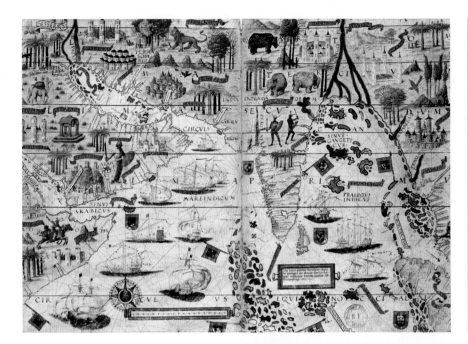

*Above:* Map of the Indian Ocean, Persian Gulf, India and North Africa, *c.1519, produced after some early Portuguese explorations.*

was based on the name of Amerigo Vespucci (1454–1512), a Florentine explorer, navigator and cartographer who originally worked for the Medici and later joined Portuguese and Spanish voyages to Central and South America. His writings about his travels were widely read.

## NEW MIDDLE CLASSES
As the European economy carried on growing, and technological innovations such as gunpowder changed the nature of warfare, people were, on the whole, confident, and the population grew – though vagrancy also increased as the new middle classes took control of large areas of land. A best-selling book in Italy, *Il Cortegiano* (The Book of the Courtier), written by Baldassare Castiglione (1478–1529) in 1514 and published in 1528, established standards for the behaviour of modern European gentlemen for centuries. This included being brave and fearless and a generous patron and promoter of the arts.

## FOUR MAIN POWERS
By 1519, there were four major rulers in Europe – four strong-willed men who fought hard and used art to

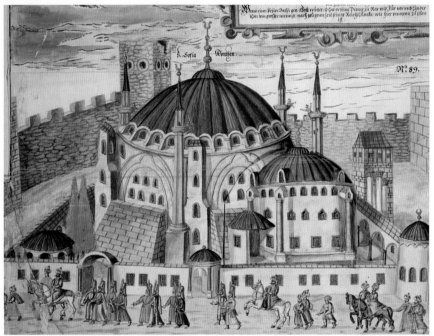

display and reinforce their power and ambition. The fall of Constantinople in the middle of the previous century had left the Roman Catholic Church as the only effective defender of Christianity, so a succession of vigorous popes made Rome an artistic showpiece to proclaim this. Europe's most powerful secular ruler was the Habsburg Holy Roman Emperor Charles V, who controlled Spain, Austria, the Low Countries and southern Italy. Francis I of France was determined that his country would be able to compete with both the Pope and Charles V, while Henry VIII of

*Above: After the Ottomans conquered Constantinople, they converted the church of St Sophia into a mosque, shown here in a 16th-century watercolour on paper.*

England aimed to be more powerful than Francis I. Initially, the resolve of these rulers to outshine each other was profitable for artists who were commissioned by them to produce ever larger and more impressive works, but by the late 1520s, warfare and religious conflicts engulfed Europe, reducing the willingness of the wealthy to put money into the arts.

# URBINO

The city of Urbino sits on a hill in north-east Italy. It has a strong medieval heritage that became prominent under the patronage of Federigo da Montefeltro, Duke of Urbino from 1444 to 1482. During that time, it developed a powerful and independent culture, where the arts were supported and encouraged.

Urbino is surrounded by the Apennine hills and situated amid all the main Italian Renaissance powers: Bologna, Ferrara, Venice, Mantua, Milan, Florence, Rome and the other Papal States. Originally relatively small, it has a long and sometimes distinguished history. It was founded in CE41 by the Romans and became an important site in the wars against the Goths in the 6th century. When Antonio da Montefeltro (c.1114 –84) repressed a revolt in Rome in 1155, he was given the title of Count of Urbino, starting a dynasty of rulers of the city.

## UPHOLDING RENAISSANCE IDEALS
Federigo da Montefeltro (1422–82) was a skilful diplomat and patron of art and literature. Under his control, Urbino expanded to three times its former size. He gave his citizens an unusual amount of political power and kept a close watch over the economic situation, for instance storing grain to avoid price increases in the event of poor harvests. He commissioned the construction of a great library and the magnificent Ducal Palace, which reflected many of the Renaissance ideals in architecture. The library was one of the largest in

Italy and is now housed in the Vatican. An avid collector of books, the Duke also kept 30 or 40 scribes busy throughout Europe, copying books he could not buy. He commissioned many copies and translations of Greek, Latin and Hebrew works, and collected every available work on medicine.

Extremely learned, with interests in the arts, classics, astrology, science, music, theology and history, Federigo was noted as a generous art patron, employing the best architects, painters and sculptors from around Europe, and buying the finest Flemish tapestries. Through his well-balanced rule, he moulded Urbino into one of the greatest cultural centres of Europe, recognized as an exemplary town embodying Renaissance ideals. His Ducal Palace was a marvel in architecture, featuring several rooms that reflected his interests in classical and humanist ideas. Once it was completed, he gathered around him

*Below: The Ducal Palace, Urbino, started in the mid-15th century, was instantly renowned as an exemplary Renaissance building with aspirational architecture.*

a bright and lively humanistic court where, for instance, Piero della Francesca (c.1415–92) wrote on the science of perspective, Raphael's father, Giovanni Santi (c.1435–94), wrote lyrically about the greatest artists of the time, and Francesco di Giorgio Martini (c.1439–1502) wrote his *Trattato di Architettura* (Treatise on Architecture).

## GUIDOBALDO AND ELISABETTA
Federigo died in the year before Raphael's birth. His son, Guidobaldo da Montefeltro (1472–1508), took over as the Duke of Urbino. Guidobaldo's wife, Elisabetta Gonzaga (1471–1526), sister of the Marquis of Mantua, was recognized for her intellectual and cultural interests. But in 1502, the couple took refuge in Mantua with Elisabetta's brother when Cesare Borgia (c.1475/6–1507) and his army occupied Urbino. The Duke and Duchess stayed with Elisabetta's brother at Mantua and later in Venice, while at the Ducal

*Below: Baldassare Castiglione, Titian, 1523. The count of Casatico, was an Italian courtier, diplomat, soldier and influential author.*

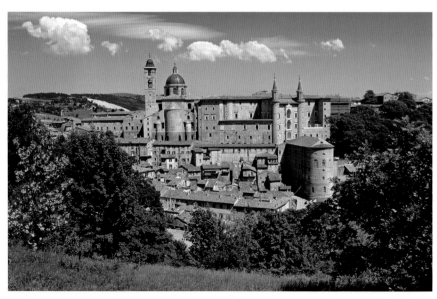

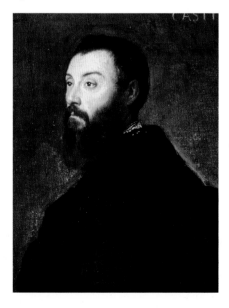

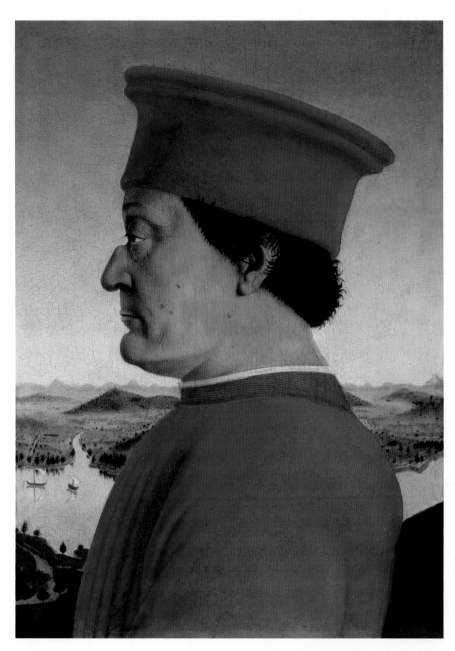

*Left:* Portrait of Federigo da Montefeltro, *1465–6, by Piero della Francesca.*

Palace in Urbino, Cesare Borgia stole from the vast assets of art and manuscripts and gave himself the title of Duke of Urbino.

In 1503, after the death of his father, Pope Alexander VI (r.1492–1503), Cesare fled, and Guidobaldo and Elisabetta were restored to power in Urbino. Three years later, they oversaw the building of the University of Urbino and, childless, adopted their nephew Francesco Maria della Rovere (1490–1538; also nephew of Pope Julius II, (r.1503–13), who succeeded Guidobaldo as Duke in 1508. Under the Montefeltros' rule, the court of Urbino remained one of the most refined and elegant in Italy.

## THE BORGIAS

A family of Spanish origin, the Borgias were based in Italy and became prominent during the Renaissance. Although they were patrons of the arts, they are remembered for their corrupt rule when Rodrigo Borgia (1431–1503) was Pope (as Alexander VI).

*Below: The city of Urbino is situated on a high sloping hillside. Even today its Renaissance heritage is apparent.*

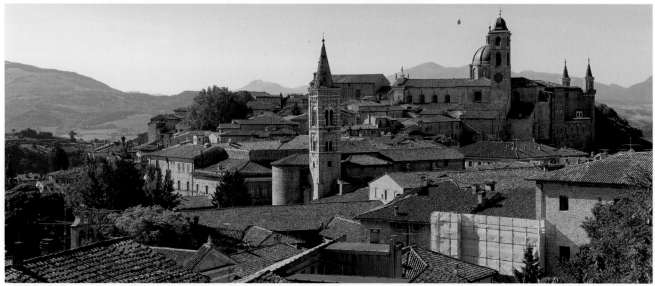

# RAPHAEL'S EARLY YEARS

At Easter 1483, while the rest of the city was still mourning the skilful ruler Duke Federigo, who had died the year before, the Santi household was celebrating the birth of a son. The popular duke Federigo was succeeded by his 11-year-old son that same year.

In the decades prior to Raphael's birth, Urbino enjoyed peace, benefiting from the wars that Federigo engaged in elsewhere. Profits of war kept Urbino's taxes low and also enabled Federigo to build his magnificent palace and library and to establish one of the most admired courts of the day. As well as employing some of the best architects, Federigo commissioned some of the greatest European artists, filling his palace with paintings, sculpture and a set of tapestries from Flanders, which was recognized as the principal centre for tapestry weaving in Europe at the time.

## AN EVENTFUL YEAR

During the year of Raphael's birth, significant events occurred elsewhere. At the beginning of the year, in Spain, the ruthless Tomás de Torquemada (1420–98) became Inquisitor General of the Spanish Inquisition, while in England, Edward IV died, leaving his sons; twelve-year-old Edward, and ten-year-old Richard. The two princes were housed in the Tower of London and were never seen again. In Germany, Martin Luther was born. Giovanni Bellini was named the official painter of the Republic of Venice. In Rome, Pope Sixtus IV (r.1471–84) opened the newly built Sistine Chapel after a team of artists – including Pietro Perugino (c.1446/50–1523), Sandro Botticelli (c.1445–1510) and Domenico Ghirlandaio (1449–94) – had painted a series of frescoes there, depicting the lives of Moses and Christ, papal portraits and *trompe l'oeil* drapery.

In 1489, when he was 17, Duke Guidobaldo married Elisabetta Gonzaga, who cultivated an elegant literary circle, attracting philosophers, writers and artists. From early in Raphael's life, the court at Urbino flourished once more.

## CHILDHOOD

Raphael was born on either 28 March or 6 April. He was the only child of the painter and writer Giovanni Santi, who studied under Piero della Francesca and was court painter to Duke Federigo. Raphael's mother, Magia di Battista Ciarla (d.1491), was a merchant's daughter – a placid and gentle woman. Unusually for the time, Magia nursed her baby herself as Giovanni did not want him to go to a wet nurse and be exposed to the manners of peasants.

There is little known about Raphael's early life, but throughout his childhood Urbino's reputation as a major artistic cultural centre continued. Giovanni carried on receiving commissions for altarpieces for various prominent local patrons, and his workshop flourished. He taught Raphael from a young age to draw and paint, 'seeing that he was much inclined to that art and of great intelligence' (Vasari).

In 1491, when Raphael was eight years old, Magia died. His father died three years later. The boy was left the

*Left:* Sacra Conversazione, *1491, fresco by Giovanni Santi in the church of San Domenico, Cagli – an important altarpiece by Raphael's father.*

*Right: An angel (believed to be young Raphael), 1491, by Giovanni Santi; detail from opposite page.*

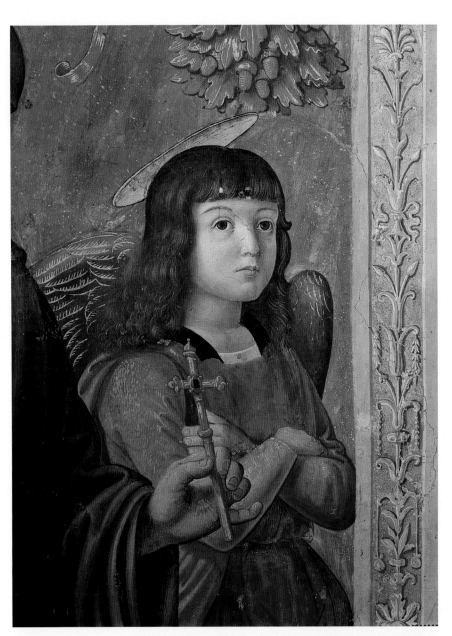

bulk of his father's estate and was entrusted to the care of his paternal uncle, Bartolomeo Santi, a local priest. Giovanni had remarried after Magia's death and it is believed that Raphael helped his stepmother Bernadina to manage his late father's workshop. The rest of Raphael's education remains unclear. Vasari wrote that he was placed in Perugino's workshop as an apprentice before the death of his mother, but, even in those days, eight years old would have been extremely young to begin an apprenticeship. Most boys became apprentices after their 11th or 12th birthday. If he did become Perugino's apprentice, it was more likely to have taken place in the late 1490s after both his parents had died; but this remains unverified, as he is not mentioned in any of Perugino's documents, while many other students are. Most historians, however, agree that Raphael almost certainly worked as Perugino's assistant from around 1500, and Perugino's influence on his early work is clear.

*Below: An engraving of 1825 by John Corner, who believed this to be Raphael – although it was actually Bindo Altoviti.*

*Below right: The house where Raphael lived in Urbino is now a museum.*

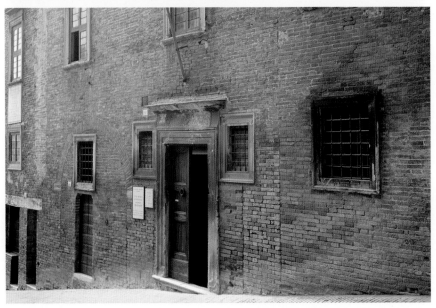

# INFLUENCES

From the 1480s onward, Giovanni Santi was at the head of a thriving painter's workshop, engaged in the staging of theatrical performances for the Urbino court, and composing a story in verse. So, growing up, Raphael was aware of the advantages of developing interests in many different aspects of culture.

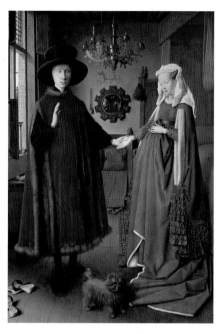

In later life, many commented on Raphael's charm and good manners. He learned these at the Urbino court, and it is quite possible that the kindly Elisabetta, wife of Guidobaldo, the Duke of Urbino, took an interest in him since she had no children of her own.

## ADVISORS AND MENTORS

Once Raphael's father died, at least two other painters advised and helped him in his career. These were Evangelista da Pian di Meleto (c.1460–1549), one of Giovanni Santi's pupils; and Timoteo Viti (1469–1523), who succeeded Santi as court painter at Urbino. Either of these two artists may have introduced Raphael to Perugino, or his father may have arranged an earlier introduction. If Raphael was not the apprentice of Perugino, it is possible that he remained at his father's workshop even after his death. Yet despite all the confusion and uncertainty that surrounded his artistic education and formative years, from early on Raphael developed his own accomplished, delicate and ornamental style.

*Above:* Adoration of the Shepherds, *after 1450, by Andrea Mantegna. One of Santi's favourite artists, Mantegna had established his reputation at age 18.*

## PATERNAL INFLUENCE

Between 1482 and 1488, Giovanni Santi wrote *The Life and Deeds of Federigo da Montefeltro, Duke of Urbino*, familiarly known as the 'Rhyming Chronicle'. Written in verse, it eulogized many of the late Duke's skills and achievements. It was popular in Urbino, and as Raphael grew up, his father was recognized for it, becoming a prosperous and popular courtier. In the small court of Urbino, Santi was particularly integrated with the central circle of the ruling family – more so than most court painters. In 'Rhyming Chronicle' he praised the arts in Italy, naming the most famous artists of the time and making it clear which of these he admired the most. His preferences influenced Raphael considerably. His two favourite artists were Perugino, who was one of the first Italian painters to use oil paints proficiently, and

*Above: A painting of Giovanni Arnolfini and his wife, 1434, by Jan van Eyck, who has always been considered one of the greatest artists of the northern Renaissance.*

Leonardo da Vinci. He also praised others, such as Andrea del Verrocchio (c.1435–88; taught Perugino), Botticelli, Luca Signorelli (c.1445–1523; a pupil of Piero della Francesca), Bellini, Paolo Uccello (1397–1475), Pinturicchio (born Bernardino di Betto; 1454–1513) and Mantegna, who was working in Mantua at Elisabetta's brother's court at the time. Soon Santi was also sent to the Mantuan court, on the recommendation of Elisabetta, to paint a series of portraits that were greatly admired when completed and which helped to establish his reputation further.

Raphael's indebtedness to the styles of his father's favourite artists is apparent in his early work. Styles he distinctly displayed as an adolescent were those of Signorelli and Perugino, demonstrating that even from his youngest years he had a remarkable

*Right:* The Coronation of the Virgin, *c.1503, by Pinturicchio (whose name means 'the dauber'). Admired by Giovanni Santi, Pinturicchio was, in turn, also revered by the young Raphael.*

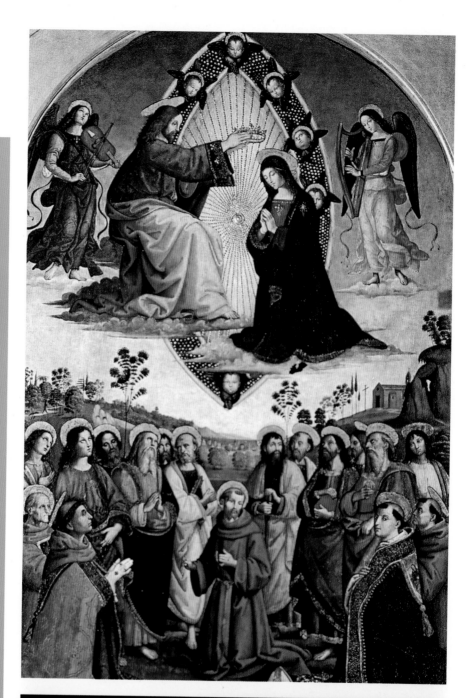

## THE NORTHERN RENAISSANCE

Santi also praised many artists from northern Europe, who developed in different ways to their Italian counterparts. The most artistically advanced countries were Flanders (modern-day Belgium) and parts of the current Netherlands. Whereas social changes in Italy were inspired by humanism, in the north intellectuals were more concerned with religious reform, believing that Rome had wandered too far from Christian values. These ideas were reflected in the artistic output. In terms of style, northern artists were particularly keen on using brilliant colours and featuring naturalistic objects and intricately detailed realism. The northern painters began mixing oil with their pigments instead of using substances such as fast-drying egg tempera. Egg tempera can be stiff to work with and often cracks, but oil does not. Artists travelled and inspired each other. From 1494 to 1495, Albrecht Dürer stayed in Italy for the first time and was influenced by the art he saw, and his own prints were greatly admired there.

capacity for assimilating and reinterpreting the work of other painters. His father's own working methods and techniques, however, formed the main source of Raphael's approach until around 1500, when he started to receive his first commissions.

*Right:* Dying Gaul, *Roman copy of a Greek original of 230–220BCE by Epigonos. Above all, the greatest influence on Italian Renaissance artists was the work of the ancient Greeks.*

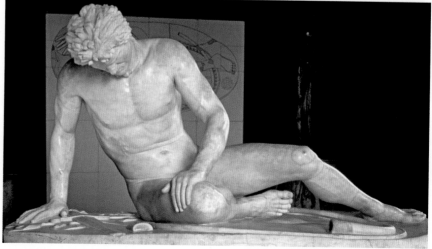

# FIRST COMMISSIONS

It is not clear whether Raphael attended school or was tutored at home, but working alongside his father, he soon started to learn the essentials of his future career by preparing panels, mixing colours and copying his father's drawings and those of other masters.

The young Raphael began receiving commissions in his own right when he was just 17 years old.

### CITTÀ DI CASTELLO
The first documented commission was a large altarpiece dedicated to St Nicholas of Tolentino for the Baronci chapel in the Sant'Agostino Church of Città di Castello, a small town between Perugia and Urbino near the Tuscan border. Evangelista da Pian di Meleto worked on it with him. Commissioned

in December 1500, it was finished in September 1501, and in the documents about it Raphael was described as a 'master', which means that by then he was accepted as a fully trained artist. The design of the altar was entirely Raphael's work, and he painted the altarpiece itself, while the predellas (the paintings running along the frame at the bottom) are attributed to Pian di Meleto. An earlier work, commissioned in 1499, but not officially documented as such, also in Città di Castello – for

the church of the Holy Trinity, is known as *A Processional Banner*. It was another large altarpiece painted for a private family chapel, and at just 17 years old, Raphael was instructed to paint according to the patrons' specifications.

### SIGNORELLI AND PERUGINO
Working in Città di Castello as a teenager, Raphael was brought into close proximity with the art of Signorelli, who was also working there at the time. Various drawings by Raphael for the works he produced there include copies of figures by Signorelli from that period.

Raphael's successful completion of the Baronci chapel altarpiece won him further commissions in Città di Castello, and while working on them he began using several of Perugino's painting methods – including opaque paints richly blended with lead white in highlighted areas, and hatching and cross-hatching in the shadows of drapery – as well some of his ideas of composition. Perugino was extremely popular at that time. Born Pietro di Cristoforo Vannucci, he trained in Perugia and Florence before being commissioned to help decorate the new Sistine Chapel in Rome by Pope Sixtus IV, from 1481 to 1482. Further commissions in Rome followed. He maintained two workshops, in Florence and Perugia. Influenced by Verrocchio (who Vasari said was Perugino's teacher), his style was praised as having 'an angelic and very sweet air' ('le sue cose hano aria angelica, et molto dolce'). In 1500, the banker and art patron Agostino Chigi (1466–1520) described him as 'the best master in Italy'.

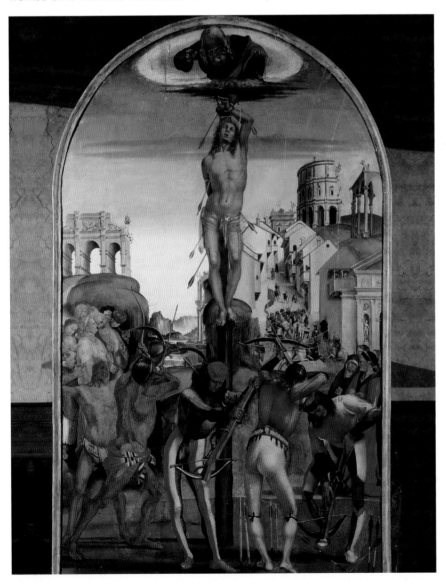

*Left:* The Martyrdom of St Sebastian, *c.1500, by Luca Signorelli – Raphael was inspired by this work in Città di Castello.*

## THE GUILD SYSTEM

Italy and the rest of Europe functioned under the guild system – associations of craftsmen in particular trades. The origins of guilds existed in many different forms in ancient cultures, but by the 14th century, trade guilds developed in Europe to protect craft workers' welfare, to maintain working standards and to assist recruitment. Artists, as was the case with all craftsmen, had to be accepted by a guild and would then begin an apprenticeship at around the age of 12. They trained for several years, and eventually, when the master considered them able enough, each apprentice had to complete a 'masterpiece', which was judged by experts of the guild. If this work 'passed', the student was allowed to call himself a master, accept commissions and start his own workshop, with assistants and his own apprentices.

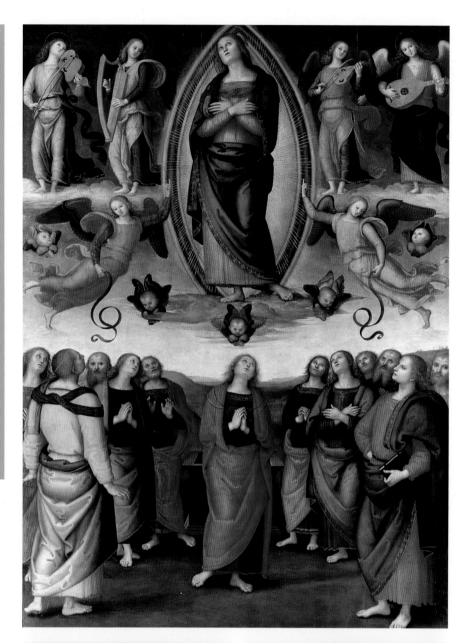

*Right:* Assumption of the Virgin, 1506, by Perugino – clear colours and symmetrical compositions are just some of the things that Raphael admired.

*Below right:* The Marriage of the Virgin, 1500–4, by Perugino. This was the inspiration for Raphael's depiction of 'the same scene.

*Far right:* The Marriage of the Virgin, 1504, by Raphael – who learned by copying those he admired.

By 1502, Pinturicchio invited Raphael to Siena to help design a fresco series in the Piccolomini Library in Siena Cathedral. Raphael created some original designs, but Pinturicchio completed the actual frescoes. Raphael returned to Città di Castello and produced a Crucifixion scene for the Gavari family chapel in the church of San Domenico. This work is now usually referred to as the Mond Crucifixion (page 105), and its style is almost indistinguishable from Perugino's.

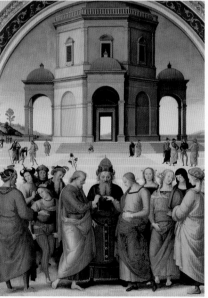

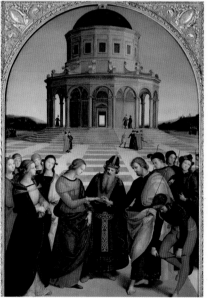

# CHURCH AND COURT

In the shadow of powerful European monarchs, rulers of the small Italian city-states assumed royal status and furnished their courts lavishly. Giovanni Santi, although described by Vasari as an artist 'of no great excellence,' was ambitious and industrious and produced works for the court of Urbino and several churches.

Vasari wrote that Santi was 'a man of good intelligence, well able to direct his children on that good path.' In his Rhyming Chronicle, Santi declared that painters should be esteemed like poets and historians, and he conveyed this attitude to his young son. From the 1480s, as well as working in Urbino, Santi worked on commissions in the neighbouring towns of Cagli, Fano and Montefiorentino. Reflecting many of the skills and styles of his favourite artists, including Melozzo da Forlì (c.1438–94), he was proficient in fresco and oil painting techniques, an unusual accomplishment for the time.

*Below:* Triptych of Virgin and Child with Archangels Michael and Raphael, *1496–1500, by Perugino, from whom Santi and Raphael learned much.*

## SECULAR AND SPIRITUAL

For his first eight years, Raphael was a cherished child of this successful court painter and his wife in a city that had been prominent in Renaissance developments and was returning to its former glory. Vasari described Raphael's family life as blissful. The idea that close family units paralleled workshops of apprentices and masters was an aspect of Italian art that Vasari aimed to portray. There is no doubt that Raphael had a happy childhood and was loved by his parents, but life in Urbino was not always smooth.

*Right:* Madonna and Child surrounded by St John the Baptist, St Francis, St Jerome, St Sebastian and sponsors, *1489, by Giovanni Santi. The artist was skilled in exploiting the clarity of certain pigments.*

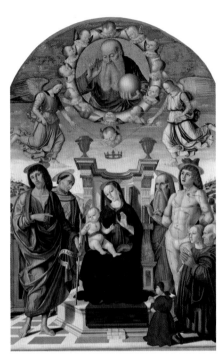

Raphael probably accompanied his father occasionally to the Ducal Palace where he could see the work in progress and observe painting methods. He would also have absorbed the concepts and themes that were popular with the aristocracy. With the spread of learning, opening of universities, increase in trade and development of a bourgeois class, secular art was in demand, while religious compositions were still required, particularly as altarpieces. Santi had gained a good reputation as a painter of diversity, which showed his son how being flexible helped keep an artist in demand.

## TENSION AND UPHEAVAL

Under Guidobaldo, Urbino retained much of the reputation of splendour his father had instigated, but in 1492, Rodrigo Borgia was ordained Pope Alexander VI. He appointed his son, the ambitious Cesare Borgia as commander

*Above: Baptism of Christ, c.1495, by Perugino, whom Santi considered the artistic equal of Leonardo.*

of the papal armies and in 1502; Cesare laid siege to Urbino and drove out the duke and duchess. He appropriated the Ducal Palace, pilfered its vast treasury of art and manuscripts and took the title of Duke of Urbino. When the Pope died in 1503, enemies rose up against Cesare and the duchy of Urbino was restored to Guidobaldo.

During the same years, Florence experienced huge upheavals. Charles VIII of France invaded the city in 1494, overthrowing the dominant Medici family. He then moved on to Naples. The Dominican friar Savonarola believed that Charles was God's instrument who had cleared the way for him to purify the corruption of Florence. He set himself up as leader of the city, calling it a 'Christian and religious Republic.' Captivated by Savonarola at first, the Florentines soon wearied of the city's constant political and economic depression – a result of his opposition to trading and making money. By 1497, groups of youths rioted. The Pope excommunicated Savonarola and the following year he was burned at the stake in the Piazza della Signoria.

*Above: The Visitation, c.1490–1, by Giovanni Santi. New portrayals of Bible stories were popular in 15th-century Italy.*

## THE BONFIRE OF THE VANITIES

Ignoring the restrictions that his enemies, Ludovico Sforza, Duke of Milan, and Pope Alexander VI, tried to impose on him, in 1497 Savonarola and his followers carried out the 'Bonfire of the Vanities'. They collected thousands of objects associated with vanity and moral permissiveness, such as cosmetics, mirrors, pagan books, chess pieces, artworks (including paintings by Botticelli and other masters), musical instruments, costly clothes and accessories and more, and burned them all in a massive bonfire in the Piazza della Signoria – the focal point of Florentine social and political life.

# HARMONY AND BALANCE

As Raphael was growing up, Renaissance developments in art were maturing. The period has been described as a flourishing of creative genius, when artists' skills blossomed and they particularly exploited the qualities of harmony and balance. From the start of his career, Raphael contributed substantially to this.

Consciously reconsidering the artwork of ancient Greece and Rome, Renaissance artists developed an interest in portraying detail and smooth, flowing contours. As successive artists worked ever more innovatively, they developed levels of attainment for which there had been no real precedents. They used the classical art of antiquity as a spur, and their forms, colours, proportions, tonal contrasts and compositions became more complex, while they sought scientific ways to represent perspective and anatomy.

## PIONEERS

Since the start of the Renaissance there had been no consistent style in painting, but a primary concern of artists was to create realistic-looking works. Realism was achieved using several methods, such as linear and atmospheric perspective to depict space and depth, and colour to convey light and shadow. Artists focused on human beings and the natural world, whether in portraits, biblical scenes or mythical stories. In the previous century, Giotto was one of the first pioneers of many of these ideas. The revolutionary impact of his art was fully assimilated within a century after his death, and his example was soon followed and built on by many others.

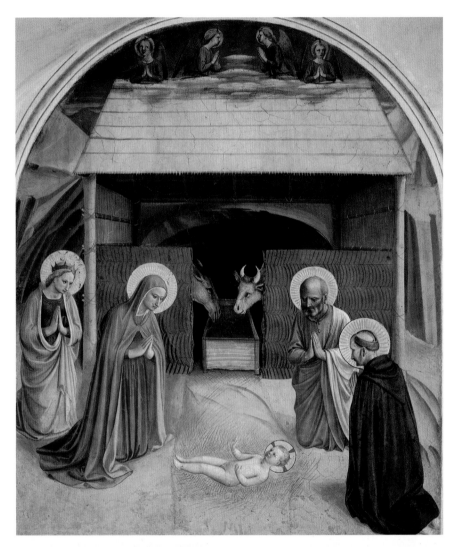

*Above right: Nativity, 1439–43, by Fra Angelico. With its clear use of perspective, his work has no superfluous details.*

*Right: Atalanta, mythological female athlete, 3rd–2nd century BCE, Greece. Renaissance artists focused on the harmonious proportions of ancient Greek art.*

*Far right: Children Singing and Dancing, 1431–8, by Lucca della Robbia. The artist's first commission shows his natural talents – and his debt to classical art.*

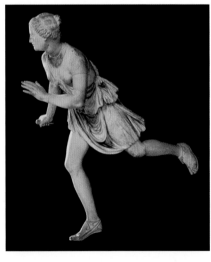

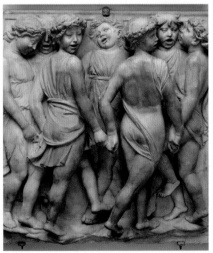

## CLASSICISM

As the Renaissance developed, artists, writers and philosophers continued to admire the art of classical antiquity. Artists in particular copied and evolved their own ideas from the art of the past. Most of this included efforts to represent figures as realistically as possible, but with restraint so that their work was not flamboyant or overly ornamental. Their work upheld a sense of reason with restraint, well-balanced proportions, rhythm and harmony flowing through. At various times from the Renaissance to the present day, classicism has taken a prominent role in art and architecture.

These included the artist Fra Angelico (c.1400–55), one of the first to portray graceful figures in perspective, who painted in brilliant colours, reconciling Renaissance advances with delicate manuscript illumination. Another example was Piero della Francesca, who used mathematical precision, linear perspective, colour and light to achieve clarity and stillness in works that portray mysticism, humanism and Christianity. Mantegna featured clarity of line and an accomplished use of perspective, while Botticelli created rhythmical lines coupled with graceful contours, spatial illusions and a sense of spirituality to arouse emotion in viewers. These were just a few artists who exemplified the harmony and balance of Renaissance painting and whose ideas fed through to Raphael at the start of his career.

### DOMINATING THE ART WORLD

Raphael responded to a wide selection of these groundbreaking artists, absorbing and adding to many of their ideas and techniques. At first, however, his strongest influences were still Perugino and Signorelli – who dominated the art world in northern Italy at the time. They both received many commissions in distinguished locations, highly visible and well paid. Raphael naturally aspired to become equally well established. He followed Perugino's methods of applying paint, blending colours and representing tone, as well as following his ideas about symmetry, equilibrium and serenity. From Signorelli he learned to portray a sculptural dynamism that he had not seen before, as well as a calmness and dignity through clear colours and balanced compositions. Both Perugino's and Signorelli's paintings were created to encourage quiet contemplation, and Raphael was quick to equal this.

### ELEGANCE AND TRANQUILLITY

Raphael emulated the elegance and tranquillity of many classical works, and began his painting career with a sure hand. He never included extraneous details and used colour and contour with clarity, showing a level of skill that set new standards in painting. By the end of 1502, he was so highly thought of that he was commissioned to paint three altarpieces in Perugia.

*Below:* La Primavera, *1477–8; Botticelli's characteristically elegant flowing style included complex stories and decoration in his paintings.*

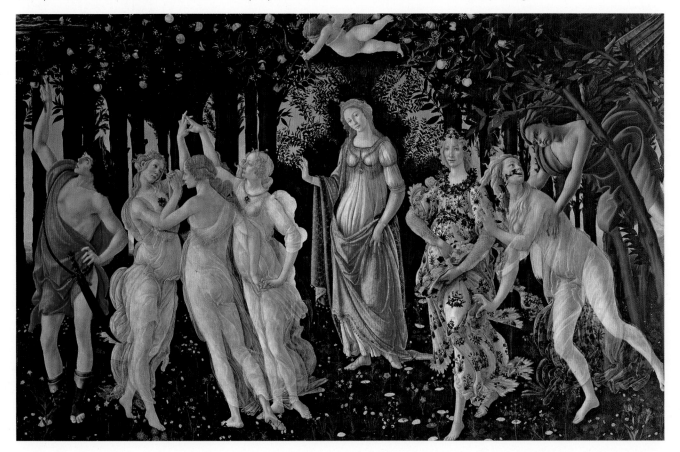

# FLORENCE

Situated on the River Arno in Tuscany, Florence had been one of the most exciting cities in Europe since the 13th century. A trading town dominated by merchants and bankers, it played a vital part in the growth of modern capitalism. Believed to be the birthplace of the Renaissance, it was the obvious destination for Raphael.

From 1500 to 1504, Raphael was kept extremely busy. He produced several altarpieces and many smaller works. Despite being in his early twenties, he met diverse challenges and made good use of a wide variety of influences.

## CITIZEN POWER

Florence remained a republic until the 1530s, run by trade guilds of elected citizens. Despite the loss of half its population through the plagues of 1340 and 1348, the instability of warfare, uprisings and conspiracies, it continued to prosper. By the 15th century, it had absorbed the territory of many of its hostile neighbours, becoming the largest city in Europe. Florentines, whose wealth was rooted in textiles and banking, were extremely proud of their independence and autonomy. They saw Florence as the ideal city, the centre of

humanist thought where the freedom of the individual was guaranteed. This flowed into developments in painting, sculpture and architecture, whereby some of the most spectacular accomplishments of the Renaissance were created by some of the greatest artists and architects who lived and worked there, such as Donatello (born Donato di Niccolò di Betto Bardi; c.1386–1466), Lorenzo Ghiberti (1378–1455), Filippo Brunelleschi (1377–1446), Giotto, Fra Angelico, Verrocchio, Ghirlandaio, Masaccio (born Tommaso di Ser Giovanni di Simone; 1401–28), Botticelli and Michelangelo.

## MACHIAVELLI

In Florence, new ground was broken not only in art, architecture and the economy, but also in philosophy and politics. Niccolò Machiavelli

(1469–1527) grew up during the Savonarola regime to be one of the most important thinkers of the Renaissance. A political philosopher and diplomat, he worked for the Florentine government but was dismissed by Lorenzo de' Medici when the Medici family gained power. Machiavelli wrote a political treatise called The Prince (1513), allegedly based on Cesare Borgia's activities, in which he advised how Italy could be united with judicious use of violence and deception and the promotion of material prosperity. Although Machiavelli dedicated The Prince to the Medici family, they disliked its sentiments and it was received with outrage by the public. In most of his other writings, Machiavelli gave a contrasting view, encouraging a spirit of patriotism, intellectual freedom and individual expression.

*Above: From 1506–7 in Florence, Raphael painted portraits of the merchant Agnolo Doni and his wife Maddalena.*

*Above: In his portraits of Agnolo and Maddalena Doni, Raphael displayed a strong influence of Leonardo da Vinci's style.*

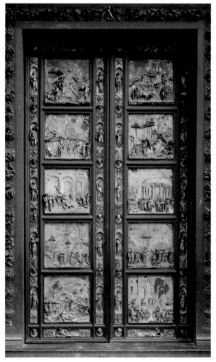

*Above: The Gates of Paradise (Baptistery of St John, Florence), created by Ghiberti, took most of the first half of the 15th century.*

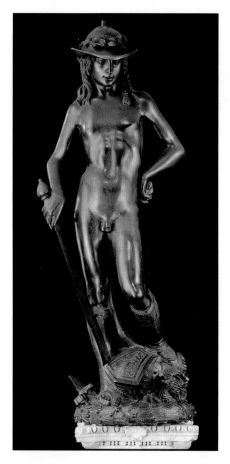

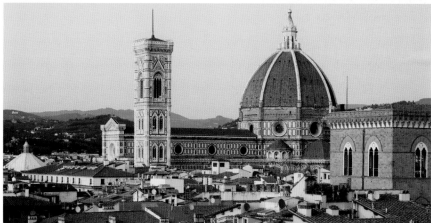

## RAPHAEL'S VISITS

Although it has been documented that Raphael went to Florence in 1504 and left in 1508, there is no proof that he stayed there for the four years. As he was in Perugia during 1505 and 1507 and in Urbino twice in 1506 and again in 1507, it seems more likely that he made several visits to Florence, where he studied earlier artists such as Donatello and Masaccio, but he was especially keen on familiarizing himself with the work of his contemporaries Michelangelo and Leonardo.

*Above: View across Florence, with the Duomo Santa Maria del Fiore, designed by Brunelleschi, in the distance.*

*Top left: David, c.1430–2, by Donatello. This is famous as the first unsupported standing work of bronze cast during the Renaissance period.*

*Top right: Apparition of the Virgin to St Bernard, 1504–7, by Fra Bartolommeo. Raphael learned about colour and handling of paint from his friend the friar.*

## THE MEDICI

A Florentine family that rose to prominence in the 15th century, the Medici dynasty originally traded in textiles, but they amassed enormous wealth and gained an international reputation through banking. From the 1430s, Cosimo dominated the political, cultural and artistic life of Florence; his son Piero (1416–69) and grandson Lorenzo 'the Magnificent' (1449–92) carried on the tradition and effectively ruled the city. From 1494 to 1512 and from 1528 to 1530, the family was expelled from Florence, but was restored twice, and in 1513, Giovanni (1475–1521), son of Lorenzo, was elected as Pope Leo X. From 1537, the Medici ruled as hereditary dukes of Florence. Although many criticized their power, Cosimo and Lorenzo created opportunities for broader experimentation in the arts and encouraged artistic patronage.

# LEONARDO DA VINCI

After spending 18 years in Milan, in 1500, Leonardo had returned to his native Florence. From his position in the Florentine government, Machiavelli had recommended that Leonardo should be summoned to paint a large fresco for the city's newly constructed council hall, the Palazzo Vecchio.

In 1504; Michelangelo was appointed to paint a second large fresco in the Palazzo Vecchio. These works were commissioned to help increase the fame and prestige of Florence. This was about the time that Raphael also arrived in Florence. As well as befriending young artists such as Aristotile (or Bastiano) da Sangallo (1481–1551) and Ridolfo Ghirlandaio (1483–1561), he responded to the innovations of local painters.

## LIVELY GESTURES

Raphael was perceived as just one of many young artists who had gone to Florence to learn and earn, but he was fascinated by Leonardo and Michelangelo who were working on their glorified depictions of two victorious Florentine battles; Anghiari and Cascina. However, this duel between the two most celebrated artists of the time eventually fizzled out

*Below: This detail from one of Raphael's most successful frescoes depicts Leonardo as Plato, one of the most revered thinkers of the time.*

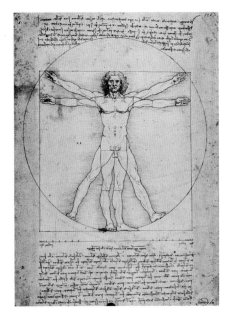

as neither finished their frescoes and both moved on to other work. But the two cartoons remained in the Palazzo Vecchio for ten years and the action-filled, violent images were a revelation to Raphael. He also saw Leonardo's Adoration of the Magi of 1481 that he had started to paint for the Augustinian monks of Saint Donato,

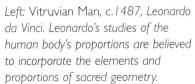

*Left: Vitruvian Man, c.1487, Leonardo da Vinci. Leonardo's studies of the human body's proportions are believed to incorporate the elements and proportions of sacred geometry.*

but had left unfinished as he had gone to work for the Duke of Milan. The panel had been kept in the hope that he would return to complete it, so Raphael had the opportunity to study the work – an innovative composition, painted in oils and featuring over forty figures. In particular, Raphael was astounded by the dynamism of Leonardo's compositions, the lively gestures and expressions as

## LEONARDO'S LIFE

Born in Vinci, near Florence, Leonardo was the illegitimate son of a public notary. He studied alongside Verrocchio in Florence, and by the late 1470s he was working as a painter, architect and engineer, attracting wealthy and important patrons and demonstrating his voracious curiosity and imagination. For the rest of his life, he worked as a painter, sculptor, architect, musician, scientist, mathematician, engineer, inventor, anatomist, geologist, botanist, cartographer and writer. He was the first artist to study the anatomy of the human body and mechanics of movement, and he made many discoveries and inventions decades before the world was ready for them. His many notebooks are filled with drawings and meticulous architectural and engineering details, though it is not known how he managed to acquire his vast knowledge. Unsurprisingly, he is known as the ultimate Renaissance man.

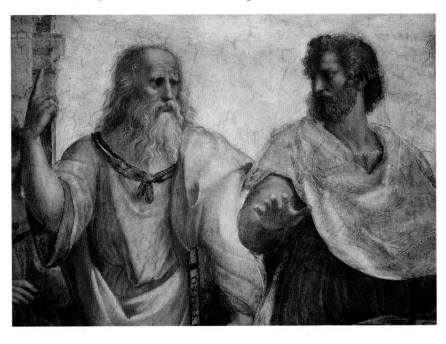

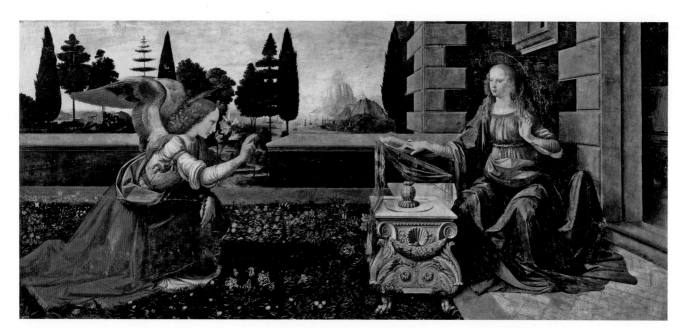

*Above:* Annunciation (*detail*), 1472–5, by *Leonardo da Vinci. This work was conceived while Leonardo and Verrocchio were sharing ideas.*

well as his application of colour, use of tone and his handling of space around his figures.

## DEFIANT BUT RESPECTFUL

Raphael had never seen anything like Leonardo's art. Softly shadowed forms (in the *sfumato*, or smoky, technique) recreated the appearance of reality that had not been achieved before. Interrelating figures were convincingly integrated within their settings. Vasari explained that Raphael 'stood confounded in astonishment and admiration: the manner of Leonardo pleased him more than any other he had ever seen'. One of the main aspects that struck Raphael was that, until that time, all the art he had seen was controlled, reinforcing the authority of those who had commissioned it, whereas much of the art he saw in Florence, starting with Leonardo's, was rather defiant, exciting and refreshing. In depicting familiar themes, Leonardo remained respectful but portrayed powerful messages in innovative ways.

*Below left:* Mona Lisa, c.1503–c.1515, *Leonardo da Vinci. Leonardo started this portrait in Florence, completing it more than a decade later.*

## NARRATIVES

During 1505, Raphael was working assiduously, completing commissions in Perugia while trying to make his name in Florence. He was enriched by seeing Leonardo's work, and although he retained his original style of figures with delicate expressions and facial features, he also incorporated some of Leonardo's ideas of using poses and glances to create narratives between figures, and to intrigue the viewers. He also adopted Leonardo's pyramidal composition for his paintings of the Holy Family.

*Below:* The Last Supper, 1495-98, *Leonardo da Vinci – a work of monumental scale and clever use of perspective.*

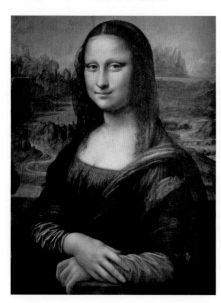

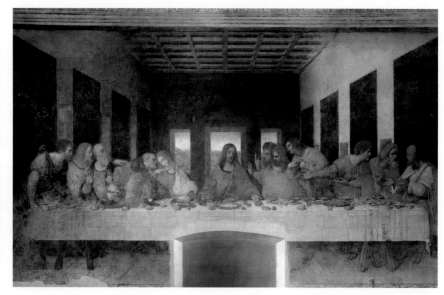

# MICHELANGELO

While in Florence, Raphael studied sculpture as well as painting, particularly the works of Donatello and Michelangelo, who had broken new ground in many different ways. As a result, Raphael's painting style became more robust, with solid-looking figures, and his depictions of space appeared more three-dimensional.

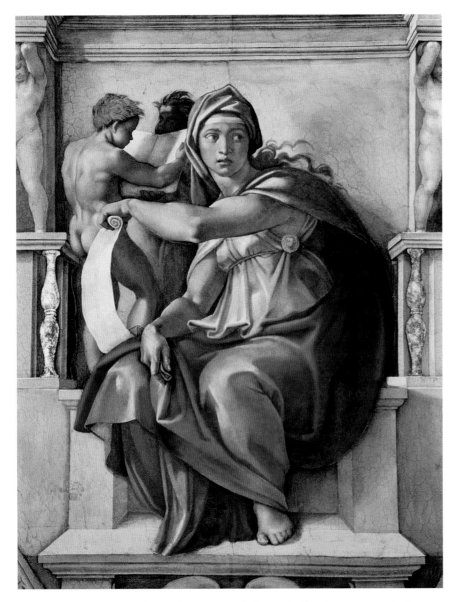

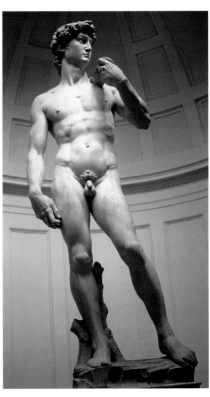

*Left:* Delphic Sibyl, *1509 – one of Michelangelo's many monumental and dynamic figures on the Sistine Chapel ceiling.*

*Above: Revered since it was first unveiled, Michelangelo's* David, *1501–4, showed Raphael that there was scope for more vigorous expression in art.*

He was often called Il Divino ('the divine one') during his life, and was admired for his *terribilità*, or sense of grandeur. Many subsequent artists tried to emulate him, but he remained inimitable and innovative; his ideas were always unconventional and his interpretations of themes were daring, sincere and dramatic.

## DAVID

When Raphael was in Florence, Michelangelo was working on important public commissions, including the fresco

Vasari stated that Raphael was drawn to Florence to see for himself the cartoons that Leonardo and Michelangelo were producing for the Palazzo Vecchio. Michelangelo was another polymath – a painter, sculptor, architect, poet and engineer with a prodigious output. He was in Florence from 1501 to 1506. In 1501 he signed contracts to create 15 statues for Siena Cathedral and several Florentine works, including his huge statue of David. With his daring and often irreverent style, he was already renowned and revered. His work was bold and unexpected and it encouraged viewers to believe in Bible stories and to question issues about humanity and humans' position in the world.

As well as being exceptionally original and skilful, Michelangelo was also passionate and committed. Persistently experimenting with new forms and ideas, he worked tirelessly.

of the Battle of Cascina in the Palazzo Vecchio, the sculpture for Siena Cathedral and the statue for the city of Florence of the biblical hero David. Between 1501 and 1504, he created a monumental 5.17m (17ft) marble statue of David as a boy about to kill Goliath, to represent the strength and valour of the Florentine people.

In June 1504 the huge, free-standing statue of *David* was installed next to the entrance of the Palazzo Vecchio, replacing Donatello's bronze sculpture of *Judith and Holofernes*. The expressive power of the sculpture made a lasting impression on Raphael – during a period when artistic innovations were emerging all the time, it was a revolutionary piece.

Unlike other artists, both Michelangelo and Leonardo studied anatomy and the mechanics of movement. Their artwork displayed genuine expressions and gestures from life, not from a collection of set poses. Raphael began synthesizing what he had seen, copying from both Leonardo and Michelangelo, and he began creating impressions of vitality and dynamism in his own work, using twisting poses, expressions, gestures and nuances of light and shade, contrasting with his earlier more static compositions.

Many other influential artists were in Florence when Raphael was there, including Botticelli, Perugino and Filippino Lippi (c.1457–1504). All well known and successful, they were, nevertheless, not as highly admired as Leonardo and Michelangelo, who were celebrities of the period. At the time (though it was about to change), Florence remained at the forefront of the Renaissance, and Raphael benefited hugely from being there; but it was not easy for any young artist. Important commissions continued to be given to older, more established artists, and Raphael had to be satisfied with smaller, domestic commissions.

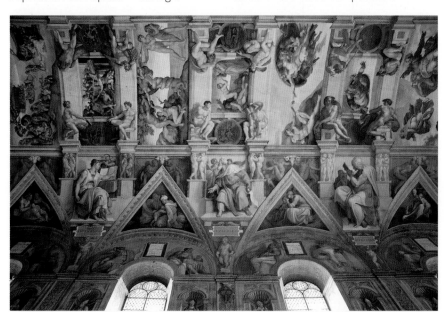

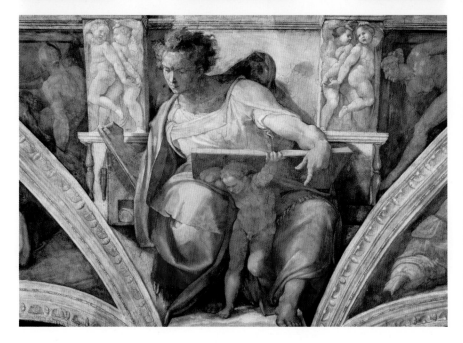

## MICHELANGELO'S BEGINNINGS

Michelangelo was born eight years before Raphael and twenty-three years after Leonardo, in Tuscany, not far from Florence. He was a second son and his father was a local magistrate, though his family descended from minor nobility. Soon after his birth, his family moved nearer to Florence and he was given to a wet nurse, a stone mason's wife, who he later insisted infused in him a love of sculpture. His mother died when he was six, and at the age of 14 he was apprenticed to Domenico Ghirlandaio, to begin learning to draw and paint; but he rejected Ghirlandaio's elegant, cultured style, and soon left. From then on he was mainly self-taught. By studying the work of others, particularly the sculpture in the gardens of Lorenzo de' Medici, Michelangelo learned his style and methods by himself.

*Above left: Sistine Chapel ceiling, 1508–12. Michelangelo painted more than 300 figures across the 40m (131ft) long, 13.4m (44ft) wide area.*

*Left: The Prophet Daniel, c.1508–10, by Michelangelo – no one had ever before translated biblical characters into such believable, dynamic figures.*

# THE MADONNA

Raphael realized that he was unlikely to succeed in Florence. He was young and unknown and competing with some of the greatest artists in Italy. He did receive some commissions from a few influential patrons. These were mainly small works for private use; many were of devotional images depicting the Virgin Mary.

From the mid-15th century, the theme of the Madonna was particularly popular in various parts of Europe. In Florence, the subject was often commissioned by wealthy citizens to decorate their palatial homes, as adornment or for private devotion. With his inherent understanding of creating balanced and harmonious compositions and his empathy toward the theme, Raphael proved himself to be particularly adept at painting images of the Madonna. Although he admired Michelangelo's work probably above all other artists, the biggest influence on these Florentine paintings was in fact Leonardo. In Raphael's Florentine Madonnas, the soft, *sfumato* effects, compositions and landscape backgrounds reflect his admiration for Leonardo, although there are elements

*Below:* Virgin and Child, *1320, Master of the Madonna of Perugia. Representations of the Virgin and Child in the 14th century were symbolic, to give worshippers a focus.*

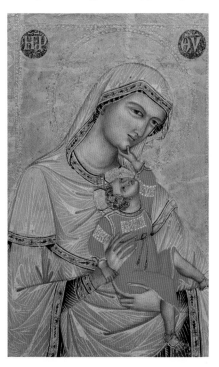

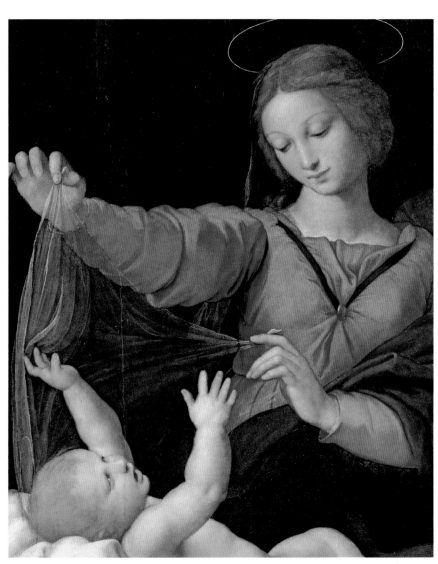

*Above: A detail of Raphael's* Madonna of Loreto, *b.1509, shows his skill in painting the holy figures in intimate moments.*

of other artists' styles, such as those of Fra Angelico and Piero della Francesca.

Unlike previous traditional images of the Madonna seated on a throne, Raphael's Madonnas are in numerous situations. He depicted her with others, with her infant son and alone, and in various moods. In the Bible, Mary is a subsidiary character and little is written about her – she is the mother of Jesus and remains in the background. but in Catholicism she is known as the 'Queen of Heaven' or 'Our Lady' and, with the Immaculate Conception and the

Assumption, is worshipped on holy days.

The earliest images of the Virgin and Child are in the catacombs of Rome, and for more than 1000 years, through the Byzantine, medieval and Early Renaissance periods, this was a common artistic theme. The Madonna came to be specifically an image of Mary with her infant son, and it remained prominent in Roman Catholic art. Raphael imbued

## THE TONDO

Circular paintings became popular in Italy in the 15th century. 'Tondo' derives from the Italian word *rotondo*, meaning round. In Florence, tondi of the Virgin had been favoured for some time, and after seeing a few, Raphael produced some of his own, proving that he could succeed in any artistic challenge.

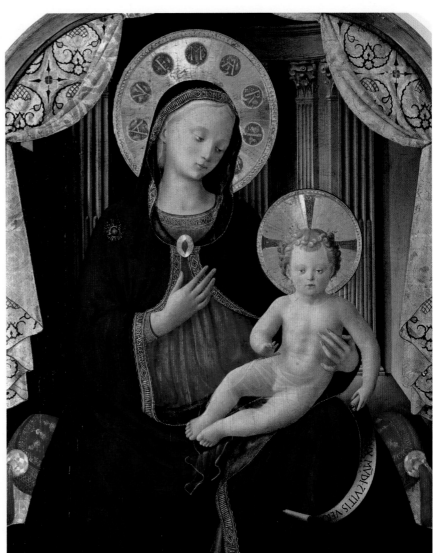

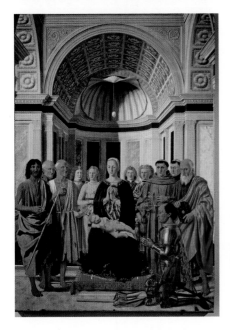

*Above:* Madonna and Child with Saints, *1472–4, by Piero della Francesca – this was painted for Federigo da Montefeltro in Urbino, and was familiar to Raphael.*

*Above:* Madonna and Child, *c.1430, by Fra Angelico (known as the 'Blessed One'). He painted this in Fiesole, a town just outside Florence.*

Mary with human emotions, making her appear gentle and loving. Through his paintings of her, she became more than just a symbol of natural motherly love or of the perfect mother – she was also the embodiment of love. She was a living, breathing, pure young woman aware of her beloved child's future suffering, and beneath her sense of tranquillity, her premonition of grief is palpable.

### MOTHERLY MADONNAS

While in Florence, Raphael copied Leonardo's cartoon of the *Madonna and Child with St Anne*, which was displayed in 1501. He was intrigued by Leonardo's skill in evoking more than just her superficial appearance, but also her underlying emotions. He probably saw other, earlier works by Leonardo which were owned by families to whom he was introduced. One of these works may have been Leonardo's *Benois Madonna* of the 1470s: a small, devotional painting of the sort that Raphael was being commissioned for. In his ensuing works, Raphael fluently incorporated some of Leonardo's ideas, but he also made them individual, showing that he was never dependent on any other artist. Raphael was not the only artist painting images of the Madonna, but he was certainly one of the first to paint her with such empathy.

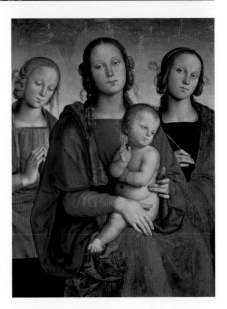

*Above:* Madonna and Child with St Catherine and St Rosa, *1493/5, Perugino – this artist's influence on Raphael is undeniable.*

# GESTURE

Although his Madonna paintings were popular with a few wealthy patrons, Raphael was still just one of many young artists in Florence. So in 1505 he returned to Perugia, where his work was admired and where he received some important commissions, several of which came from women connected to powerful families.

The works he created in Perugia at that time show how Raphael was readily exploiting the new ideas he had seen in Florence. One of the paintings he produced there was the *Colonna Altarpiece*, which had been commissioned by the Franciscan nuns of Sant'Antonio in Perugia, probably two years earlier. The pyramidal composition was inspired partly by Leonardo, and other changes in his style were apparent, such as a greater focus on expressive gesture. Although he remained respectful of his clients' tastes, Raphael now felt assured enough to paint as he chose.

## INTERACTION BETWEEN FIGURES
Raphael's Perugian works display a gradual abandonment of his pre-Florentine manner, such as some of the colours and paint application techniques he had used. Another work from this time is the *Ansidei Altarpiece*, painted for a family chapel in the church of San Fiorenzo. The patron, Niccolò Ansidei, admired Perugino's work, which was why he commissioned Raphael; but in fact the latter's painting exceeded expectations. The sculptural approach, with solid-looking architectural elements and soft but firm tonal gradations, was different, as were the natural poses and gestures and interaction between the figures, giving a sense of real human emotion and character.

Although these Perugian works still hold on to Perugino's influence, they also incorporate more natural poses and facial expressions than Raphael's earlier altarpieces. In several multi-figure compositions he demonstrated this new understanding of ways of depicting gesture, movement and human interaction. In emphasizing natural stances and expressive interplay, he made his figures more human, attracting viewers' attention and opening up fresh opportunities for interpretation and analysis. He constantly rearranged the sacred figures in his compositions, painting natural intimations in a fluid style, building up relationships of affection and intimacy and never repeating himself. The Perugian patrons had never before seen this approach in painting.

*Below:* Altarpiece of the Seven Joys of the Virgin, *c.1480, Master of the Holy Family – a detailed, figure-packed composition of the northern Renaissance.*

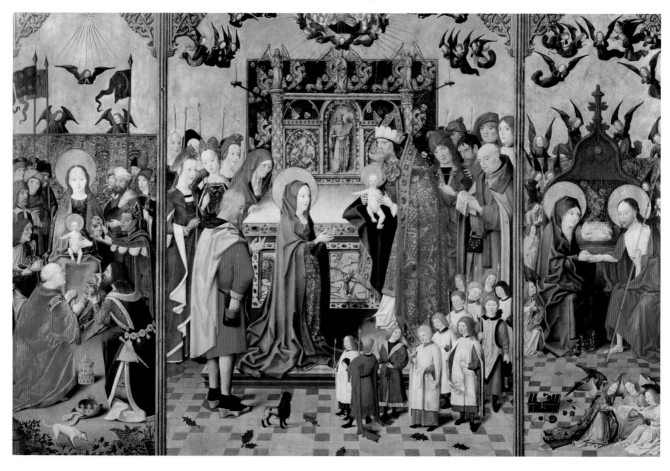

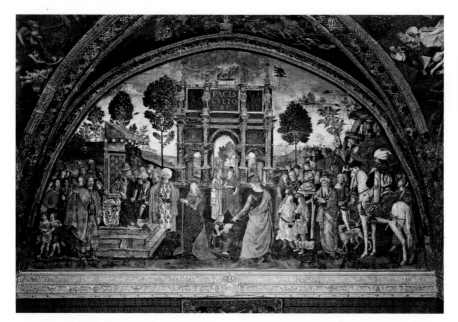

*Left:* The Disputation of St Catherine of Alexandria, 1492–4, by Pinturicchio. Like Perugino, Pinturicchio was a proponent of the Umbrian artistic tradition.

## RESOURCEFULNESS

It was not unusual that an artist should move on from the influences of his early years. What was remarkable was that Raphael managed so quickly to develop such new and accomplished ways of working. He was inspired and influenced by many different artists and yet his emerging style was never confused or muddled. Instead, it was always completely controlled. For instance, his new, livelier figures were complemented by landscape backgrounds that had first been inspired by Perugino and then by Fra Bartolommeo's unusual (for the period) open-air studies of the Tuscan landscape. Once he was working in Perugia, the versatile and resourceful Raphael – armed with his sketches and studies from Florence – incorporated everything he had learned. After Florence, as well as developing greater technical dexterity and a more fluid and natural style, Raphael created a sense of immediacy in his work, which he achieved in several ways. As much as some of his Madonnas showed the influence of Leonardo, so his figure paintings were palpable demonstrations of his admiration for Michelangelo.

*Above:* Coronation of the Virgin (detail), c.1490, by Botticelli. The gestural approach developed in Florence with masters such as Botticelli.

*Right:* Study for a Sacra Conversazione, c.1500, in which Raphael shows his emotive, empathetic style emerging.

# ANGELS AND SAINTS

In conjunction with unexpected portrayals of familiar biblical stories, many Renaissance artists made a point of depicting saints and angels in their paintings. These had been featured in Christian art before, but never in such a human way as they were in the 16th century.

Keen to establish himself as a painter of altarpieces, which was a dependable way of becoming known, Raphael painted religious scenes with angels and saints that had individual and engaging characteristics, and could be believed in. They were not the stiff, symbolic creatures of earlier art, but a combination of Perugino's harmonious renderings and the vigorous expressiveness of artists such as Michelangelo and Fra Bartolommeo.

## CHRISTIAN THEMES

Raphael was not the only artist painting angels and saints with such conviction. Verrocchio, Michelangelo, Leonardo, Ghirlandaio, Perugino and Bellini were just a few others that he had studied who painted realistic-looking angels and saints with individual characteristics. They became such a popular addition to religious paintings that some patrons insisted on having groups of singing or

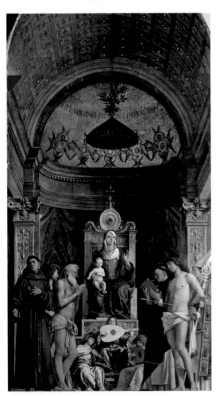

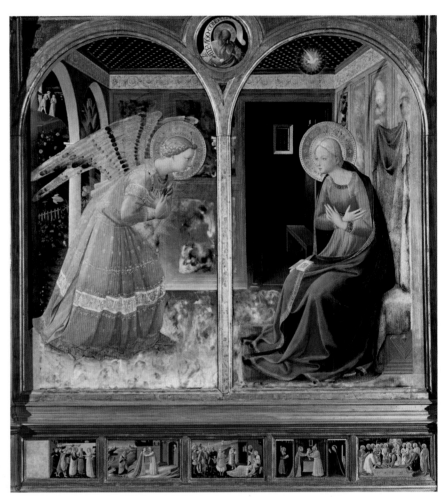

*Left:* Sacra Conversazione, 1487–8, by Giovanni Bellini. The 'sacra conversazione' was a Renaissance development: an image of the Virgin and Child with saints.

*Above:* The Annunciation (Montecarlo Altarpiece), 1440, by Fra Angelico contains an earlier portrayal of angels.

playing angels within their commissions simply to add interest to a work. Madonna paintings in particular were regularly supplemented by angels or rows of saints. In 16th-century Italy, the Catholic Church continued to exert enormous power in society and so Christian themes remained the most important in an artist's repertoire. To be able to paint believable saints and angels was one aspect of attracting further commissions. With his usual stylistic versatility, Raphael painted all his

angels from life, using models and then adding wings, flowing ribbons and other angelic features. He worked in a similar way when depicting saints, always adding elements that made individual saints identifiable to viewers, and never repeating any angel's or saint's pose. The demand increased for paintings imparted with such human characteristics, and the more of these that Raphael produced, the more proficient he became at portraiture, which earned him further commissions.

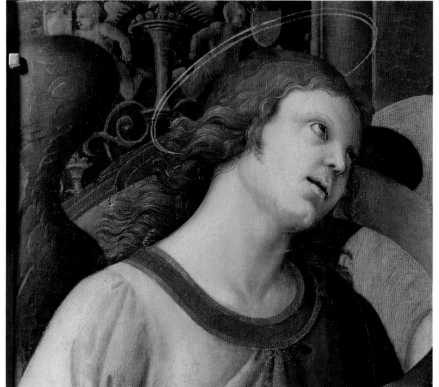

*Above left: Raphael extended his 'humanizing' of angels and saints by incorporating charming little cherubs and putti as part of some of his compositions.*

*Above right: Christ in Glory with Romuald and other Saints, 1492, by Domenico Ghirlandaio – Raphael was particularly inspired by this artist.*

*Left: Detail of Angel Holding a Scroll, 1501, a fragment of Raphael's first commission, the Baronci altarpiece for Sant'Agostino in Città di Castello.*

## PUTTI

Raphael painted small Cupid-like figures with tiny wings as cherubs or putti in some works. In the Bible, cherubs were described as having four wings, the stature and hands of a man and the hoofed feet of a calf. Similar figures appeared in ancient Roman art and golden cherubs were described in the Biblical Book of Exodus. Raphael's cherubs are usually called putti; male infants with wings signifying the presence of God. Originally, cherubs were seen as sacred and putti were mythical, but these distinctions were blurred during the Renaissance.

## THE COURT OF URBINO

By 1506, Raphael was travelling between Florence, Perugia and Urbino, working prolifically and attracting the high regard of members of the rich bourgeoisie. His work was varied and becoming increasingly complex, and he was gaining a reputation for being industrious, quick and accomplished. It is not known how often he returned to Urbino, but it is recorded that he was back there in October 1507 to attend to his affairs. Immediately, Duke Guidobaldo, his wife and his sister commissioned him to paint their portraits and some other small works. Meanwhile, Raphael was working on another altarpiece in Perugia. Commissioned by Atalanta Baglioni, it was for her family chapel in San Francesco al Prato, to commemorate the murder of her son. *The Entombment* (also known as *The Deposition*) was a ground-breaking work, welcomed for its sincerity in showing the torment of a grieving mother as well as the acute anguish of losing a loved one. Everyone appears human, yet the Virgin Christ, Nicodemus, St John the Baptist and the three other Marys have almost imperceptible halos.

# ROME

By the end of 1508, aged 25, Raphael had established his reputation in Urbino and Perugia and had achieved his first commission for a Florentine altarpiece. For most artists this would have been sufficient success for a lifetime, but Raphael was more ambitious than that.

Under Pope Nicholas V (r.1447–55), the Renaissance moved from Florence to Rome. He encouraged scholars and artists to attend his papal court, inspiring an intellectual environment mirroring that of Florence. In 1450 he proclaimed a jubilee, inviting pilgrims from all over Europe to the city.

## URBAN RENEWAL

Pope Nicholas V also instigated an urban renewal of Rome, with the construction of a new St Peter's Basilica. After Nicholas, Sixtus IV, an avid patron of the arts, commissioned several architectural projects and artworks, specifically the building

of the Sistine Chapel, which he had decorated by some of the most renowned artists, including Botticelli, Michelangelo, Ghirlandaio, Perugino, Signorelli and Pinturicchio. These events initiated a golden period in Rome's history, when it became the centre of innovations and developments in architecture and art. Artists and architects flocked to Rome to work on various papal projects, changing the image of the city and stretching their capabilities.

*Below: From the* Rosarium Decretorum *codex, this shows Pope Nicholas V receiving a book.*

### A HOLY YEAR OF JUBILEE

Jubilees were mentioned in the Old Testament Book of Leviticus. In 1300, Pope Boniface VIII declared a holy year; following which jubilees became celebrated approximately every 25 or 50 years in the Catholic Church, generally involving pilgrimage to Rome. A Jubilee was a special year of pardons and forgiveness of sins, when prisoners and slaves were freed. Jubilees helped to bring an attitude of optimism to Rome.

## SUMMONED TO THE CITY

Toward the end of 1508, Raphael was called to Rome to work on the decoration of some new apartments created in the Vatican Apostolic Palace for Pope Julius II. It is not clear how the Pope knew of Raphael, but he could have gained his attention in several ways. It was most likely through two men in particular: Julius's closest adviser, the architect Donato Bramante (1444–1514), who came from Urbino; and his nephew Francesco Maria della Rovere, who had just become Duke of Urbino. Both men knew and respected Raphael and were aware of his burgeoning reputation.

From his arrival, Raphael was inspired by the idealized, classical art of Rome's ancient past, but he was also impressed with the new buildings and artwork that were in evidence almost wherever he looked and the sense of excitement and anticipation that pervaded the city. Michelangelo had been working there since the summer, in the Pope's own chapel, and this was particularly inspiring for Raphael, who revered Michelangelo above all other artists (though this sentiment was not reciprocated). At first, Raphael worked alongside a team of other artists in the Vatican, mainly old friends including Signorelli, Pinturicchio and Perugino. Their task was to decorate the rooms (stanze) of the Pope's suite of private apartments. Within a short time, however, Raphael had been given responsibility for painting four of the rooms by himself.

## THE PRIVATE LIBRARY

On 13 January 1509, Raphael received a payment for his part in painting the ceiling of the room intended to be the Pope's personal library, later named the Stanza della Segnatura by Vasari. In the early 16th century, libraries contained only low shelves of books (up to shoulder height), so paintings often featured on the walls and ceiling above the books. Despite the importance given to this room, Pope Julius II, a complicated and dynamic personality, maintained that he was a soldier, not a scholar. While Raphael worked

painstakingly on the new rooms, the Pope was often away fighting tyrannical rulers in Perugia and Bologna or driving the French out of the territories that bordered the Papal States. Raphael meanwhile began creating an innovative idea for the Pope's new library. As with other patrons, he took Julius's personality into consideration, surprising others with his adaptability and political perception.

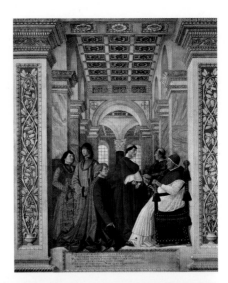

*Right:* Pope Sixtus IV installing Bartolommeo Platina as Director of the Vatican Library, *c.1477, by Melozzo da Forli (c.1438–94), who hugely influenced Raphael.*

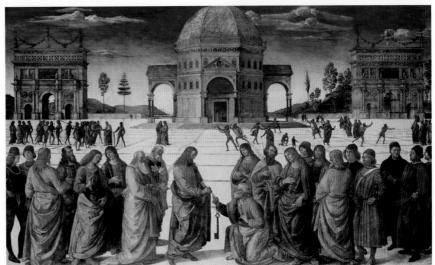

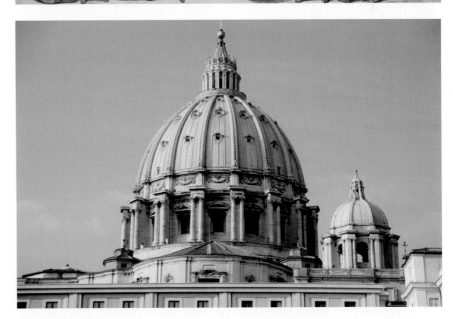

*Top:* Christ Handing the Keys to St Peter, *1481-82, by Perugino. This large Sistine Chapel fresco was painted 26 years before Raphael worked there.*

*Above: The Dome of St Peter's Basilica – Pope Nicholas V commissioned the rebuilding of the old St Peter's, but little had been done by the time he died.*

# POPE JULIUS II

Of all the popes that made creative changes in Rome, Pope Julius II made the greatest. Although he was nicknamed 'Il Papa Terribile' (the fearsome pope) and 'Il Papa Guerriero' (the warrior pope), art and architecture reached the height of magnificence under him.

In 1503, Giuliano della Rovere, the nephew of Pope Sixtus IV, was elected Pope Julius II. He took the name for all its associations with ancient Rome, and he was determined to establish new and fertile opportunities for daring artistic endeavour. With his active foreign policy, he dealt with local threats to papal authority as well as defeating revolts and eliminating foreign powers from the Italian peninsula. He formed alliances with powerful families of Rome, engaged in military campaigns in Perugia and Bologna and participated in treaties, leagues and negotiations with numerous influential individuals in efforts to maintain control. Wanting greatness for the papacy and peace in Italy in general, he also forged close friendships with Louis XII of France and the Holy Roman Emperor, and in 1506 he established the Swiss Guard as papal protectors.

## AMBITIOUS BUILDING PROJECTS

As he began his papacy, Julius was dissatisfied with the condition of Rome, which had been experiencing a long period of decline. Immediately, he entered into ambitious building projects and a fervent patronage of the arts. Pope Nicholas V had been influenced by the ideas of the polymath Leon Battista Alberti (1404–72), an architect, author, artist, poet, priest, linguist and philosopher who had dreams of a Roman Renaissance. But Nicholas had died before most of the ideas had come to fruition. Pope Sixtus IV had also made a start on improving the city and Julius II resolved to finish the vision they had of Rome rising to greatness once more.

Through high taxes and ownership of a rare chemical mine that had become indispensable in fabric dyeing, Julius had money. He began by employing the architect Bramante in

*Above: Pope Julius II, c.1511, a drawing by Raphael.*

1505, encouraging him to use the ruins in the ancient Roman forum as a stone quarry and in particular, in 1506, to demolish the ancient and venerated church of St Peter's that had been built by the first Christian emperor, Constantine. Julius and Bramante together were responsible for the construction of new churches and roads across Rome, but the reconstruction of St Peter's Church was the greatest project of all. Bramante

*Above: Detail of Pope Julius II, from a painting by Raphael, 1511–14.*

*Above: The Swiss Guard at St Peter's.*

## THE SWISS GUARD

Renowned for their courage and loyalty, Swiss Guards have served in foreign European courts since the late 15th century. After Pope Alexander VI had used Swiss Guards in battle, Julius II requested a permanent force to be established in Rome. In 1506, 150 Swiss soldiers arrived at the Vatican and took an oath of loyalty to the Pope. A small force of them have ever since been responsible for the safety of the pope and the security of the Apostolic Palace. In 1512, Julius granted them the title 'Defenders of the Church's freedom'.

began building a church that mirrored the ancient domed temple of the Pantheon in central Rome, but he died in 1514, before it was finished. Eventually, it took 8 architects and 21 popes to see the building of the new St Peter's through to completion — and by then it was an entirely different form from Bramante's vision.

## A TEAM OF ARTISTS

Julius had an extremely violent temper, hated informants and sycophants and was decisive. When he moved into the Apostolic Palace, he took over the apartments of his former enemy, Alexander VI but unable to bear it, he decided to move to four new rooms above. The new suite of rooms ran from east to west along the northern part of the building, and Julius employed his team of highly respected artists to decorate the rooms Although Perugino was established as supervisor of them all, the group of artists did not necessarily work in collaboration, but they worked quickly, each hoping to excel over the others and to be noticed by the Pope.

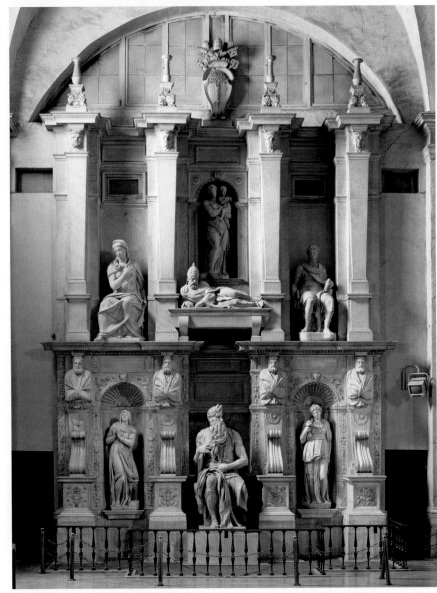

*Right: San Pietro in Vincoli (St Peter in Chains) in Rome where Michelangelo's statue of Moses, part of Pope Julius II's tomb, is located.*

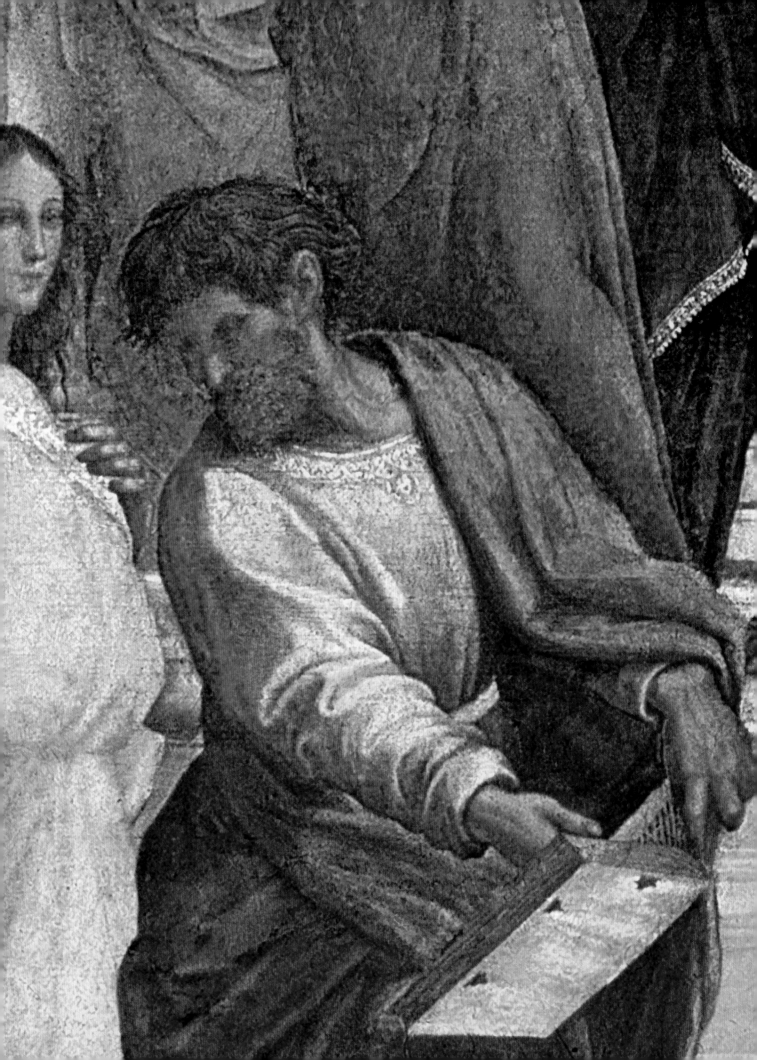

# THE VATICAN FRESCOES

By 1508, although Raphael had painted several Madonnas, altarpieces and portraits, he had not undertaken any grand projects or large frescoes. The artists called together by Pope Julius II to decorate the Vatican apartments each painted particular areas, and it became apparent that Raphael's interpretation of the complex doctrine in the Stanza della Segnatura was superior. Julius commissioned him to paint the whole room by himself. As well as containing books, the Stanza della Segnatura was to be where the Pope signed and sealed important papal documents. In preparatory drawings, Raphael worked out an original plan that emphasized the room's function: poets, philosophers, mathematicians and theologians from the past and present in grand architectural settings.

*Above: A detail of* The School of Athens *by Raphael depicting the ancient Greek mathematician Euclid (flourished in the 3rd century BCE) with some students.*
*Left: Detail from* The School of Athens, *1509–10, in the Stanza della Segnatura. This figure is often identified as 5th-century BCE Greek philosopher Parmenides of Elea.*

# STANZE DI RAFFAELLO

Julius II commissioned Raphael to decorate all four of his new rooms, known collectively as the Stanze di Raffaello: the Sala di Costantino (Hall of Constantine), the Stanza della Segnatura (Room of the Signature), the Stanza d'Eliodoro (Room of Heliodorus) and the Stanza dell'Incendio di Borgo (Room of Fire).

Raphael had been recommended to the Pope by others, but he had to prove himself amid the intense competition. Many established artists, including Perugino, Il Sodoma (born Giovanni Antonio Bazzi; 1477–1549), Baldassare Peruzzi (1481–1536), Lorenzo Lotto (c.1480–1556) and Viti (who, after Raphael's father's death, had become court painter in Urbino), were trying to gain the Pope's patronage, so when Julius commissioned Raphael to complete the Stanza della Segnatura, he worked on several detailed preparatory sketches. The theme was to be the harmony between worldly and spiritual wisdom, which Renaissance humanists considered to be the link between Christian and Greek philosophies – and Raphael's approach was fresh and original.

## INNOVATIVE IDEAS

Raphael's 'test area' was the ceiling of the Stanza della Segnatura. The central octagon on the ceiling had been painted by Sodoma, and other areas had been completed by Johannes Ruysch (c.1460–1533). To this, Raphael added four tondi and four quadrangular sections, which complemented the other artists' work perfectly.

On seeing the inventiveness and precision of his work, Julius instantly recognized a superior talent. According to Vasari, Raphael's approach excited Julius so much that, without hesitation, he awarded him the entire commission to complete the decoration of the room and, 'He caused all the pictures of the other masters, both ancient and modern, to be destroyed.' There was

considerable outrage when the Pope ordered the relatively unknown young man to obliterate frescoes by great artists such as Piero della Francesca, Signorelli and Perugino in order to cover the walls with his own works. However, the same happened in 1535, when Michelangelo (who by then had long been established as one of the greatest living artists), in order to paint *The Last Judgement*, had to paint over work by Perugino.

Although Julius was keen to know what his commissioned artists were doing and was always in charge, he

*Below: Detail of the Stanza della Segnatura ceiling. While Raphael was painting it, the Pope commissioned him alone to decorate his other new rooms.*

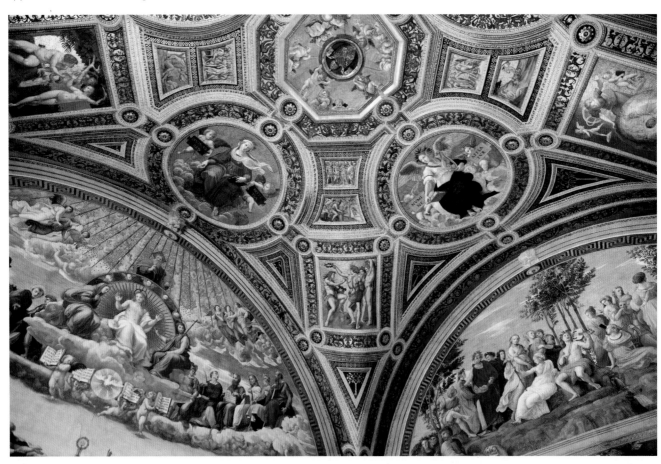

*Top: Two details from Raphael's frescoes in the Vatican rooms, 1511–14.*

*Above: This detail is from the painting* The Fire in the Borgo, *a complex composition that reveals Raphael's admiration of Michelangelo's work.*

nevertheless left them to their own devices (though he would often appear in the Sistine Chapel to ask Michelangelo whether he had finished yet). He was quite an unusual patron in this, but his confidence paid off, as in both the Raphael rooms and the Sistine Chapel ceiling, Raphael and Michelangelo worked more effectively when left to work independently.

*Above: A detail from* The School of Athens *in the Stanza della Segnatura.*

## COMPLEX CHALLENGE

When he undertook the Pope's commission, Raphael had very little experience of painting large frescoes or huge compositions featuring large groups of people. He was unprepared for the work involved; the planning, the preparation and the execution. So it is particularly remarkable that he rose so well to the challenge, achieving such coherent, complex and sophisticated results. As a consequence, Julius II commissioned him to paint the rest of the rooms by himself.

## THE POPE'S PRIVATE LIBRARIAN

Pope Julius II often said he was no scholar and that he hated to speak in public, so his private librarian, the scholar, actor and orator Cardinal Tommaso Inghirami (1470–1516), rose to prominence. He liked to tell stories, and when Raphael began painting the Pope's rooms, he spent a great deal of time in the Stanza della Segnatura, reading aloud and relating stories to Raphael and his assistants. The room echoed with his voice and the artists' friendly banter.

# THE SCHOOL OF ATHENS

In June 1509, a year after Michelangelo had started painting the Sistine Chapel ceiling, Raphael started work in the Stanza della Segnatura. He began by illustrating Biblical episodes, classical mythology and Aristotle's and Plato's philosophies – then the room's second major fresco, *The School of Athens*.

One of four large frescoes in the room, *The School of Athens* represents truth acquired through reason, or philosophy. In the Early Renaissance it was customary to paint allegories to explain these principles, and this would have been expected of Raphael. Instead, however, he painted a scene in which the greatest thinkers and philosophers of the past and present are gathered together in a large, classical architectural setting. The surroundings are based on the remains of the Basilica of Constantine in the Roman Forum and Bramante's vision for the new St Peter's Basilica. Painted between 1509 and 1510, the fresco is considered to be one of Raphael's greatest works.

## FAITH AND TRUTH

The idea of grouping so many thinkers and writers from across the ages was entirely Raphael's, and it epitomizes the humanist thinking of the Renaissance. But without the kinds of documented or recognized personal symbols that are associated with, for example, Christian figures, it is difficult to determine which philosophers are depicted. Raphael wrote no descriptions of the work, and no contemporary documents explain the painting, but he included some signs to identify each figure. Many of the characters are actually portraits of some of the greatest artists and architects of the time, including Bramante (as Euclid) and Leonardo

*Above: The largest building in the Roman Forum, the Basilica of Constantine (here depicted in an 18th-century painting) formed the basis for the architectural setting in* The School of Athens.

*Below: Raphael's interpretation of the anti-social Greek philosopher Diogenes – detail from* The School of Athens.

### PORTRAIT OF MICHELANGELO

Vasari claimed that while Raphael was working in the Stanza della Segnatura, Bramante secretly smuggled Raphael into the Sistine Chapel to allow him to see what Michelangelo was painting there. Raphael was so impressed that he added to his fresco a portrait of Michelangelo as Heraclitus, sitting on the steps wearing his stonecutter's boots. (It is known that he added this portrait because his original full-scale preparatory drawing survived with no sign of Michelangelo.)

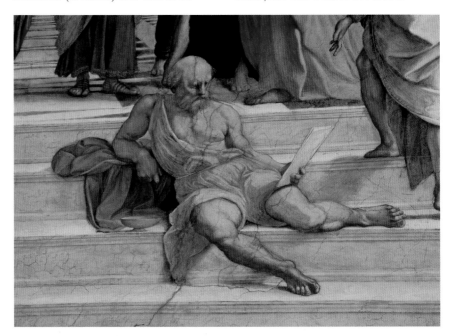

(as Plato), along with a self-portrait of Raphael. The painting represents the terrestrial world, in contrast with the depiction of the celestial world on the *opposite wall: The Disputation of the Holy Sacrament (or The Disputa)*. Whereas *The Disputation* focuses on Faith, *The School of Athens* is about Truth. The painting depicts distinct areas of knowledge and was a clever adaptation of accepted decorations of libraries; since antiquity it had been customary to display portrait busts of authors among their books.

## PLATO AND ARISTOTLE

The two figures in the centre of the painting, isolated and framed by an arch, are Plato and Aristotle. Plato (as Leonardo) points to the sky, holding the *Timaeus* – one of the dialogues that he wrote in about 360BCE in which he discussed the nature of the physical world and humanity. Aristotle holds a copy of one of his volumes of *Ethics* –and gestures toward the earth. In this exceptionally simple way, Raphael synthesized the two great thinkers' contrasting philosophical ideas. Small groups and secondary figures are gathered around the two main ones; some talk while others listen, and some write or meditate. The whole picture conveys a classical cultural world that is dominated by intellect.

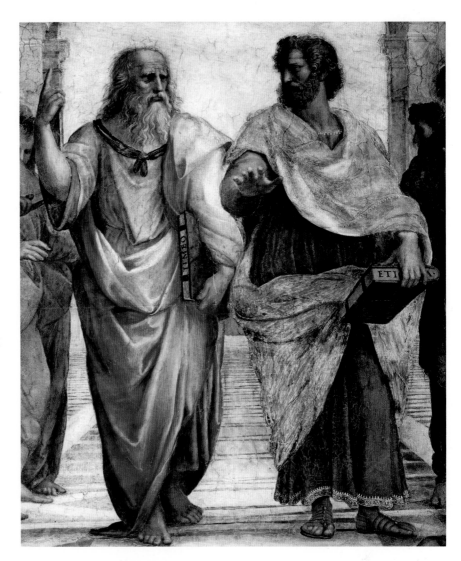

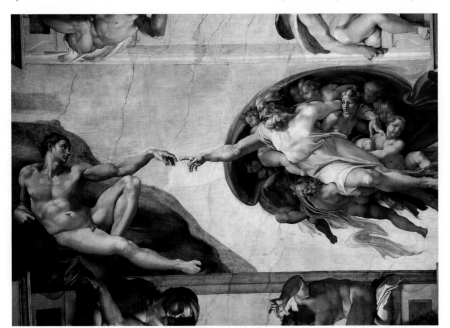

*Below: The Creation of Adam, by Michelangelo – the Sistine Chapel ceiling had an impact on Raphael's fresco style.*

*Above: Detail from The School of Athens – Plato is on the left, and Aristotle, his student, is on the right.*

## THE NEW ATHENS

It is not established how much Raphael knew of ancient philosophy, but it is known that in January 1508 a professor from the University of Rome, Battista Casali, had delivered a lecture to the Pope, describing Rome as a 'new Athens', reminding the audience that the fall of Constantinople in the mid-15th century had passed a responsibility on to Rome to uphold the legacy of Latin culture, and that of the ancient Greeks. Although the conquest had occurred more than 150 years before, the Ottoman Turks were becoming a threat to Italy. The Pope and those who attended the oration were stimulated by Casali's words, and Raphael's ideas in *The School of Athens* led on from the professor's principles.

# STANZA DELLA SEGNATURA

Raphael's work in the Stanza della Segnatura included frescoing the four walls and the ceiling. His began with the ceiling, after Sodoma had already painted the central octagon and Ruysch had decorated the mouldings. When Julius commissioned him, he retained some of their paintings, fitting them into his own scheme.

The ceiling of the Stanza della Segnatura is covered in gold mosaics, interspersed with a regular pattern of images that link all four of the frescoes in the room. Above each fresco is a tondo, each featuring a large, female allegorical figure. The women sit on thrones in the clouds and personify *Poetry, Philosophy, Jurisprudence* and *Theology*. On the wall under *Poetry* is a fresco of some of the greatest poets assembled on *The Parnassus*. Under *Philosophy* is *The School of Athens*. Under *Jurisprudence* is a fresco showing two kinds of law: the civil law of the secular state and the canon law of the Church.

Finally, under the tondo representing *Theology* is *The Disputa*, which portrays theologians contemplating the mystery of the sacrament.

## DELICATELY COLOURED

The tondi are all delicately and subtly coloured. The women's clothes, the clouds beneath their thrones and their features are all different. For instance, *Philosophy* is on apricot-coloured clouds of the sunrise and *Poetry* is on pink-coloured clouds depicting sunset. *Theology's* dark clouds imply night, while *Jurisprudence* (or *Justice*) sits on white clouds edged with gold, indicating day. *Philosophy* wears a star-embroidered tunic and flowered mantle, and she holds books of moral and natural philosophy. Two putti on either side of her carry inscribed tablets. *Poetry* holds a lyre and a book. She has putti at her sides, carrying tablets that claim she is inspired by the gods. *Theology* also holds a book, and looks away from the two putti at her sides. And *Jurisprudence* holds a sword and scales, her eyes are downcast and four putti flank her.

## CLASSICAL STYLE

Below each tondo in the triangular corner spaces are ornately bordered squares representing *The Temptation, The Judgement of Solomon, The Creation of the Planets* (or *Astronomy*) and *Apollo and Marsyas. Astronomy* was Raphael's first painting in the Vatican and the work that inspired Julius to commission him for the whole room. Astronomy is represented by a woman leaning on a

*Above left:* The Creation of Eve, 1510, *by Michelangelo, whose original Sistine Chapel paintings stunned everyone.*

*Left: The ceiling of the Stanza della Segnatura. Poetry (left), Philosophy (right), Theology (top) and Jurisprudence (bottom).*

*Right:* The Judgement of Solomon, *c.1510, is at the bottom right of the ceiling with* Philosophy *above it;* Temptation *above that.*

*Below right:* Pope Julius II Ordering Bramante, Michelangelo and Raphael to Construct the Vatican and St Peter's, *1827, by Horace Vernet – a 19th-century interpretation of 16th-century events.*

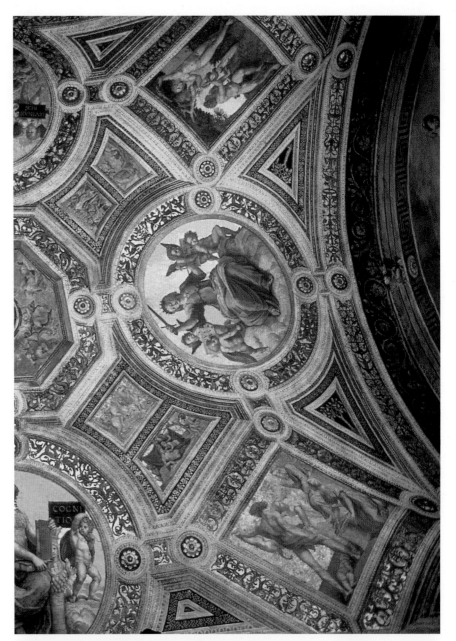

huge celestial sphere. Dressed in green, she seems more like a pagan goddess than a saint or an angel. She watches the Earth revolve in the centre of the celestial sphere as, nearby, two putti holding books skate on small clouds and smile at each other The work shows the influence of Perugino, Signorelli and Fra Bartolommeo, and the palette echoes the colours of early Christian mosaics.

In *The Judgement of Solomon,* King Solomon sits on his throne watching the real mother lunging forward to an executioner who, with his back to viewers, holds her baby by the heels. The false mother kneels, pointing to a dead baby. In *The Temptation,* Adam sits by the tree as the female-headed serpent coils around the trunk. Eve stands nearby, a beautiful, almost classical Greek goddess. *Apollo and Marsyas* is an attempt by Raphael at representing ancient, classical themes: in the centre, a shepherd holds a laurel-leaf crown above the head of a god who sits holding his lyre and making a sign to another shepherd who is holding a knife. Marsyas is tied to a tree, his toes barely reaching the ground.

In the corners of the ceiling are representations of the four elements, Fire, Earth, Water and Air.

## MICHELANGELO'S CEILING

From 1509 to 1511, as Raphael was painting this ceiling, he was acutely aware of Michelangelo working nearby in the Sistine Chapel. In August 1511, Michelangelo unveiled the first half of his ceiling to huge acclaim. Raphael was spurred on with even greater determination.

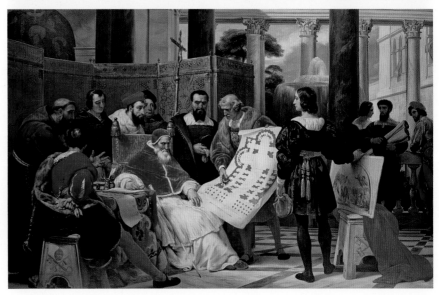

# DISPUTA, PARNASSUS AND JUSTICE

The entire Stanza della Segnatura portrays the four areas of human knowledge, symbolizing Western learning of the time. The *School of Athens* represents philosophy, The Disputa religion, The Parnassus poetry, and Justice law. With these frescoes, Raphael's power of assimilation and capacity for learning came into its own.

Appreciating Julius's desire for recognition as both a spiritual and secular leader, Raphael painted the frescoes representing theology and philosophy facing each other. In this way, he created an impression of the Pope being a balanced, cultured and knowledgeable religious authority.

The first fresco that Raphael painted in the room was *The Disputa* (or *The Disputation of the Holy Sacrament*), on the wall where the theological books were to be kept. Illustrating various religious themes, including the role of the Eucharist, the Church's place in the world and the relationship between Father, Son and Holy Spirit, Raphael took a unique approach. At first, the space he had to cover overwhelmed him, and his early sketches lack many details that he subsequently included.

Until that time, it had been customary for artists to paint groups of figures in simple rows or even in triangular arrangements, but Raphael moved away from this. Taking advantage of the great, semicircular space, he created dynamic groupings while still maintaining harmonious symmetry.

## HEAVEN AND EARTH

Belief in transubstantiation – or the transformation of the bread into the actual body of Christ – is fundamental to Catholicism. In *The Disputa*, the issue is debated by theologians of the past and present, among them Julius II, Sixtus IV, Savonarola and Dante. Sixtus IV is dressed in gold and Dante stands behind him wearing a laurel wreath. The picture features both heaven and earth, with Christ showing his wounds in the centre of the composition, surrounded by his mother, John the Baptist and other biblical figures, including Adam, Abraham, Moses and Jacob. God blesses them from above.

Raphael's interpretations made these remote figures believable and accessible. The image as a whole alludes to the tranquillity of heaven and the bustle of earth.

## ANCIENT AND MODERN

On the north wall, around a window, Raphael painted *The Parnassus*, showing poetry as a means of reaching God. According to classical myth, Parnassus was the dwelling place of Apollo and the Muses and the home of poetry. Raphael painted Mount Parnassus to resemble the hill of the Vatican, which can be seen from the window within the work. The central figure in the scene is the Greek god Apollo, who plays the lira da braccio, a Renaissance musical instrument, while other figures in the work hold ancient musical instruments. Flanking Apollo are nine ancient and nine modern poets, who are accompanied by the nine Muses. Among the poets are Ovid, Virgil, Sappho, Dante, Petrarch, Boccaccio and Homer. The composition is an adaptation of reliefs displayed on Roman sarcophagi.

*Left: Dante (in red) as represented in* The Disputa, *1508–11 (detail).*

*Above: This pencil drawing* Head of a Muse *was executed between 1510 and 1511, in preparation for Raphael's* Parnassus *fresco, designed as a summary and celebration of poetry both ancient and modern. This was a cartoon for the head of the third muse to the right of Apollo.*

## THE MUSES

In Greek mythology, the nine Muses are beautiful goddesses who personify creative inspiration of literature and the arts. Each Muse has a name and a specific symbol alluding to an area in the arts, such as music, drama or poetry.

## TWO KINDS OF LAW

Different from the three other frescoes in the room, Justice seems to return to a traditional decorative scheme for libraries of illustrating the Four Faculties. Rather than creating a scene as in the other frescoes, Raphael divided the wall into three individual sections. Vignettes on either side of the window illustrate civil and canon law, while above are the figures of Fortitude, Prudence and Temperance, representing three of the cardinal virtues.

The three females are accompanied by putti representing the three theological virtues (Faith, Hope and Charity). Demonstrating strength,

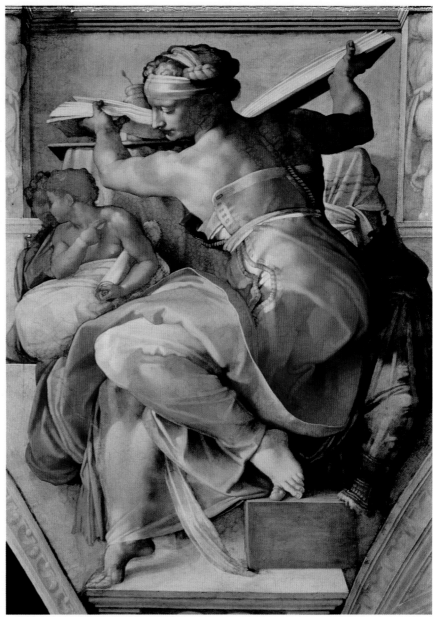

*Above: Raphael's figures took on aspects of Michelangelo's from the Sistine Chapel; this is Michelangelo's* Libyan Sibyl *of 1511–12.*

*Right: Colour lithograph after the ceiling tondo of* Justice.

Fortitude sits with a lion in her lap bending an oak branch, while Charity shakes the tree behind her; to see truth, Prudence has two faces, one young and looking into a mirror and one old and looking back, behind her. Hope carries a flaming torch; and Temperance holds a bridle to restrain excess, while Faith points heavenward.

# GOD HELPING HIS PEOPLE

Raphael's innovations in the Stanza della Segnatura were revolutionary. The Pope was a powerful patron, and the young artist had undertaken a massive responsibility. He was not overwhelmed by this, nor by the intense rivalry around him. Instead, his enthusiasm increased, and his work was admired.

Vasari described Raphael's development in Rome as his most extreme transformation. In March 1509 he had been appointed *Scrittore dei Brevi Apostolici* – a painter of the Vatican Palace with a regular salary. Once he had completed the Stanza della Segnatura, in 1511, he began on the adjacent room, later called the Stanza d'Eliodoro. The room was where Julius began his day and was also used for official functions, so the scenes, in contrast with the contemplative Stanza della Segnatura, needed to be energetic.

## UPLIFTING IMAGES

Recently, the Pope had returned from an unsuccessful campaign against the French in northern Italy. He had lost Bologna, and returned to a hostile faction of cardinals who were trying to depose him. Ill and disheartened, Julius asked Raphael to paint an uplifting cycle of images, depicting God coming to the aid of his people. Four events were

*Below:* The Judgement of Solomon, 1508–10, by Sebastiano del Piombo – an unfinished painting, produced before the artist went to Rome.

selected, two from the Bible and two from the history of the Church: *The Expulsion of Heliodorus*, the story of a Syrian soldier ordered by his king to plunder the Temple of Jerusalem;

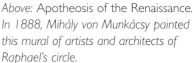

*Above:* Apotheosis of the Renaissance. *In 1888, Mihály von Munkácsy painted this mural of artists and architects of Raphael's circle.*

*The Liberation of St Peter,* telling of Saint Peter's escape from King Herod's dungeons; the story of *The Repulse of Attila* by Pope Leo I and *The Mass at Bolsena*, an event of 1263 at a Mass when blood trickled from the host, convincing the sceptical officiating priest of transubstantiation.

On the ceiling, Raphael painted images of divine intervention from the Old Testament: the Burning Bush, the Announcement of the Flood to Noah, Jacob's Dream and the Sacrifice of Isaac.

The room was purposely designed to reaffirm the Pope's position and the strength of the Church – suppressing all those who sought to undermine him.

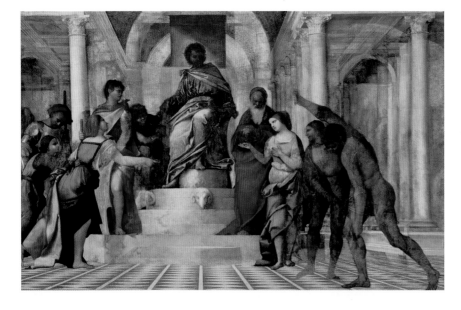

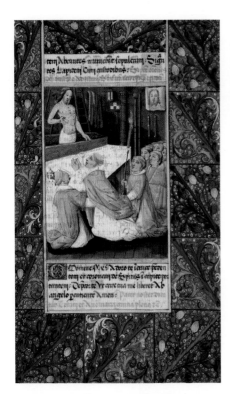

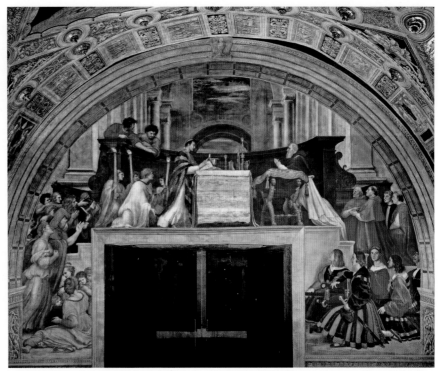

*Above: An earlier depiction of* The Mass at Bolsena, *1469, by Jean Colombe.*

*Above right:* The Mass at Bolsena, *c.1512–14, by Raphael.*

*Right: Detail of Rose Garland Festival by Dürer, including Julius II, painted during the artist's second visit to Italy, in 1505–7.*

## EXPERIENCES AND INFLUENCES

In contrast with the previous room, Raphael painted fewer figures on a larger scale in each fresco. By then he had studied Michelangelo's ceiling carefully, as well as the remains of ancient Roman artworks. He had also been stimulated by another artist, through the banker Agostino Chigi; in August 1511 Chigi returned from a visit to Venice, accompanied by the painter Sebastiano del Piombo (*c.*1485–1547).

## CREATIVE FREEDOM

All the frescoes in the room are dramatic and dynamic, with animated gestures and strong tonal contrasts. *The Expulsion of Heliodorus* features a mounted warrior sent from God, trampling on Heliodorus as he runs from the Temple with his booty. Julius also appears as protector. In *The Mass at*

Bolsena, Raphael made original use of the irregular space around a window and once again featured the Pope. In *The Liberation of St Peter*, three successive moments are shown: in the centre, the angel appears as Peter sleeps; on the left, he is freed; and on the right, the warders discover his escape.

Raphael used Julius as the model for Saint Peter. Revolutionizing history painting, his use of light and shadow symbolizes the Church's spiritual light. The first three frescoes in the room were completed with great success by the end of 1512. In February 1513, Pope Julius II died.

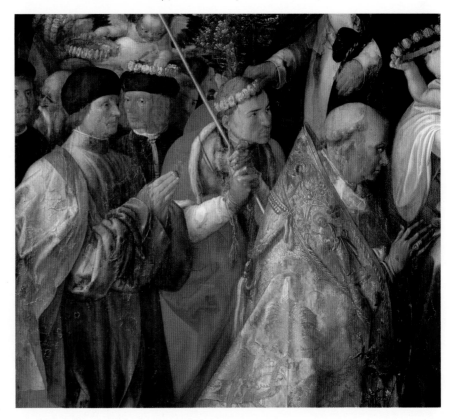

# WORKING METHODS

Raphael's reputation now rose to extreme heights in Italy. He had always produced thorough preparatory drawings for his projects, to help him work out techniques and paint application methods. The competitive atmosphere among artists encouraged innovation, and he worked with a variety of materials.

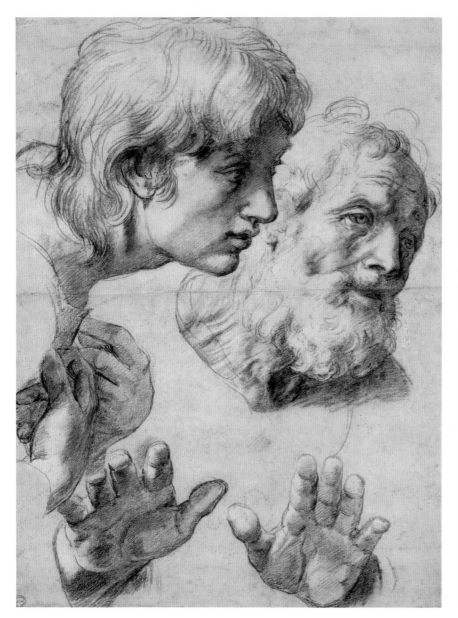

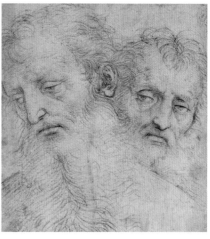

*Above: Working in chalk, Raphael drew these two heads as studies for apostles in c.1503.*

## IMPRIMATURA

The term *imprimatura* comes from the Italian for 'first paint layer', and describes an initial stain of colour or underpainting applied by an artist on to a work surface or ground. Raphael used imprimatura regularly, either in off-white or a darker colour. Imprimatura is a transparent stain and it helps artists to establish tones or highlights in paintings. Successive layers of colour are applied over the imprimatura in thin layers, leaving some of it showing through in the final work.

Raphael used drawings as detailed plans for final works, particularly in planning spatial arrangements. In the relatively recent past, artists had only expensive vellum to work on, but with the rise of printing there was a greater availability of paper. Once Raphael had planned a composition through a drawing, he usually transferred it to a fresh sheet of paper, where he added details such as drapery – which he did by pouncing

*Above: In this study for* Transfiguration, *c.1517, Raphael sketched two apostles and their hands in black chalk touched with white.*

charcoal dust through pin-pricked outlines. Once these preliminary drawings were complete, his assistants could follow them, enabling them to continue a project in his absence if he had to work elsewhere.

## SILVERPOINT

From his earliest years, Raphael mastered various methods of drawing. Through his associations with Perugino he became proficient in silverpoint, a method of drawing on a prepared surface using a metal stylus. With silverpoint, mistakes cannot be corrected, and this suited Raphael's neat, assured and precise style. In conjunction with silverpoint, he also

produced drawings from life in charcoal and chalk, including studies of individual figures and groups, as well as smaller details such as heads, limbs, hands, feet, drapery, architecture, landscape and more finished compositional drawings. He also filled sketchbooks with washes of paint to try out colour combinations. The sketchbooks include observational drawings of other works of art or architecture, toddlers and mothers with children, all later informing his paintings. From the time he visited Florence, he began making pen and ink preparatory drawings, following Leonardo's and Michelangelo's methods. He often added washes of colour or highlights in lead white to pen and ink drawings to work out tonal or colour contrasts.

## MECHANICAL METHODS

To scale up his drawings to the final images, Raphael often used the grid method, and he regularly used a ruler and compasses to incise the outlines of architectural elements.

Before painting on wood, he primed the surface with a layer of gesso (a white mixture of chalk and animal glue). For his frescoes, he used the buon fresco method, a technique of painting on a wall while the plaster is still wet. As the plaster dries, the paint becomes a part of the wall; thus, the method necessitates a rapid, faultless execution, suiting Raphael's meticulous approach.

## TECHNIQUES AND MEDIA

Raphael witnessed a considerable range of techniques as he grew up, both through his father's workshop and from his contact with Perugino. Both Santi and Perugino worked on panel and canvas and used a range of media, including egg tempera, oils and combinations of the two, as well as buon fresco. Although he used many of their techniques during the early part of his career, later he absorbed new ideas from other Renaissance painters. Raphael painted foregrounds, sky and backgrounds with broadly horizontal strokes, while the main elements of his compositions, such as the figures, were painted in more precise detail. He used his fingers to create a *sfumato* effect.

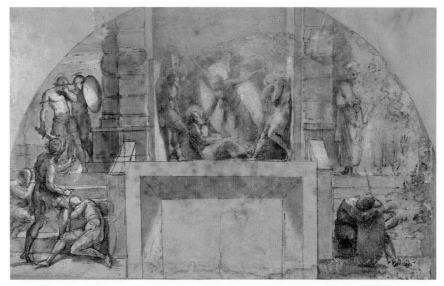

*Top: This detailed study for* The Liberation of St Peter *in the Stanza d'Eliodoro was produced in pen and ink wash and pencil on paper.*

*Above:* Young Monk Reading, *c.16th century. This is one of Raphael's precise contour drawings, executed in charcoal on paper.*

# ARTISTIC REPUTATION

The period now known as the High Renaissance initiated a new notion of the artist as genius. Leonardo, Michelangelo, Raphael, Titian, Mantegna and Dürer were all revered as such, and Raphael's work became increasingly in demand. He tackled all commissions with unfailing enthusiasm.

Raphael remained ambitious, always looking to enhance his position and to learn new techniques. By 1513, he was comfortably off, highly respected, a popular teacher and an art collector. He had a large circle of friends and acquaintances and was much admired. His good looks and charm were as renowned as his aspirations and drive.

### THE EXCHANGE OF GIFTS

According to Vasari, in about 1514 Dürer and Raphael exchanged works of art with each other as a kind of correspondence. They had not met when Dürer was in Italy, between 1505 and 1507, but later, when Raphael was established, Dürer sent him a self-portrait, and in return Raphael sent Dürer some of his drawings. Dürer had heard of Raphael's rising reputation and sent his painting in acknowledgement of this. This delighted Raphael, who already greatly admired Dürer's work.

From early on in his career, Dürer had been producing prints of his paintings, and these had established his reputation across Europe. He complained that painting did not make enough money in comparison with his prints, and from 1513 to 1516 he produced mainly prints rather than paintings. Raphael admired the painting that Dürer had sent, but he had already been hugely inspired by Dürer's prints. Vasari wrote:

*'After he had seen Albrecht Dürer's method of engraving, Raphael became anxious to discover what could be done for his own work with this craft, and so he caused Marcantonio of Bologna to undertake a very thorough study. Marcantonio became so proficient that Raphael commissioned him to make prints of his first works.'*

### MARCANTONIO RAIMONDI

An engraver from Bologna, Marcantonio Raimondi (c.1480–c.1534), known as Marcantonio, moved to Rome in 1510 and met Raphael soon after. By 1511, the two artists had established a working relationship. Unlike Dürer, Raphael did not make his own prints and was one of the first artists to employ someone else to do this. His arrangement with Marcantonio seems to have been quite flexible, and Marcantonio became known in his own right for his prints of Raphael's work. Some of his engravings were copies of Raphael's paintings or of drawings that were never made into finished works, and Raphael also created designs especially to be turned into prints. Through this, Raphael's art became known throughout Europe. It is not clear how the financial arrangements were established between them, but it is likely that Raphael accrued a

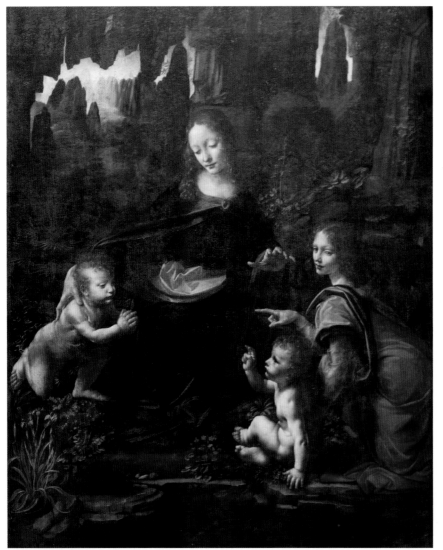

*Left:* Virgin of the Rocks, *1497, by Leonardo da Vinci. The concept of genius was established during the High Renaissance by artists such as Leonardo.*

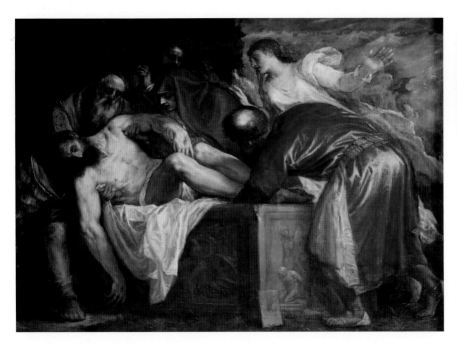

*Above:* The Burial of Christ, 1559, by Titian, whose dynamic compositions leant themselves to prints.

*Above right:* Christ Bearing the Cross, 1495, by Dürer. With its crisp and energetic lines, Dürer's style leant itself to woodcut prints.

percentage from the sale of the prints. Even if not, his reputation and career benefited from the widespread circulation of the prints. Although the production of prints was quite common in northern Europe, until Raphael instigated the idea, it was practically unknown in Italy. Titian was one of the only other established Italian artists of the time who recognized the potential of printmaking as a way of increasing his reputation, but he did not make such an industry of it as Raphael did.

## EMINENT FRIENDS

Raphael's burgeoning reputation meant that cardinals and influential foreign visitors, wished to be introduced to him. Owing to his early experiences at the court of Urbino, he mixed easily in these lofty circles. Two of his most eminent, long-standing friends were Bernardo Bibbiena (1470–1520), and Pietro Bembo (1470–1547). Both became cardinals, writers and patrons of the arts, and Cardinal Bibbiena was close friends with the new Pope. Raphael painted several works for him, including some fairly erotic frescoes for his bathroom in the Vatican. In 1514, somewhat reluctantly, the artist became engaged to Maria Bibbiena, Cardinal Bibbiena's niece.

*Left: A portrait of Marcantonio, who became exceptionally successful as the engraver of Raphael's art.*

# COMMISSIONS AND ACCLAIM

Through his exalted status, Raphael began receiving commissions from some of the most prestigious patrons in Rome. These were both public and private, including Madonnas and altarpieces, as well as portraits of members of the papal court and other consequential figures.

During this period, Raphael continued working unrelentingly for the new Pope. Most other artists would have found the Vatican projects so demanding and protracted that they would not have undertaken any further work, but Raphael also worked tirelessly on other commissions. In July 1514 he wrote to his uncle, who had previously urged him to marry. The following letter reveals his determination, pride in his achievements and also his comparative modesty:

'As of today, I find myself to be worth in Rome 3,000 ducats and a yearly income of 50 gold scudi that His Holiness has given me for work at St Peter's and 300 gold ducats for expenses, which I will receive as long as I live; and I am certain to have more. Then I am paid for whatever work I decide to do on my own; and I have begun to paint another room for his Holiness, which will amount to 1,200 gold ducats.'

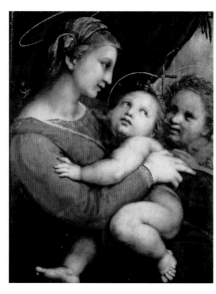

*Above:* Madonna della Tenda, 1514, by Raphael. One of the many Madonnas he painted in Rome.

### CONFIDENT COLOUR

Some of the other commissions that he undertook while still working in the Vatican included Madonna della Tenda

*Above:* Madonna of the Chair or Madonna della Seggiola, 1513–14, one of Raphael's most intimate works in this genre.

*Below:* The interior of Santa Maria del Popolo, one of the Roman churches where Raphael worked for a patron.

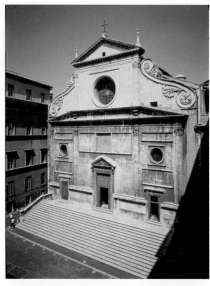

## THE VENETIAN STYLE

Although still debated, it is generally accepted that the Renaissance began in Florence in the 14th century and was superseded by Rome and Venice in the early 16th century. Venice was a lively, bustling port, with merchants and sailors constantly passing through. The decorative arts flourished and ideas from various countries and cultures were amalgamated. Venetian painting became known for its beautiful, luminous colours and representations of glowing light, as well as for its voluptuous, seductive subjects. Painters such as Bellini, Giorgione, Titian, Tintoretto, Mantegna and Paolo Veronese (1528–88) painted with smooth, velvety brushwork and built up rich, clear colours. Their particular technique focused on colour and light over line and was carried out in stages. First they coated their canvases with a white primer that was similar to gesso. Then they covered this with a mid-coloured paint, and next they marked on areas of white for the highlights and darker hues for the shadows. Finally, once all this was dry, they built up transparent glazes of warm and cool colours in gleaming, jewel-like oils.

(1514) and Madonna della Seggiola (1513–14), which are not as linear as his earlier Florentine Madonnas but are just as tender and feature warmer colours, probably through the influence of Sebastiano. Raphael's innovative approach to altarpieces also gained him several further commissions, including the Madonna del Foligno of c.1511–12. This was painted in bold colours that were probably inspired by Michelangelo's ceiling and Sebastiano's paintings, as well as the painting styles and ideas of Venetian art, for which Raphael had a particular admiration.

### PERCEPTIVE PORTRAITS
Along with portraits of several consequential churchmen, Raphael also painted many other portraits around that time of influential characters

*Above:* Self-portrait, *1566–8, by Vasari –* *Vasari's own painting was never as* *famous as his book,* Lives of the Most Excellent Painters, Sculptors and Architects.

*Above right: The façade of the church* *of Sant'Agostino, Rome, where Raphael* *painted a fresco strongly influenced* *by Michelangelo.*

including Baldassare Castiglione, who had written Il Cortegiano and who was friends with Francesco Maria della Rovere – Duke of Urbino, and nephew of Julius II. Having accompanied Julius on one of his campaigns in 1512, Castiglione was sent to Rome as an ambassador of the Duke of Urbino, and there became good friends with Raphael.

# LEO X

During the last years of his life, Julius II commissioned Raphael to work on projects beyond the Vatican, including pictorial and architectural works for public and private buildings. After his death, the newly elected Pope, Leo X continued his predecessor's artistic patronage of Raphael.

When Julius died, Raphael was both saddened and concerned. The Pope had been a passionate supporter of the arts and it was difficult to believe that another pope would feel as favourably inclined toward artists and architects in general and Raphael in particular. Yet within a month of Julius's death, Giovanni de' Medici, the son of Lorenzo 'the Magnificent', was elected to succeed him. Taking the name Leo X, Giovanni brought the rich cultural heritage of his native Florence to Rome.

He upheld many of Julius II's aims, including trying to fuse classical culture with Christian values and continuing to turn Rome into a magnificent city where artists, writers, humanists and philosophers congregated.

## PEACEMAKER

Unlike Pope Julius II, Leo X had the reputation of a peacemaker. Rather than spend money on hostile campaigns, he preferred to surround himself with luxury and pageantry, and

so the demands on Raphael intensified. Increasingly, he had to leave a lot of his work to his pupils and workshop assistants. His studio expanded and, no longer just an artist and teacher, Raphael became a manager and businessman.

Leo admired Raphael's work as much as Julius had done, and Raphael's fortunes rose rapidly under his patronage. With a few alterations, Julius II's private apartments became Leo's rooms and the project continued without interruption. The scene Raphael had been working on when Julius died was adapted to include a portrait of Leo X. This final fresco in the Stanza d'Eliodoro depicted Pope

*Above: In black and white chalk on paper, Raphael's pupil Giulio Romano drew this portrait of Leo X in 1520–1 for the fourth of the Pope's private rooms.*

*Left: A detail from* The Adoration of the Magi, *c.1475, by Botticelli, which features a portrait of Leo X's illustrious father, Lorenzo 'the Magnificent'.*

*Right: Leo X Meeting Francis I of France, 1529, by Vasari – a posthumous painting of the Pope.*

*Below right: An illustration of 1880 showing Leo X promulgating a papal bull – a method he used to confront the Protestant Reformation.*

Leo the Great repelling the invasion of Attila the Hun in the 5th century. Clearly a reference to the new Pope (here making a feature of his namesake) and his intention to establish peace throughout Christendom, *The Repulse of Attila* was illustrated to serve as a warning to any prospective invader of Italy. The theme had been chosen by Julius, but Leo used it to proclaim the restoration of the greatness of Rome.

## THE TAPESTRIES

Following his predecessors, Pope Leo X was determined to make his own mark on the Sistine Chapel, so he decided to cover the lower walls with a tapestry cycle. In 1515 he commissioned Raphael to design the ten tapestries illustrating episodes from the lives of St Peter and St Paul, which would tell of the greatness of the Roman Catholic Church and the legitimacy of papal succession. Tapestry design was usually undertaken in Flanders, where the tapestries were made, and not by Italian painters. Aware that his work would be seen adjacent to Michelangelo's ceiling, Raphael took great care in perfecting his complex designs. Nevertheless, he still completed the huge project by December 1516, astonishingly in just over a year. The cartoons were sent to the Brussels workshop of the tapestry weaver Pieter van Aelst (1502–50) early in 1517, and seven tapestries were completed by December 1519. Enormously prestigious, the tapestries cost at least five times as much as Michelangelo's ceiling had done. For his part, Raphael was paid 1,000 ducats.

### FRIENDSHIP

At the beginning of August 1514, Leo X appointed Raphael to succeed Bramante as chief architect at St Peter's. Before he died in March of that year, Bramante had named his successor. Although honoured, Raphael was apprehensive – this was his most demanding responsibility, as he had never been trained as an architect. Raphael became closer to Leo X than he had been to Julius. It began with their mutual friendship with Cardinal Bibbiena and extended through the Pope's appreciation of Raphael's modern ideas, compliant attitude and artistic skill. It continued with Raphael agreeing to become engaged to the Cardinal's niece, though he never married Maria Bibbiena, and still carried on seeing his mistresses.

# THE THIRD ROOM

By summer 1514, Raphael had begun the third room in the papal suite, the Stanza dell'Incendio. Julius probably intended it to be his tribunal room, but Leo X chose to use it as a dining room. The name of the room, however, derives not from its function, but from one of the paintings there: *The Fire in the Borgo*.

## CONSERVATION

By 1514, Raphael and his friend Castiglione had become extremely concerned over the 'pillaging' of Roman ruins. Using ancient materials for building was accepted practice during the 16th century. Marble statues were smashed to produce whitewash, and the remains of the buildings were totally demolished. Raphael and Castiglione were so troubled by this that they wrote to the Pope to ask him to protect the ancient buildings and works of art. Their letter was one of the first examples of a call for the conservation of cultural heritage. The Pope responded by putting Raphael in charge of inspecting all the Roman ruins and fining anyone who took objects that were deemed to be of historical importance, such as marble statues or stones that bore ancient inscriptions.

*Left:* Raphael Adjusting His Model's Pose for His Painting of the Virgin and Child, *c.1800, by Fragonard.*

The ceiling of the Stanza dell'Incendio had already been painted by Perugino, and Raphael left this intact. Each of the frescoes in the room is taken from the life of a previous pope called Leo, and each is a portrait of the then current Pope Leo X. The main painting in the room, *The Fire in the Borgo*, depicts a miracle performed by Leo IV in 847. From a balcony on the old St Peter's Basilica, Pope Leo IV calmly makes a sign of benediction and stops a fire that has been raging in the Borgo quarter just outside the Vatican walls. The painting is theatrical, dramatic and energetic, with the main action taking place in the background and terrified groups of muscular figures in the foreground. The fire can only be seen to the side of the painting. The image symbolized the mood of reconciliation that the Church expected from the new pontiff, while the composition and contents reflect Raphael's interest in architecture and a strong influence of Michelangelo.

Because of Raphael's many other commitments, more of the painting in this room was undertaken by his students and assistants than any of his previous works. These younger artists included Giulio Romano (c.1499–1546), Perin del Vaga (1501–47), Polidoro da Caravaggio (c.1499–1543), Giovanni da Udine (1487–1564), Giovan Francesco Penni (1488/96–1528) and Raffaellino del Colle (1490–1566), who each became fairly successful later.

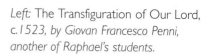

*Left:* The Transfiguration of Our Lord, c.*1523, by Giovan Francesco Penni, another of Raphael's students.*

*Above:* Madonna and Child, *1530, by Giulio Romano, who was one of Raphael's most successful students.*

The Fire in the Borgo is probably the only fresco in this room that was completed by Raphael. In contrast with many of his other works in Rome, the colours are subdued and mellow, showing Raphael's innate ability to change the mood of an image through clever manipulation of his materials.

## ARCHITECTURAL DUTIES

While members of his workshop were completing several of his designs, Raphael concentrated on his many other commissions and architectural duties. By the time the fourth room, the Sala di Costantino, was due to be started, he could only suggest ideas, and did not make final decisions about the

*Below:* The Fire in the Borgo, *by Raphael, c.1516–17; the main painting in the Stanza dell Incendio.*

paintings there. As a result, the last three frescoes in the third room and all the works in the fourth room were produced by his pupils and assistants and are not as inventive or pioneering as Raphael's works in the other rooms.

While continuing to produce a vast quantity of work, including the huge tapestry cartoons, and undertakings for the wealthy papal banker Agostino Chigi, Raphael worked assiduously on the architectural designs of St Peter's and other buildings in Rome, commissioned by the Pope.

Most of his constructions within St Peter's were subsequently altered or demolished after his death, but from drawings, his architectural design appears to have been as innovative as his paintings, inspired by ancient classicism, the Pantheon and buildings designed by both Bramante and Brunelleschi. For a few years, as well as being revered as one of the greatest painters, he was the most important architect in Rome.

*Below: A 19th-century artist's impression of* Raphael in the Vatican, 1832, *by Emile Vernet.*

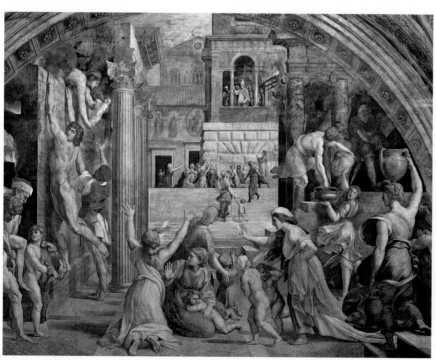

# AGOSTINO CHIGI

For several years, the Sienese banker and papal treasurer Agostino Chigi exerted an enduring influence on the cultural life and artistic activities of Rome. In 1509 he had a house built and employed the most celebrated artists of the time to decorate it, including Peruzzi, Sebastiano, Sodoma and Raphael.

After accompanying Julius II on two of his greatest military campaigns in 1506 and 1510, Chigi went to Venice for a few months in 1511 to try to buy support for the Pope. On his return, with his enormous wealth (he was the richest man in Europe at the time), Chigi was able to commission some of Rome's most impressive frescoes outside the Vatican. He aimed to make his home, which later became known as the Villa Farnesina, the epitome of opulence and elegance. The frescoes the artists painted reflected the contemporary fashion for ancient Greek and Roman styles.

## 'IL MAGNIFICO'

Chigi came from a powerful banking family, and, like Lorenzo de' Medici, was nicknamed 'Il Magnifico'. He was sociable, astute and esteemed in many circles. His climb to magnificence had started with Julius II, to whom he became indispensable as a financier and diplomat, and his success continued with his work for Leo X. After moving to Rome in about 1487 from his native Siena, Chigi became a patron of literature, science and the arts. In his new home, he held lavish banquets, and staged plays, masques and concerts.

Raphael is first recorded as working for Chigi as a designer of plate. He designed some bronze salvers, plus other silver and bronze items. He also worked on architectural projects and paintings. One of his most celebrated works for the banker was a fresco to decorate the loggia of his new villa. *The Triumph of Galatea* is based on a mythological tale and features a sea nymph riding on a dolphin-drawn shell chariot. While working at Chigi's villa, however, Raphael and Sebastiano's early friendship turned to rivalry, with Sebastiano writing to his friend Michelangelo to complain of Raphael.

*Above: Building the Chigi Chapel in Rome for Agostino Chigi was Raphael's first experience in architectural design and planning. This is the dome, built in 1516.*

*Left: Built for Chigi in 1509–11, this palatial home was later named the Villa Farnesina. 17th-century engraving.*

PALAZZO DE GHIGI ALLA LVNGARA ARCHITETTVRA DEL FAMOSISSIMO BALDASSARRE PERVZZI DASIENA CHE FV ECCELENTE PITTOR E GIOMETRA L. ANNO. MDXVIII

## RIVALRY

Rivalry between artists during the High Renaissance was rife as they strove to acquire prestigious commissions. The rivalry between Raphael and Michelangelo is still being debated. Raphael was attractive, charming and affable; Michelangelo was irascible and volatile. Raphael welcomed visitors into the stanze in the Vatican, but Michelangelo banned all from the Sistine Chapel until he had completed the work. Raphael had very few responsibilities, but Michelangelo's father and brothers made excessive demands on his finances. Raphael openly admired all of Michelangelo's work, while Michelangelo was not interested in Raphael. Once Raphael had become known in Rome, however, Michelangelo resented the younger artist emulating his painting style. Yet in 1512, when Michelangelo was asked by Johannes Goritz , one of Raphael's patrons, if he thought Raphael's work was worth the exorbitant sum he was asking for it, Michelangelo declared: 'For that knee alone it's worth the price.'

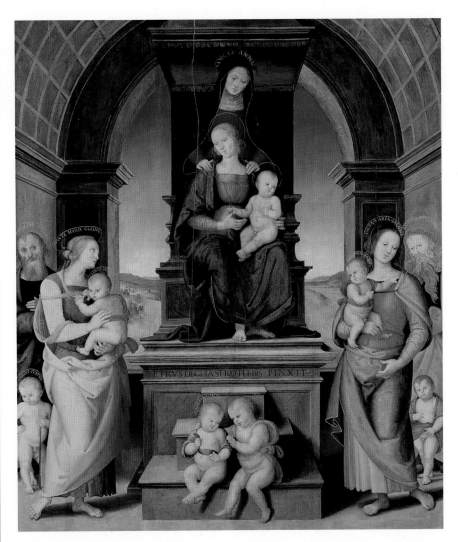

*Above right: The Family of St Anne, c.1507, by Perugino, whom Chigi described in 1500 as 'the best master in Italy'.*

## PRIVATE CHAPELS

Raphael decorated several areas of Chigi's villa. He also devised the architecture and decorations of two chapels for Chigi in the church of Santa Maria della Pace; a frieze of sibyls, angels and putti. The monumentality and colouring of his work there shows his response to Michelangelo. In 1512, Chigi commissioned Raphael to design and decorate a private chapel in the church of Santa Maria del Popolo. The arrangement of this chapel is light and clear, with elements including detailed mosaics in a contemporary design; subtly coloured marble pillars, and other features recalling the art and architecture of ancient Greece and Rome.

*Below: Detail of Mary with Child, John the Baptist and St Catherine of Alexandria, 1510, by Sebastiano – painted while he was still in Venice.*

*Below: Drawing of Jonah by Raphael's student da Udine, 1520.*

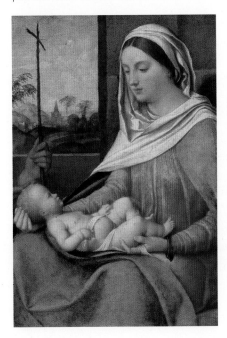

# MOVEMENT AND PASSION

By around 1510, Raphael's reputation in Rome was established. Rivalry between artists was widespread, and in his attempt to attain pre-eminence in his field, he pushed the boundaries of contemporary artistic ideals. His harmonious paintings seem at variance with the efforts he exerted to complete his commissions.

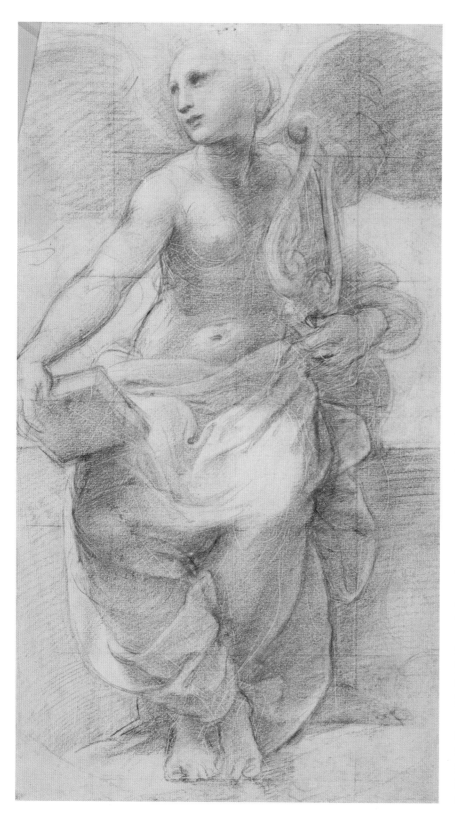

With legends about his skills spreading across Rome and the rest of Europe, many rich patrons implored Raphael to work for them, while his reputation in the papal court strengthened even further. Foreign ambassadors arriving in Rome either came with instructions from their superiors to commission him or they sent word home that owning an artwork by Raphael would gain them great prestige. If the Pope gave a painting by Raphael to a foreign visitor, it was seen as a gesture of high papal favour, and Leo X often used it as a method of gaining goodwill and forging alliances with foreign powers.

### ALLIANCE WITH FRANCE

In 1515, the Pope signed an agreement of friendship with France. It declared that the French King Francis I agreed to ensure the Vatican's authority over the Catholic Church in France; and in return, Leo promised to support Francis's claim to the throne of Naples. Three years later, Leo commissioned two paintings from Raphael to be sent to the royal court of France as gifts to commemorate the marriage of the Pope's nephew, Lorenzo II de' Medici (1492–1519), the current Duke of Urbino and leader of the Florentine republic, to Madeleine de la Tour d'Auvergne (c.1501–19). The couple later became the parents of Catherine de' Medici (1519–89), the notorious future Queen of France.

With such demand for his work, Raphael had to prioritize, and he often left interested patrons waiting. If the Pope commissioned him, all other work had to be put aside, which had the

*Left: Allegorical Figure of Poetry, c.1509–10. Raphael first sketched this figure intended for the Stanza della Segnatura as a nude, demonstrating his ability to depict figures in motion.*

*Below: Group of Four Figures, 1512–15 – Raphael's fluid portrayals of dynamic, engaging figures shown through drapery and folds.*

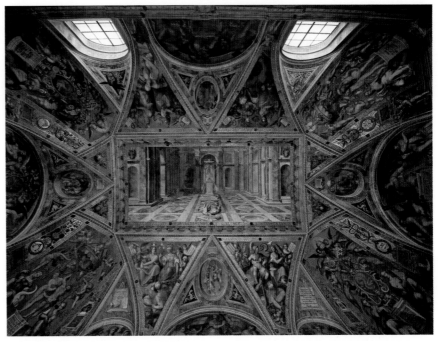

effect of making other patrons even more eager for his work. Alfonso d'Este, the Duke of Ferrara (1476–1534), was one such patron who sent many letters to Raphael, variously pleading, cajoling, demanding or flattering the artist to work for him. He even sent small advance payments, and Raphael replied numerous times assuring him that he would soon begin the work but that he was inundated with requests from the Pope and Cardinal Giulio de' Medici (1478–1534).

## COMPETING FOR COMMISSIONS

Pursued as he was by so many powerful patrons, it would be natural to assume that Raphael simply continued working on the commissions he was given – but his ambition pushed him further than that.

On several occasions, he vied with other artists for different commissions, never worrying about risking his reputation if he did not obtain the work. In any case, it would have been difficult to reduce his status at the time; he was celebrated in countless poems and, even before Michelangelo, he was called 'divine'.

*Right: Created in the Vatican Palace by Bramante, this gallery was painted by Raphael's pupils – after his sketches and under his supervision.*

Rather than making his painting more structured, Raphael's architectural work seemed to encourage him to paint in a livelier and more passionate style. The clear, bright colours that he used in his tapestry cartoons – created to complement Michelangelo's ceiling – also gave him fresh ideas, and he became known for his skilful and modern manipulation of colour. His cartoons influenced tapestry design in Flanders and consequentially

*Above: Painted to harmonize with Raphael's frescoes, this was completed in 1585 by Tommaso Laureti on the ceiling in the Sala di Costantino.*

inspired many northern European painters. So, as Raphael was busily synthesizing other artists' approaches and methods, artists that were around him took up his ideas and tried incorporating them into their work.

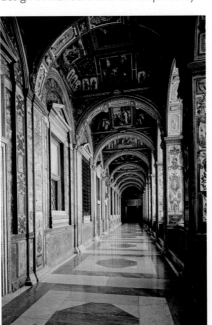

## THE DUCHY OF URBINO

It is a mark of Raphael's diplomacy and charm that he remained on good terms with the duchy of Urbino throughout its many turbulent years fraught with changes. Although Julius II's favoured nephew, Francesco Maria della Rovere, was Duke from 1508, in 1516, Leo X's forces had him ousted in order to give his own nephew, Lorenzo de' Medici, the dukedom. Raphael had been friendly with the previous dukes, and despite the animosity between the della Rovere family and the Medici, he remained close to both popes and dukes and continued working for them all.

# VILLA FARNESINA

Via Sancta, later called via della Lungara, was originally a narrow street used by Roman pilgrims on their way to the Vatican. Alexander VI and then Julius II developed it into an elegant, wide street, and several powerful families built palaces there with gardens stretching down to the banks of the River Tiber.

With other palatial villas nearby, via della Lungara was the obvious location for Chigi to build his home. At that time the area fell just outside the city walls, so the building was essentially perceived as a country villa. Probably as early as 1505, Chigi began planning his small but luxurious dwelling, which when it was completed in 1509 became known as Viridario (after the Roman for pleasure garden) or Villa Suburbana (meaning Roman villa). Lavish and elegant, it combined the

*Below: Salon of the Perspectives, Villa Farnesina – the name of this room derives from the false perspectives created by Peruzzi's fresco images of Rome.*

advantages of a home in the city with the delights of a country house. In his will, Chigi stipulated that the building was to remain in Chigi descendants' possession for ever; but his wish was breached as early as 1577, when the villa became the property of the powerful Farnese family and was renamed the Villa Farnesina.

## UNASSUMING AND EXTRAVAGANT

The architect of the villa, Peruzzi, came from Siena like Chigi himself and had been a pupil of Bramante. He was

*Right: The elegant but unostentatious façade of the Villa Farnesina, built by Peruzzi, 1509–11.*

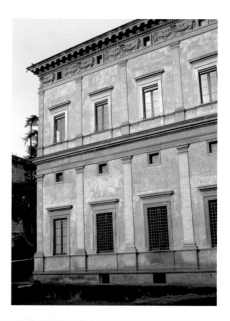

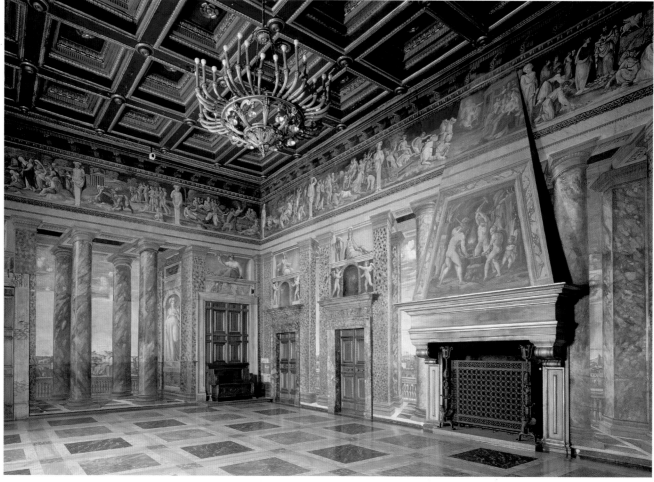

*Right: A detail of Raphael's vibrant and lively* Triumph of Galatea, *1512–13.*

*Below: The Loggia of Psyche, Villa Farnesina; Raphael designed this room – full of light and life – to celebrate the marriage of Chigi.*

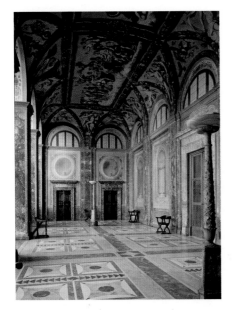

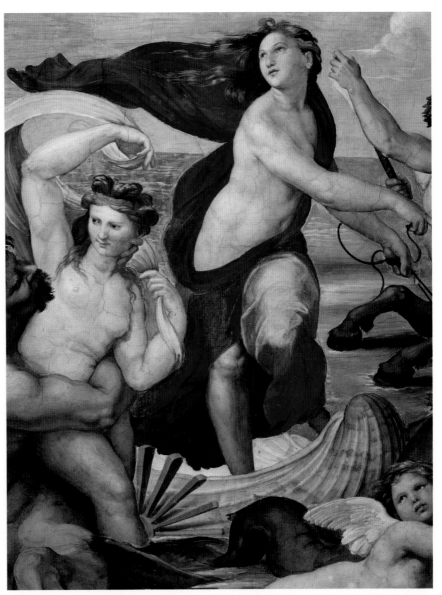

assisted by Giuliano da Sangallo (c.1443–1516), a Florentine sculptor, architect and military engineer. After the villa's construction, Peruzzi's ideas, including unpretentious dimensions, simple exterior materials and luxurious interiors, became the archetype of many middle-class suburban villas. Fairly plain on the outside, inside it was decorated with frescoes and multicoloured marble. The murals reflected aspects of Chigi himself, including astrological allusions to his date of birth and references to success. Chigi was unassuming and earnest, but he was also a showman, and these elements of his personality were all reflected in the decorations. The villa was different from palazzos of the time, which were large and rectangular, resembling fortresses; Chigi's villa was built in an airy U shape. The novelty of the construction and layout encouraged others to build attractive, spacious villas with large, lush gardens close to the centre of Rome.

## THE LOGGIA OF PSYCHE

Although Raphael's fresco of The *Triumph of Galatea* is probably the most well known of his works in the Villa Farnesina, the frescoes for the Loggia of Psyche were also designed by him, and the palatial stables within the grounds were built to his architectural designs. It may be apocryphal, but a story is often told of one of Chigi's extravagant banquets, when he welcomed his guests into the stables without telling them. He had adorned the walls with lavish tapestries and decorations to trick them into believing it was his banquet hall.

Raphael was commissioned to decorate the Loggia of Psyche in 1517, five years after painting *Galatea*. The loggia was a space that connected the living room and the garden, so was light and fresh. Raphael reflected this by treating the ceiling as almost part of the garden: he divided the area with paintings of garlands of exotic fruits that had recently been discovered in

the explorations of the Americas. He also designed two large ceiling pictures that suggest tapestries stretched across the room. For this area, Raphael was assisted by the same members of his workshop who worked in the Vatican with him, including Romano, del Vaga, da Caravaggio, da Udine, Penni and del Colle. The frescoes in the loggia represent episodes in the story of Cupid and Psyche, including Cupid talking to the Three Graces, Venus going to Olympus on her chariot pulled by doves, Psyche completing the tasks set for her by Venus, and the marriage of Cupid and Psyche. Although the preparatory drawings, compositions and concepts of the artwork are all Raphael's, the bulk of the painting was actually carried out by his pupils.

# SANTA MARIA DELLA PACE

Raphael had started to work for Chigi at a time when the banker had decided to marry a woman of humble origins he had met in Venice. The Loggia of Psyche was created to celebrate the marriage, but Chigi also asked Raphael to design and decorate the Chigi family chapels in two separate churches.

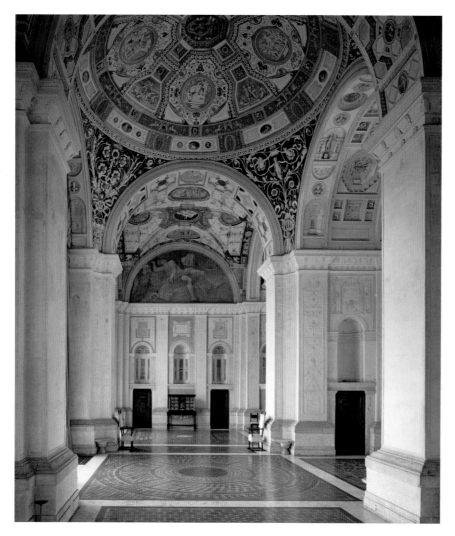

Chigi was one of the most influential men in Europe when Raphael was working for him, but although his path in banking had been almost faultless (popes relied on him; he had lent money to powerful figures such as Cesare Borgia and Guidobaldo da Montefeltro; he had started his own bank; and he had proved to be indispensable on papal campaigns and diplomacy missions), he had a weakness. While in Venice, he had fallen in love with a young woman of the lower classes. He brought Francesca Ordeaschi back to Rome and moved her into his new villa.

*Above: The loggia and entrance hall of the Villa Madama in Rome, designed by Raphael c.1517.*

Before moving to the Villa Farnesina, Chigi had lived in a house in Via dei Banchi with his first wife, Margaret Saracens, who had died in 1508. The couple had no children, but he had an illegitimate daughter with a courtesan who died in 1511.

Chigi courted and planned to marry Margherita Gonzaga, the illegitimate daughter of Francesco Gonzaga, Marquis of Mantua, in an attempt to secure a place in Italian aristocracy.

## THE VILLA MADAMA

Believed to be designed mainly by Raphael, the Villa Madama – which was never finished – was built just outside Rome on the banks of the River Tiber for Cardinal Giulio de' Medici, a cousin of Leo X who later became Pope Clement VII. The name Madama came from a later occupant of the villa: Margaret of Parma. Raphael was at this time working with a small group of architects and artists, including Antonio da Sangallo the Younger (1484–1546), Romano, Peruzzi and da Udine, and the architectural works he was producing were as proficient and original as his paintings.

These marriage plans were unsuccessful, however, and after living together for eight years, Chigi and Francesca finally married. Despite the fact that Chigi was marrying his mistress, it is an indication of his importance that the Pope officiated at his wedding.

## THE FOUR SIBYLS

The church of Santa Maria della Pace was built in 1482 on the foundations of a pre-existing church. Commissioned by Pope Sixtus IV, the cloister was built by Bramante from 1500 to 1504; his first work in Rome.

Raphael began working on the Chigi Chapel in Santa Maria della Pace in 1511, when Chigi had first arrived back in Rome from Venice with his mistress and Sebastiano. *The Four Sibyls Receiving Divine Instruction* is a frieze of the sibyls Luma, Persia, Phrygia and Tibur each receiving a revelation from an angel and interspersed with putti. Positioned over the arch of Chigi's private chapel, the

frieze is composed so that the figures' gestures and movements interact with the holy inscriptions. It is clearly influenced by Michelangelo's newly unveiled Sistine Chapel ceiling.

While Raphael was gaining greater skills and prestige with his architectural projects, he was also striving to represent the human form with increasing vigour and monumentality. In 1512, the chief keeper of papal records, Johannes Goritz from Luxembourg, commissioned him to paint a fresco of the prophet Isaiah in the church of Sant'Agostino, which had been built in the year of Raphael's birth using marble that was taken from the Colosseum.

With a striking resemblance to several of Michelangelo's figures on the Sistine Chapel ceiling, Raphael's Isaiah is powerful and solid-looking, twisting animatedly to hold a Hebrew scroll foretelling of the birth of Christ. It was a strange space on which to work, as it is situated high up on a tall and fairly narrow pillar, but Raphael took full advantage of it, creating a dynamic and dominating image that also gives the impression of being part of a much larger work.

It was paintings like this that aggravated Michelangelo so much. Many others tried to copy him, but only Raphael attained a similar level of brilliance.

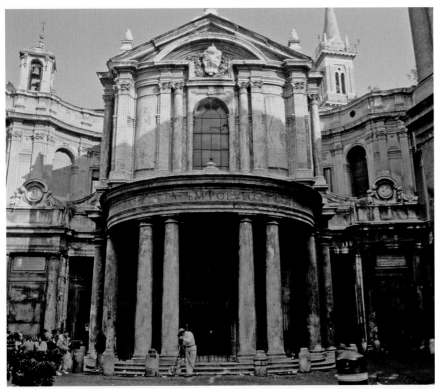

*Left: The Baroque façade of the church of Santa Maria della Pace, Rome, with the private Chigi Chapel inside.*

*Below left: Raphael's fluent red chalk study for the Phrygian Sibyl in Santa Maria della Pace wears classical drapery and was probably drawn from a male model.*

*Below right: In red chalk on paper, these studies of angels were part of Raphael's planning for his work in Santa Maria della Pace, Rome.*

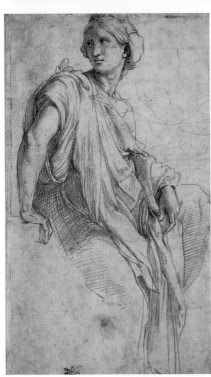
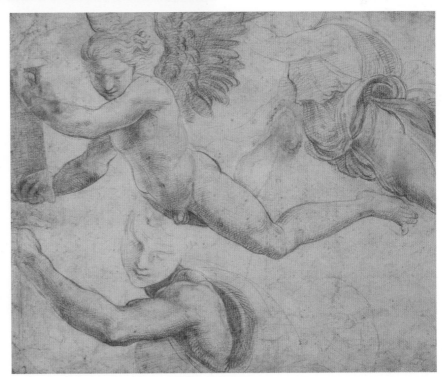

# SANTA MARIA DEL POPOLO

Although there are no portraits identifiable as Chigi, from the work produced for him and the stories handed down about him, an idea of his character can be shaped. Pope Julius II allowed him to bear the della Rovere symbol of an oak in his coat of arms, and granted him chapels in their family churches.

The two churches in Rome where Julius had granted Chigi private chapels were Santa Maria della Pace and Santa Maria del Popolo. At the edge of one of the most famous squares in Rome on a main exit and entry route to the city, the latter was rebuilt in the 15th century on the site of an older church. Bramante enlarged the apse in 1502, and the Chigi Chapel was built in 1513, designed by Raphael and completed more than a century after his death by Gian Lorenzo Bernini (1598–1680). Bernini's patron was Agostino's descendant Fabio Chigi, who became Pope Alexander VII in 1655. Raphael designed the chapel (one of six in the church) for family worship, but it ended up as Chigi's burial place. As with the Villa Farnesina, it was later copied by many middle-class Italian families.

## INNOVATIVE ELEMENTS

To create an airy space in the Chigi Chapel, Raphael followed the shape and proportions of the cupola of the Pantheon and added four columns and arches. His opulent marble, bronze and mosaic details were unique in churches at the time, but reflected the notion of Rome being the most magnificent city on Earth. Julius had granted Chigi the right to the chapel in 1507. It was dedicated to the Virgin of Loreto, whom the Pope revered, and the chapel has a powerful presence with its frescoes, tondi and contrasting surfaces and shapes. Raphael began with the design of the architecture, while much of the decoration was completed four years later. In the centre of the roof dome is a painting of God the Father in Benediction, surrounded with blue and gold mosaics and stucco. The ceiling was created by Raphael to present a portrayal of the Creation of the World surrounded by the Sun, the six known planets and a zodiac sign. As with all he did, his representations and use of materials were highly original and reflected Renaissance ideals.

## ELONGATED PYRAMIDS

In total contrast, but still innovative, are the sleek, elongated marble pyramids that rise above the cornice. These stand

*Left: A view of the Chigi Chapel in Santa Maria del Popolo, built by Raphael in 1513 and completed by Bernini in 1652.*

*Below: Six years after Raphael's death, his rival Sebastiano was commissioned to paint this fresco: Nativity of the Virgin.*

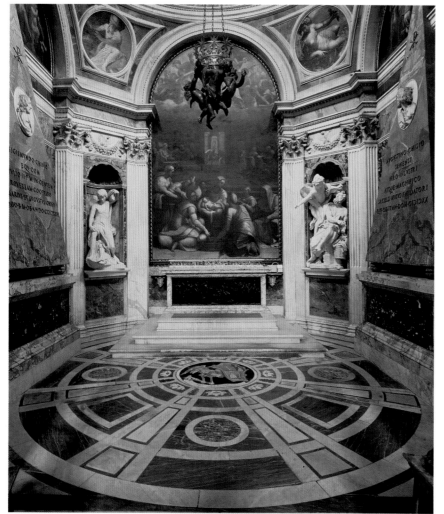

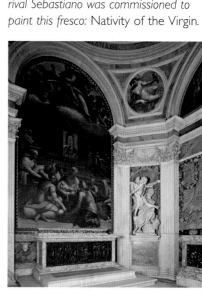

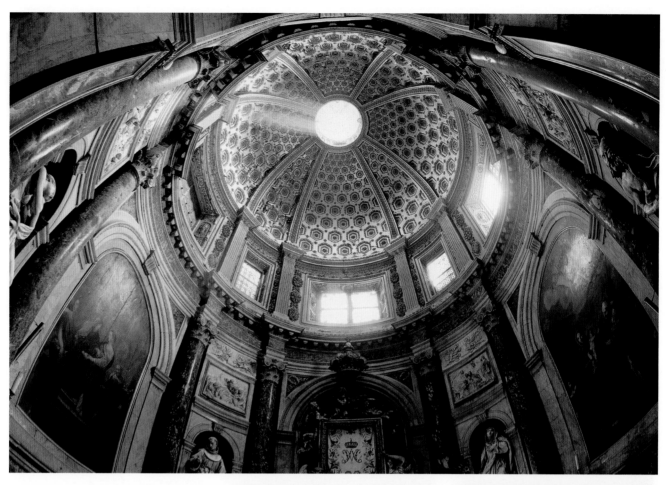

*Above: In 1655, a descendant of Agostino, Fabio Chigi, became Pope. Four years later he had this private chapel built in Siena Cathedral, by Bernini.*

on top of the sepulchres of Chigi and his brother Sigismondo and are in bold contrast with traditional reclining tomb figures. They appear timeless, modern and radical at the same time. The entire area of the chapel features contrasting coloured marble that helps to emphasize aspects of the classical Corinthian pillars and entablature. Although the chapel today features several other elements that were added both during Raphael's time and after his death, his initial plans for it remained inspiring and stimulating. At the time of his death, the wall cladding, ceiling mosaics and statues of *Jonah and Elijah* by Lorenzetto (originally Lorenzo di Ludovico di Guglielmo 1490–1541) were all complete. Lorenzetto, part of Raphael's circle and brother-in-law of Raphael's assistant Romano, created the statues to Raphael's design.

## RAPHAEL'S PRICE

While Raphael was working on the two chapels for Agostino Chigi, another legend about him developed, in connection with his work for Chigi. The tale relates that Raphael was not content with the 500 scudi that Chigi had paid for his fresco in the church of Santa Maria della Pace, so a mutual acquaintance of both Chigi and Michelangelo was asked to give his opinion on the worth of Raphael's work (once more). Not allowing any rivalry to come before artistic merit, Michelangelo pronounced that each head that Raphael had painted was indeed worth the asking price, which was 100 scudi. Without hesitation, Chigi then paid this amount, but declared that Raphael should be satisfied with that and no more, 'for if I have to pay for the drapery, I'll be ruined'.

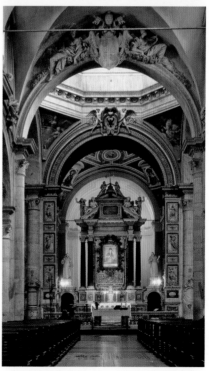

*Above: The impression Raphael achieved with the Chigi Chapel in Santa Maria del Popolo was one of drama, opulence and originality.*

# LARGE ALTARPIECES

From the start of his career to his elevated status at the end of it, Raphael painted altarpieces. During the 15th century, church altarpieces were positioned behind officiating priests and became a focus for worshippers. Thus, altarpieces were major elements in any Renaissance artist's repertoire.

During Raphael's lifetime, altarpieces remained one of the most significant and status-raising assignments that an artist could work on. Depending on the artist, location or patron, they varied in size, complexity, themes and styles. Some represented biblical narratives that required interpretation, while others simply portrayed divine figures.

## INSPIRING WORSHIPPERS

Raphael initially learned altarpiece painting techniques in styles that were popular in the Le Marche and Umbrian regions of Italy. Later he developed ideas from innovative artists' methods in Florence, and by the time he had reached Rome he had pioneered his own approaches. He became an expert in creating works that satisfied religious requirements while overturning artistic conventions.

It is believed that Raphael's first altarpiece work was in 1497, when he was 14 years old: a painted panel depicting the *Nativity of the Virgin* which forms part of Perugino's altarpiece *Madonna and Child with Saints* in Santa Maria Nuova, Fano. His earliest documented commissions were in Città di Castello, where a drive to create new altarpieces was under way. By the time he reached Florence and then Rome, he was stretching the confines of tradition with original altarpieces that impressed his patrons and inspired worshippers.

In Rome he perfected his production of cartoons that could be transferred mechanically to wall or panel and

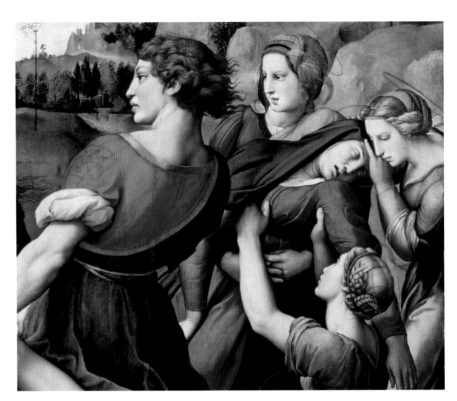

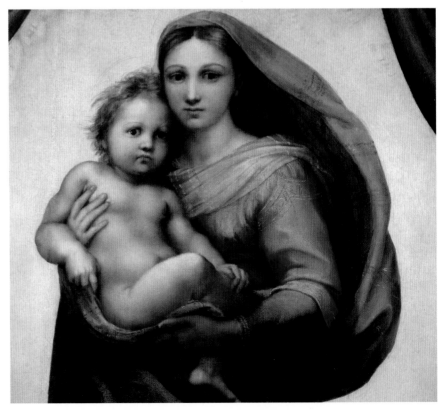

*Top right: Detail from Raphael's* Deposition, *1507, described by Vasari: 'Raffaello imagined…the sorrow that the… relatives…feel in laying to rest the body of him…their best beloved.'*

*Right: Detail from* The Sistine Madonna, *c.1513–14, who occupies an imaginary space framed by heavy curtains.*

completed by assistants. His drawings and studies were particularly detailed and carefully worked out so that delegation was straightforward. While he was working on the Stanza d'Eliodoro, he created three major altarpieces: the *Madonna del Pesce* (or *The Holy Family with Raphael, Tobias and St Jerome*; 1513–14), the *Madonna di Foligno* (1511–12) and *The Sistine Madonna* (c.1513–14). Later, he produced *Christ Falling on the Way to Calvary* (c.1516–17), *The Ecstasy of St Cecilia* (c.1516–17) and *Transfiguration* (1520). *The Holy Family with Raphael, Tobias and St Jerome* was commissioned by a Neapolitan nobleman,

*Below:* The Christ Child – *drawn in red chalk by Raphael in the build-up to planning an altarpiece.*

Geronimo del Doce, for his family chapel at the monastery of San Domenico in Naples. Raphael designed the work, selected the palette, painted the faces and produced detailed preparatory drawings of it, but his assistants probably completed the rest of the lively composition with its deep colours and strong tonal contrasts.

The *Madonna del Foligno* was created for the high altar of the Franciscan church of Santa Maria in Aracoeli, commissioned by Sigismondo de' Conti, Julius II's secretary. By then Raphael was known for his lifelike figures, and here, in a golden halo, Mary appears to be a normal mother, while Christ looks like

*Below:* Madonna and Child in Glory with Angels, *1520, by Correggio – a contemporary and admirer of Raphael.*

any little boy. Created just after that painting, *The Sistine Madonna* was commissioned by Julius II for the church of San Sisto in Piacenza, the burial place of Pope Sixtus II, whom Sixtus IV had elected to be patron saint of the house of della Rovere. Original and progressive, *The Sistine Madonna* appears simultaneously monumental and ethereal.

## NARRATIVE IMAGES

As well as peaceful Madonnas and saints, Raphael portrayed stories. *Christ Falling on the Way to Calvary*, also known as *Lo Spasimo*, was created for the church of Santa Maria dello Spasimo in Palermo. It shows the agony of the Virgin when witnessing the suffering of her son, and is similar in content and vigour to his Perugian *Deposition* of 1507.

### ATMOSPHERIC PERSPECTIVE

Raphael developed a means of painting atmospheric perspective through the use of colour and light. He also softened background tones and incorporated more detailed foreground elements. *Madonna di Foligno* and *The Sistine Madonna* are two examples of this method. He created a sense of depth with an evocation of natural open spaces, without relying on the depiction of architecture which had been a favoured Renaissance scheme.

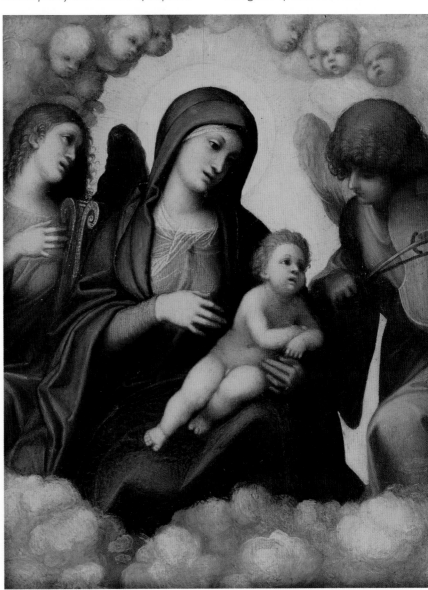

# LIGHT AND COLOUR

Giovanni Santi taught Raphael the value of studying and assimilating the work of others. Through introductions to Urbino's courtly circles, Raphael gained connections and manners that helped his career. But his spectacular rise to fame was the result of his own natural genius, energy and determination.

Raphael's absorption of ideas and sensitivity toward emotion were only part of his skill. He developed a refined approach, noted for its unprecedented clarity and grace and that reflected the Grand Manner – an idealized aesthetic style derived from classical art. Driven to surpass even the most illustrious of his role models, he amalgamated all these elements and represented colour and light with increasing complexity. This made European art academies view him, more than any other artist, for centuries as the embodiment of stylistic perfection.

## BELLEZZA DI COLORE

When Michelangelo said of Raphael, 'Everything he had of art, he had from me,' he was not entirely correct.

*Below: Detail from* Portrait of a Woman, *1507 – Raphael's subtle and sensitive tonal gradations can be seen clearly.*

Raphael did emulate others, particularly Michelangelo, but he was also extremely innovative. For instance, he was the first artist to adapt his colours to individual commissions; unlike other artists, he did not have one set palette, but used colour mixes to suit different situations and needs. Also, in many of his works he juxtaposed colours from opposite ends of the spectrum, to create optical vibrations. From his earliest works, he built up soft shadows from translucent colours, but after his time in Florence he developed this even further, combining Leonardo's subtle, *sfumato* tones with the Florentine taste for striking colour effects. The result was a unique style that was subsequently called *unione*, which was bright yet harmonious.

The paintings in the Stanza della Segnatura and *The Sistine Madonna* are examples of Raphael's *unione* style,

### RAPHAEL'S WORKSHOP

When he first arrived in Rome, Raphael had no workshop of his own. However, since his youth he had thrived in the company of other artists, and he soon established an organized and productive workshop, becoming good friends with his pupils and assistants. By 1515 he had the largest workshop known to date; Vasari reported that 50 artists accompanied him to the Vatican each day. He supervised his apprentices and assistants working on his designs, and allowed a few to copy and enlarge his designs and add their own ideas into his projects. Raising their importance made his workshop popular, and instigated changes in the way all artists' workshops functioned.

*Left: Detail from* Marriage of the Virgin, *1504 – Raphael's early layered method of applying oil paint deliberately created a golden glow.*

moods. A revolutionary idea, this inspired subsequent artists and initiated further ideas for artistic expression.

## CREATING A GLOW

With increasing complexity, Raphael painted unusual effects of light, applying thin washes of glowing colours including tawny gold, pale ivory and yellow. Many of the pigments he used were not available after the 16th century, such as pale mauve-grey azurite, lead-tin yellow, green malachite and metallic bismuth (an unusual dark grey pigment with a shiny, sparkling appearance).

He used pigments that most other contemporary artists did not, including red lead and orpiment, and he added crushed glass to some paint, which worked as a siccative (drying agent) but which also increased the translucency of the paint.

No other artist before him had captured the glow of lamps or light emanating from holy figures as he did.

which was his method of creating unity and soft shadows without losing the *bellezza di colore*.

Conversely, to express more dramatic effects, he created strong chiaroscuro, with distinct contrasts of dark and light tones. In his first paintings, he had used Perugino's glazing method to build up reflective colours and soft shadows; and later, working closely with Sebastiano, he created his

own version of the Venetian technique, with clear, layered applications of thin paint mixed with whitewash, interspersed with pure, unblended colours. Another skill he developed after Florence was the use of colour to express different

*Below: Detail from* Marriage of the Virgin, *1504. Using classical colours of red and blue, Raphael juxtaposes pure bright pigments.*

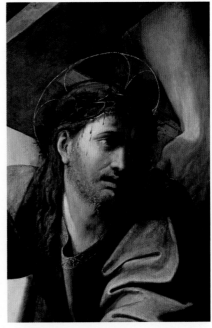

*Above: Detail from* Christ Falling on the Way to Calvary, *c.1514–16. This very modern-looking close-up demonstrates a mix of unione and chiaroscuro.*

# THE TAPESTRIES

Leo X was a man of great sensibilities. On his appointment, he filled the Sistine Chapel with magnificent choral music and commissioned Raphael to design ten tapestries to hang on the lower register of the chapel wall on special occasions. They depict miraculous events from the lives of St Peter and St Paul.

The vibrant colours Raphael used demonstrate his competitiveness with Michelangelo, as his tapestries were to be displayed beneath Michelangelo's ceiling. When the tapestries were made, the colours varied from his cartoons as the threads could not perfectly replicate his paints, but gold and silver thread was added for extra brilliance.

Knowing that his designs were to be produced by craftsmen working in another medium, Raphael concentrated on strong compositions and broad effects rather than trying to depict meticulous details.

### MIRROR IMAGE
By 1517, the cartoons had been sent to Brussels, the most prestigious centre of tapestry production, to be woven in the workshop of Pieter van Aelst in the low-warp method. For this, the cartoons were cut into vertical strips and placed on the looms beneath the thread. Weavers worked on what would become the back of the tapestry, so producing a mirror-image of Raphael's cartoons. After they had been woven, the cartoons were probably sold by Pieter van Aelst to other weavers' workshops, though *The Stoning of St Stephen* was bought by a private collector in Venice and was subsequently lost. Later, several further tapestries were made from the cartoons in different Brussels workshops, including a set for Henry VIII in 1542 and another for Francis I at around the same time. Both were later destroyed. Reproduced in the form of prints, the tapestries, along with images of Michelangelo's ceiling, became the most famous and influential designs of the High Renaissance, and during the 18th and 19th centuries, Raphael was the most revered artist of all time. From the 17th century, his cartoons in particular were seen as vital examples of history painting. Endlessly copied in a variety of media, at one point they were described as 'the Parthenon sculptures of modern art'. While Raphael and van Aelst were toiling away at the tapestries, Martin Luther was writing his 95 Theses that initiated the Reformation and shook the Catholic Church to the core. As such, the tapestries are often seen as the final great work of art of a united Christendom.

### DYNAMIC AND HARMONIOUS
At just over 3m (10ft) high and between 3m and 5m (10–16ft) wide, and with the complexity of the religious stories portrayed, these tapestries were a great undertaking for Raphael. He created dynamic compositions that project eloquent gestures, varied poses, believable characters and harmonious relationships between figures and architecture or natural landscapes. Uniquely, he added wide and elaborate borders, borrowing elements from ancient Roman reliefs.

*Below: In 1521, Leo X excommunicated Martin Luther. This shows him supervising the burning of Luther's books.*

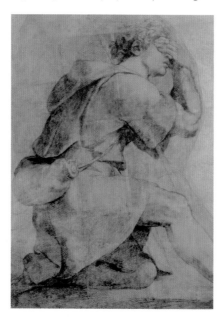

*Below: Moses before the Burning Bush, 1514. As well as his large cartoons, Raphael produced preparatory drawings.*

### CARTOONS
The word cartoon originated in the Middle Ages to describe a preparatory drawing. It derives from the Italian cartone and the Dutch karton meaning a large or thick piece of paper. Cartoons are full-sized drawings executed on strong paper for works in another medium, such as paintings, stained glass and tapestries. Each of the Raphael cartoons was executed on a large surface made up of between 180 and 200 sheets of handmade paper, trimmed and pasted together. Raphael drew his cartoons in charcoal before painting in body colour, made up of distemper, pigment, water and animal glue.

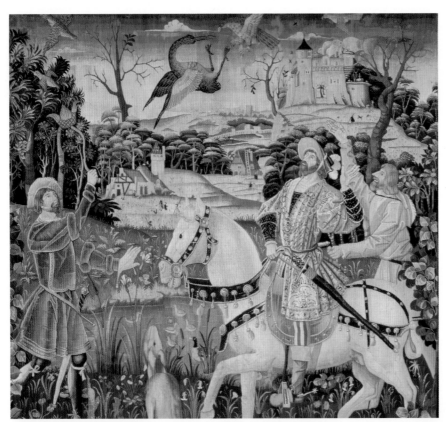

## TAPESTRY HISTORY

Produced by many different cultures, tapestries became popular in Europe during the Middle Ages. As well as insulating walls, they were status symbols. The most popular medieval images were biblical stories, myths, allegories and contemporary scenes of peasants working or nobles hunting. By the 16th century, the centre of tapestry production had moved from France to Flanders, and tapestries were no longer designed by weavers but by respected artists. Raphael's radical cartoons changed tapestry fashions irrevocably.

*Left:* Flight of the Heron, *a Flemish tapestry of the 15th century.*

*Below: In Raphael's cartoon of 1515–16, St Paul is preaching at Athens on the immortality of the soul.*

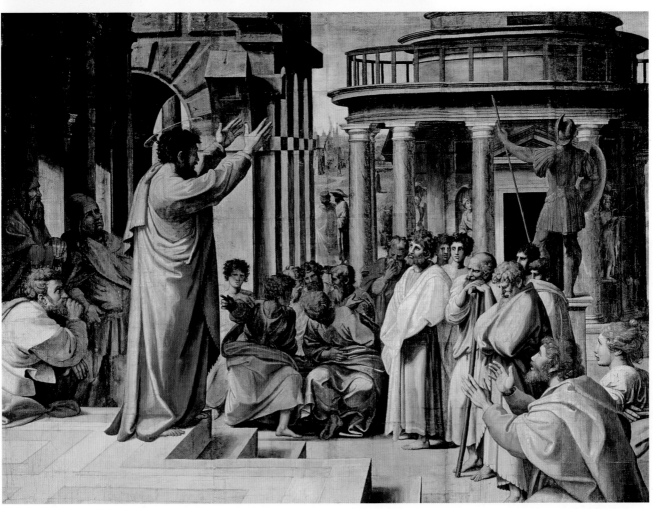

# NARRATIVE WORK

After his time in Florence, Raphael's ability to portray stories became fluent and dynamic. With unusual and dramatic compositions, unexpected details, expressive figures, gestures and features and various ways of representing perspective, he pioneered a new approach to devotional, mythical and historical subjects.

Alongside the more serious task of serving the educational and spiritual requirements of his patrons, Raphael often featured charming, witty or sensuous elements in his narrative paintings to give extra interest and portray an intricacy that was unsurpassed. For the first time, a painter was uncovering inner feelings of those he was representing and deliberately evoking the emotions of viewers. This more human approach to the representation of stories evolved through his appreciation of the work of artists around him and of the skills of artists of classical antiquity, as well as a close observation of nature.

## YOUTHFUL MATURITY

Raphael's surprising combination of youthful freshness and mature acuity disclosed his nature that was said to have been courteous, charming, seductive and humorous. This interest in and appreciation of human emotions and reactions was not unique, but his way of portraying them was, and

*Below: Detail from* The Fire in the Borgo, *1514, which Raphael painted as if viewers are looking on to a stage set – an example of his dramatic trompe l'oeil skills.*

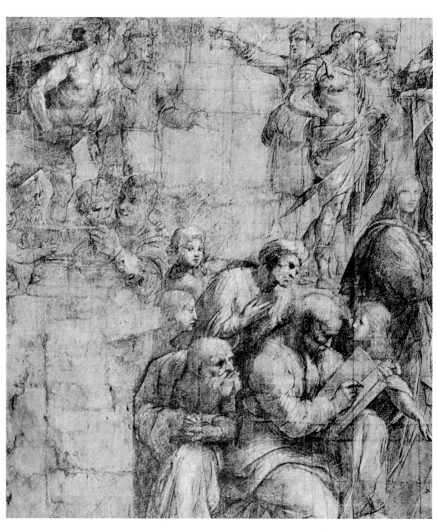

*Above: This detailed cartoon of Pythagoras for* The School of Athens *was drawn in c.1509.*

through this he influenced and altered the traditions of narrative history painting. One of the main reasons why his work (and not the work of Leonardo or Michelangelo) was seen as the epitome of artistic achievement by so many academies for such a lengthy period was his ability to appeal to viewers on human terms – to portray underlying emotions and create harmonious and candid classical-style paintings that are filled with grandeur.

## INVENZIONE

Artists from disparate parts of Italy approached narrative painting differently. Scholars and artists described their approaches as emphasizing either *disegno*: drawing or design, or *colore*: colour and its application. Although neither ignored the other, Florentine and Venetian artists relied heavily on one more than the other. Florentine artists focused more on *disegno*, while Venetian painters, with their layering and blending of glowing colours, paid close attention to *colore*. Vasari, a Florentine artist and writer, described *disegno* as the most important aspect of art, but Lodovico Dolce (1508/10–68), a Venetian writer, believed that *colore* was the way to achieve the realities of nature.

Raphael treated both elements equally. In his drawings, he concentrated on relating figures to each other and within the entire composition, considering physical and psychological relationships between them; and he captured stories from original and unusual viewpoints. At the same time, he aimed to emulate the subtle richness of Venetian colouring. Vasari described this discipline of considering the overall composition through *disegno* and *colore* and putting it all together with imagination and inventiveness as '*invenzione*'.

### TROMPE L'OEIL

A French phrase that means 'fool the eye,' trompe l'oeil is a style of realistic painting and the creation of illusions of three-dimensional reality. It became popular during the Renaissance as artists explored the boundaries between image and reality through perspective, foreshortening, meticulous details and tonal contrasts. Trompe l'oeil illusions could be playful or intellectual. For instance, when Giotto was apprenticed to Cimabue (c.1240–1302), he painted a fly on the nose of a portrait drawn by his master. The fly looked so realistic that Cimabue tried to brush it off several times before he realised it was painted on.

*Above: In this detail from* The Triumph of Galatea, *1512–13, the physical and psychological relationships between the figures can be seen clearly.*

*Below: A study by Raphael of a toddler for* The Holy Family of Francis I, *commissioned by Pope Leo X in 1518 as a gift to Claude, wife of the King of France.*

# PORTRAITS

Partly through Raphael's influence, and the trend for classical art, by 1510 most artists aimed for perfection in their portraits. Raphael aimed for naturalism over idealism and minimized his subjects' imperfections without removing them, so they looked like more attractive versions of themselves.

Portraits of highly esteemed members of society had largely been abandoned since classical antiquity. However, from the 15th century onward, not only monarchs, the high clergy and noblemen, but those in other social groups, such as merchants, bankers, scholars and artists, sat for their portraits, in order to proclaim their status and keep themselves in the public eye. Flattering likenesses that played down defects while still retaining a natural look, instigated by artists such as Raphael, Bellini, Botticelli, Dürer, Leonardo and Melozzo da Forlì, became popular. In enhancing certain features, Raphael improved on nature while imbuing a sense of grace and dignity upon his sitters, and in capturing penetrating yet fleeting gazes, he revealed elements of their underlying personality.

*Below: Raphael drew these* Studies for the Figure of Bramante *before incorporating his friend into* The School of Athens.

*Below: Raphael drew this cartoon portrait (c.1510) from life in charcoal and white lead on paper for* The School of Athens.

## UNDERDRAWING

Before executing any painting, Raphael made a preliminary drawing of each composition on a primed support, which he then painted over. This was common practice at the time, for the purpose of working out a final composition. Most of Raphael's underdrawings are formal and detailed, but some are free and expressive. He began by marking in the main shapes and then built up details such as tone, drapery, hair or jewellery and often changed his mind as he drew. Changes can be seen through several of his works.

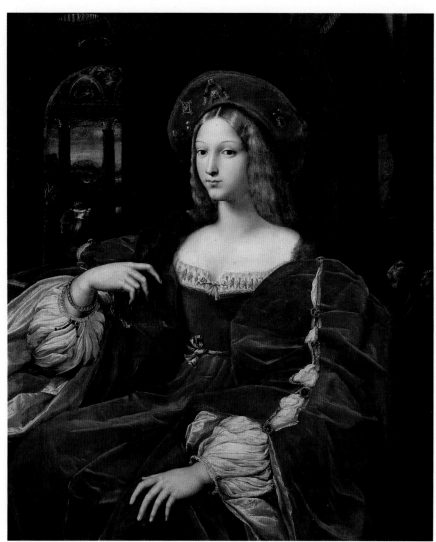

## THE RISE IN POPULARITY OF THE PORTRAIT

Portraits were always among Raphael's strongest works. While his early portraits derived from the clean contours of Netherlandish artists such as Hans Memling (1430–94) that had been practised by Santi and Perugino, his style softened after he had seen the work of artists such as Ghirlandaio and Leonardo's *Mona Lisa*.

As court painters became more established across Italy, portraits of the powerful and prominent became ever more popular, and those painted by the most admired artists were particularly coveted. Always mindful of his position in society, Raphael charged high prices for his portraits, yet demand for them continued to increase, and he found himself among the elite of society – mixing with the wealthiest, the most powerful and the leading intellectuals of his day. He earned his place among them because he was perceived as the model of rational, enlightened and well-ordered artistic practice.

## 'MORE LIKE HIM THAN HE IS HIMSELF'

'Raphael, who asks respectfully to be remembered to you, has made a portrait of our friend Tebaldeo, which is so lifelike that the painting is more like him than he is himself. For my part, I have never seen a likeness more

*Above left:* Head of a Young Boy, *c.1517, red chalk on paper, by Polidoro da Caravaggio, another of Raphael's assistants.*

perfect,' wrote Pietro Bembo to Bernardo Bibbiena in April 1516. The two churchmen knew Raphael well; he had painted a portrait of Cardinal Bembo about ten years before and one of Cardinal Bibbiena in 1516.

By the time Raphael painted the portrait of his friend Castiglione, in 1514–15, he was exceptionally accomplished at capturing subtlety of tone and the fine nuances of subdued colour. The portrait appropriately reflected the behavioural ethics of the sitter, which was important in the light of his bestselling book, *Il Cortegiano*. While extremely lifelike, the image also radiates a suitable sense of dignity, reserve and emotional restraint.

*Above: While Raphael painted the face, Giulio Romano, the best-known of his assistants, is believed to have painted the rest of the portrait of the famous beauty* Dona Isabel de Requesens, c.1518.

Raphael's group portraits were equally accomplished. His *Pope Leo X with Cardinals Giulio de' Medici and Luigi de' Rossi,* painted in 1518 to celebrate Lorenzo de' Medici's marriage, is a concentration of three figures in a close interior space. It was quite unique. Raphael's official purpose was to show the Pope in full command of his powers, despite underlying intrigues that were known to many at the time. Many other portraits by Raphael appear within large frescoes or similarly large works. His portraits of women are, like his Madonnas, sensitive, affectionate, rich in texture and idealistic.

# THE HOUSE OF ESTE

Under the aegis of the powerful d'Este family, Ferrara grew in splendour during the Renaissance period. As its artistic and academic community thrived, a rivalry arose with Venice. Competing for cultural dominance, the two cities intensified their emphasis on support of the arts and civil etiquette.

The House of Este was an influential dynasty with royal connections. Niccolò II d'Este (1338–88), Lord of Ferrara, and his brother Alberto V d'Este (1347–93), Lord of Ferrara and Modena, were the first members of the family to focus significantly on cultural improvement. In 1391, Alberto founded the University of Ferrara, and their descendants continued their encouragement of the arts and study for several generations. In the early 16th century, Duke Alfonso I d'Este (who ruled Ferrara from 1505 to 1534) became involved in the Italian Wars,

fighting against Venice and ambitious popes who sought to extend their authority in northern Italy. For his involvement, Pope Julius II excommunicated him in 1510.

## THE CAMERINO D'ALABASTRO
In July 1512, Alfonso visited Rome to ask forgiveness of Pope Julius II. He was shown around the Vatican and viewed the apartments that had been decorated by Pinturicchio for his wife Lucrezia's father, the Borgia Pope Alexander VI. He admired Michelangelo's Sistine Chapel ceiling,

but did not view the Pope's private apartments that Raphael was decorating. Yet within a couple of years, Alfonso had contacted Raphael and secured a promise from him to paint a picture for him. Approximately two years later, in March 1517, Raphael had still not produced the painting, and Alfonso's ambassador in Rome, the Bishop of Adria, asked when he would fulfil his promise.

## UNCOMPLETED COMMISSION
The work Raphael had agreed to paint was for Alfonso's small Camerino d'Alabastro (Alabaster Chamber) in his palace in Ferrara. However, in 1518 he was working on a painting for the King of France, and on frescoes in the Stanza dell'Incendio and in Chigi's Roman villa, so was too busy to begin Alfonso's commission. Exactly what happened is not clear, but Raphael accepted an advance payment from Alfonso for the work and expressed his desire to begin, but he then said he was too busy painting portraits of the Pope and the cardinals Bibbiena, Medici and Pucci. To placate Alfonso, Raphael sent him 'a cartoon for a fresco of Leo IV', and the following year he sent another, this time of the *St Michael* he had painted for Francis I of France, and possibly the cartoon of Isabel de Requesens as well.

By the end of February 1519, Raphael had still not produced the promised painting. Exasperated, the Bishop of Adria warned Raphael to 'think carefully about what it means to give your word to someone like this and then to show that you value us no more than a low commoner, telling us so many lies'; but almost immediately,

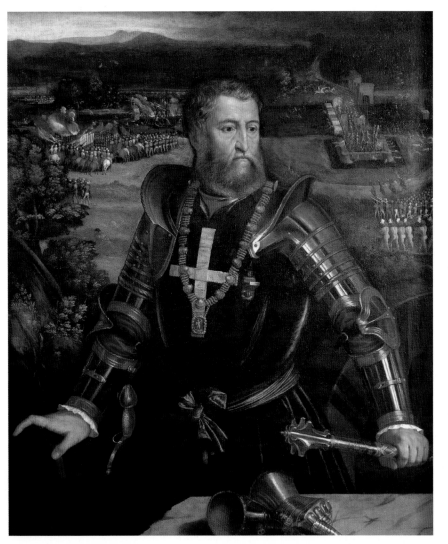

*Left:* Duke Alfonso I d'Este of Ferrara, by Dosso Dossi (c.1490–1548) – this was produced after Raphael's death.

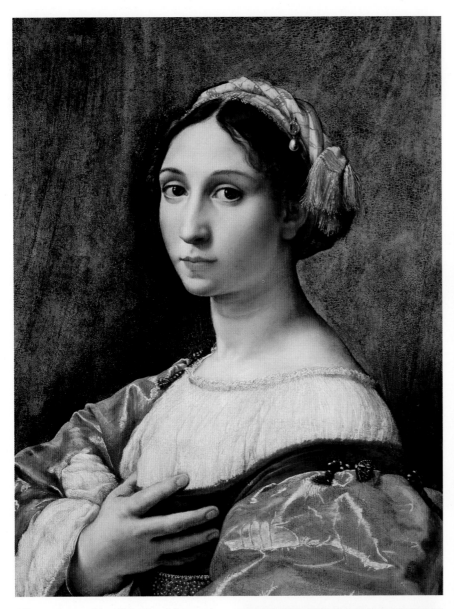

*Left: Portrait of a Young Girl, Raphael, c.1515-20. While Raphael was evading commissions from important patrons such as Duke Alfonso d'Este, he completed portraits of alluring young women.*

*Below: An engraving by Marcantonio of Raphael's figure 'Justice' from the Stanza della Segnatura's ceiling.*

Alfonso sent a friendlier plea. Ultimately however, Raphael never completed the commission. After his death, the artists of his workshop offered to undertake the work, but Alfonso declined.

## ANCIENT LITERATURE

Meanwhile, Raphael was becoming even more renowned through his continuing collaboration with the printer Marcantonio. His appetite for the arts of the ancients was immense, and increasingly he spent time consulting ancient texts as much as ancient sculpture to help inform his compositions. Fascinated by literature and how stories were expressed through words, he aimed to interpret this in his art, with action and activities in sequence.

### THE ITALIAN WARS

From 1494 to 1559, conflicts continued in many of Italy's city-states, the Papal States, most of the major countries of western Europe (Spain, France, England, Scotland and the Holy Roman Empire) and the Ottoman Empire. These hostilities became known as the Italian Wars. Originally fought over the duchy of Milan and the kingdom of Naples, the clashes soon became a universal struggle for territory and supremacy.

*Right: Another portrait of Alfonso d'Este, after Titian, attributed to Bastianino (c.1536–1602).*

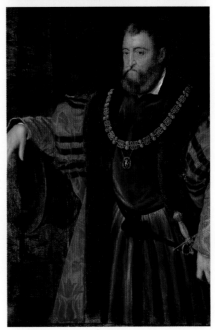

# ORDER OF THE GOLDEN SPUR

In 1515, after the Pope had given Raphael the title of 'Prefect' with authority over all antiquities found in Rome, he began a visual survey to record all ancient artefacts. By then, he had been the Pope's chief architect for a year and although inexperienced, he was proving himself extremely capable.

When first given the responsibility for designing St Peter's in 1514, Raphael wrote to his uncle Simone Ciarla: 'What place in the world can compare with Rome? What enterprise is more worthy than this of St Peter's, which is the first temple in the world? It is the greatest building that has ever been seen and it will cost more than a million gold ducats.' Unfortunately, like Bramante, Raphael died before he saw the project through – and St Peter's was not completed until the 17th century.

## INNOVATIVE CONTRASTS

It may seem incongruous that a painter with no architectural training could be appointed to such a prominent position, yet during that time it was not as radical as it might seem today. No official architectural training existed then and architects were generally those who had been trained in other areas of art. From the moment the Pope made Raphael chief architect, his career proliferated

*Above: In this etching with a brown wash of 1833, Agostino Tofanelli (1770–1834) produced an artist's impression of Raphael working as an architect on a house on the Palatine.*

even more. He designed several buildings for private patrons as well as the Pope, among others the Vatican loggias, Chigi's memorial chapel, the Villa Madama, several palaces and a small church. His architectural work always incorporated classical elements with unexpectedly contrasting aspects. For instance, in the Chigi Chapel in Santa Maria del Popolo, he used Italian and African marble, Oriental granite plus bronze and glass. The result is opulent and imposing, yet not overpowering.

As with his painting, Raphael's architectural ideas began with emulation, which he then reinterpreted. His architectural influences included the Ducal Palace in Urbino and the Pantheon. Many of his earliest

*Above: The Tempietto, c.1502, is a small tomb in the courtyard of San Pietro in Montorio, both designed by Bramante, who inspired Raphael's architectural designs.*

structures however, were influenced by architecture he had seen in paintings, rather than real buildings.

## ARCHITECTURAL DRAWINGS

Although he began as papal architect in 1514, there is evidence of earlier architectural studies by Raphael on the backs of other drawings from his time in Florence, but how involved he was with actual building at that time is not known. His setting for the School of Athens demonstrates his love of airy, classically-inspired interiors. According to Vasari, he took a leading role in discussions at the house of the Florentine architect Baccio d'Agnolo (1462-1543). Yet few of his architectural drawings from his time in Rome have survived. Several survive

and in 1517, he bought the Palazzo Caprini, an elegant building in Rome designed by Bramante. He lived there in grand style but in 1519 he began negotiations to buy a plot of land and designed a new residence for himself. The site faced via Giulia, a grand thoroughfare designed by Julius II, which had become one of the most fashionable residential streets in Rome. Sadly, the 'Palazzo Sanzio' was never built.

*Below: Raphael drew immense inspiration from the ancient Roman ruins and artefacts around him in Rome.*

*Above: With his passion for the art of antiquity, Raphael was one of the first to bring to an end the looting of ancient Roman monuments.*

however, by Antonio da Sangallo the Younger, who trained under Bramante and who was appointed second architect on the St Peter's project and worked closely with Raphael.

Raphael set up an architectural workshop that functioned in a similar manner to his painting workshop, with the employment and training of many apprentices and assistants. While this was usual, his innovative ideas meant that unusually, he allowed assistants to produce their own work as well as working on their master's.

## PALAZZO SANZIO
Because of his diligence, skills and innovations, Leo X made Raphael a 'Groom of the Chamber' or papal valet, which gave him courtier status and an even higher income. As his achievements, output and fame escalated, his standard of living also rose

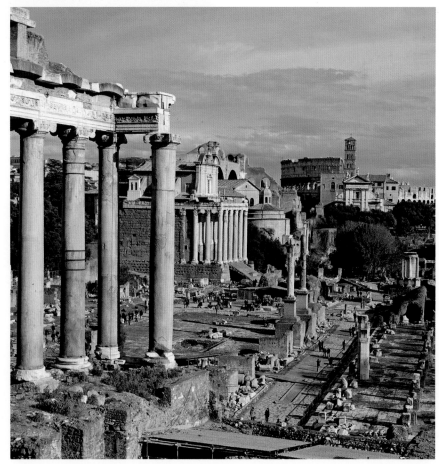

# 'MEASURELESS GRIEF'

Even at his most successful, Raphael strove to enrich his skills. According to Vasari, he realized that 'he could never rival the accomplishments of Michelangelo,' but when he died unexpectedly at only 37, he was revered by many as one of the greatest artists who had ever lived.

During his career, admiration of Raphael continued to spread and he was commissioned by patrons within and beyond Rome. Yet he never became complacent. The desire by many to own a work 'de sua mano' (of his hand) was immense. One of his last works, for a monastery in Palermo, is documented as having been executed by his pupils, but he probably worked on it himself.

## LO SPASIMO DI SICILIA

In about 1516, the donor of the Olivetan monastery and church of Santa Maria dello Spasimo in Palermo commissioned Raphael to paint an altarpiece. The resulting work depicts Christ collapsing on the way to Calvary. As Simon of Cyrene lifts the Cross from his shoulders, Christ turns and sees his mother behind him. Her shudder of pain, so powerfully portrayed, reflects the painting's name *Lo Spasimo* (The Torment). By 1518 Raphael had sent the work to Palermo. According to legend, a storm wrecked the ship carrying it, but the painting was rescued by the Genoese, who would not relinquish it until ordered to do so by the Pope. Vasari declared that after

its installation in Sicily, the picture became as famous as Mount Etna. It is not known why Raphael completed the work for this patron when more consequential patrons were left waiting.

Extreme emotions like those represented in *Lo Spasimo* were among Raphael's primary concerns in the last

*Left: Battle Piece, c.1520–46, by Giulio Romano after a study by Raphael.*

*Above: An engraving of Raphael, thought to be by Marcantonio.*

and most ambitious of all his oil paintings: *Transfiguration*. Like *Lo Spasimo*, *Transfiguration* was made for export from Rome, though in the event it never left. The work, commissioned at the end of 1516 by the Pope's cousin Cardinal Giulio de' Medici, was intended for the Narbonne Cathedral in France.

## LA FORNARINA

Vasari described Raphael as 'a very amorous person, delighting much in women and ever ready to serve them'. Despite his engagement to Maria Bibbiena, while in Rome he had a girlfriend, Margherita Luti, nicknamed 'La Fornarina' (she was the daughter of a baker – *fornaro*). He became so obsessed by her that he could not concentrate while painting the frescoes in Agostino Chigi's villa. Cleverly, Chigi invited Margherita to stay in his villa so that Raphael could see her whenever he wished, and the frescoes were soon completed.

*Above:* Honours Rendered to Raphael on His Deathbed, *1806, by Pierre-Nolasque Bergeret (1782–1863).*

Simultaneously, the Cardinal commissioned Sebastiano del Piombo to paint the *Raising of Lazarus,* which was completed by 1519; but Raphael took longer as he was working on a new idea. He combined the *Transfiguration* with an incident that follows it in the Bible, in which the apostles try to cure a possessed boy, but only Jesus can perform the miracle.

The painting is full of colour, action and emotion, featuring strong chiaroscuro, dramatic gestures, tranquillity and tension.

## RAPHAEL'S DEATH

In 1520, Raphael – full of life, in love, immensely popular and at the height of his powers – became suddenly ill. Theories conflict over the cause of his death, but after 15 days of suffering, on 6 April, probably his 37th birthday, he died. The nation mourned, the Pope was said to be 'sunk in measureless grief' and observers predicted that the

tragedy augured darker events to come. Raphael's body lay in state in the Vatican, and *Transfiguration* was carried before him in the funeral procession. At his request, he was buried in the Pantheon and the inscription on his tomb was written by Pietro Bembo: 'Here lies that famous Raphael by whom Nature feared to be conquered while he lived and when he was dying, feared herself to die.'

*Below:* The Last Moments of Raphael, *1866, by history painter Henry Nelson O'Neil (1817–80).*

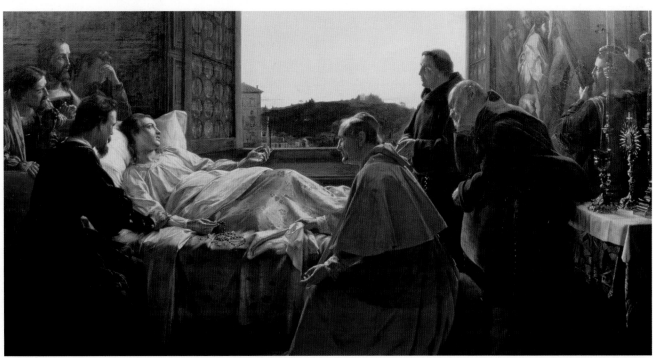

# THE GALLERY

Often referred to as 'the god of art,' Raphael's impressive achievements developed around two main factors: his remarkable skill and his social status. From early on, he styled himself as an elegant man of culture rather than as an artisan and for the most part, he remained impeccably professional throughout his life. The range of his accomplishments was incredible and despite dying three years before his 40th birthday, he became one of the most celebrated and influential painters the world has ever known. Perceived by academic institutions as the ideal artist, demonstrating clarity, discernment, elegance and acuity, he has been revered and emulated for almost five centuries throughout the world. Recognized for his images of charming, gentle Madonnas, vivid biblical, mythical and narrative works and perceptive, lifelike portraits, Raphael's art always portrayed his optimism and enjoyment of life.

*Left: Detail of putti from* The Triumph of Galatea, *1512-14, fresco, Villa Farnesina, Rome, Italy, 300 x 220cm (10 x 7ft) Two playful little boys have been transformed into putti by Raphael's careful touch. These lifelike, mischievous figures have been placed in an arc in the composition. Detailed elements such as the coloured wings and curly hair add credibility to the figures, while their elusive charm reveals just one element that helped to make Raphael so popular.*

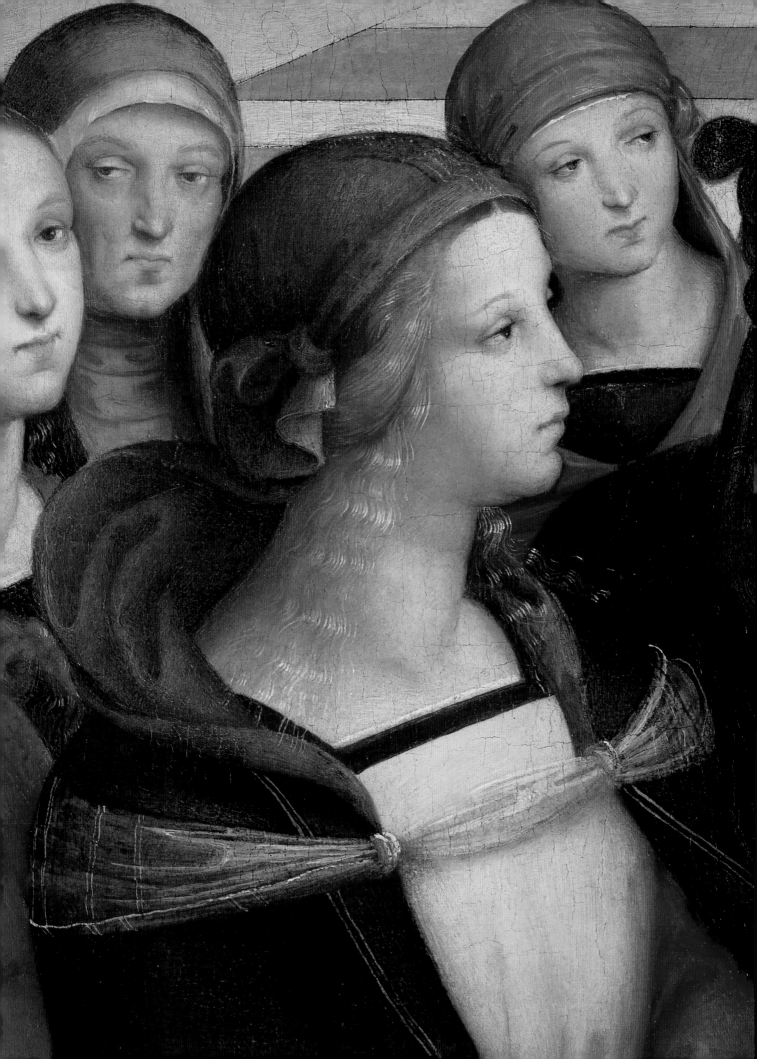

# PAINTING
# REALITIES

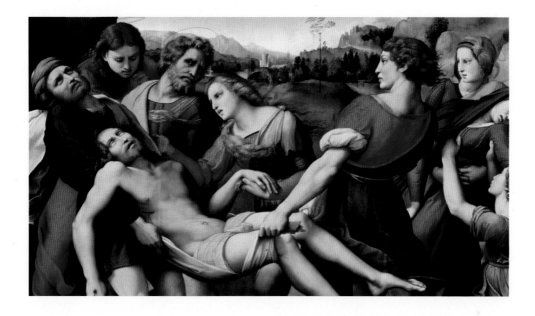

From panel paintings to fresco cycles, from oil on canvas to drawings and studies and from architectural plans to tapestry designs, Raphael's abilities were enhanced by his resolve and diligence. From demonstrating exceptional artistic talents as a child, he worked unrelentingly, determined to advance his capabilities and reputation. Although usually indebted to others, he never, as Michelangelo claimed, simply copied and reproduced but his ability to assimilate and reinterpret was masterful and original. Coupled with his considerable skill as a manager who organized his pupils, assistants and colleagues, Raphael increased the potential of future artists and architects and changed the way workshops functioned. His art had an impact on the world, but the uniqueness of his talents proved impossible to imitate..

*Above: detail of* The Deposition of Christ, *1507, oil on panel, Gallery Borghese, Rome, Italy, 179 x 174cm (70 x 68in)*

*Left: Raphael, detail of the* Marriage of the Virgin, *1504, oil on panel, Pinacoteca di Brera, Milan, Italy, 170 x 118cm (67 x 46in). Portraying a marriage ceremony between Mary and Joseph and also known as* Lo Sposalizio, *this detail shows Mary's attendants standing behind her.*

*Saint Sebastian*, 1499–1500, black chalk on white paper, Hamburger Kunsthalle, Hamburg, Germany, 26 x 18.8cm (10 x 7in)

In the 15th century, artists began to use paper more widely and the resulting drawings show clearly how many developed their ideas. Raphael produced many drawings; as compositional studies, as preparation for paintings and to practice his skills. He drew this as an observational figure study in one of many attempts at creating figures whose naturalism of pose and expression appeal directly to viewers.

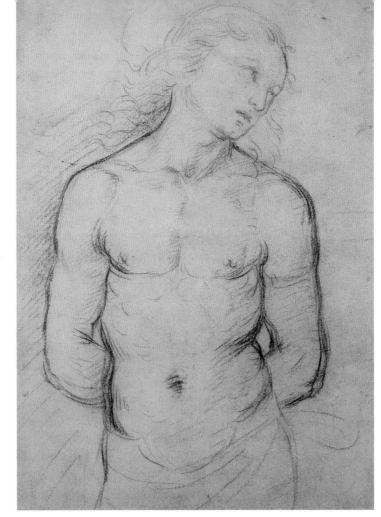

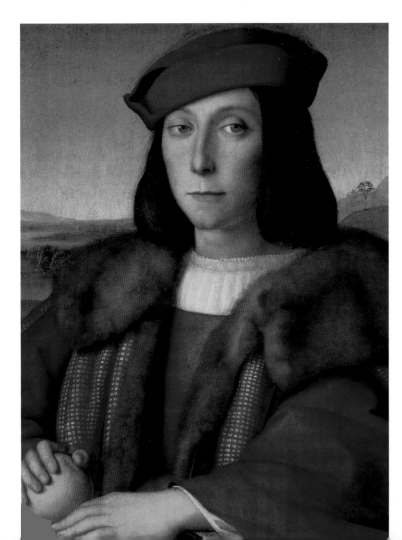

*Portrait of a Man Holding an Apple, c.*1503–4, tempera on wood, Galleria degli Uffizi, Florence, Italy, 48 x 35.5cm (19 x 14in)

Believed to be of Francesco Maria della Rovere, Duke of Urbino from 1508 to 1538, nephew of Pope Julius II and Guidobaldo da Montefeltro, this is finely executed with great attention to detail, but it does not have the charisma of the majority of Raphael's paintings. The composition appears to have been inspired by some Florentine portraits he had recently encountered, with detailed renditions of various textures, a harmonious pyramid shape and soft landscape background.

*Head of a Youth, possibly a Self-portrait, c.1500,* grey-black chalk heightened with white bodycolour on white paper, Ashmolean Museum, Oxford, England, 38 x 26cm (15 x 10in)

Created with great economy of line, traditionally this is identified as an early self-portrait. The subject looks directly at viewers as an artist would look in a mirror when creating a self-portrait. His hat, hair and facial features have been drawn in more detail with soft, short and varied marks while the contours of the face are created with delicate hatching, but the drawing seems somewhat tentative, and does not show Raphael's usual sureness of touch.

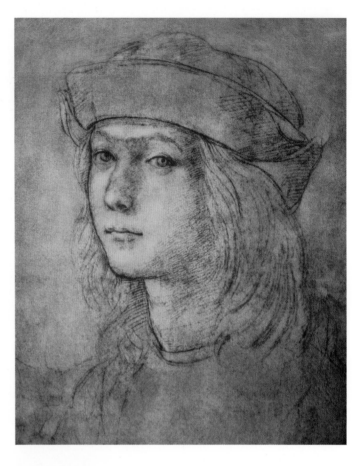

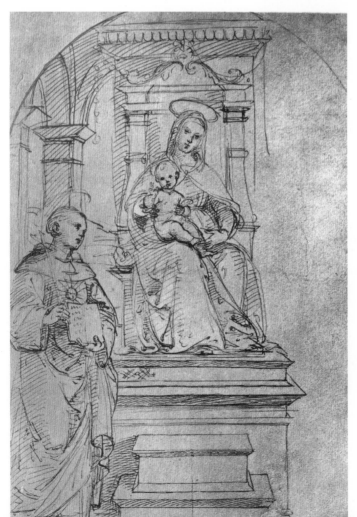

*Madonna with Nicholas of Tolentino,* 1500, brown ink over black pencil, Städel Museum, Frankfurt, Germany, 23.3 x 15.4cm (9 x 6in)

This is a compositional study for a 'Sacra Conversazione,' ('sacred conversation') that describes an altarpiece in which saints group around the Virgin and Child, on one panel, rather than on separate pieces as in a diptych or triptych. The figures do not actually appear to converse. Here, Raphael was working out a composition for the *Ansidei Madonna*. The drawing features the Virgin and Child with Saint Nicholas of Tolentino and the painting was commissioned by Bernardino Ansidei for his family chapel in a Perugian church.

*Angel,* 1500–01, oil on wood, Pinacoteca Civica Tosio Martinengo, Brescia, Italy, 31 x 27cm (12 x 11in)

One of the four fragments of an altarpiece and part of Raphael's first recorded commission, this angel was painted for Andrea Baronci's chapel in the church of Sant'Agostino in Città di Castello. Also known as the Baronci altarpiece, this was dedicated to Saint Nicholas of Tolentino and Raphael completed it over nine months. It was a remarkable achievement for a teenage artist.

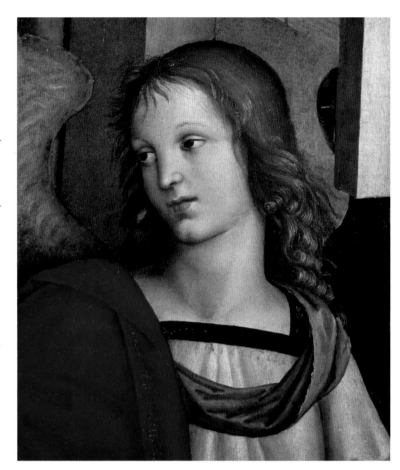

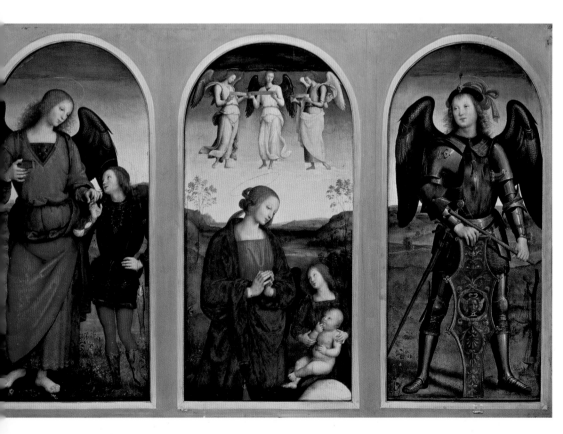

*Three Panels from an Altarpiece, Certosa,* c.1496–1500, oil and egg tempera on poplar, Pietro Perugino, National Gallery, London, England, central panel 127 x 64cm (50 x 25in), side panels 126 x 58cm (50 x 23in)

Pietro Perugino was admired and renowned before Michelangelo and Raphael. This altarpiece was commissioned by a Carthusian monastery when Perugino was at the height of his powers and reputation. The three remaining panels of six feature the Virgin and Child flanked by two archangels, Michael and Raphael. Michael wears armour and Raphael is accompanied by young Tobias. The work is graceful and angelic, characteristic of Perugino's idealized style.

*Head and Shoulders of a Young Woman*, 1500–03, silverpoint on white paper, British Museum, London, England, 25.7 x 19cm (10 x 7in)

Long after he began drawing with chalks and pen and ink, Raphael continued to use silverpoint as he found the medium sympathetic to his careful style. With subtle marks, he has given the impression of soft tonal contrasts, wisps of hair and the young woman's delicate veil. The study served as the head of the Virgin in the *Solly Madonna* on page 105, painted just after Raphael had completed this drawing.

*The Three Graces,* c.1504–05, oil on wood, Musée Condé, Chantilly, France, 17 x 17cm (7 x 7in)

Thought to be inspired by a damaged ancient marble statue in Siena Cathedral, Raphael painted these nude figures, which are believed to be the three Graces of classical mythology; daughters of Jupiter and the personification of grace and beauty, seduction and fertility. The golden globes they hold may also refer to the Hesperides; daughters of Atlas who guard the golden apples of immortality. Additionally, they could represent the three golden balls which were the arms of the Medici.

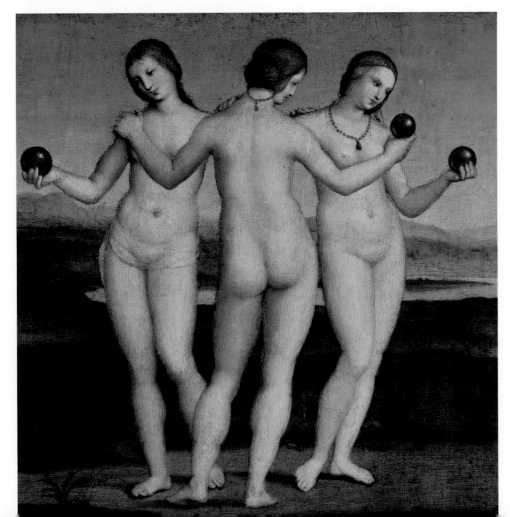

*Saint Francis of Assisi,* panel from the predella of the Colonna Altarpiece, *c.*1502, oil on panel, Dulwich Picture Gallery, London, England, 25.8 x 16.8cm (10 x 7in)

Identified by the wound on his side, this image of Saint Francis was painted as one of two outer panels from the predella (a long narrow strip forming the lower edge of an altarpiece) of the *Madonna and Child Enthroned with Saints,* also known as the Colonna altarpiece. Raphael painted it for the Franciscan nuns of Saint Anthony of Padua in Perugia but by the 17th century, the impoverished nuns had to dismantle the altarpiece and sell the paintings.

*The Resurrection of Christ,* 1499–1502, oil on panel, São Paulo Museum of Art, São Paulo, Brazil, 52 x 44cm (20 x 17in)

Probably a section of an unknown predella or even part of the Baronci altarpiece, this painting shows Perugino's influence, while Raphael's precocious talents and natural dramatic and original style were already becoming apparent. The composition is controlled with all elements placed to give viewers an impression of geometric balance and rhythm. Colours are bright and the figures are dynamic, all created with a clean and clear style.

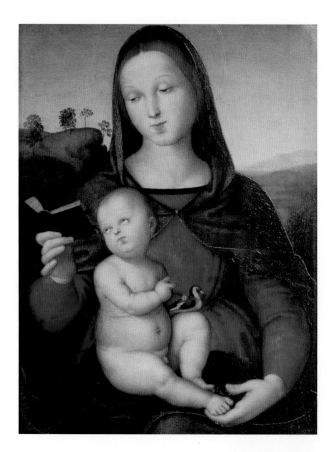

*Madonna and Child (Solly Madonna)*, 1500–04, oil on panel, Staatliche Museen zu Berlin, Gemäldegalerie, Berlin, Germany, 52 x 38cm (20 x 15in)

Reading a sacred book, the Virgin also holds her baby's foot. He is playing with a goldfinch and looks up at his mother's book. In Christian art, the goldfinch is associated with the Passion and represents the premonition Jesus and Mary had of the Crucifixion. Painted for private devotion, this work resembles the small Madonna paintings that Perugino became famous for. It is called the Solly Madonna because it was owned by the British banker and art collector Edward Solly (1776–1848).

*The Gavari Crucifixion (Mond Crucifixion)*, 1502–03, oil on panel, National Gallery, London, England, 280 x 165cm (110 x 65in)

With the style greatly influenced by Perugino, this is set against a Florentine landscape. Christ is flanked by two angels, collecting the blood from his hands and side. At the base of the Cross stand the Virgin and Saint John and kneeling in front of them are Saint Jerome and Mary Magdalene. The work served as the altarpiece of a side chapel in San Domenico in Città di Castello.

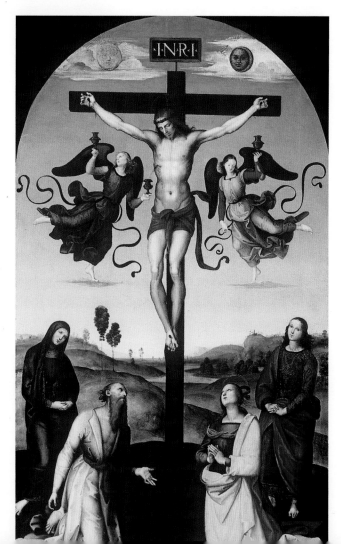

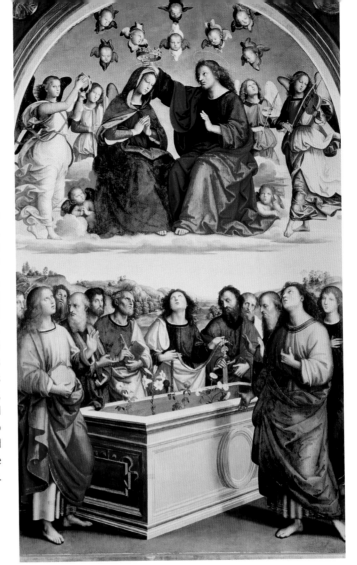

*The Coronation of the Virgin (Oddi Altarpiece)*, 1502–04, oil on wood, transferred to canvas, Pinacoteca Vaticana, Vatican City, Rome, Italy, 267 x 163cm (105 x 64in)

It is probable that the patron of this work; Leandra Baglioni, commissioned the altarpiece in memory of her husband, Simone degli Oddi, who died in 1498 in exile as the Oddi and Baglioni families were enemies. The upper section of the work is closer to Perugino's style, while the apostles below look more solid, with livelier gestures and movements, giving rise to speculation that Raphael had already visited Florence when he painted it.

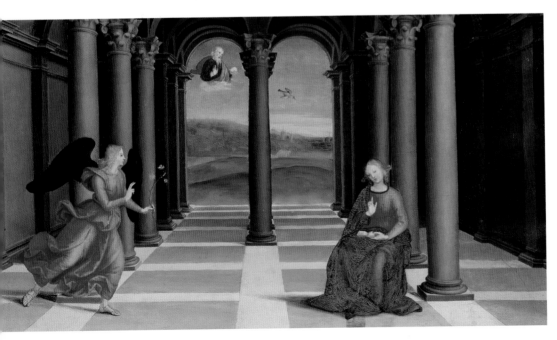

*The Annunciation*, 1502–04, oil on wood, transferred to canvas, Pinacoteca Vaticana, Vatican City, Rome, Italy, 27 x 50cm (11 x 20in)

This is one of the three predellas of the Oddi altarpiece commissioned by Leandra Baglioni for her own chapel in the church of San Francesco al Prato in Perugia. The strong linear perspective suggests that Raphael had already studied several Florentine paintings, such as Annunciations by Leonardo, Botticelli and Fra Angelico.

*Adoration of the Magi,*
*c.*1502–04, tempera grassa
(egg-oil) on canvas,
Pinacoteca Vaticano, Vatican
City, Rome, Italy,
27 x 50cm (10.6 x 19.7in)

This was the centrepiece of
the three predellas that ran
beneath the *Coronation of*
*the Virgin.* Colourful and
dynamic, it was flanked by
two restrained portrayals of
*The Annunciation* (left) and
*Presentation at the Temple.*
The clear chiaroscuro
gives the painting the
appearance of a
high relief.

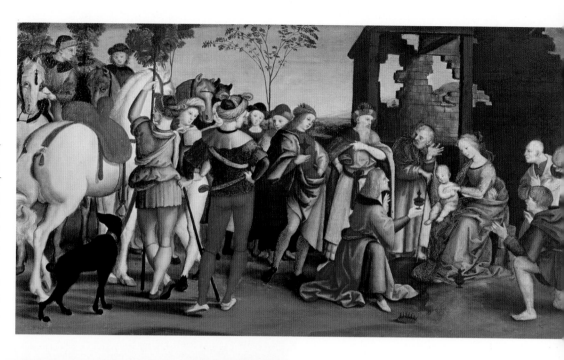

*Portrait of Pietro Bembo,*
*c.*1504–06, oil on wood,
Museum of Fine Arts,
Budapest, Hungary,
54 x 39cm (21 x 15in)

Pietro Bembo was a friend
of Raphael from their time
together in Urbino and then
in Rome. A cultured man,
Bembo was a poet, humanist
and cardinal and the two
men shared many tastes.
This composition, with
Bembo filling the space, the
position of his hands and his
elusive smile, reveals the
influence of Netherlandish
painting, while the
background shows the
newer ideas Raphael had
learned in Florence.

*Portrait of a Man, c.*1502, oil on wood, Gallery Borghese, Rome, Italy, 45 x 31cm (18 x 12in)

The fact that this work was previously attributed to Hans Holbein (c.1497–1543) and Perugino shows how Raphael could absorb and reinterpret other artists' styles with expertise. Although the sitter is unidentified, judging by the shape of his hat, he is probably a duke. Raphael idealized his face minimizing any defects.

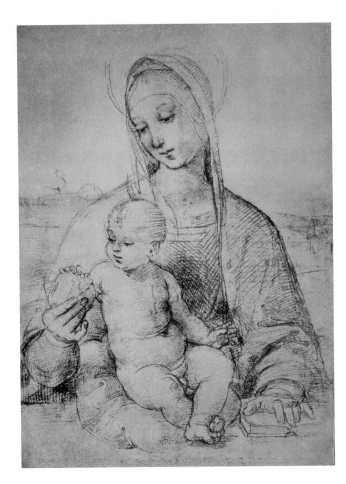

*The Virgin and Child with a Pomegranate, c.*1504, black chalk on paper, Graphische Sammlung Albertina, Vienna, Austria, 41.8 x 29.8cm (16 x 12in)

This tender image characterizes Raphael's skill in representing the bond between mother and child, but it contrasts with other similar works in that Mary is not sitting, but standing behind a parapet while her baby sits on a cushion. The drawing represents a young woman with her hand on a sacred book. Both are preoccupied by the pomegranate which symbolizes the Resurrection.

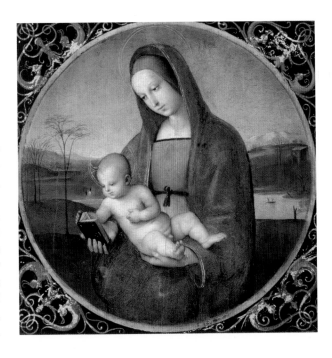

*Madonna Conestabile, c.*1503–04, oil on wood, transferred to canvas, The State Hermitage Museum, St Petersburg, Russia, 17.5 x 18cm (7 x 7in)

In this tiny work, the Madonna Conestabile, named after a previous owner, shows Mary holding her baby in her left hand and a sacred book in her right. With the baby appearing to read the book and sadness crossing Mary's face, the painting represents peace, contemplation and foreknowledge of the Passion to come. Their curved contours echo the tondo format while behind them winter turns to spring, symbolizing hope.

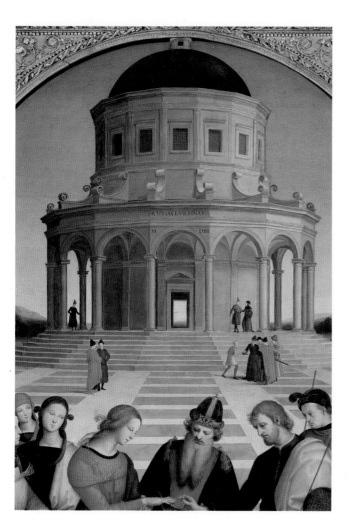

*Marriage of the Virgin* (detail of the painting below)

Raphael signed his name on the frieze of the portico of this temple. The date of the work, MDIIII (1504) is painted on the spandrel of the arch. Painted for the Albizzini Chapel dedicated to Saint Joseph in the Church of San Francesco in Città di Castello, Raphael painted the work when he was heavily influenced by Perugino.

*Marriage of the Virgin, (Lo Sposalizio)* 1504, oil on panel, Pinacoteca di Brera, Milan, Italy, 174 x 121cm (68 x 48in)

Originally commissioned for a Franciscan church in Città di Castello, the painting changed locations several times, before ending up in the Pinacoteca di Brera in Milan.

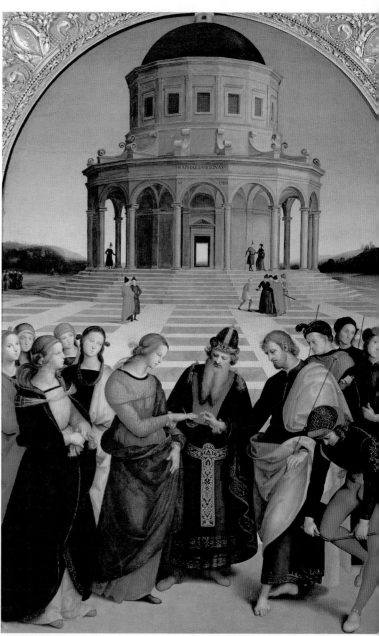

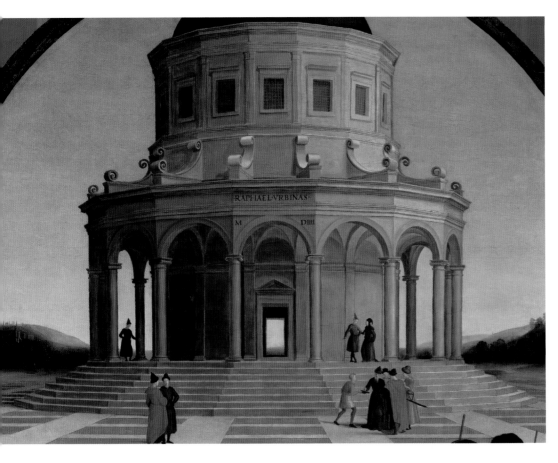

*Marriage of the Virgin* (detail of the painting on page 109)

The use of perspective – both linear and atmospheric – helps to give this painting depth and balance. Raphael has clearly delineated the receding perspective lines, with the tiles of the pavement leading back toward the round temple and figures gradually diminishing in size. This early work already demonstrated that Raphael was assimilating elements of Perugino's and Piero della Francesca's styles. The harmonious space and architecture appears to be almost surreal, bathed in golden light and seeming to rise out of the idyllic landscape.

*Marriage of the Virgin* (detail of the painting on page 109)

This partial view of the temple in the background of the painting shows Raphael's dextrous tonal contrasts and simplistic figures. Inspired by an almost identical work by Perugino, this aspect of figures and building in the background show more appealing and humanistic elements. Raphael's architectural representations were always detailed and accomplished.

*Marriage of the Virgin* (detail of the painting on page 109)

The steps in the background of Lo Sposalizio reveal how precisely Raphael rendered every aspect of his work, from the meticulous manmade elements, to the softly depicted landscape. He made sure that the colours contrasted for maximum impact. This background was purposefully created to appear calm and still, so as not to detract from the action in the foreground.

*Marriage of the Virgin* (detail of the painting on page 109)

This painting represented a holy – and legendary – marriage taking place at the foot of the Temple steps. Behind the main protagonists, life continues and here a group of men are giving money to a beggar. It is natural, everyday details like this that helped to make Raphael so popular. Despite his lofty ideals and yearning for recognition, he usually incorporated elements that were individual and appealing.

*Marriage of the Virgin* (detail of the painting on page 109)

With tiny brush marks and a careful application of deep and pale colours, Raphael created a misty, atmospheric background, featuring buildings, foliage and figures, including one on a horse. Without crowding the image, he placed small groups of figures in judicious places, all busily occupied and each able to be 'read' as an individual story. These elements create a perfect foil for the main action in the foreground.

*Marriage of the Virgin* (detail of the painting on page 109)

This is the focal point of the painting that portrays the legend of the beautiful young woman who had many suitors all wishing to marry her. The high priest asked the suitors – all male descendants of David – to each bring a wooden stick and to wait for a night. By the morning, one of the sticks would have blossomed and its owner could marry Mary. The next morning as described, buds and flowers had burst out of one of the rods and the air was full of fragrance. The staff belonged to Joseph.

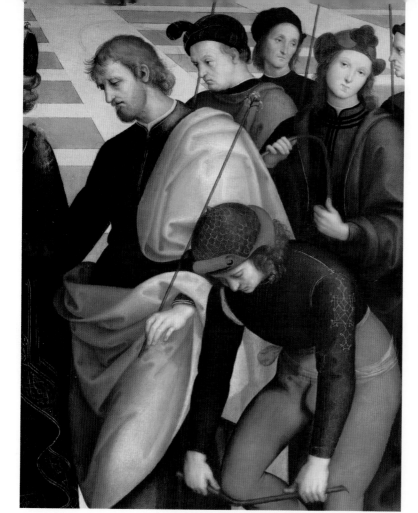

*Marriage of the Virgin* (detail of the painting on page 109)

As described in the story, the disappointed suitors attended the wedding of Mary to Joseph, but this young man in red and green shows his anger by breaking his staff as the marriage takes place. The man behind him is about to snap his staff too, while Joseph calmly weds his bride, holding his blossoming stick proudly.

*Marriage of the Virgin* (detail of the painting on page 109)

In this detail, close-ups of the hands of Mary and Joseph can be discerned clearly at the point in which Joseph is about to place the ring on Mary's finger. The ring is at the centre of the painting, as at the time it was the most precious relic of the city of Perugia. In 1473, a friar had stolen it from the nearby town of Chiusi, and it was the subject of intense political discord.

*Marriage of the Virgin* (detail of the painting on page 109)

Although this early style is so similar to Perugino's, it is not clear whether or not Raphael was ever an official member of the older master's workshop. In comparison with Perugino's version of this painting, this work by Raphael was already more spontaneous and natural looking. This priest, for instance, has a more credible appearance and stance.

*Marriage of the Virgin* (detail of the painting on page 109)

The Marriage of the Virgin, although not mentioned in the Gospels was described in several apocryphal sources and the painting was created to promote the theological status of the Virgin Mary. This detail demonstrates 21 year old Raphael's colourful, strong and confident skill in depicting any aspect. Here, the fabric of Mary's clothing can be studied. Raphael often painted her wearing red for the Passion and blue for Heaven.

*Saint Sebastian,* c.1502–03, oil on wood, Pinacoteca dell'Accademia Carrara, Bergamo, Italy, 43.9 x 34.3cm (17 x 13in)

Holding an arrow, an emblem of his martyrdom, Saint Sebastian has a 'sweet' expression and double halo.

These elements were typical of Raphael and demonstrate several significant lessons that he absorbed from Perugino in a few months. The graceful hand is typical of Perugino, but the picture is suggestive of Pinturicchio in the gilding and decorative stitching on the clothing.

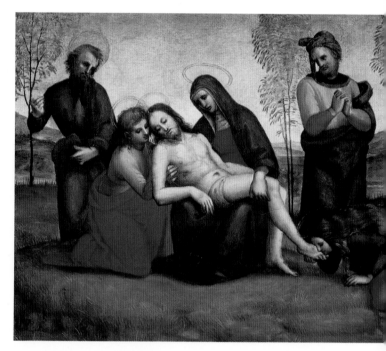

*Pietà,* c.1504, oil on panel, Isabella Stewart Gardner Museum, Boston, MA, USA, 23.5 x 28.8cm (9 x 11in)

Also known as *Lamentation over the Dead Christ,* this small panel originally formed part of the predella of an altarpiece for the convent of Sant'Antonio in Perugia. At the time, Raphael was rapidly overtaking Perugino in accomplishment and appeal. In the centre of the work, Saint John and the Virgin hold the body of Christ, while Joseph of Arimathea and Nicodemus stand behind and Mary Magdalene kneels to kiss Christ's foot.

Detail of *Pietà,* c.1504, oil on panel, Isabella Stewart Gardner Museum, Boston, MA, USA, 23.5 x 28.8cm (9 x 11in)

The bright colours, simplicity of composition and charmingly depicted figures are perfectly balanced in this small painting. In this detail, the grief-stricken Saint John the Baptist holds his dead cousin tenderly. The delicate double halos are reminiscent of the style of Perugino, although Raphael was beginning to consider other styles by this time.

*Self-portrait,* 1504-06, oil on panel, Galleria degli Uffizi, Florence, Italy, 47.5 x 33cm (19 x 13in)

This self-portrait shows Raphael as a young man of between 21 and 23 years old in three-quarter profile, wearing a beret which holds his long chestnut hair off his forehead. The light bathes only his face, leaving the background in darkness. The motive for the painting is not known and it is also unclear whether Raphael painted it during his time in Florence or later when he returned to Urbino.

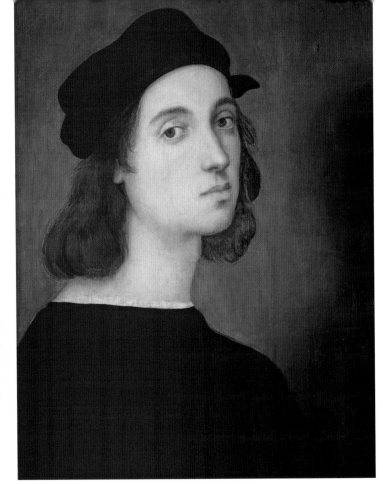

*Saint Michael, c.*1503–05, oil on poplar, Musée du Louvre, Paris, France, 30.9 x 26.5cm (12 x 10in)

In the New Testament Book of Revelation, the Archangel Michael fought with the devil, described as taking the shape of a fantastic beast. Raphael interpreted this as a mythical dragon in a work thought to be produced for Guidobaldo da Montefeltro. The emphasis on chivalric qualities was particularly pertinent at the time as Guidobaldo had recently regained Urbino from Cesare Borgia's occupation. As well as youthful freshness, this shows an emerging maturity.

*Study for the Madonna del Granduca (Madonna of the Grand Duke), c.1505,* black chalk over stylus on paper, Galleria degli Uffizi, Florence, Italy, 21.3 x 18.4cm (8 x 7in)

A fairly rapidly executed study, Raphael modified this Virgin and Child when he painted it. It shows his change of style after he had been to Florence; the theme is rendered more realistically with emphasis on tonal modelling, rather than concentrating solely on harmony. The Virgin's eloquent, contemplative glance characterizes Raphael's skill in conveying the bond between mother and child.

*Madonna del Granduca (Madonna of the Grand Duke), c.1506,* oil on panel, Galleria Palatina, Pitti Palace, Florence, Italy, 84.4 x 55.9cm (33 x 22in)

The Grand Duke Ferdinand III of Tuscany (1769–1824), who ruled from 1790 until his death, particularly admired this work and kept it with him, which led to its name. Apart from that, little is known of the painting. It was probably created after Raphael had studied the work of Leonardo as it is carefully rendered with sfumato style tonal qualities. Originally there was an arched window behind the Virgin overlooking a landscape.

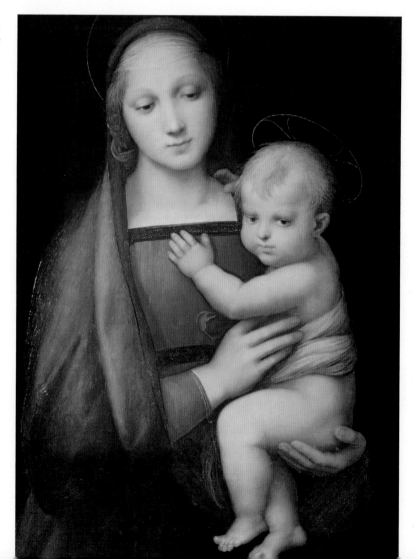

*Tondo of the Virgin and Child with John the Baptist and a Holy Boy (The Madonna Terrranuova)*, c.1505, oil on wood, Gemäldegalerie, Staatliche Museen, Berlin, Germany, diameter: 87cm (34in)

In this work, Raphael was still fairly faithful to Perugino's manner; the idealized features, the 'sweet' style of the faces and the clearly lit background. The light that reflects on to the faces throws the whole image into strong chiaroscuro. Probably painted for Taddeo Taddei, this tondo was executed soon after Raphael's arrival in Florence and many features that he incorporated were repeated in similar works for other patrons.

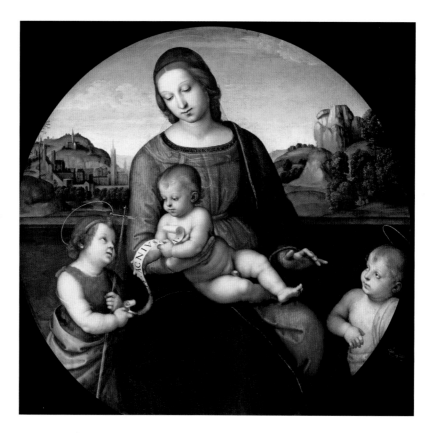

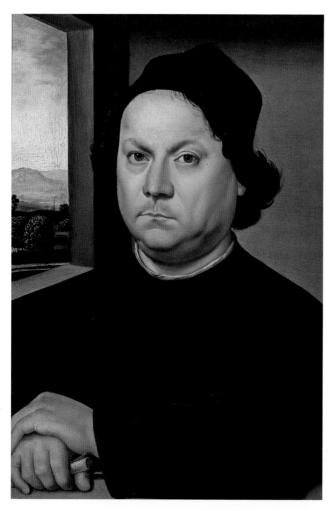

*Pietro Perugino*, c.1504, tempera on wood, Galleria degli Uffizi, Florence, Italy, 57 x 42cm (22 x 16in)

Raphael painted this portrait of Perugino around the time of his first visit to Florence, when he was already aware of new ideas beyond those of his sitter. The window to the side of Perugino with a glimpse of landscape beyond came directly from the influence of the styles of northern Renaissance painters and the detail and realism derived from the studies he had made of artists working in Florence.

*An Allegory: Vision of a Knight*, c.1504, oil on poplar, The National Gallery, London, England, 17.1 x 17.3cm (7 x 7in)

From a passage in the *Punica*, an epic poem by the Latin poet Silius Italicus (25–101), the Roman hero Scipio Africanus (236–184 BC) is sleeping under a bay tree.

In a dream, two ladies appear; Virtue (soberly dressed in front of a steep and rocky path) and Pleasure (with flowing hair and looser robes). They represent the ideal qualities of a knight. The book, sword and flower they hold also indicate desirable knightly attributes of scholar, soldier and lover.

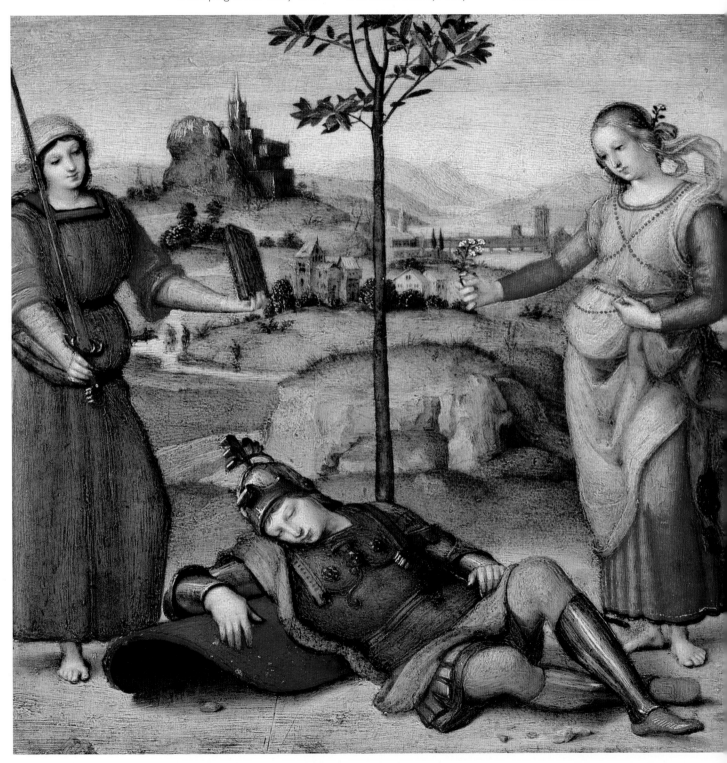

*Madonna and Child Enthroned with Saints (The Colonna Altarpiece)*, *c.*1504, tempera and gold on wood, The Metropolitan Museum of Art, New York City, NY, USA, main panel, 169.5 x 168.9cm (66 x 66in); lunette, 64.8 x 171.5cm (25 x 67in)

Painted for the small Franciscan convent of Sant'Antonio in Perugia, this altarpiece was displayed in a part of the convent reserved for the nuns. According to Vasari, the nuns requested that Raphael painted Christ and Saint John the Baptist fully clothed. Earlier depictions of Mary had shown her as a remote figure, but through several influences, Raphael's Madonnas became more intimate.

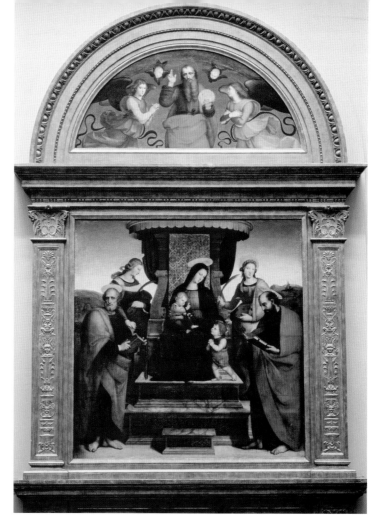

Main panel of *Madonna and Child Enthroned with Saints (The Colonna Altarpiece)*, (detail of the main panel above)

The saints here include Saint John as a young boy and Peter, Catherine, Cecilia and Paul. Although the influence of Perugino is still strong, by now, Raphael had started to experiment with new styles of representation, including different types of halos. The chiaroscuro and bright colours are a perfect foil for the soft landscape in the background and the accurately rendered architectural details.

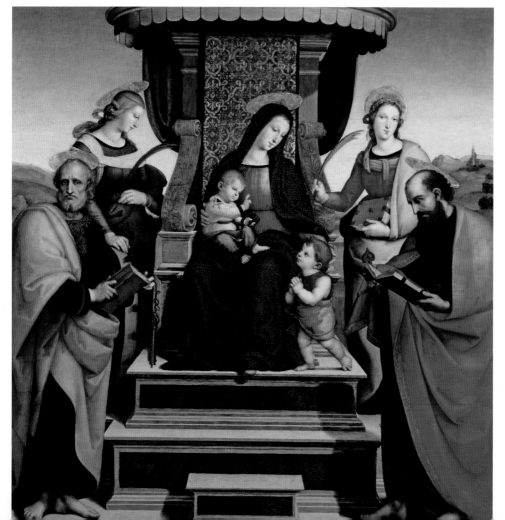

Detail of *Madonna and Child Enthroned with Saints (The Colonna Altarpiece)*, c.1504, tempera and gold on wood, The Metropolitan Museum of Art, New York City, New York, USA, main panel, 169.5 x 168.9cm (66 x 66in)

This shows Saint Peter clearly. He was an apostle and one of the founders of the Church and he holds a large key symbolizing the keys of Heaven given to him by Christ. His bright yellow mantle indicates his faith and the book he carries is the Gospel. Behind him stands Saint Catherine of Alexandria with her hand on a wheel, alluding to her martyrdom. The Christ child is fully dressed to protect the modesty of the nuns.

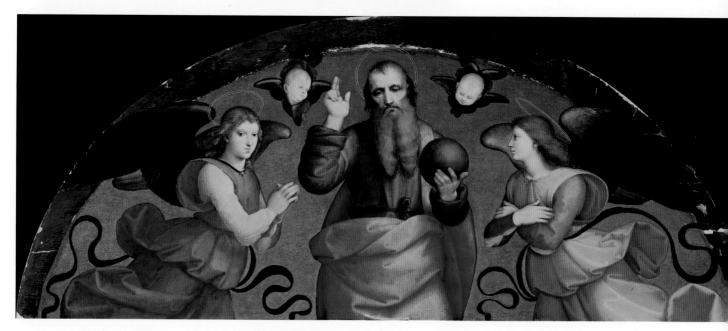

Detail of *Madonna and Child Enthroned with Saints (The Colonna Altarpiece)*, c.1504, tempera and gold on wood, The Metropolitan Museum of Art, New York City, New York, USA, lunette, 64.8 x 171.5cm (25 x 67in)

God the Father and two adoring angels are painted in strict symmetry to match the structure of the main panel's composition. The decorative elements and brilliant colours of this lunette still echo the styles of Perugino and Pinturicchio, but it was soon after this that Raphael became more experimental and tried out some further innovative ideas.

*The Procession to Calvary,*
*c.1504–05,* oil on poplar,
The National Gallery,
London, England,
24.4 × 85.5cm (10 × 34in)

This is the central part of the
predella that was displayed
below the main panel of
the Colonna Altarpiece.
Christ carries the Cross to
Golgotha. Behind him, Simon
of Cyrene helps carry the
Cross and behind him, the
fainting Virgin is supported
by the three other Maries.
Wringing his hands nearby is
Saint John the Evangelist.

Raphael created these works
for the Perugian churches
at a time of great civic
upheavals, but he managed
to maintain friendly relations
with all concerned.

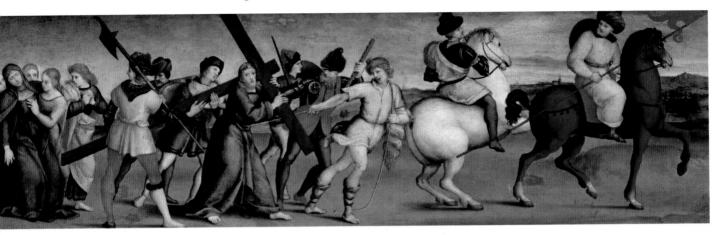

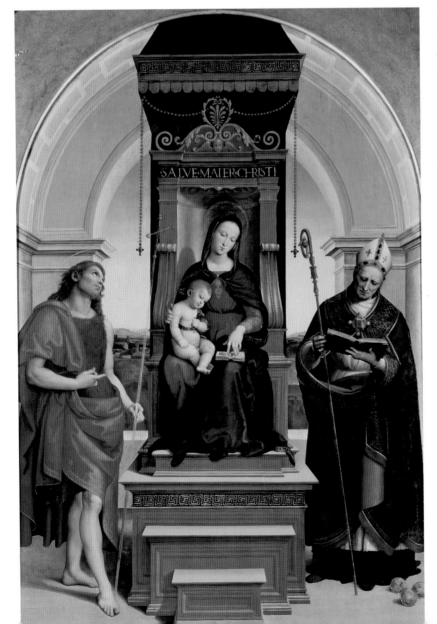

*The Madonna and Child with
Saint John the Baptist, (The
Ansidei Madonna),* 1505, oil
on poplar, The National
Gallery, London, England,
216.8 × 147.6cm (85 × 58in)

This Sacra Conversazione
shows the Virgin on a high
throne with Saint John the
Baptist on the left and Saint
Nicholas of Bari on the right.
The three golden balls on
the floor represent the bags
of gold Saint Nicholas gave
as dowries to three poor
girls. The work is known
as *The Ansidei Madonna*
because it was
commissioned by a
prosperous wool
merchant Niccolò Ansidei
(c.1469–1527) for his family
chapel dedicated to Saint
Nicholas in the church of
San Fiorenzo in Perugia.

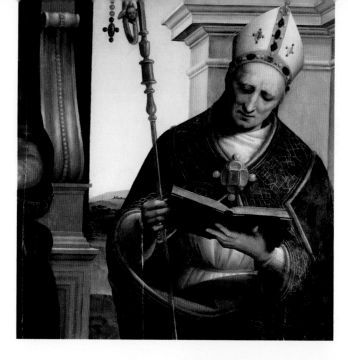

Detail of *The Madonna and Child with Saint John the Baptist, (The Ansidei Madonna)*, 1505, oil on poplar, The National Gallery, London, England, 216.8 x 147.6cm (85 x 58in)

Clearly influenced by Donatello's sculpture, Masaccio's representations of perspective and Piero della Francesca's landscape, this work was revolutionary at the time it was painted. The angle of Saint Nicholas' crozier and the tilt of his head balance the composition. Scarlet coral beads, a common charm against evil as the colour of Christ's blood, hang from the canopy. The Virgin and Child sit on an ornately carved wooden throne.

*Saint John the Baptist Preaching*, 1505, oil on poplar, The National Gallery, London, England, 26.2 x 52cm (10 x 20in)

This picture is one of three that formed the predella for the Ansidei Madonna. It was placed beneath the image of Saint John in the main painting. This neat, precise and meticulous style was enhanced with fresh, bright colours, reflecting Raphael's earliest artistic influences.

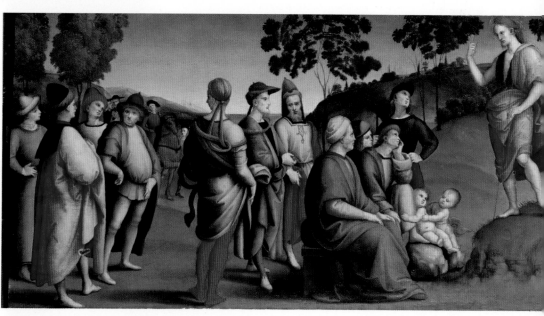

Enthroned Madonna and Child with Musician Angels 1505, fresco, Church of San Sebastiano, Panicale, Italy, width at base 390cm (153in)

Only rediscovered in 2005, this fresco was painted by Raphael during the period he was painting several altarpieces in and around Perugia. Although it has deteriorated badly, it can be seen to be heavily influenced by Perugino and traditional altarpieces that presented the Madonna and Child as overly large in comparison with the surrounding, colourfully attired saints.

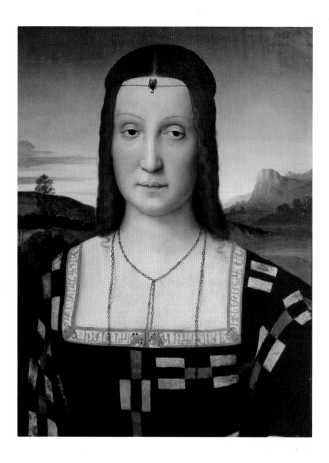

*Portrait of Elisabetta Gonzaga,*
1504–06, oil on panel,
Galleria degli Uffizi,
Florence, Italy,
52.5 x 37.3cm (21 x 15in)

With a scorpion jewel on
her forehead and fine gold
necklaces around her neck,
this is Elisabetta, Duchess of
Urbino through marriage to
Guidobaldo da Montefeltro
and sister of Francesco II
Gonzaga, Marquess of
Mantua. Raphael reflected his
admiration of Flemish art,
which was also greatly
appreciated at the court of
Urbino. Cultured, refined and
sociable, Elisabetta
encouraged the arts and
literature and held gatherings
of writers and artists at her
husband's court.

*Portrait of Guidobaldo da
Montefeltro, c.1506, oil on
panel, Galleria degli Uffizi,
Florence, Italy,
70 x 50cm (27 x 20in)*

A delicate portrayal of
Guidobaldo da Montefeltro,
Duke of Urbino, created to
accompany the portrait
of his wife Elisabetta. This
young man was determined
to continue his father's legacy
of encouraging the arts. The
landscape seen through the
window behind him is of
Urbino. Guidobaldo was
approximately 35 years old
when this work was painted;
he died the following year.

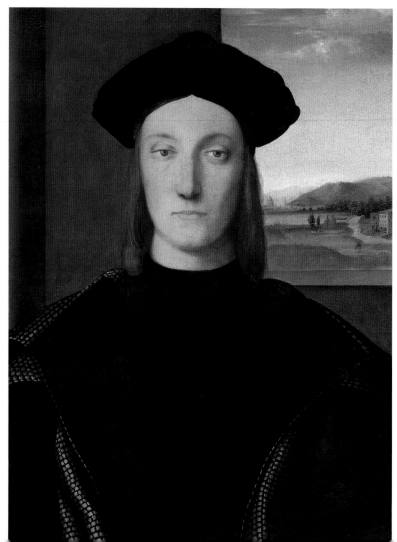

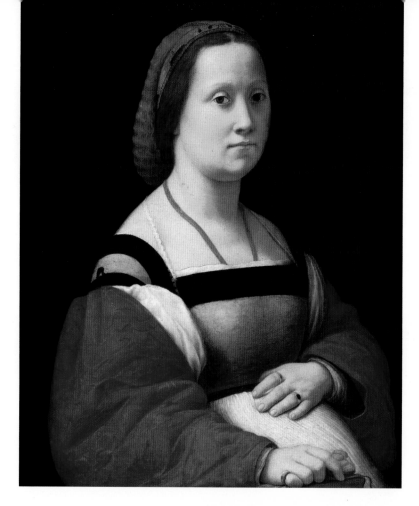

*La Donna Gravida, c.*1505, oil on wood, Galleria Palatina, Pitti Palace, Florence, Italy, 66 x 529cm (26 x 21in)

La Donna Gravida is Italian for The Pregnant Woman and this was painted by Raphael between 1505 and 1507, during his visits to Florence. Although the identification of the woman is not verified, she is heavily pregnant and looking directly at the viewer, with her left hand resting on her stomach emphasizing her condition. Paintings showing pregnancy were unusual during the Renaissance period. Once in Florence, Raphael began to change his depiction of light, creating more solid and lifelike images.

*A Warrior on a Horse, Fighting Two Figures,* 1505, pen and brown ink, plus traces of fountain pen on yellow paper, Galleria dell'Accademia, Venice, Italy, 27.1 x 21.6cm (11 x 8in)

This is one of several sheets made by Raphael during this period of pen drawings of nude warriors, none of which can be connected to any known commission. It is possible that he was preparing for a decorative scheme, but if so, it was never undertaken. In any case, the drawings helped Raphael to hone his skills in creating richly varied groups of figures.

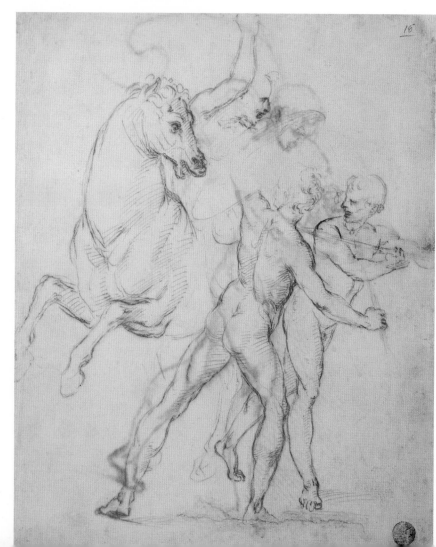

*Flagman,* 1505, fountain pen, pen and brown ink on yellow paper, Galleria dell'Accademia, Venice, Italy, 28 x 22.1cm (11 x 9in)

Created with curves and elliptical shapes, this reveals Raphael's drawing technique of sketching in the main elements initially then adding the others around them. In common with all his work at this time, Raphael drew on other artists' styles he admired. As Vasari explained, his gracefulness of style derived from his combining the best elements he saw in both old and contemporary masters. The unknown sitter with the little unicorn-like creature on her lap has become accepted as an allegory of chastity.

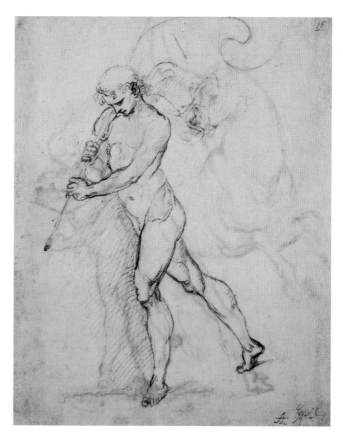

*Woman with a Unicorn,* 1505–06, oil on wood, transferred to canvas, Galleria Borghese, Rome, Italy, 65 x 51cm (26 x 20in)

Although Raphael drew the original study for this and started the painting, it is probable that he did not complete it. The young woman is wearing a yellow silk gown and white blouse with her velvet sleeves fastened by ribbons. Around her neck hangs a precious pendant formed by an emerald, ruby and pearl drop. The unknown sitter with the little unicorn-like creature on her lap has become an allegory of chastity.

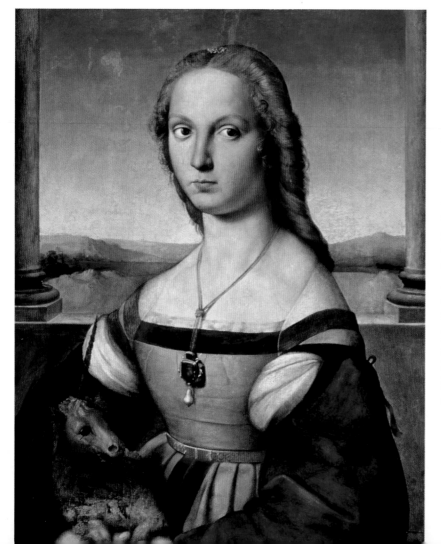

*Portrait of Agnolo Doni,* 1506–07, oil on panel, Galleria Palatina, Pitti Palace, Florence, Italy, 65 x 45.7cm (26 x 18in)

Wealthy cloth merchant Agnolo Doni was also a collector of gems and antiquities and a patron of important artists. Vasari declared: '…Agnolo Doni – who was very careful of his money in other things, but willing to spend it, although still with the greatest possible economy, on works of painting and sculpture.' Rendering his clothing, jewels and hair in great detail to show his wealth and social standing, Raphael also emphasized Doni's astute gaze and upright, businesslike stance.

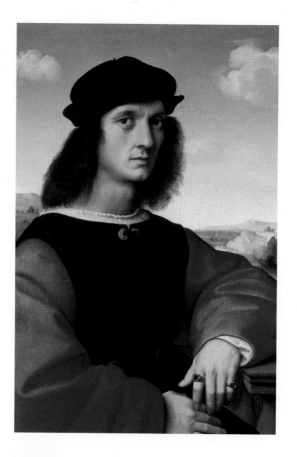

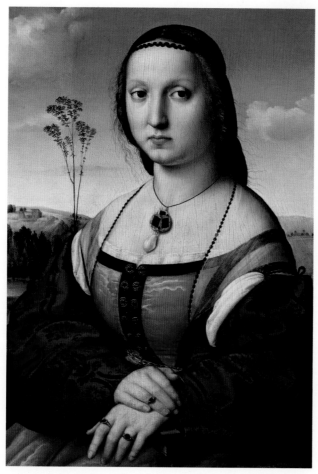

*Maddalena Doni,* 1506–07, oil on panel, Galleria Palatina, Pitti Palace, Florence, Italy, 65 x 45.8cm (26 x 18in)

Maddalena Strozzi married Agnolo Doni in 1504 when she was just 15 years old. Created at the same time as the portrait of her husband, this shows her wealth through her expensive clothing and jewellery. The pendant around her neck has several symbolic meanings, mainly surrounding chastity and purity. It features a unicorn and an emerald above a ruby and a sapphire, below which hangs a huge pearl drop.

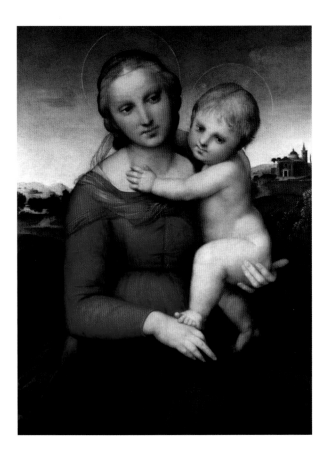

*Small Cowper Madonna,*
*c.1505,* oil on panel,
National Gallery of Art,
Washington DC, USA,
59.5 x 44cm (24 x 17in)

During Raphael's time in
Florence from late 1504
until 1508, it is known
that he produced at least
17 Madonna paintings; all
different. These were often
given as wedding presents,
so Raphael painted some
through specific commissions
or painted some
speculatively on the chance
that they would sell. With a
gentle tilt of the head and
pensive expression, here
the Virgin and Child are in
close embrace.

*Study for Bridgewater*
*Madonna, c.1507,* pen and
brown ink over silverpoint
on pink prepared paper,
Graphische Sammlung
Albertina, Vienna, Austria,
26.2 x 19cm (10 x 7in)

Raphael produced this
drawing in preparation for
the work that became
known as the *Bridgewater*
*Madonna.* The baby stretches
diagonally across his mother's
lap. She rests her left hand
on his waist, while her right
hand supports him from
beneath his hand. The figures
have been sketched rapidly,
while the pink tinge of the
paper lends a warm flesh
tone to the image.

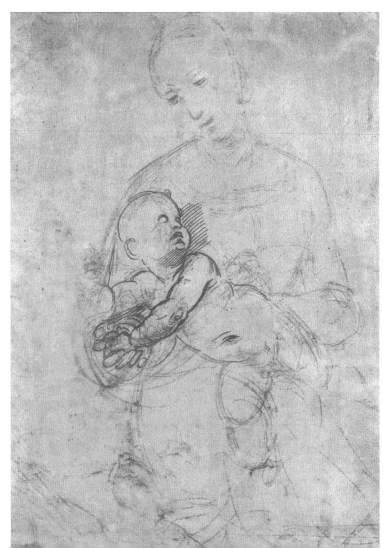

*The Virgin and Child (The Bridgewater Madonna),* c.1507, oil on wood, transferred to canvas, Duke of Sutherland Collection on loan to the National Gallery of Scotland, Edinburgh, Scotland, 81 x 56cm (32 x 22in)

Named after a later owner of the work, this Virgin and Child is one of the most complex compositions of Raphael's Madonnas. He had already explored the idea of the child stretching across his mother's lap, but had never created so much dynamism in the pose. Constantly revising the shapes as he worked, this was originally shown in a landscape setting.

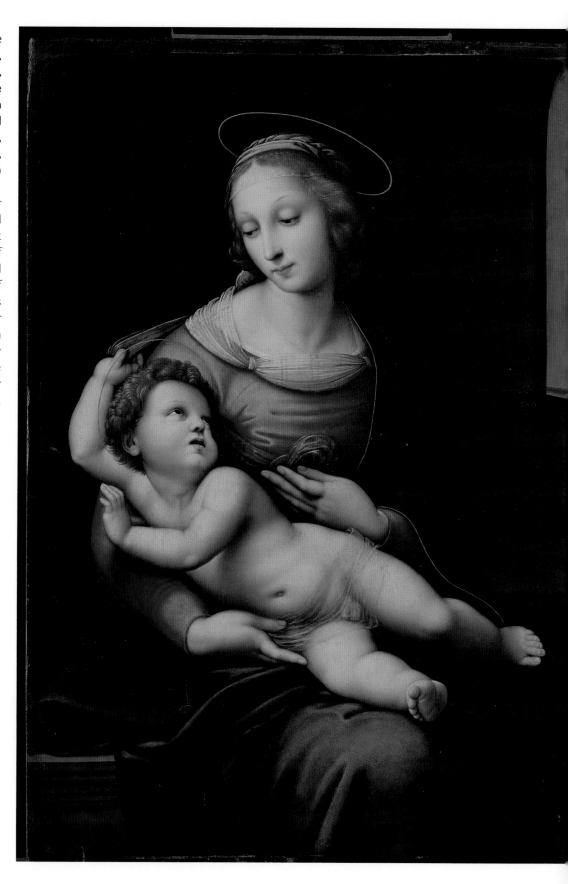

*Studies for Madonna and Child with the Infant Baptist,* c.1505–06, black ink on pink paper, Graphische Sammlung

Albertina, Vienna, Austria, 26 x 19.1cm (10 x 7in)

These appear to have been drawn from the same models as the previous sketches, but Raphael changed to black ink and concentrated on the child here. This is a 'schizzo' or rapid sketch, which appears spontaneous and speedy, created with his usual arcs and curves. Many of the ideas in these studies were later used in Madonna and Child paintings.

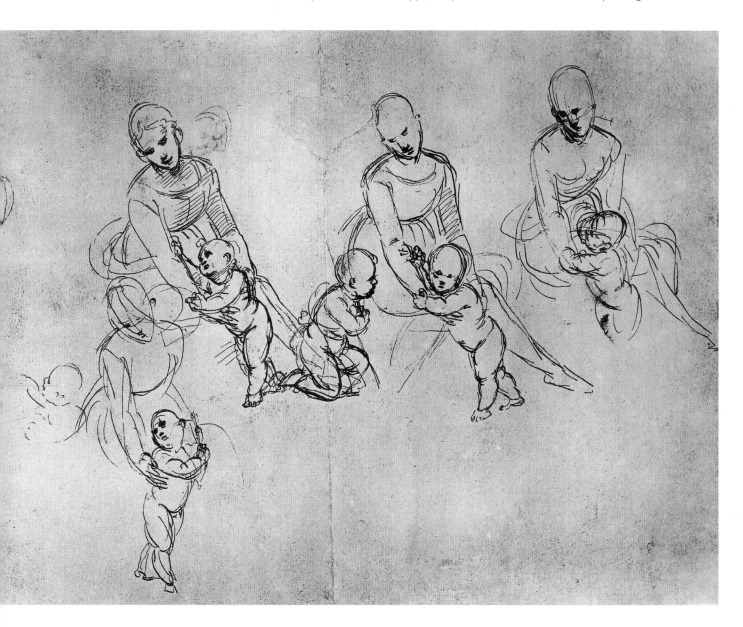

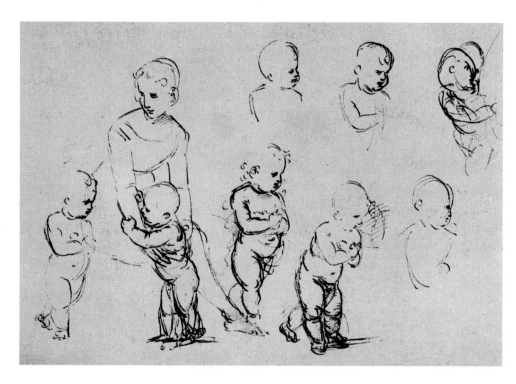

*Studies for Madonna and Child with the Infant Baptist,* c.1505–06, black ink on pink paper, Graphische Sammlung Albertina, Vienna, Austria, 26 x 19.1cm (10 x 7in)

This is another sheet of explorations, known as an 'abbozzo', or more fully worked draft. The work shows his ingenuity and diversity in his interpretations. Many were later incorporated into different works and several derived from paintings by Leonardo and Michelangelo. These drawings are revealing, showing his graphic shorthand and mark-making.

*Studies for Madonna and Child with the Infant Baptist,* 1505–06, black ink on pink paper, Graphische Sammlung Albertina, Vienna, Austria, 26 x 19.1cm (10 x 7in)

This is on the other side of the above sheet. Five preparatory drawings for this work survive, and this shows Raphael experimenting with several groupings. Both infants; Jesus and the Baptist are represented standing, even though in the final work, St John kneels. In all the sketches, the Virgin kneels to hold her baby. This sketch and others on these pages show how carefully meditated the final painting was.

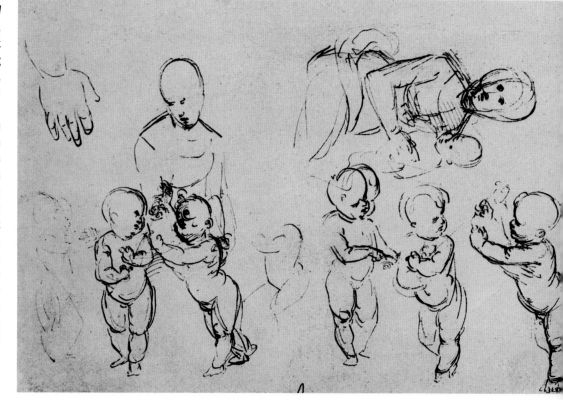

*Madonna and Child with the Infant Baptist (Madonna Belvedere or Madonna of the Meadow), 1505–06, oil on panel, Kunsthistorisches Museum, Vienna, Austria, 113 x 88cm (44 x 35in)*

According to Vasari, Raphael painted this for Taddeo Taddei. The Virgin, in the centre of the panel, has a soft expression portraying her love and concern as she holds her son and glances at her nephew. Christ is playing with the long cross held by Saint John the Baptist. The landscape background is depicted in both linear and atmospheric perspective, demonstrating the speed with which Raphael incorporated new ideas into his art.

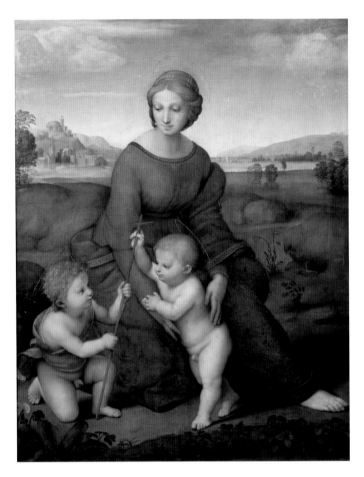

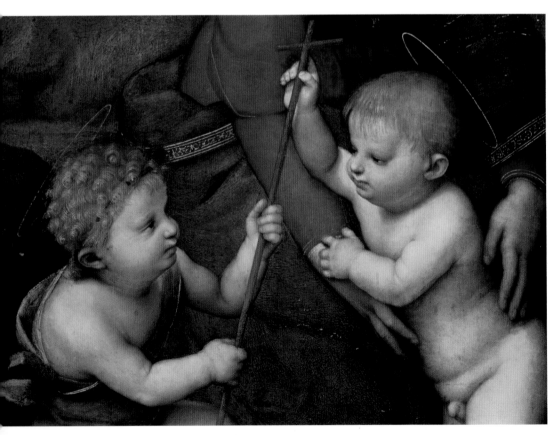

*Madonna and Child with the Infant Baptist (detail of painting above)*

This detail closes in on the pyramidal composition that Raphael used in this work having admired it in Leonardo's work. The two little boys are painted from life and through their exchanged looks, they display their relationship; Saint John the Baptist is the kindly older child, allowing his younger cousin to hold his cross. The Virgin's hands steady her toddler son.

*Madonna del Cardellino*, c.1505, oil on wood, Galleria degli Uffizi, Florence, Italy, 111 x 77.5cm (in)

Another work in the pyramidal composition and featuring the two little boys as in the previous works, this is much larger, but painted at the same time. Whereas in the previous painting Jesus takes his first steps, in this work, the toddler leans back on to his mother's knees, stroking the goldfinch in his cousin's hands – the bird is a symbol of Christ's future Passion.

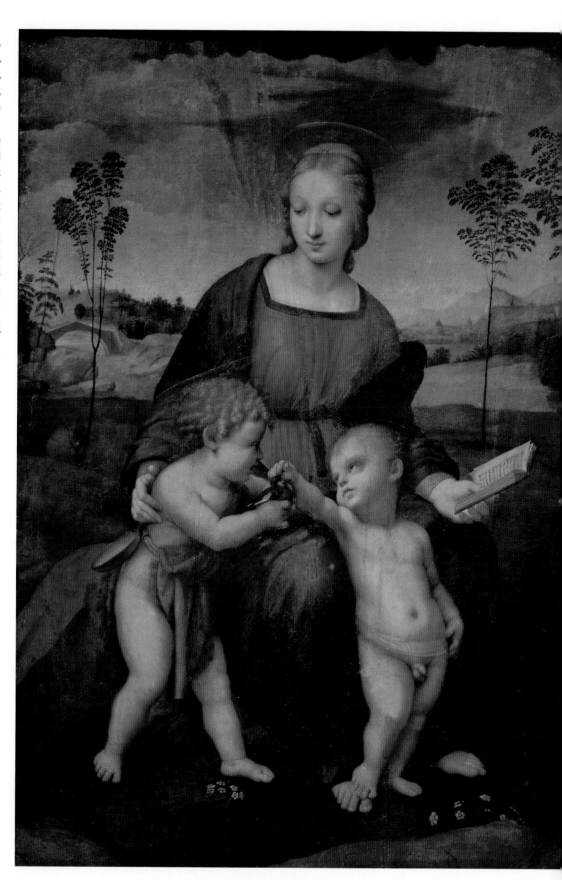

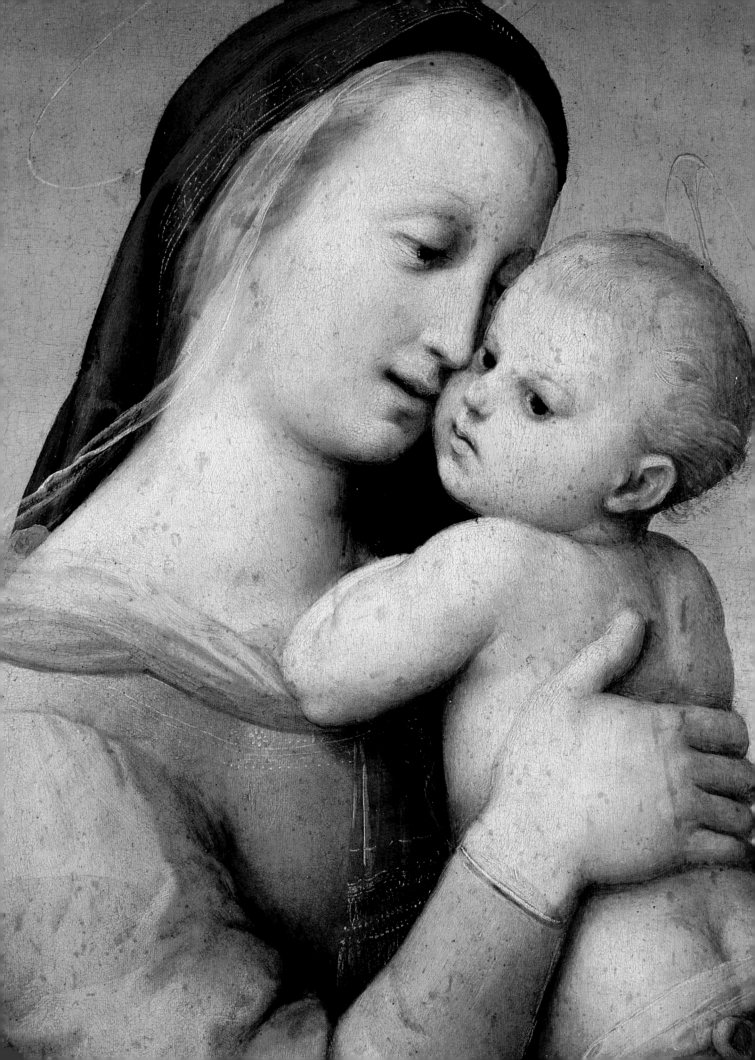

# PAINTER OF PERFECTION

It may seem improbable that relatively short trips to Florence resulted in such great changes in Raphael's work, but the nature of his approach and application meant that he absorbed and responded to all he saw with alacrity and acuity. A particular skill was his ability to judiciously select only those components that advanced his own style especially well. He soon developed accomplished methods of recording light, tone and perspective, incorporating individual and charismatic elements of charm and discernment.

*Above: Detail of the Niccolini-Cowper Madonna, 1508, oil on panel, National Gallery of Art, Washington DC, USA, 80.7 x 57.5 cm (32 x 23in).*

*Left: Detail of the Tempi Madonna, 1508, oil on panel, 75 x 51cm (30 x 20in)*
*This painting expresses the tender and anxious emotions of motherhood, while the soft modelling and chiaroscuro reveal influences of Michelangelo, Leonardo and Fra Bartolomeo.*

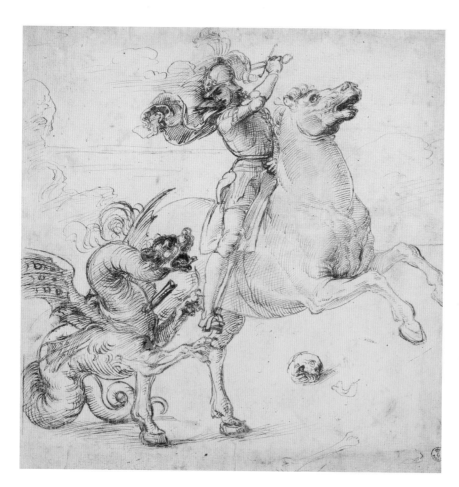

*Study for Saint George and the Dragon, c.1504–05*, pen and brown ink over traces of black chalk, Galleria degli Uffizi, Florence, Italy, 26.5 x 26.7cm (10 x 10in)

In this cartoon for his painting of Saint George, Raphael astutely portrayed the saint looking determined and resolute, the dragon angry and the horse panicking. It is thought that he based the work on the classical *Horse Tamers* from the Quirinal Hill in Rome, but it is also thought that he had not visited Rome at that date.

*Saint George and the Dragon, c.1504–05*, oil on poplar, Musée du Louvre, Paris, France, 30.7 x 26.8cm (12 x 10in)

George was a 4th-century Christian soldier from Cappadocia who, according to legend, killed a dragon to save the Princess of Silene. The broken lance immediately demonstrates the struggle that has already ensued, while the Princess can be seen escaping. These peripheral features establish the story around the main figures in the painting. The saint's confident stance and expression emphasize his courage and confidence as he is about to kill the dragon.

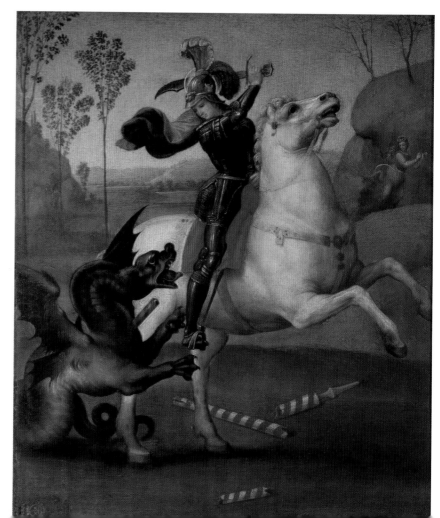

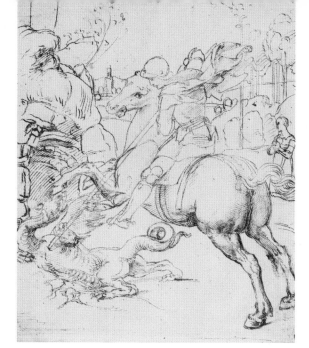

*Cartoon for Saint George and the Dragon, c.1506,* pen and ink over black chalk, pricked for transfer, Galleria degli Uffizi, Florence, Italy, 26.3 x 21.3cm (10 x 8in)

Pouncing was a method of transferring a finished drawing or design on to another surface such as canvas, panel or fresco, by dabbing pounce (fine powder of charcoal or chalk) through pinpricks made around contours of the drawing. The design is then replicated on the surface below as a series of dots. For this work, Raphael modified and refined the design for his final work.

*Saint George and the Dragon, c.1506,* oil on wood, National Gallery of Art, Washington DC, USA, 28.5 x 21.5cm (11 x 8in)

In this painting Raphael turned Saint George's horse around, creating an unusual but equally compelling composition. The Princess of Silene can be seen praying as George fights the dragon.

In contrast with Raphael's previous rendition of the story, this horse appears so relaxed as almost to be smiling. These paintings of Saint George were created for the Duke of Montefeltro, showing him as a dragon slayer to celebrate the recent return of the Montefeltros to Urbino after Cesare Borgia had lost supremacy.

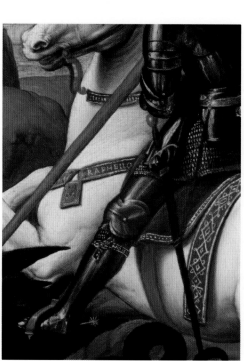

*Saint George and the Dragon,* (detail of painting above)

Saint George was the patron of the Order of the Garter. This work was painted to refer to the Order bestowed upon Duke Guidobaldo in 1504 by Henry VII of England. Drawing attention to it, Raphael painted the garter on Saint George's leg below his knee. He also inscribed his name on the horse's saddle with an unusual spelling of 'Raphello'.

*Christ Blessing,* 1505, oil on
panel, Pinacoteca Civica
Tosio Martinengo,
Brescia, Italy,
30 x 25cm (12 x 10in)

In this small work, Christ
wears the crown of thorns,
his left arm raised in an act
of blessing and his right hand
almost touching the wound
on his side. As in so
many of Raphael's works, a
combination of influences is
apparent. Along with the
clean and clear styles of
Perugino and Santi, the
precise approach of
contemporary Flemish art
can also be distinguished.

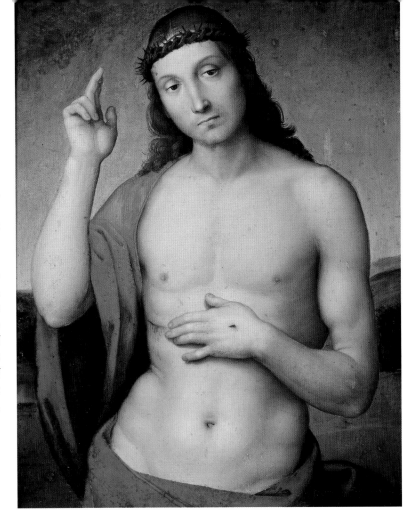

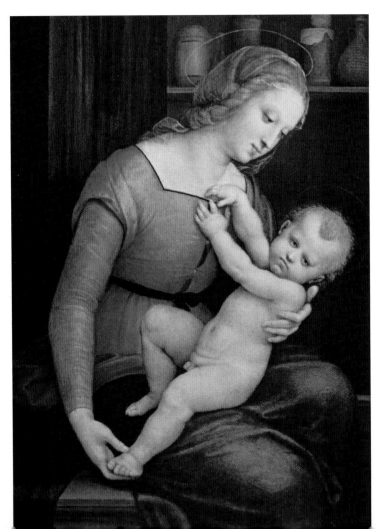

*Madonna d'Orleans,*
c.1505–06, oil on panel,
Musée Condé,
Chantilly, France,
31.7 x 23.3cm (12 x 9in)

A small Madonna made for
private devotion; Raphael
used almost imperceptible
brush marks to create this
natural pose of mother and
child. One of the unique
aspects of Raphael's work in
comparison with similar
works by other artists of the
time was his emphasis on
the human element. This
focuses on the maternal
feelings of the Virgin, rather
than her holiness. The Christ
child is similarly a natural
baby, wriggling on his
mother's lap.

*Study for the Entombment,* c.1507, pen and brown ink over traces of stylus underdrawing and black chalk squared in brown in, red chalk and stylus on paper, Galleria degli Uffizi, Florence, Italy, 28.9 x 29.8cm (11 x 12in)

Also known as *The Deposition*, this is one of sixteen surviving preparatory studies for the altarpiece Raphael made for Atalanta Baglioni (see page 43) for her family chapel in the church of San Francesco al Prato in Perugia. It is believed that he made even more studies but these have not survived; the many studies serve to demonstrate the care he lavished on the project.

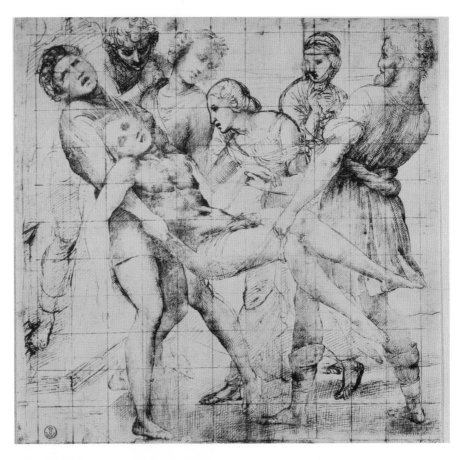

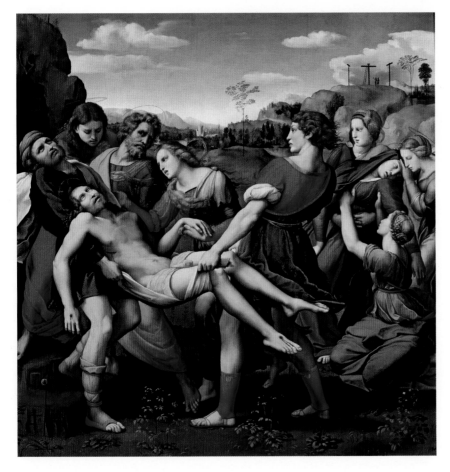

*The Entombment of Christ,* 1507, oil on panel, Galleria Borghese, Rome, Italy, 184 x 176cm (72 x 69in)

Associated with violent events that occurred in Perugia at the start of the 16th century instigated by several members of the Baglioni family, this altarpiece commemorates the death of a young man. Grifonetto Baglioni had participated in the assassination of Guido and Astorre Baglioni. In revenge, Grifonetto was murdered. Grifonetto's mother commissioned this work, with her son featuring as the dead Christ. A complex composition, it won Raphael many admirers.

*Faith*, 1507, oil on poplar, Vatican Museums, Vatican City, Rome, Italy, 18 x 44cm (7 x 17in)

This and the following two panels made up the predella of the Baglioni altarpiece, the Entombment of Christ. Representing the three Theological Virtues, they contrast greatly with Raphael's previous works for similar usage. They are not brightly coloured and they are not telling stories. These were also the last predellas he painted, partly because they became unfashionable and partly because he passed any others commissioned on to his pupils and assistants.

*Hope*, oil on poplar, Vatican Museums, Vatican City, Rome, Italy, 18 x 44cm (7 x 17in)

The previous painting represents Faith and the next symbolizes Charity. This work expresses Hope. In the preceding work, Faith holds the communion wafer aloft, while Hope here is praying. The figures on either side of each Virtue reveal Raphael's interest in toddlers as they grow from babies to children. On either side of Faith and Hope, the figures with wings are angels; those next to Charity are putti.

*Charity*, oil on poplar, Vatican Museums, Vatican City, Rome, Italy, 18 x 44cm (7 x 17in)

The greatest and most worldly of the Virtues, Charity, is flanked by putti with a flaming cauldron and another distributing coins. Raphael's decision to depict these three panels as imaginary sculptures probably relates to the traditional representation of the Virtues in tomb sculpture. The technique is known as grisaille: which is a method of painting in monochrome and modelled to produce the illusion of sculpture or relief.

*Virgin and Child with Saints Elizabeth and John, c.1506,* pen and ink over chalk on paper, Print Room, Windsor Castle, Berkshire, England, 23.4 x 18cm (9 x 7in)

Drawn by Raphael during his Florentine period, this work does not correspond directly with any known painting. Raphael often changed his mind as he built on ideas in successive drawings. He frequently developed his ideas, working initially in chalk and moving on to pen and ink. This natural looking scene of two mothers with their young sons was admired by the Florentines at a time when small paintings used for private worship were particularly fashionable.

*The Holy Family,* 1505-06, tempera and oil on canvas, The State Hermitage Museum, St Petersburg, Russia, 72.5 x 56.5cm (28 x 22in)

Painted while Raphael was visiting Florence, this relatively small work is believed to have been commissioned by Guidobaldo da Montefeltro. Unusually, this Joseph is beardless and particularly elderly in comparison to his young wife. Subtler colours, with a more compact composition than many of his previous works, this reveals a strong influence of Leonardo – particularly in the soft chiaroscuro used to create the tones.

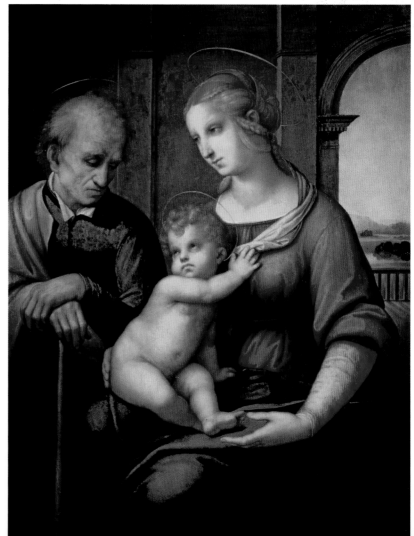

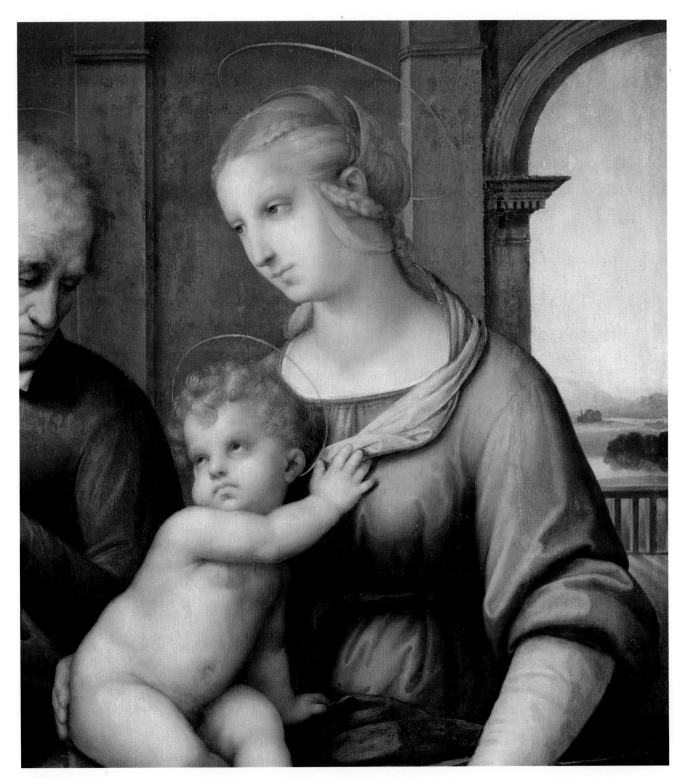

*The Holy Family,* (detail of painting opposite)

Placing the Holy Family in a contemporary bourgeois setting, Raphael communicated with viewers who could relate to the biblical stories more readily if they were familiar and recognizable to them. The device of painting an arch revealing a landscape beyond was a fairly common method of opening up an image and at the same time, shedding light into a scene that had developed from northern Renaissance paintings.

*Madonna of the Pinks,*
c.1506–07, oil on fruitwood,
The National Gallery,
London, England,
28.8 x 22.9cm (11 x 9in)

A young and tranquil mother smiles at her infant son who sits on a soft white pillow on her lap. Mary is shown as a fashionable and comfortably-off contemporary young Italian woman, sitting in a bedchamber, with her green bed curtain tied in a knot and a window revealing a sunny landscape behind her. Known as dianthus or 'flower of God', the pink carnation the baby plays with was a traditional symbol of divine love.

*La Muta* (detail of painting opposite)

The young woman is thought to be Giovanna Feltria, daughter of Federigo da Montefeltro, the powerful and influential Duke of Urbino before Raphael's birth. Giovanna often commissioned Raphael and they knew each other well. Drawings beneath this painting show how he altered the image several times, from capturing the sitter as a young girl to this more mature lady. Giovanna had been widowed in 1501, which might explain the dark colours and the sitter's sombre expression.

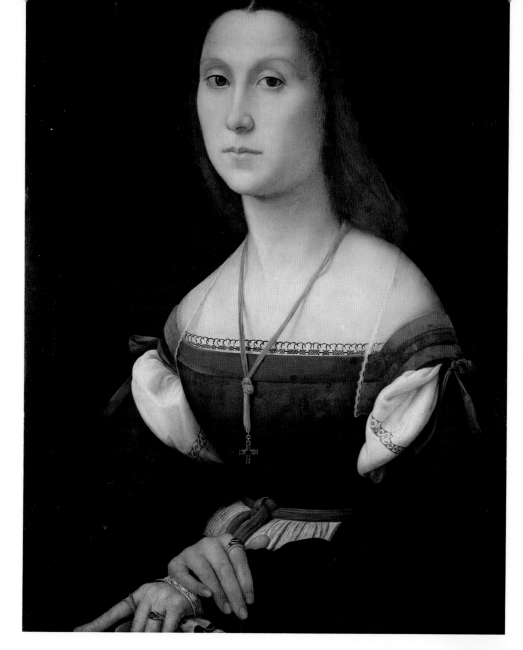

*La Muta*, 1507–08, oil on panel, Galleria Nazionale delle Marche, Urbino, Italy, 64 x 48cm (25 x 19in)

In three-quarter view, this portrait reflects the style Raphael began using in Florence. He abandoned the 'sweet' style of Perugino and among other things he began rendering tone with intense colours, chiaroscuro and sfumato. Here he has rendered the sitter's intricately-made dress in great detail and his device of dark plain background has the effect of making her skin appear to glow.

**La Muta (detail of painting above)**

This detail shows Raphael's meticulous application of thin oil paint with small brushes building up translucent layers of detailed impressions of textures such as fabrics, skin and jewellery. Unseen here, the sitter's long, graceful fingers fold elegantly, displaying the changing highlights on her rings and the twisted and knotted necklace attached to a cross around her neck.

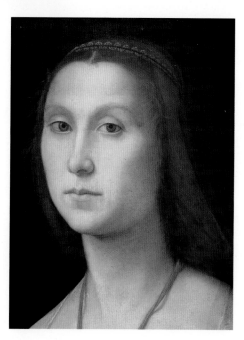

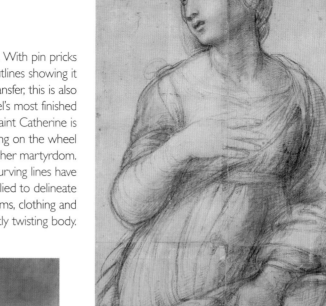

*Saint Catherine of Alexandria,* 1507–9, Black chalk with touches of white chalk on four sheets of beige paper pasted together, Musée du Louvre, Paris, France, 58.7 x 43.6cm (23 x 17in)

A study for the painting of the same name, created when he was still working on the Baglioni altarpiece. With pin pricks around the outlines showing it was used for transfer; this is also one of Raphael's most finished drawings. Saint Catherine is standing, leaning on the wheel symbolizing her martyrdom. Long, curving lines have been applied to delineate her arms, clothing and slightly twisting body.

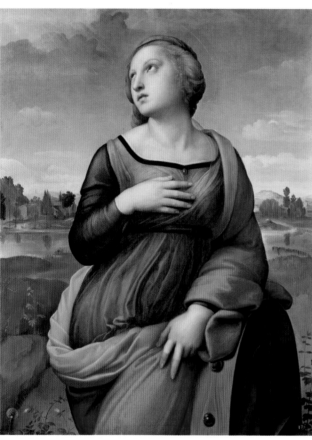

*Saint Catherine of Alexandria,* c.1507, oil on wood, The National Gallery, London, England, 72.2 x 55.7cm (28 x 22in)

Catherine of Alexandria was a 4th-century princess who converted to Christianity. When she would not relinquish her faith, the Roman Emperor Maxentius planned to torture her by having her bound to a spiked wheel, but a thunderbolt destroyed the wheel. She was beheaded instead. This was painted just before Raphael went to Rome. Saint Catherine's suffering is softened by the elegant rendering of the drapery, which swirls around her, and the light on her face.

Study for *Madonna Canigiani,* c.1507, Graphische Sammlung Albertina, Vienna, Austria, 23.4 x 18cm (9 x 7in)

This drawing of the Virgin, Jesus, the infant Saint John the Baptist and Saint Elizabeth is another relaxed image of the Holy figures behaving as a normal family. Mary sits on the ground, facing her older cousin Elizabeth. The two mothers hold their children as Jesus cheerfully accepts the scroll which John, with a serious look on his face, has offered to him.

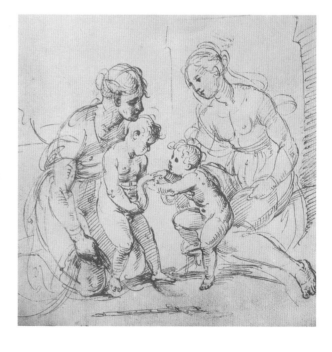

*The Holy Family with Saint Elizabeth and Saint John (The Canigiani Madonna),* c.1507, Alte Pinakothek, Munich, Germany, 131 x 107cm (52 x 42in)

The largest, busiest and most ambitious of Raphael's Florentine Madonnas, this family gathering is still in the pyramidal composition that he preferred and follows the previous drawing quite closely. Commissioned by the Florentine politician Domenico Canigiani (1487–1548), Raphael created the relationships between the figures through eye contact and natural poses. Saint Joseph stands behind the two women, looking down and leaning on his staff. An open landscape with views of towns forms the background.

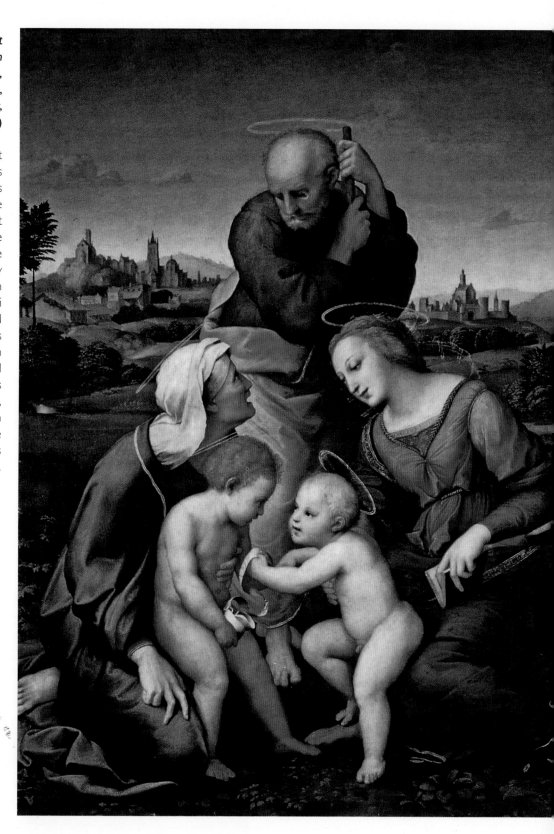

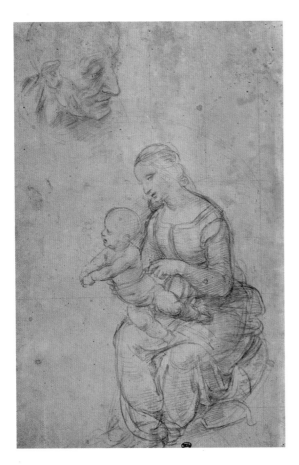

*Study for the Holy Family with Palm Tree, c.1506,* metalpoint on prepared pale pink paper, Musée du Louvre, Paris, France, 22.6 x 15.4cm (9 x 6in)

A small study of a Madonna and Child, with a head of an old man in the corner. The loving embrace of a mother and child, with her eloquent expression, typifies Raphael's great flair in finding new means of portraying the bond between the Virgin and Child, and he repeatedly explored the subject in small metalpoint studies like this.

*La Belle Jardinière,* 1507, oil on panel, Musée du Louvre, Paris, France, 122 x 80cm (48 x 31in)

Signed Raphaello Urb on the Virgin's mantle and dated MDVII, this was painted for the Sienese nobleman Filippo Sergardi, a high cleric at the court of Pope Leo X. Sitting in front of an open landscape, Mary helps her little son to stand. Their gazes lock while the young Saint John kneels beside Jesus, holding a long thin cross. Although this seems a simple composition, the work is the culmination of all Raphael had learned and assimilated in Florence.

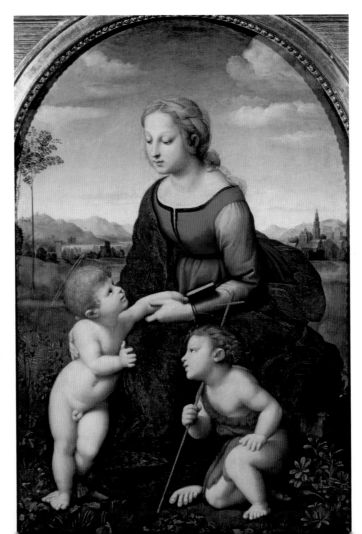

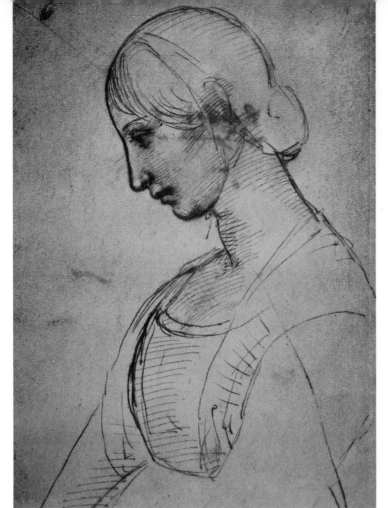

*Girl in profile, c.1507–08,* yellow-brown ink over engraved drawing on paper, Galleria degli Uffizi, Florence, Italy, 26.2 x 18.9cm (10 x 7in)

An observational sketch, this shows how with a few curving lines Raphael always captured the essence of his Madonnas, beginning with a simple drawing of a serene young woman. This work is a concetto – or concept – these were the rough sketches drawn before the more detailed disegno. Always an admirer of women, Raphael was proficient at portraying their emotions. This is unusual as he rarely painted Madonnas in complete profile.

*The Holy Family with a Lamb,* 1507, oil on wood, Museo del Prado, Madrid, Spain, 32 x 22cm (13 x 9in)

By the end of his Florentine period, Raphael's compositions had become more dynamic and complex. Through his close observations of human interaction, he explored different ways of grouping the Holy Family. This strongly diagonal composition leads viewers' eyes across the work. Jesus sits astride a lamb, looking up, while Mary and Joseph smile down at him. The colours are vivid and rich, the tonal contrasts deep and varied.

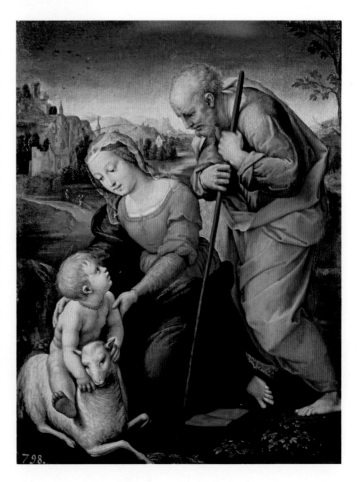

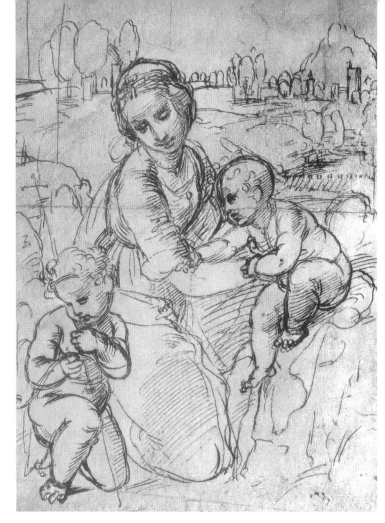

Study for *Madonna and Child with the infant Saint John the Baptist (Madonna Esterházy)*, c.1507, pen and ink on paper, Galleria degli Uffizi, Florence, Italy, 22.4 x 15.8cm (9 x 6in)

This exploratory drawing offers a vivid and intimate glimpse of Raphael's creative thinking on paper. The quick sketch helped him to formulate general ideas although he also started to focus on several details. The study captures the energy and movement of the three figures, while also incorporating some soft tonal effects through careful hatching. The pyramidal grouping of the figures is balanced by the horizontally arranged landscape background.

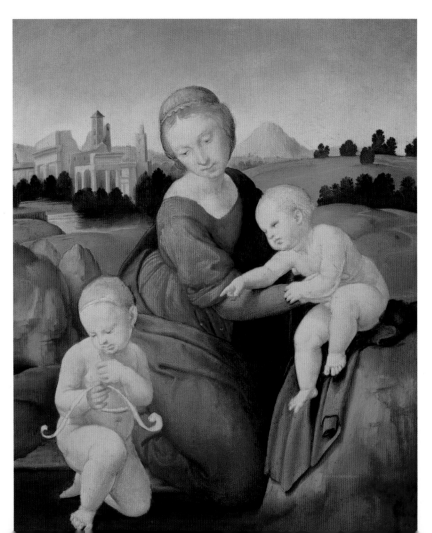

*Madonna and Child with the infant Saint John the Baptist (Madonna Esterházy)*, c.1508, tempera and oil on poplar, Museum of Fine Arts, Budapest, Hungary, 29 x 21.5cm (11 x 8in)

This is also known as the Esterházy Madonna. With classical references including Roman monuments in the background and the infant Saint John holding a lyre, this unfinished work shows Raphael's painting methods. The composition follows his preparatory drawing above, but he never began building layers of stronger tones and colours to complete the painting. Mary's head rises above the small children and the background, symbolizing her importance.

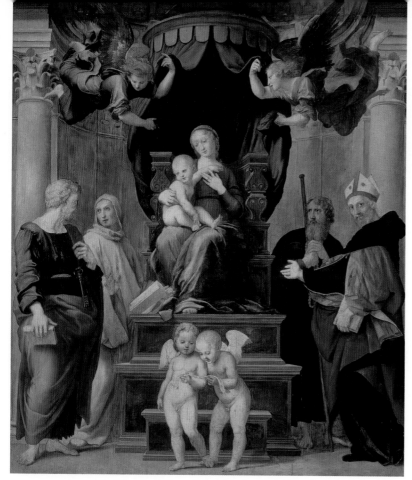

*Madonna and Child with Saints Peter, Bruno, Jacob and Augustin (Madonna del Baldacchino)*, 1507–08, oil on wood, Pitti Palace, Florence, Italy, 279 x 217cm (110 x 85in)

In Florence in 1507 or early 1508, Raphael began working on an altarpiece for the Dei chapel in the church of Santo Spirito which was dedicated to Saint Bernard.

It was his only Florentine altarpiece and it was left unfinished when he went to Rome later that year, so it never reached its intended destination. The Dei family later commissioned a replacement from another artist. This shows Raphael's mature handling and interpretation of a large and busy altarpiece at this period.

*Madonna and Child with Saints Peter, Bruno, Jacob and Augustin (detail of painting above)*

The two angels at the base of Mary's throne put their heads together to read an inscription on a scroll. Absorbed in their own little world, they show

Raphael's interest in children's gestures and their ways of moving and expressing themselves as they develop. Light bathes all the figures and interior architecture of the work, enhancing its spiritual qualities and creating a supernatural glow.

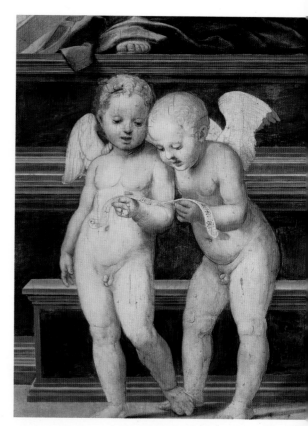

*Madonna and Child with Saints Peter, Bruno, Jacob and Augustin (detail of painting above)*

This is a Sacra Conversazione, with figures arranged around the throne of the Virgin Mary, which is covered with a canopy (baldacchino) that is held open by two angels and within a classical architectural background. From the left are the saints Peter, Bernard of Clairvaux, James the Elder and Augustine.

*Leda and the Swan,*
c.1505–07, pen and dark
brown ink over black chalk
on paper, The Royal
Collection, UK,
31 x 19.2cm (12 x 8in)

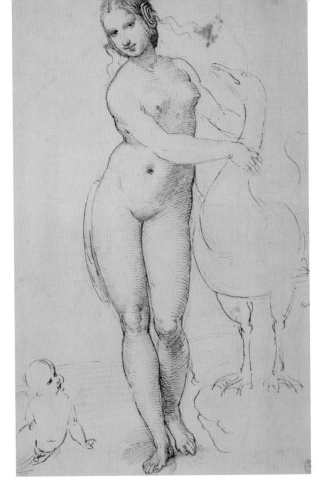

Copying the work of other
artists is the traditional
method for learning drawing
and painting skills. Here,
Raphael copied a drawing by
Leonardo. It is apparent that
he was more interested in
Leda's pose than in her
relationship with the swan
and he has emphasized her
shape using carefully hatched
lines to indicate tone. As in
other studies of artists
he admired, this shows
how he gathered his new
understanding of methods
of representation.

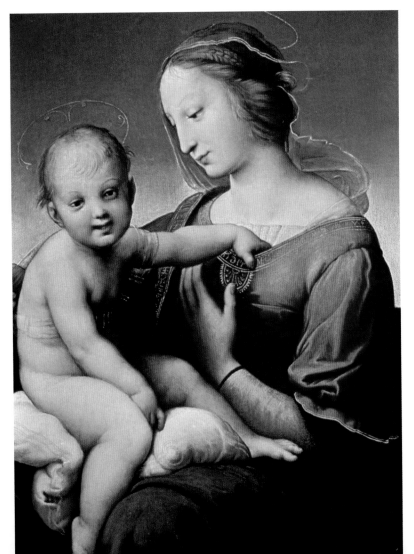

*Niccolini-Cowper Madonna,*
1508, oil on panel,
National Gallery of Art,
Washington DC, USA,
80.7 x 57.5cm (32 x 23in)

This is probably the last
work that Raphael painted in
Florence before he left for
Rome. Set against a plain
blue sky, the Virgin and Child
fill the space. Smiling cheekily,
the little boy holds on to his
mother's bodice while she
smiles at him. Their
interaction emphasizes the
comfortable relationship
between mother and child.
On the border of Mary's
bodice is the inscription:
MDVIII.R.V.PIN, meaning
'1508 Raphael of Urbino
painted it'.

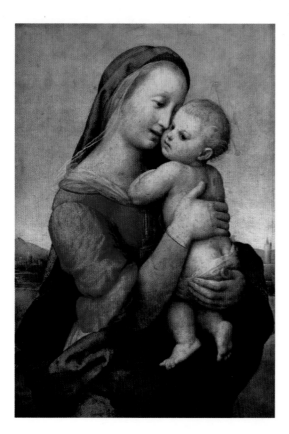

*Madonna and Child
(Tempi Madonna),* 1508, oil
on wood, Alte Pinakothek,
Munich, Germany,
77 x 53cm (30 x 21in)

A simple composition,
this work has a plainer
background than many of
Raphael's other Madonnas
of this time. Light seems to
emanate from the figures,
who represent the tender
emotions of a mother and
child, while the sculptural
effect of the image seems
to have been developed
from the works of Donatello
and Masaccio.

*Madonna Studies, (Studies for
the Bridgewater Madonna and
Madonna Colonna),* c.1508,
yellow-brown ink on paper,
Graphische Sammlung
Albertina, Vienna, Austria,
26.2 x 19.3cm (10 x 8in)

Raphael made these sketches
in rapid succession, working
out his ideas repeatedly and
catching his general ideas
in moments. His skills in
capturing the essential
elements of figures had
become extremely
accomplished by this time
and his ability in accentuating
natural gestures,
spontaneous emotions and
graceful and elegant poses
had never been surpassed.
These sketches were made
in one session and were
used later in at least two
carefully composed paintings
of the Madonna.

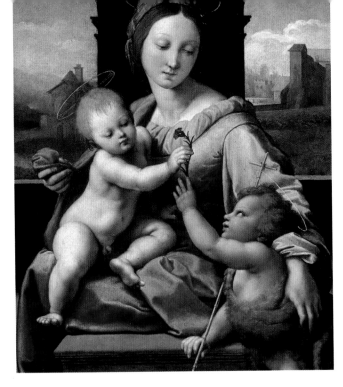

*The Garvagh Madonna,*
c.1509–10, oil on wood,
The National Gallery,
London, England,
38.9 x 32.9cm (15 x 13in)

Painted by Raphael when he first lived in Rome, this small work is usually called the Garvagh Madonna after Lord and Lady Garvagh who owned it for approximately 50 years. Depicted is the moment when John gives Jesus a carnation or pink – the flower is a symbol of divine love. The oval of the Virgin's head set between two arches reveals Raphael's growing interest in pure geometric forms. The landscape beyond the arches shows his proficiency in rendering aerial perspective.

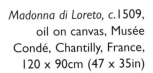

*Madonna di Loreto,* c.1509,
oil on canvas, Musée
Condé, Chantilly, France,
120 x 90cm (47 x 35in)

The theme of a waking child playing with his mother's veil was one that Raphael had already explored in the Bridgewater Madonna (see page 129). It illustrates Raphael's willingness to try new and revolutionary poses. Originally displayed in the church of Santa Maria del Popolo in Rome, this work, also known as *Madonna and Child with Saint Joseph* and *Madonna of the Veil*, was admired for the action, tenderness and chiaroscuro portrayed.

*Madonna di Loreto* (detail of painting above)

As one of Raphael's most copied works, this critically acclaimed painting reveals how he continued to experiment with new solutions to illustrate the relationship between the Virgin and her child. The veil was a reminder of Mary wrapping her baby in it during the Nativity and again at the Crucifixion. It represents Christ's shroud, and the waking baby is a symbol of the deliverance he brings to humankind.

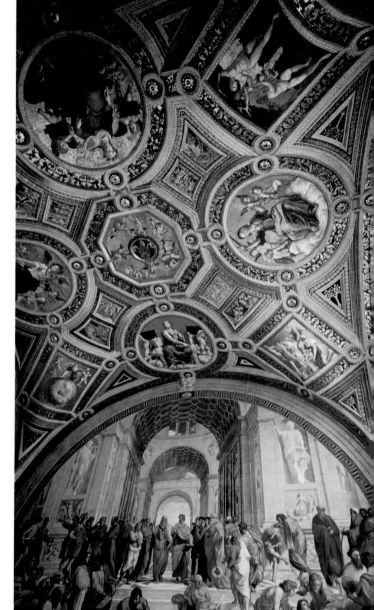

**Section of the ceiling and wall of the *Stanza della Segnatura*, 1508–11, Vatican Palace, Vatican City, Rome, Italy**

Although Raphael was beginning to be noticed, by the time he reached Rome, he had still only painted altarpieces, portraits and Madonnas. As far as whole room decorations were concerned, he was untried. Yet something in his work and attitude convinced Julius II to commission him to decorate his private apartments. With Michelangelo working on the Sistine Chapel Ceiling nearby, Raphael was determined to produce something outstanding. This room was part of the result.

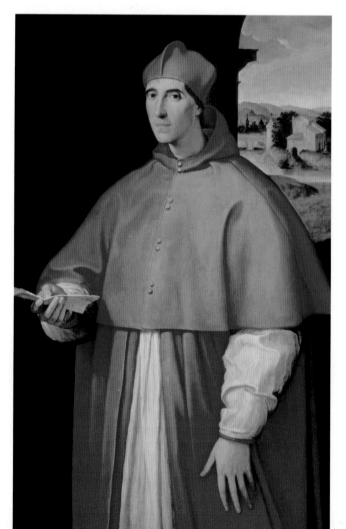

*Portrait of Cardinal Alessandro Farnese*, 1509–11, oil on panel, Museo Nazionale di Capodimonte, Naples, Italy, 139 x 91cm (55 x 36in)

Probably commissioned by the sitter himself, this is a portrait of the future Pope Paul III. Alessandro Farnese was the brother of the Borgia Pope Alexander VI's mistress, Giulia Farnese. In this painting, he stands in front of a window, showing a bright day outside. In his long-fingered hand, he holds a letter, possibly indicating the information that he had recently been elected Bishop of Parma.

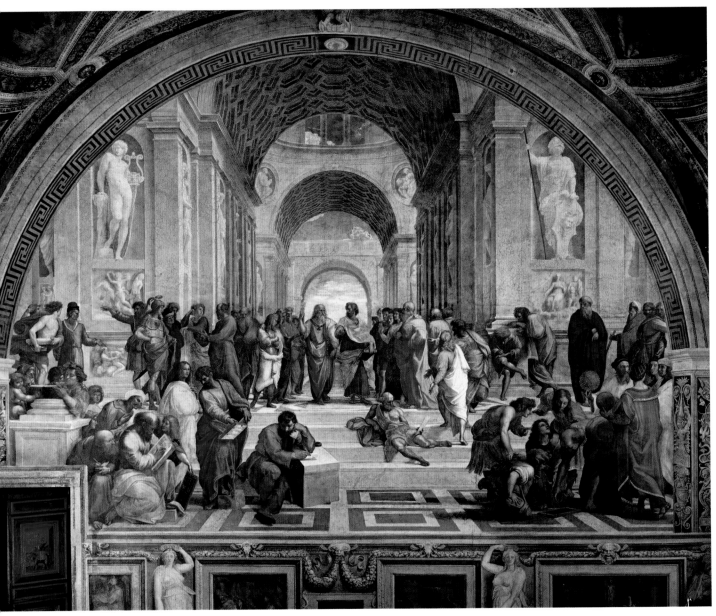

*The School of Athens,*
1509–10, fresco, Apostolic
Palace, Vatican City,
Rome, Italy,
500 x 770cm (200 x 300in)

This huge fresco includes a magnificent architectural setting inspired by Bramante's plans for the new Saint Peter's Basilica. Philosophers and other wise men from antiquity surround the two main figures of Plato and Aristotle in the centre under an arch. Every figure in the scene is doing something to indicate their thoughts and works and Raphael grouped them as if they were debating philosophical matters together.

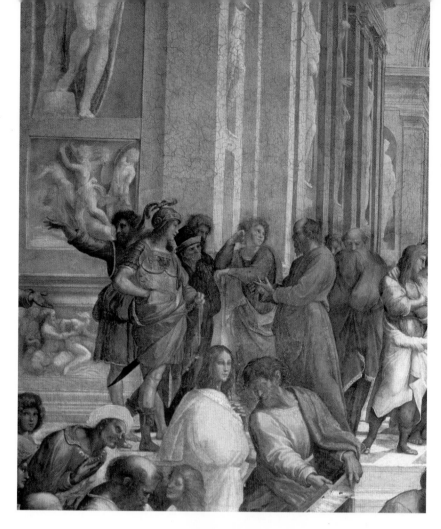

*The School of Athens* (detail of the painting opposite)

In blue at the back, is Alexander the Great (356–323 BCE), the king of Macedon who conquered most of the ancient world and was taught by Aristotle. In yellow is Parmenides (5th century BCE) who influenced Plato. In white next to him is Hypatia c.370–415 CE), a philosopher, mathematician and astronomer, here modelled by Francesco Maria della Rovere, Duke of Urbino.

*The School of Athens* (detail of the painting opposite)

Plato, with the face and physique of Leonardo, points to the sky holding the *Timaeus* in his other hand, while Aristotle standing beside Plato, points to the ground holding a copy of *Ethics* in his other hand. In this simple way, this indicates the contrast between Plato's idealism and Aristotle's realism. Although the fresco is crowded and full of activity, these two figures stand out on their own.

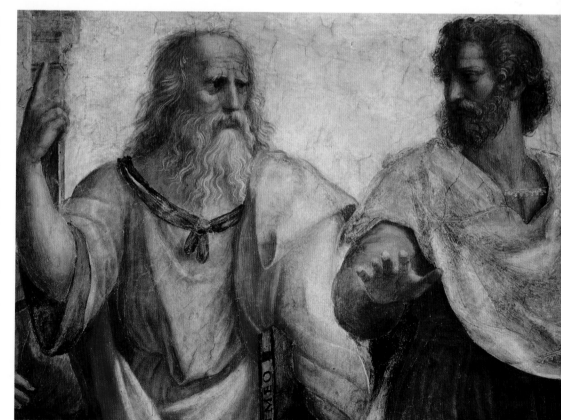

*The School of Athens* (detail of the painting on page 156)

Chritias (c.460–403 BCE) wearing a small hat, was an Athenian political leader and writer, related to Plato and he had some early training with Socrates. Dashing by is Diagoras (5th century BCE), a Greek poet who became an atheist after he experienced an injustice and the gods left it unpunished. In front of them in blue is Democritus (c.460–370 BCE) a Greek philosopher who had theories on the universe and happiness.

*The School of Athens* (detail of the painting on page 156)

Behind this group, leaning nonchalantly against the marble architecture, swathed in mauve and gold and observing his companion as he writes, is the Greek philosopher Pyrrho (c.360–270 BCE), known as the sceptical philosopher. The figure writing is believed to be the Greek philosopher Zeno of Elea (c.490–430 BCE) or Archelaus (5th century BCE) who was probably Socrates' teacher.

*The School of Athens* (detail of the painting on page 156)

Here, Euclid (*c.*325–265 BCE) an ancient Greek mathematician and founder of geometry is teaching some pupils. Raphael painted this mainly before he had seen any of Michelangelo's ceiling, and this dynamism and naturalness of pose and gesture was completely unique to him. To many other artists, the problems of including so many figures on one flat space would have been daunting, but Raphael made it seem easy.

*The School of Athens* (detail of the painting on page 156)

While Raphael welcomed friends and the curious to view his work in progress, Michelangelo strictly forbade any to see his painting until it was complete. Uninterested in Raphael's work, he was not aware that Raphael paid a secret visit to view the Sistine ceiling before he had finished it. As a tribute, Raphael incorporated the figure of Michelangelo in the foreground of *The School of Athens.*

*The School of Athens* (detail of the painting on page 156)

Heraclitus (c.535–475 BCE), was a Greek philosopher who maintained that conflict and change are natural elements of the universe; as a result, he became known as the pessimist philosopher. Raphael painted him in the centre foreground of this work as an addition – he was not in the early plans. Heraclitus is a portrait of Michelangelo, complete with the boots he was said to rarely remove.

*The School of Athens* (detail of the painting on page 156)

The figure in the gold and blue cloak with his back to viewers is Ptolemy (c.90–c.168 CE) Ptolemy was an astronomer, mathematician and geographer who believed that heavenly bodies orbit the Earth. He holds an Earthly sphere, while in front of him, Zoroaster (dates unknown) an Iranian prophet, holds a heavenly sphere. Bending down, teaching geometry is Euclid. model for him was Bramante.

*The School of Athens* (detail of the painting on page 156)

This figure is thought to be Pythagoras (c.582–507 BCE), a Greek philosopher and mathematician who founded a school in southern Italy. Pythagoras aimed to discover the mathematical principles through musical harmony and geometry. Revered as a great mathematician, mystic and scientist, here he explains his theorem to three other philosophers – who all lived at different times and in other locations.

Drawing after Raphael: from *The School of Athens*, 16th century, black chalk on paper, Chatsworth House, Derbyshire, England, 37.4 x 34.6cm (15 x 14in)

Allegorizing the vices of lust and wrath, Raphael painted marble reliefs beneath his statue of Apollo in *The School of Athens*. Not only did this create a majestic setting for his philosophers, but it also showed his remarkable skills in fresco. Within the work he represented architecture, sculpture, mosaic and other decorative elements, along with the range of figures and groupings. This drawing, by an unknown artist, is a copy of Raphael's painting of the small relief.

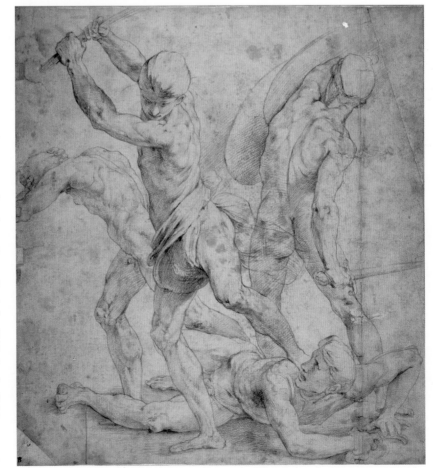

# 'PRINCE OF PAINTERS'

By the time Raphael had completed his decoration of the Stanza della Segnatura, his reputation was established in Rome. Through his talents, constant hard work and unstinting energy, his fame continued to increase. Soon, not only the papal court and other artists in Rome knew of and admired him, but his name spread across Italy and the rest of Europe as a master of great skill and accomplishment. Along with his elegant lifestyle, courtly charm and access to the elite of Rome, he became known as 'The Prince of Painters.' No other artist was as revered for his portrayals of grace, balance and harmony.

*Above: Detail of* The Sistine Madonna, *1513, oil on canvas, Gemäldegalerie Alte Meister, Dresden, Germany, 265 x 196cm (104 x 77in).*

*Left: Detail of* Portrait of a Cardinal, *1510-11, oil on panel, Museo del Prado, Madrid, Spain, 79 x 61cm (31 x 24in).*

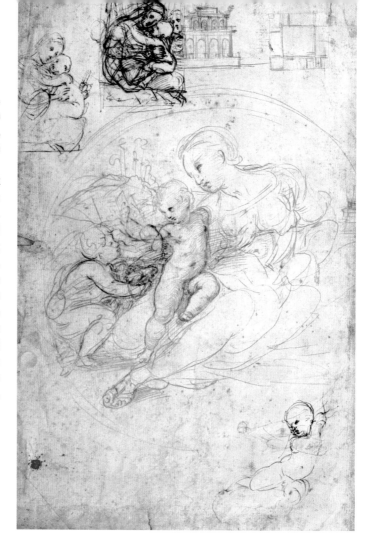

*Study for The Alba Madonna,*
*c.1508–09, pen and ink on*
paper, Private Collection,
dimensions unknown

This is a quick sketch that
Raphael developed into an
accomplished tondo painting.
The Virgin leans in toward
her young son and nephew,
as if she is talking to them.
The little Saint John the
Baptist also leans in to Jesus
and Mary. Experimenting to
find the happiest way to
group Mary and her son and
this masterly composition
can be seen to fit into the
circular format.

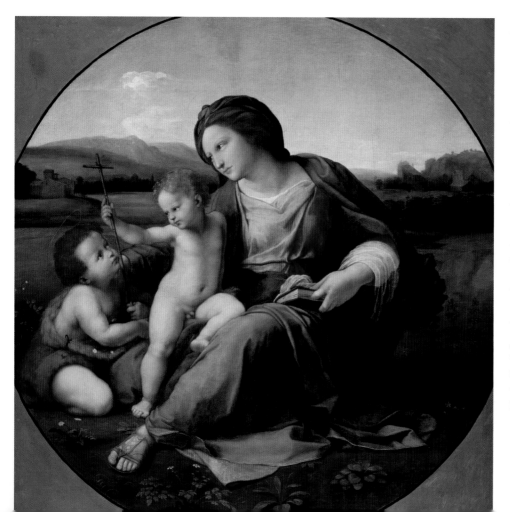

*Alba Madonna,* 1510, oil on
panel transferred to canvas,
National Gallery of Art,
Washington DC, USA,
diameter: 94.5cm (37in)

This tondo differs from
Raphael's Madonnas of his
Florentine period. His palette
here is softer and more
subtle and muted. The
Virgin's pose is majestic,
resembling a classical statue
and, rather than wearing
contemporary dress, she is
in ancient Roman robes. In
the background is a Roman
landscape. Taking the cross
from Saint John the Baptist,
Jesus reveals his awareness
of his destiny, while Mary
and John pass a look of
foresight and understanding
between them.

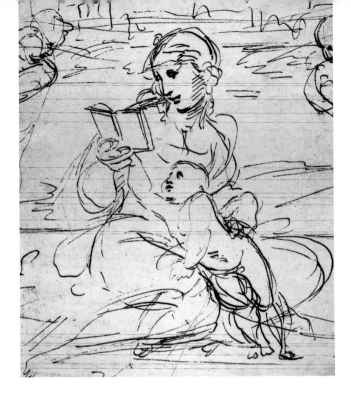

*Study of a Madonna,* 1509, pen and brown ink over traces of silverpoint, Graphische Sammlung Albertina, Vienna, Austria, 19.6 x 15.3cm (8 x 6in)

Here is a typical mother trying to read while her toddler stretches up to touch what she is looking at. It is yet another example of Raphael portraying his understanding of human emotion and relationships. To add the required spirituality to this theme, he put this Madonna and Child in a landscape between two cherubs. He initially used silverpoint to create an indented outline like an invisible preliminary sketch.

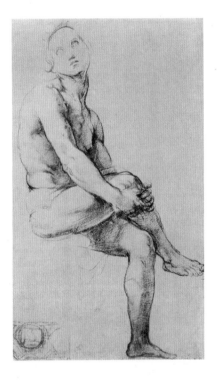

Study of Adam for *The Disputation of the Sacrament,* c.1509, black chalk on paper, Galleria degli Uffizi, Florence, Italy, 35.7 x 21cm (14 x 8in)

With his usual arcs and curving lines, Raphael sketched this image of a male figure to be used as Adam in his painting. Ultimately he changed the figure, but this dynamic pose shows the strong ideas he had from the start for the fresco. The painting acclaims the basis for acceptance of the Catholic doctrine and, considering the growing dissatisfaction with the Church at the time, it needed to be firmly portrayed.

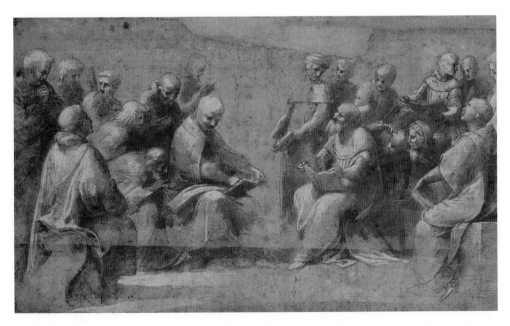

Study for *The Disputation of the Sacrament,* c.1508–09, pen and brown ink, with washes of brown and white bodycolour on light brown paper, Musée Condé, Chantilly, France, 23.1 x 40.7cm (9 x 16in)

This study reveals Raphael's sophisticated draughtsmanship. Twenty churchmen discuss the main issues of the Catholic Church and the sacraments. The figures are quite finished, but Raphael adjusted the plan for the final fresco, following one of his other two designs for the work.

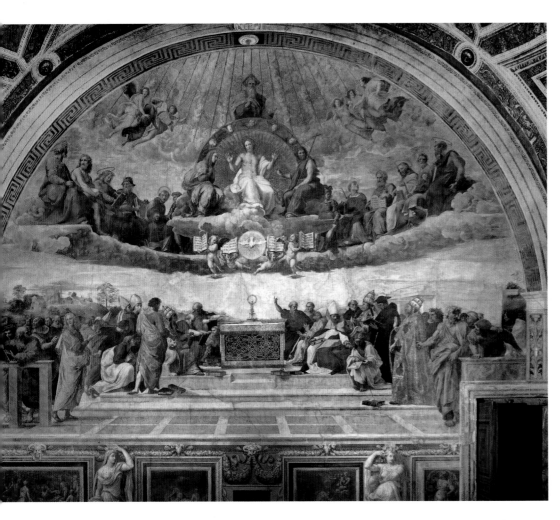

The Disputation of the
Sacrament (The Disputa),
1508–11, fresco,
Apostolic Palace,
Vatican City,
Rome, Italy,
base: c.770cm (303in)

Moving away completely
from tradition, Raphael
created a variety of
imaginary portraits in the
Stanza della Segnatura to
express knowledge and
revelations of truth through
other's actions and deeds.
Whereas *The School of
Athens* on the opposite wall
represents truth acquired
through reason, this fresco
represents the triumph of
the Catholic faith.
Theologians make up the
Church's architecture as they
discuss the mystery of
transubstantiation.

The Disputation of the
Sacrament (The Disputa),
(detail from picture above)

Describing this part of the
fresco, Vasari wrote: '… God
the Father above sending
out the Holy Spirit over
a number of saints who
subscribe to the Mass and
argue upon the Host which
is on the altar…' This is the
highest part of the work,
with God looking down
benignly and blessing the
figures below. In the room
setting, he is also blessing
all those who enter.

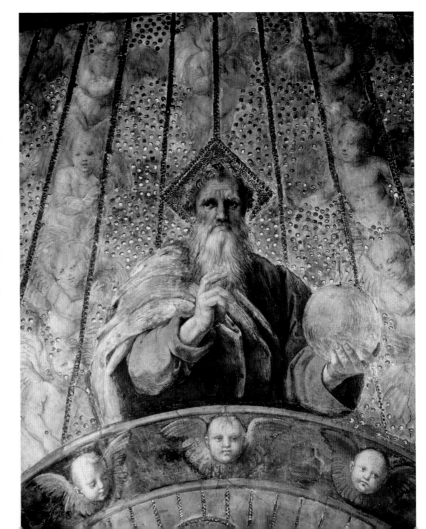

*Parnassus*, 1510–11, fresco, Apostolic Palace, Vatican City, Rome, Italy, base: c.670cm (264in)

Soon after he completed the *Disputa* and the *School of Athens*, Raphael painted the Parnassus on the north wall of the Stanza della Segnatura. He had to work around a window, so he created an arched composition. The painting represents the mount of Parnassus, which according to classical myth was the home of the god Apollo, the Muses (who personify the nine types of art) and of poetry. The painting represents Apollo and the Muses surrounded by contemporary and ancient poets.

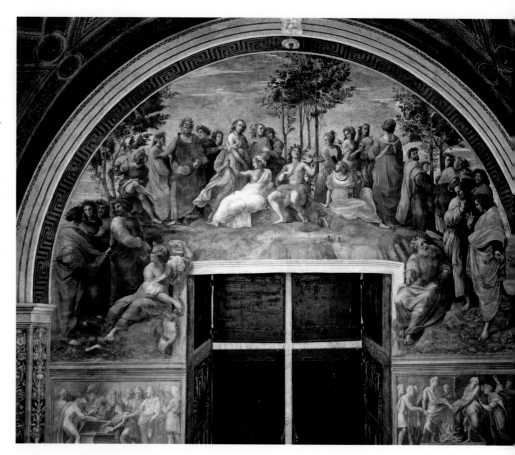

**Parnassus (detail of the painting above)**

This detail shows a group from the 18 illustrated Greek and Italian writers, including the blind Homer (c.850 BCE), with Dante (1265–1321) and Virgil (70–19 BCE) in the mythical location of Mount Parnassus that Raphael depicts as a rocky landscape. All the poets wear laurel wreaths made from the trees that are sacred to Apollo and which grow on Mount Parnassus.

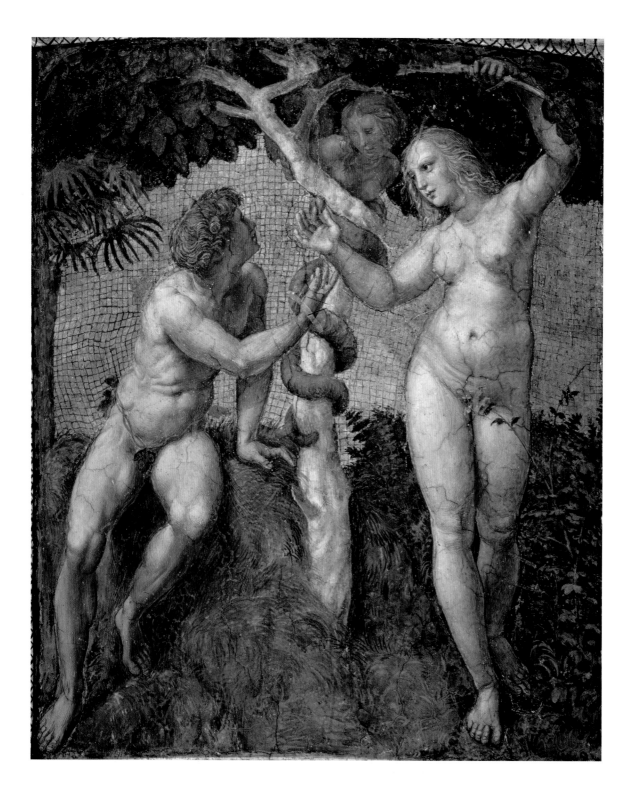

*Adam and Eve, c.*1508–11, fresco, Apostolic Palace, Vatican City, Rome, Italy, 120 x 105cm (47 x 41in)

Part of the ceiling decoration of the Stanza della Segnatura, this fresco depicts the Temptation of Adam and Eve from the Old Testament book of Genesis. As the serpent transforms into a female form, she tempts Adam to eat from the Tree of Knowledge. Eve is womanly and voluptuous, but is made to look like an ancient mural or mosaic.

*Poetry*, 1508–11, fresco, Apostolic Palace, Vatican City, Rome, Italy, diameter: 180cm (71in)

The ceiling of the Stanza della Segnatura is organized in tondi and rectangles around a central octagon. Poetry in one tondo sits on some clouds, holding a closed book and a lyre, wearing a poet's laurel wreath in her hair. Putti flank her, each holding a plaque bearing an inscription. This was one of four tondi on the room's ceiling; the other three are of Theology, Justice and Philosophy. *Parnassus* is on the wall below Poetry.

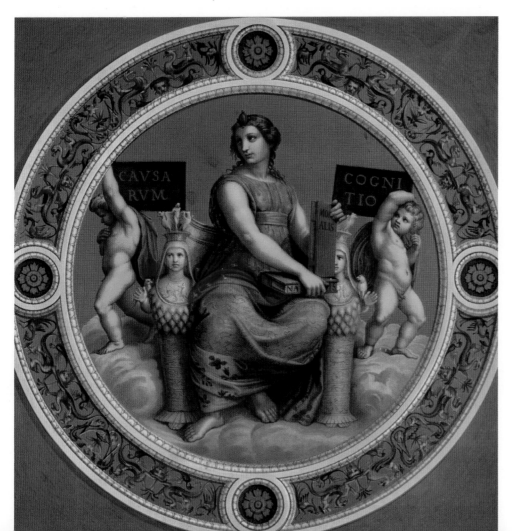

*Philosophy*, 1508–11, fresco, Apostolic Palace, Vatican City, Rome, Italy, diameter: 180cm (71in)

Painted in the same style as the other three tondi on the ceiling in this room, this medallion representing Philosophy portrays one of the areas of knowledge that was to be contained in the Stanza della Segnatura when it was a library. Building up areas of light and shade, all four roundels were created to look like classical wall paintings and mosaics.

NB The brown background is not part of the tondo.

Detail of ceiling in the Stanza della Segnatura, c.1508-11, fresco, Apostolic Palace, Vatican City, Rome, Italy

Another detail of the ceiling of the Stanza della Segnatura, this shows the richness and splendour of the decoration, but also Raphael's amalgamation of biblical stories, history, mythology and legend, using completely fresh interpretations and fitting them in almost impossible spaces, so they can be 'read' from all angles from below.

*Apollo and Marsyas,* 1509–11, fresco, Apostolic Palace, Vatican City, Rome, Italy, 120 x 105cm (47 x 41in)

In one of the corners of the ceiling, between Poetry and Theology, Raphael depicted the ancient Greek myth, *Apollo and Marsyas.* Marsyas is a satyr; part man, part animal, who challenges the god Apollo to a musical contest. When the god inevitably wins, he punishes Marsyas by hanging him from a tree and stripping off his skin. The flaying of Marsyas became a popular theme in classical and then Renaissance art as it symbolizes divine authority being unchallengeable.

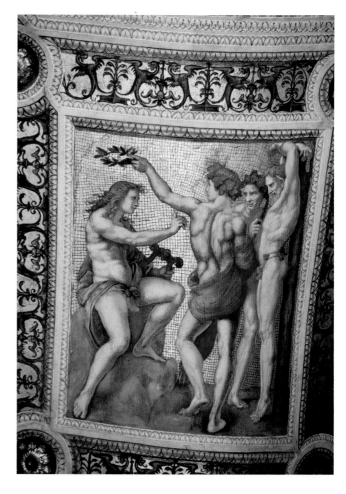

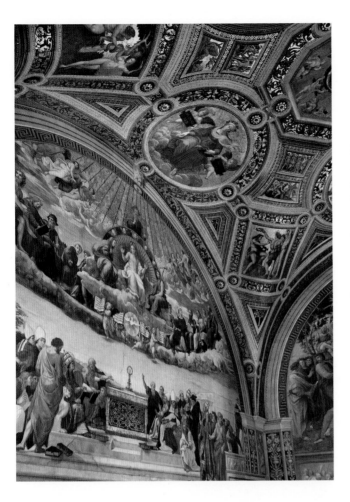

**Detail of the ceiling in the** *Stanza della Segnatura,* **Apostolic Palace, Vatican City, Rome, Italy**

A corner detail of the ceiling of the Stanza della Segnatura, this shows the richness and splendour of the decoration, the precision of form and ornament and Raphael's skilful amalgamation of Biblical stories, history and mythology. His interpretations are unique and fit smoothly into the almost impossible shapes and spaces, enabling them to be 'read' from all angles below.

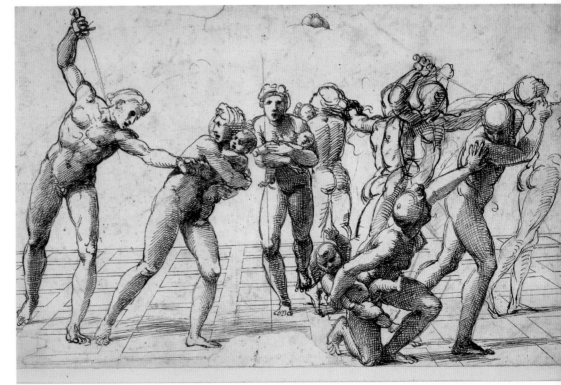

Study for *Massacre of the Innocents, c.*1510, pen and ink over red chalk, The British Museum, London, England, 23.2 x 37.7cm (9 x 15in)

Marcantonio made an elaborate print from this. Raphael drew it when he was midway through painting the Stanza della Segnatura. The figure with his arm raised, wielding his sword is the same figure of the executioner in *The Judgement of Solomon,* seen from a different angle. This is one of a series of studies that still survive for this work that was created solely for reproduction in print. The outlines are pricked, except for the two figures on the right.

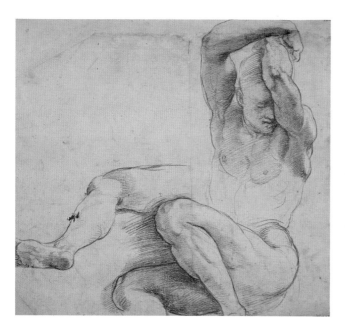

Study for a soldier in a *Resurrection, c.*1513–14, black chalk on paper, The British Museum, London, England, 29.3 x 32.7cm (11 x 13in)

This nude man with raised arms, shielding himself from a bright light or blow to the head is one of a series of similar studies, believed to have been preparation for an unfinished altarpiece for Agostino Chigi and was probably part of Raphael's planning for a *Resurrection of Christ.* The man's muscles are emphasized by tonal gradations and have a resemblance of Michelangelo's figures in the Sistine Chapel.

*Portrait of Pope Julius II,* 1511–12, oil on wood, The National Gallery, London, England, 108 x 81cm (42 x 32in)

Thirty years after Raphael's death, Vasari wrote of this portrait: '…so true and so lifelike…the portrait caused all who saw it to tremble as if it had been the living man himself.' This became so influential and Raphael's style copied so much that to our eyes it can never appear as amazing as it did in the 16th century. Many flocked to see it in the Santa Maria del Popolo.

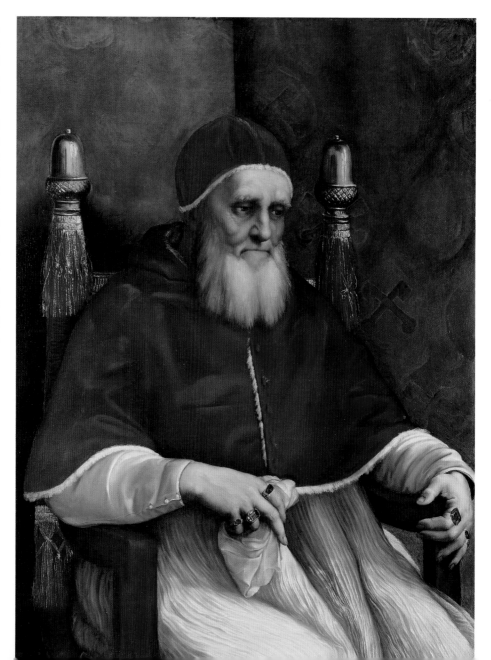

*Portrait of Pope Julius II,*
*c.1512, oil on panel,*
Galleria degli Uffizi,
Florence, Italy, 108.5 x
80cm (43 x 31in)

Believed to be a copy by
Raphael of the original

portrait opposite, the
composition of this subject
was unusual for its time, as
traditionally papal portraits
were painted from the front
or in direct profile. It was
also unprecedented of
Raphael to paint the Pope

(Il Papa Terribile) baring his
emotions. In a pensive
mood, this reveals how
close he was to Raphael in
order to show his inner
feelings. It set a standard
formula for papal portraits
that endured for centuries.

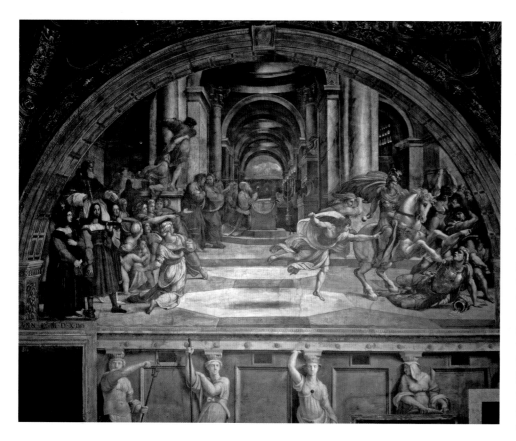

*The Expulsion of Heliodorus,*
1512–15, fresco, Apostolic
Palace, Vatican City,
Rome, Italy,
width 750cm (295in)

Julius II looks dejected in the previous portraits because he had recently been defeated by the French and had lost the city of Bologna to them. Simultaneously, several cardinals had gathered in Pisa to discuss his deposition. He determined to reassert the power of the Church. In the room that became known as the Stanza di Eliodoro, Raphael painted Heliodorus being caught for attempting to steal Temple treasure that had been collected for widows and orphans.

*The Expulsion of Heliodorus*
(detail from the painting
above)

Raphael's depiction of crowded scenes was masterful. Here he has crammed the figures into the small space on the left of the painting. Some figures are scrabbling on to the magnificent marble architecture to obtain a better view, while babies and toddlers clutch the women in fear of the events. Pope Julius II on his throne, watches sternly, a strong and reassuring presence.

Detail from *The Expulsion of Heliodorus*, 1512–15, fresco, Apostolic Palace, Vatican City, Rome, Italy, width 750cm (295in)

On the left sitting beside the widows and orphans, Julius II watches from his throne carried by bearers. The face of the litter bearer at the back is another self-portrait of Raphael – almost a reverse of the self-portrait in *The School of Athens*. The portraits of patron and painter interact as the Pope's hand can be seen to be almost blessing Raphael who is in service to his lord.

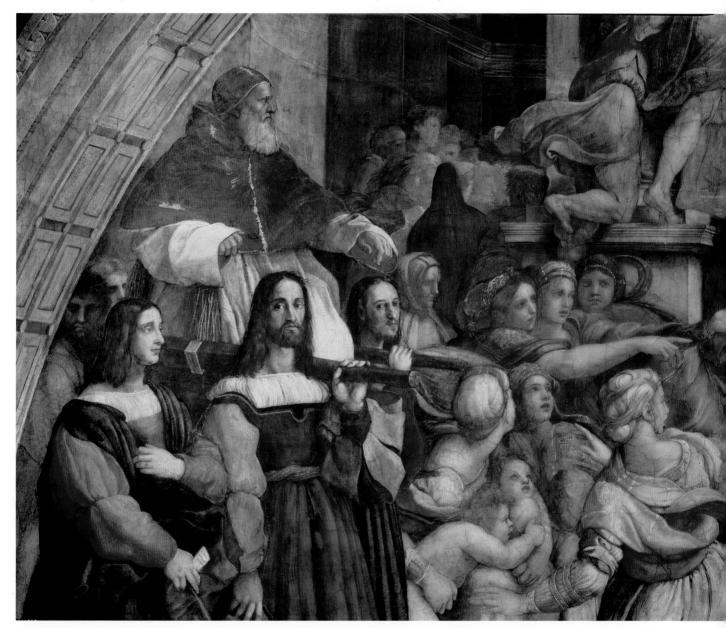

**The ceiling of the *Room of Heliodorus*, Apostolic Palace, Vatican City, Rome, Italy**

This room was originally used for the private audiences of the Pope and was decorated by Raphael immediately after the Segnatura. The room's images documented the miraculous protection bestowed by God on the Church. The four episodes of the Old Testament on the ceiling show: Noah leaving the Ark (Genesis 8: 15-20), the Sacrifice of Isaac (Genesis 22: 1-14), Moses before the Burning Bush (Exodus 3:1-12), and Jacob's Dream (Genesis 28: 10-22).

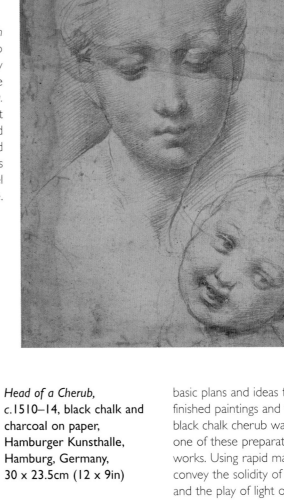

**Study of the *Heads of the Virgin and Child*, c.1509–11, metalpoint on pink prepared paper, The British Museum, London, England, 14.3 x 11cm (6 x 4in)**

Taken from what has become known as Raphael's 'pink sketchbook,' this refined and elegant image of Mary resembles his *Garvagh Madonna*, while he seems to have used the laughing baby as the infant Jesus in the *Large Cowper Madonna*. Raphael was an expert at metal- and silverpoint and used it for detailed and loose studies throughout his career. Here he used parallel hatching to build tone.

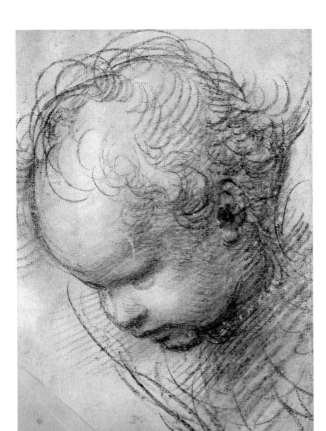

***Head of a Cherub*, c.1510–14, black chalk and charcoal on paper, Hamburger Kunsthalle, Hamburg, Germany, 30 x 23.5cm (12 x 9in)**

Raphael explored and mastered all the different drawing materials available to him. He used chalk extensively to work out basic plans and ideas for finished paintings and this black chalk cherub was one of these preparatory works. Using rapid marks to convey the solidity of flesh and the play of light on faces and figures was a technique he employed increasingly. His firm curves and flicks here convey the downy hair too.

*Portrait of Tommaso Inghirami,*
*c.*1510, oil on panel, Galleria
Palatina, Pitti Palace,
Florence, Italy,
62.3 x 89.5cm (24 x 35in)

Sitting at his desk, Tommaso
Inghirami (1470–1516), is
caught in a natural pose,
rather than a formal portrait
position that was customary
at the time. In his
revolutionary manner, Raphael
was showing the erudite
Humanist in his own
environment, displaying both
his cultured mind and his
ecclesiastical career. Julius II
had appointed him as prefect
of the Vatican Library and Leo
X kept him on in the position.

Detail of *Portrait of Tommaso*
*Inghirami, c.*1510, oil on
panel, Galleria Palatina, Pitti
Palace, Florence, Italy,
62.3 x 89.5cm (24 x 35in)

Depicting hands was a
severe test of a Renaissance
artist's skill. In order to reveal
the character of his sitters,
Raphael demonstrated his
proficiency in the use of oils.
Tommaso (also known as
Fedra) Inghirami's plump,
bejewelled hands are in the
act of writing, juxtaposing
his intellectual and
material interests.

*Kneeling draped female figure,*
*c.1505–07, graphite, pen*
*and brown ink on paper,*
*Musée Condé,*
*Chantilly, France,*
*16.7 x 11.8cm (7 x 5in)*

A kneeling woman clasps her
hands in prayer with her
head raised in a quick study
for a narrative painting. The
man's head seems to have
been a source of inspiration
for Raphael's figure of
Nicodemus in the *Deposition*.
The entire sketch shows
how Raphael's working
methods developed after he
had moved to Rome. His
figure studies and the
investigation of anatomical
structures became more
lifelike and less unworldly.

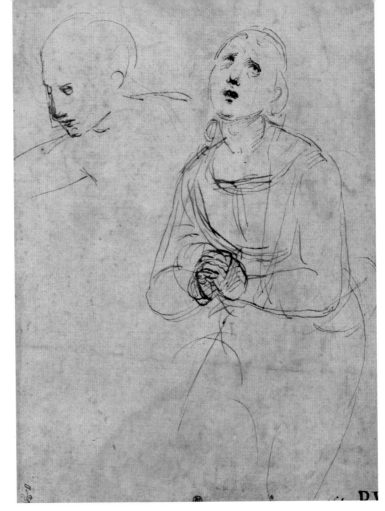

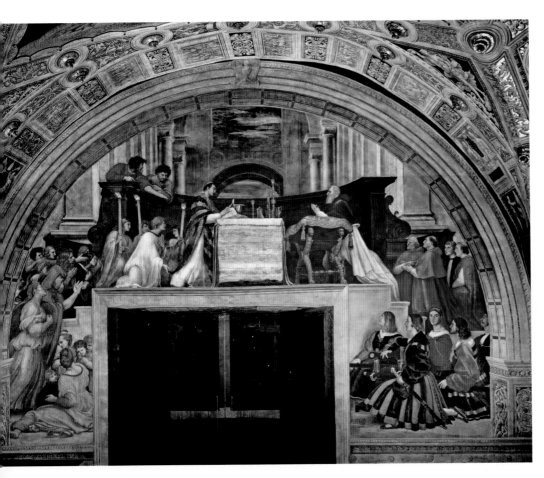

*The Mass of Bolsena,*
*c.1512–14, fresco, Apostolic*
*Palace, Vatican City,*
*Rome, Italy,*
*width: 660cm (260in)*

From the Stanza d'Eliodoro,
*The Mass at Bolsena* shows
an incident that is said to
have taken place in 1263.
A Bohemian priest who
doubted the doctrine of
transubstantiation celebrated
Mass at Bolsena, when the
consecrated bread began to
bleed. Julius is kneeling to the
right with his relatives behind
him: cardinals Leonardo
Grosso della Rovere,
Raffaello Riario, Tommaso
Riario and Agostino Spinola.
The Pope's daughter, Felice
della Rovere, is on the left at
the bottom of the steps
dressed in black.

Detail of the Swiss Guard in *The Mass of Bolsena*, c.1512–14, fresco, Apostolic Palace, Vatican City, Rome, Italy, width: 660cm (260in)

Beneath the portrait of the Pope kneel some of the Vatican's first Swiss guards, mercenaries hired by Julius to help him on his military campaigns who have remained to guard St Peter's and the Pope ever since. Their plush velvet uniforms were soon redesigned by Michelangelo. Although not verified, some believe that one of the Swiss guards is a self-portrait of Raphael.

*Madonna and Child (The Mackintosh Madonna)*, c.1509–11, oil on wood, transferred to canvas, The National Gallery, London, England, 78.8 x 64.2cm (31 x 25in)

Also known as the *Madonna of the Tower*, referring to the building in the background, the title *Mackintosh Madonna* came from its last owner. Slightly damaged, this work is an intimate portrayal of a mother and child as well as of the Virgin and Child. Painted while Raphael lived in Rome, little of his original painting remains.

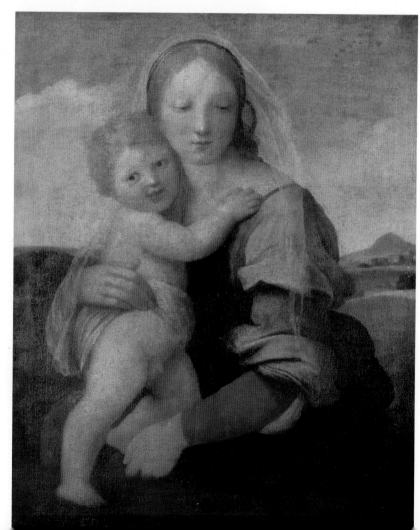

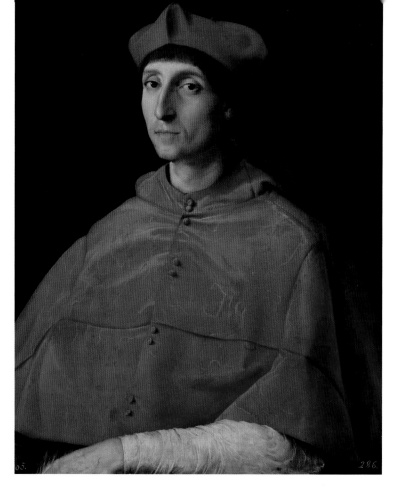

*Portrait of a Cardinal, c.1510,* oil on panel, Museo del Prado, Madrid, Spain, 79 x 61cm (31 x 24in)

Known for his cruelty, Francesco Alidosi, a close friend of Julius II, was murdered violently in the year this was painted. With his usual fine handling of paint, Raphael broke tradition by using the dramatic red of the cardinal's cape and cap as striking visual motifs. As always in his portraits, Raphael has revealed his subject's inner personality. The penetrating and severe glance characterized the man who was feared within the Vatican and beyond.

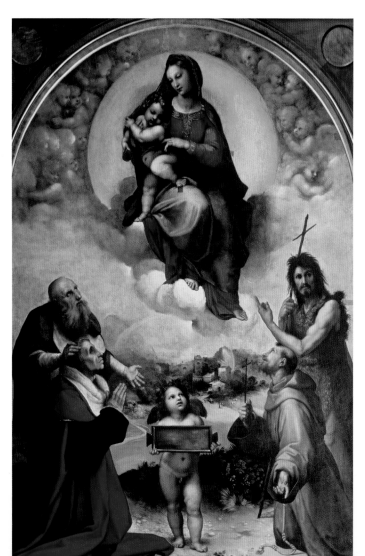

*Madonna di Foligno,* 1511–12, oil on wood, transferred to canvas, Pinacoteca Vaticana, Vatican City, Rome, Italy, 320 x 194cm (126 x 76in)

Commissioned by the Pope's secretary, Raphael painted this for the altar of the church of Santa Maria in Aracoeli. It was later transferred to the convent of Sant'Anna di Foligno, from where it gained its most common name. With one of the most atmospheric landscapes of the Renaissance in vivid colours, it portrays the Virgin and Child on a cloud surrounded by a ring of cherubs with three saints and the patron gathered beneath.

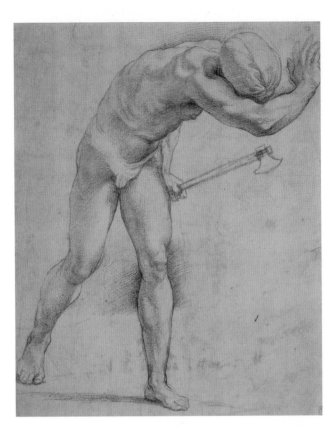

*Figure with an Axe, c.1512,*
chalk on paper, The Royal
Collection, UK,
**32 x 25.5cm (13 x 10in)**

By the second decade of the
16th century Raphael's use
of chalk was extremely
accomplished. The painting
of the *Resurrection of Christ*
that this study was for was
never executed. The work
shows Raphael's sensitive
building of tonal qualities,
making the most of the
characteristics of chalk.
The figure represents one
of the guards who watched
over Christ's tomb and was
blinded by the light of the
Resurrection.

*Madonna with a Blue
Diadem,* 1512, oil on wood,
Musée du Louvre,
Paris, France,
**68 x 48.7cm (27 x 19in)**

Although there are no
known preparatory drawings
by Raphael for this painting,
it is clear that he planned the
composition. Similar to
*Madonna di Loreto* (see page
154), it is believed to have
been completed by his
student, Giovan Francesco
Penni. The colours are rather
more gem-like than Raphael
was using at the time,
although the intimacy of the
scene can be attributed to
Penni's master.

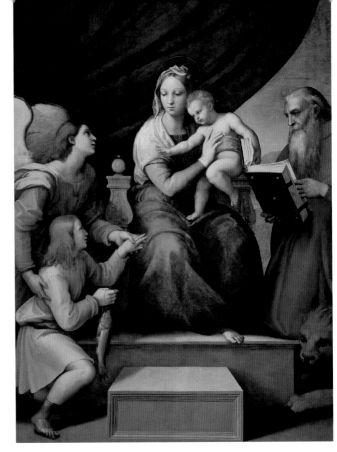

*Madonna of the Fish, c.1512,* oil on panel, transferred to canvas, Museo del Prado, Madrid, Spain, 215 x 158cm (85 x 62in)

This painting depicts the Virgin and Child with Tobias, the Archangel Raphael and Saint Jerome. The lion lies at Saint Jerome's feet while he studies a book. After guiding the young Tobias to the River Tigris, the Archangel presented him to Mary. Tobias carries a fish whose heart, liver and gall performed incredible miracles. Raphael leading Tobias always symbolizes protection, particularly of the young.

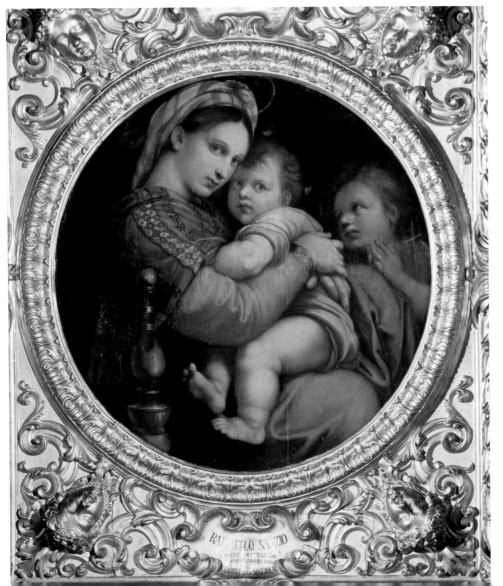

*Madonna of the Chair,* 1513–14, oil on panel, Galleria Palatina, Pitti Palace, Florence, Italy, diameter 71cm (28in)

Possibly Raphael's most accomplished resolution to the problem of designing circular compositions, this work is named after Mary's seated position within the curved arm of a chair. Credibility of the relationship is created through the figures' hugging pose, their heads touching and the baby wiggling his toes, while little Saint John looks on. Contrasts of patterned fabrics suggest the exoticism of ancient Rome, while the bend of Mary's head suggests that she is rocking her child.

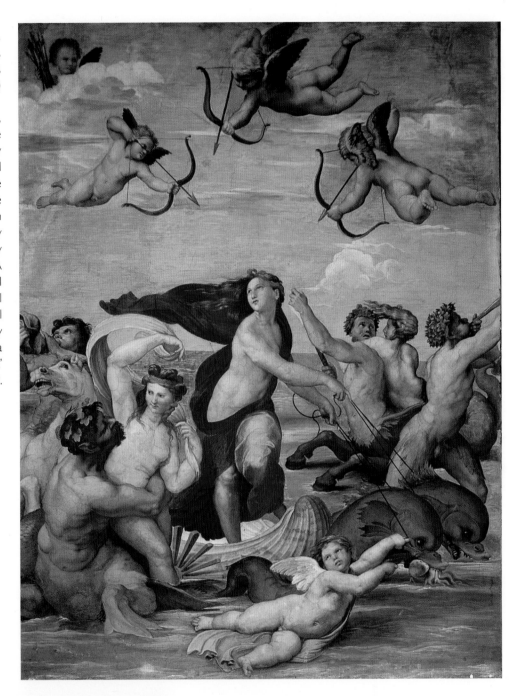

*The Triumph of Galatea,* 1512, fresco, Villa Farnesina, Rome, Italy, 295 x 225cm (116 x 89in)

In Chigi's Roman villa, Raphael illustrated a verse based on classical texts by Angelo Poliziano, which had also helped to inspire Botticelli's *Birth of Venus.* The fresco shows the sea nymph Galatea on a shell drawn by dolphins and surrounded by other nymphs and tritons. A papal courtier asked Raphael where he had found a model of such beauty. Raphael replied that he did not copy anyone but followed 'a certain idea' in his mind.

**The Triumph of Galatea (detail from the painting above)**

Sebastiano del Piombo was already working in the Villa Farnesina when Raphael started this painting and an intense rivalry grew between the two artists. Sebastiano's hatred is documented in many letters to Michelangelo. Nonetheless, work continued apace and here, Raphael's competitiveness is apparent. Beautifully composed putti echo each other's gestures and movements in the sky over the main part of the image.

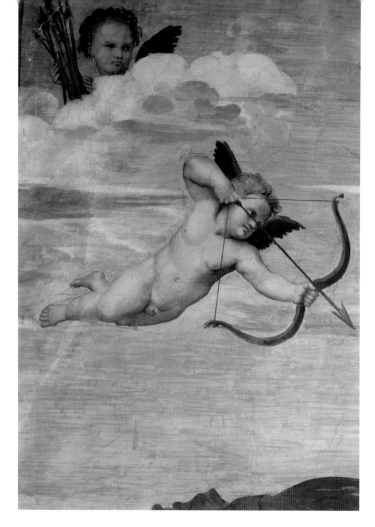

*The Triumph of Galatea*
(detail from the painting on page 183)

Chigi's Roman villa was designed as a model of luxury and elegance. On the ground floor, Peruzzi, Sebastiano and Raphael all painted frescoes based on classical mythology. Inspired by ancient Roman painting as well as Michelangelo, Raphael aimed to depict ideal beauty in his painting of Galatea. Here, the small putti with Cupid's bows and arrows aim at Galatea's heart. Raphael's compositional skills are demonstrated in the harmonious placement of these freely moving figures.

*The Triumph of Galatea*
(detail from the painting on page 183)

The poem Raphael illustrated here describes how the clumsy giant Polyphemus sings a love song to Galatea and, riding over the waves, she laughs at his uncouth song with other tritons and nymphs around her. In this considered composition, every figure corresponds to another and there is an impression of constant movement throughout the picture. Here, a nymph rides off with a triton, while another triton blows a trumpet.

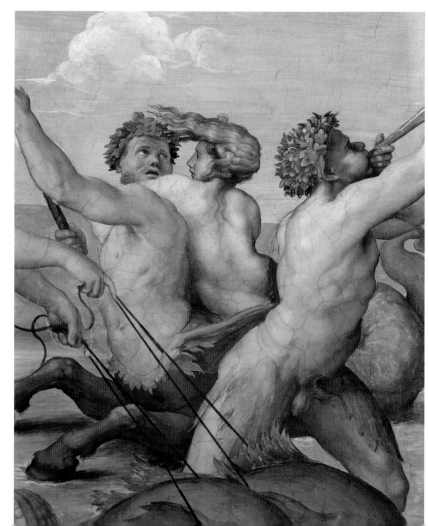

*The Loggia della Galatea (Loggia of the Galatea),* 1506–10, interior of the Villa Farnesina, Rome, Italy

This view from within Chigi's villa shows the frescoes by Sebastiano and Raphael side by side on the wall. Sebastiano portrayed the giant Polyphemus who loves Galatea, while Raphael portrayed the livelier and more beautiful subject of Galatea sailing across the waves, surrounded by her friends. Although Sebastiano's work was accomplished and powerful, it appears static and dull next to Raphael's vigorous painting.

*The Loggia della Galatea (Loggia of the Galatea),* 1506–10, interior of the Villa Farnesina, Rome, Italy

This room on the ground floor of Chigi's Roman villa was originally a loggia facing the garden. It was designed by Peruzzi and decorated by him, Raphael and Sebastiano. *The Loggia of the Galatea* has a ceiling painted by Peruzzi featuring Chigi's horoscope symbols, lunettes showing scenes from Ovid's *Metamorphoses,* thus *Polyphemus* and the *Triumph of Galatea* complement the ancient Greek theme.

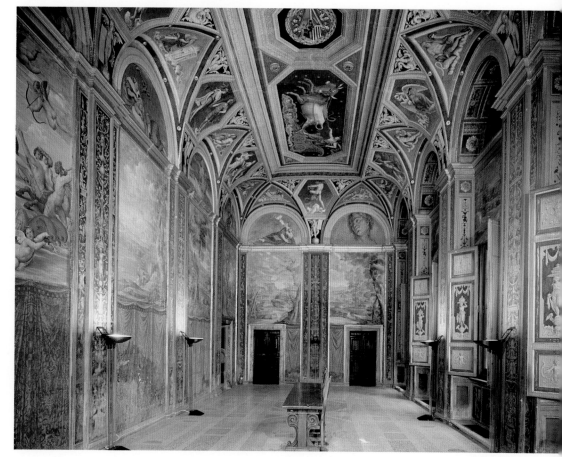

Detail of *Juno on her Chariot*,
Sebastiano del Piombo,
1511, fresco, Villa Farnesina,
Rome, Italy,
width 220cm (87in)

This is a detail of the vault in
the *Loggia of the Galatea*
positioned directly above
Raphael's Galatea. Painted by
his friend Sebastiano del
Piombo, it depicts Juno on
her chariot and various other
mythical figures that relate to
the positions of the planets
around the zodiac on the
patron's birth. The blue,
white and gold compositions
perfectly complement
Raphael's more fluid and
animated paintings on the
wall beneath.

*The Prophet Isaiah,* 1511–12,
fresco, the Church of
Sant'Agostino, Rome, Italy,
250 x 155cm (98 x 61in)

As he gained even greater
recognition within the papal
court and was pursued by
many powerful patrons,
Raphael tried new and more
daring ideas. From 1511 to
1512, among many other
commissions, he worked in
the church of Sant'Agostino
on a fresco for the Head
Chancellor of the papal
court, Johann Goritz of
Luxemburg. Echoing
Michelangelo's figures in
the Sistine Chapel, this figure
of Isaiah is the powerful
result. Isaiah carries a
Hebrew scroll bearing his
prophecy foretelling the
birth of Christ.

*The Holy Family with the Infant Saint John the Baptist,* c.1513–14, oil on poplar, Kunsthistorisches Museum, Vienna, Austria, 154.5 x 114cm (61 x 45in)

As Raphael's prestige rose, he was followed increasingly by pupils, assistants, friends and other admirers. Michelangelo, who preferred to work alone, scoffed at this, but Raphael enjoyed the company of others and as an astute businessman, he utilized the situation, employing several assistants to complete large parts of many works. This painting for instance, although planned and drawn by him, was completed largely by his assistants.

*Lot's Wife turning to Salt,* 1518–19, fresco, Apostolic Palace, Vatican City, Rome, Italy, 133 x 106cm (52 x 42in)

Leo X employed Raphael to decorate further parts of the Vatican. The decorations by Raphael and his workshop include festoons of flowers, fruit and animals. On the vaulted ceiling, Raphael and his assistants created 52 scenes that became popularly known as 'Raphael's Bible.' This image of Lot's flight was executed mainly by Luca Penni (c.1500–57). The fresco shows Lot's wife, who turned into a pillar of salt after disobeying God.

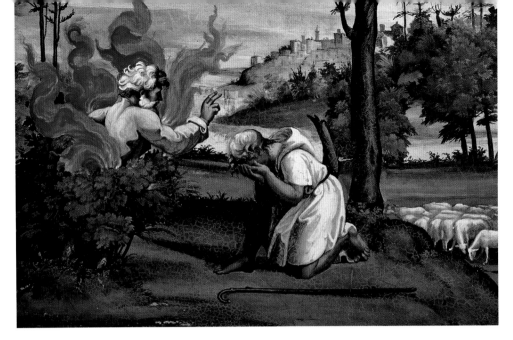

*Moses and the Burning Bush*,
1518–19, fresco, Apostolic
Palace, Vatican City,
Rome, Italy
133 x 106cm (52 x 42in)

The decoration of the loggia
links classical antiquity and
Christianity. Beginning with
the Creation of the World,
Raphael painted in sequence.
He was assisted mainly by
Guillaume de Marcillat
(c.1470–1529).

*Hanno*, c.1514–15, brown
and black ink with white
chalk and charcoal on
greyish paper, Staatliche
Museum, Berlin,
27.8 x 28.5cm (11 x 12in)

Hanno was the white Asian
elephant given by King
Manuel I of Portugal to Pope
Leo X at his coronation. He
became a regular feature of
papal processions. It has not
been verified if this drawing
of pen and ink, heightened
with white chalk, was made
by Raphael or is a copy after
him by Guilio Romano.

*The Finding of Moses*,
1518–19, fresco, Apostolic
Palace, Vatican City,
Rome, Italy
133 x 106cm (52 x 42in)

Bramante began the
construction of the loggia in
1512 under Pope Julius II.
The 52 frescoes on biblical
subjects testified to Raphael's
inexhaustible imagination.
Raphael's depictions were
unlike any other seen before.
Painted by Raphael with Giulio
Romano, here Pharaoh's
daughter finds the baby Moses
in a basket in the Nile.

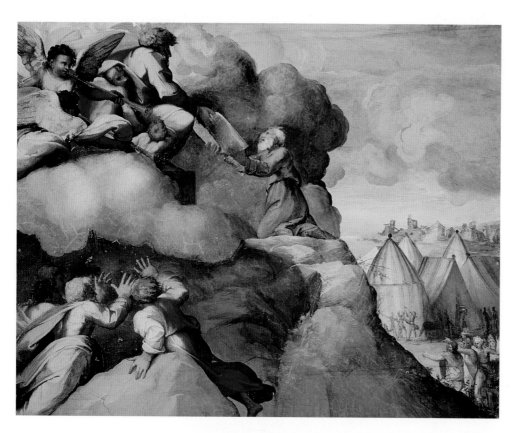

*Moses Receives the Tablets of the Law,* 1518–19, fresco, Apostolic Palace, Vatican City, Rome, Italy
133 x 106cm (52 x 42in)

This shows the moment when God gives Moses the tablets containing the Ten Commandments. Below him, the Israelites appear awe-struck. Raphael's decoration of the Pope's loggia was widely copied. Baldassare Castiglione wrote of it: '…And now he [the Pope] has provided himself with a painted loggia, worked in stuccoes, all'antica, the work of Raphael, as beautiful as can be and perhaps more [beautiful] than anything that can be seen today in the modern style'.

*The Passage of the Red Sea,* 1518–19, fresco, Apostolic Palace, Vatican City, Rome, Italy
133 x 106cm (52 x 42in)

Assisted by Bartolommeo di David (c.1480–1546) and Luca Penni, Raphael once again created a diagonal, dynamic and colourful narration of a powerful Bible story. This is the moment when the Israelites have crossed the Red Sea and the Egyptians are being drowned behind them. Raphael's blending of Greco-Roman antiquity and Christianity was perceived as exceptional in these paintings.

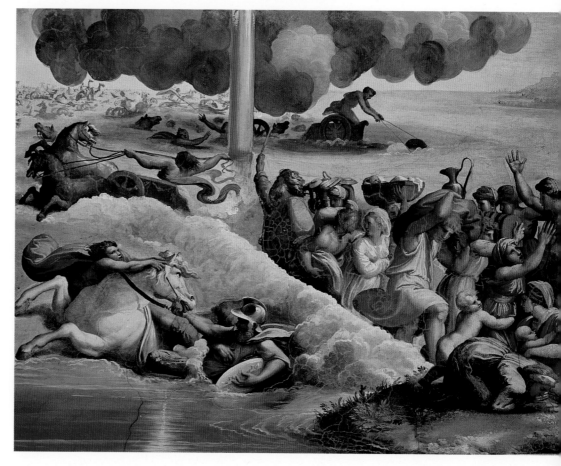

*Moses Strikes Water from the Rock*, 1518–19, fresco, Apostolic Palace, Vatican City, Rome, Italy
133 x 106cm (52 x 42in)

Another unique and original composition, for this painting, Raphael was assisted by Pellegrino da Modena (c.1465–1523) and Tommaso Vincidor (1493–1536). With every painting in the loggia, Raphael combined his knowledge of antiquities found in the ruins of Emperor Nero's Domus Aurea (Latin for 'Golden House') and modern ideas. The images resonate with Michelangelo's scenes on the Sistine Chapel ceiling.

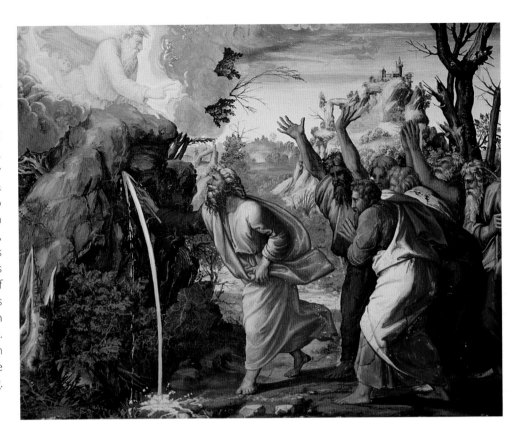

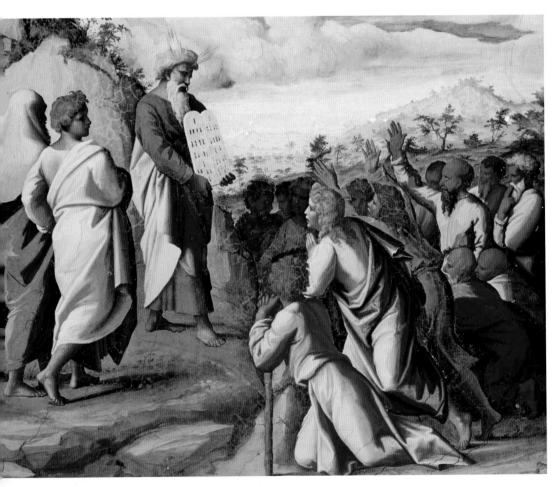

*Moses Presents the Tables of the Law*, 1518–19, fresco, Apostolic Palace, Vatican City, Rome, Italy
133 x 106cm (52 x 42in)

Assisted by Giulio Romano, this painting like the others of 'Raphael's Bible,' with their angular and simply coloured elements later influenced the 20th-century Art Deco movement. Two vaults of the loggia were taken up with the stories of Moses and the people of Israel. In every painting of him, Moses is shown alone, leading his people, and every composition is full of life.

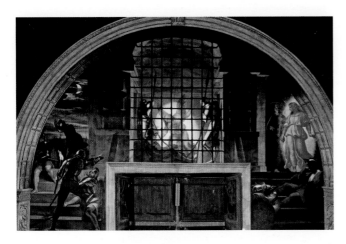

*The Liberation of Saint Peter,* 1512, fresco, Apostolic Palace, Vatican City, Rome, Italy, **width: 660cm (260in)**

Raphael painted this representation of Saint Peter's deliverance from prison by divine intervention in the same room as the *Expulsion of Heliodorus* and the *Mass of Bolsena.* Representing a great triumph within the Catholic Church, it was painted while Julius II was still alive and it emphasized the importance of the Church to all who saw it. The fresco shows three episodes: the angel appearing to the sleeping Peter, his escape, and the guards discovering he has fled.

*The Liberation of Saint Peter,* 1512, pen and pencil with black wash and white highlighting, Galleria degli Uffizi, Florence, Italy, **25.7 x 47.1cm (10 x 18in)**

This detailed study for the fresco in the Stanza d'Eliodoro is so highly finished that it would have been referred to during the preparation of the larger cartoon that would have informed Raphael and his assistants as they painted the fresco. With its precise spatial positioning of the figures, their gestures and interaction, Raphael envisioned exactly how the fresco would look when completed.

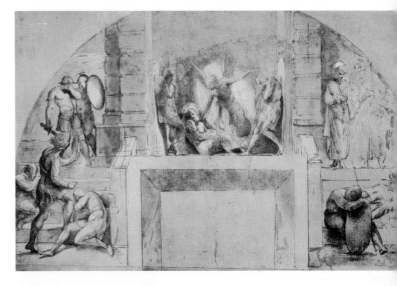

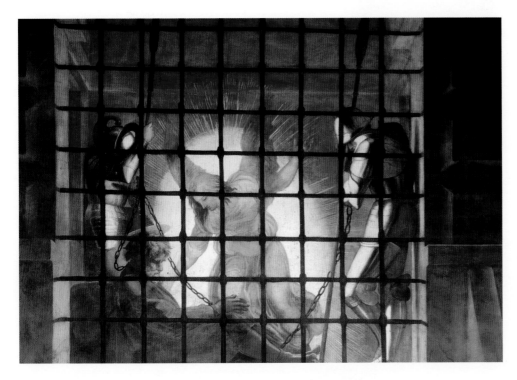

Detail of *The Liberation of Saint Peter,* 1512, fresco, Apostolic Palace, Vatican City, Rome, Italy, **width: 660cm (260in)**

This vivid detail of the fresco in the Stanza d'Eliodoro shows the angel appearing to the sleeping Peter. The use of light and shade was astonishing to those viewers who had never experienced the illumination of electricity. While Raphael was painting this – using Julius II as the model for Peter – the Pope died. Saddened, Raphael finished the fresco and the new Pope, Leo X commissioned him to carry on with the rest of the rooms.

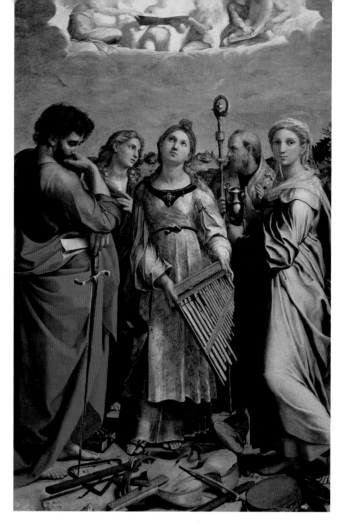

*The Apotheosis of Saint Cecilia*, 1514–16, oil on panel, transferred to canvas, Pinacoteca Nazionale di Bologna, Italy, 238 × 150cm (94 × 59in)

Raphael painted this for the Bolognese noblewoman Elena Duglioli dall'Olio's (1472–1520) chapel in the church of San Giovanni in Bologna. Elena had the chapel built after Cardinal Alidosi gave her a relic of Saint Cecilia. Here, Cecilia, the daughter of a Roman patrician, listens to a choir of angels, while several musical instruments at her feet (a bass viol, three flutes, a tambourine and an organ) are scattered. The earthly instruments cannot compare to the angels' music.

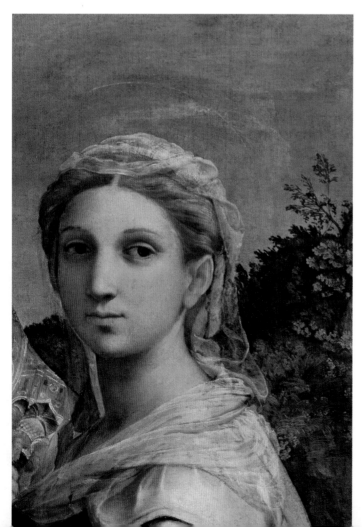

Detail of *The Apotheosis of Saint Cecilia*, 1514–16, oil on panel, transferred to canvas, Pinacoteca Nazionale di Bologna, Italy, 238 × 150cm (94 × 59in)

In the painting, the other saints: Paul, John the Evangelist, Augustine and Mary Magdalene, do not seem to be able to hear the celestial choir, but are there as witnesses to the event. This beautiful Mary Magdalene is the only figure in the work looking out directly at viewers, showing that her thoughts are of the world, not of the heavens like Cecilia.

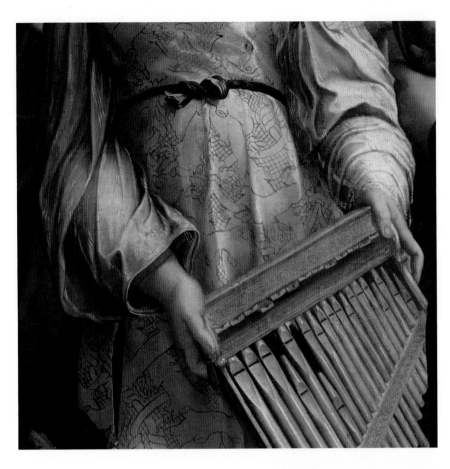

Detail of *The Apotheosis of Saint Cecilia*, 1514–16, oil on panel, transferred to canvas, Pinacoteca Nazionale di Bologna, Italy, 238 x 150cm (94 x 59in)

This altarpiece depicts a key moment in Saint Cecilia's life. Forced into marriage by her father, she heard heavenly voices during the wedding service. The earthly music sounded as if it was being played on broken instruments, referring to the abandonment of earthly pleasures. The painting also celebrates the theme of chastity as Cecilia's belt is a traditional Renaissance symbol for chastity. John the Evangelist was the patron saint of virginity and Paul praised celibacy in I Corinthians.

*Seated Woman Reading with Child*, c.1512–14, metal-point & white bodycolour on paper, Chatsworth House, Derbyshire, UK, 19 x 14cm (8 x 6in),

These two figures capture a scene that most contemporary viewers can relate to. Trying to interest the little boy in a book, the woman holds him close, but this is to little avail as the child tries to wriggle free, fascinated by the artist. His gaze creates an instant connection with viewers, even though Raphael drew this over 500 years ago. Although the child wants to escape, Raphael conveys the trust and love between him and the woman (who could be a servant or his mother) through the relaxed way he leans into her body.

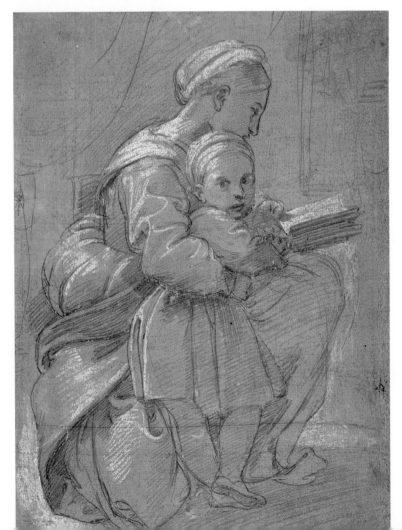

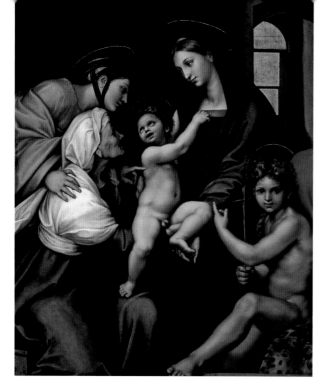

*Madonna dell Impannata,*
1513–14, oil on panel,
Galleria Palatina, Pitti
Palace, Florence, Italy,
160 x 126.5cm (63 x 50in)

Owned by the wealthy
Florentine banker, Bindo
Altoviti, according to some
critics, this painting was
completed entirely by
Raphael's assistants, while
others insist that Raphael
painted at least the faces
of the laughing baby, Mary
and Elizabeth. Similar to
*The Canigiani Madonna* (see
page 147), this is an
innovative portrayal of
the Holy Family. Gathered
together in a natural, relaxed
mood are Saints Catherine,
Elizabeth and John, plus
Mary and Jesus. Diffused
light emanates from the
background window
covered by linen (the
impannata).

*Virgin and Child, c.1512,*
black chalk on grey paper,
Chatsworth House,
Derbyshire, England,
41.2 x 22.5cm (16 x 9in)

In a pyramidal composition,
this compelling drawing
implies a sense of
movement with a twist
of the Virgin's head, causing
her veil to swish, while
Christ also twists a little,
implying a wriggling toddler.
Raphael's use of chalk
was accomplished and
powerful, showing his
understanding of the fall of
light and the creation of
atmosphere through tonal
modelling. The tender
embrace of mother and
child and their own
individual expressions and
gestures embody one of
Raphael's greatest talents.

**Detail of** *The Sistine*
*Madonna,* 1513, oil on
canvas, Gemäldegalerie Alte
Meister, Dresden, Germany,
265 x 196cm (104 x 77in)

Possibly commissioned by
Julius II for the church of San
Sisto in Piacenza, this is a
detail from the last of
Raphael's Madonnas. Here,
the Pope points beyond the
work to a painting of the
Crucifixion that was hanging
opposite. Raphael intended
to inspire the monks to
contemplate Christ's
presence during prayer.

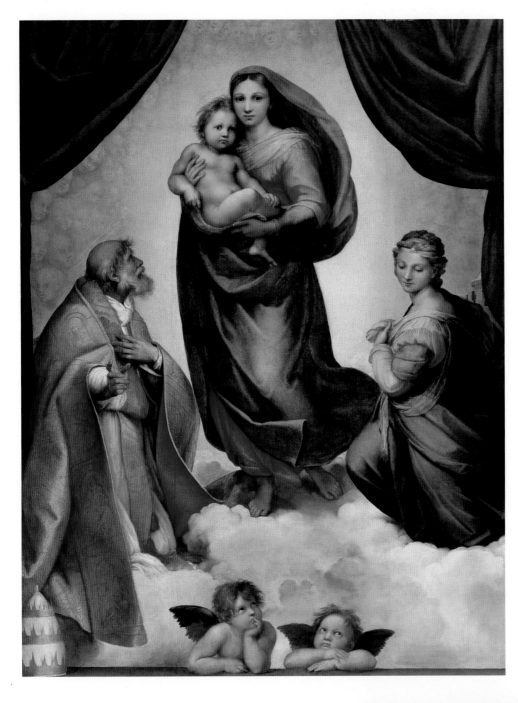

*The Sistine Madonna,* 1513, oil on canvas, Gemäldegalerie Alte Meister, Dresden, Germany, 265 x 196cm (104 x 77in)

It was believed that the church of San Sisto held relics of Pope Sixtus II and St Barbara, so Raphael painted this altarpiece to feature Saints Sixtus and Barbara in the presence of the Madonna and Child. It was an entirely new concept. Through the stage-like setting, the curtains, clouds and ethereal light, with the Virgin and Child standing on clouds, were dramatic illusions, and it created a tranquil, contemplative atmosphere in the church.

Detail of *The Sistine Madonna,* 1513, oil on canvas, Gemäldegalerie Alte Meister, Dresden, Germany, 265 x 196cm (104 x 77in)

Floating on the clouds, Saint Barbara gives the impression of protecting the Virgin and Child. Her gesture echoes that of Pope Sixtus opposite, while her downward gaze shows her humility at being in the presence of the Madonna and Child. Her elaborate hairstyle and clothing are those of a wealthy Italian woman of the time, encouraging recognition and respect from viewers.

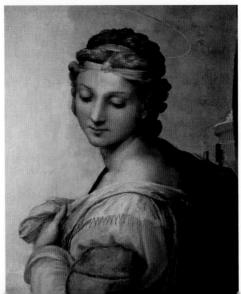

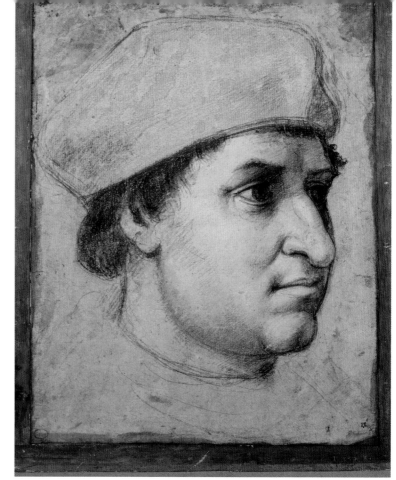

*Portrait of a Cardinal,* c.1513–20, black, red and white chalk on paper, Wilton House, Wiltshire, England, UK, 30 x 23.9cm (12 x 9in)

This portrait study probably dates from late in Raphael's life. The realistic emphasis on the slightly puffy flesh resembles *Leo X with two Cardinals* of 1518. It is the only known work by Raphael in which he uses a combination of red, black and white chalk. Although the subject has not been identified, the image appears stunningly lifelike and three-dimensional.

*Plan of the Chigi Chapel,* c.1512, pen and bistre on white paper, divided into squares by etching, Galleria degli Uffizi, Florence, Italy, 31.5 x 27cm (12 x 11in)

In 1507, Julius II allowed his close friend Agostino Chigi to purchase a chapel in Santa Maria del Popolo and turn it into a family mausoleum. After being designed by Raphael, work on the chapel began between 1513 and 1514 under the supervision of Lorenzetto. This is Raphael's plan for the Chigi Chapel. He created a centralized octagon under a dome decorated with mosaics representing the Creation of the World.

**Interior of the *Chigi Chapel*, 1513–15, Church of Santa Maria del Popolo, Rome, Italy**

The angled and rational plan of the Chigi Chapel included four arches, of which only the entrance arch opens and the other niches contain large sculptures. A subtle use of coloured marble draws attention to the decorations that combine classical and Renaissance elements. This immense marble pyramid echoes Raphael's favourite compositions of his Madonna paintings, while the disparate decorations create an imposing space.

**Interior of the *Chigi Chapel*, 1513–15, Church of Santa Maria del Popolo, Rome, Italy**

Continued by other artists after Raphael's death, most of the Chigi Chapel followed his original plans. It was Raphael's first venture into architectural design and after this; the practice became exceptionally significant to his development. The main painting on the wall is *The Birth of Mary* by Sebastiano del Piombo and the two statues, of Jonah and Habakkuk were made after Raphael's designs. The adjacent marble pyramids cover sepulchres for Agostino and Sebastiano Chigi.

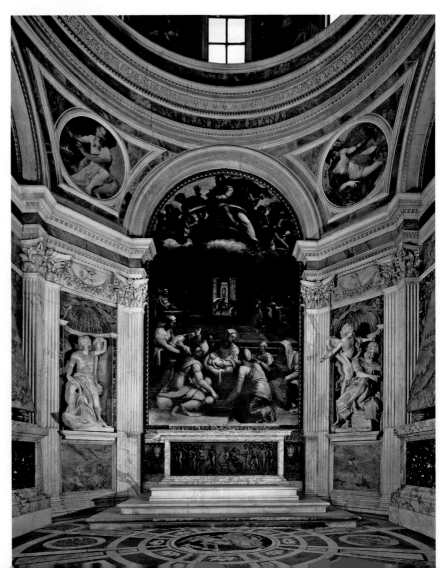

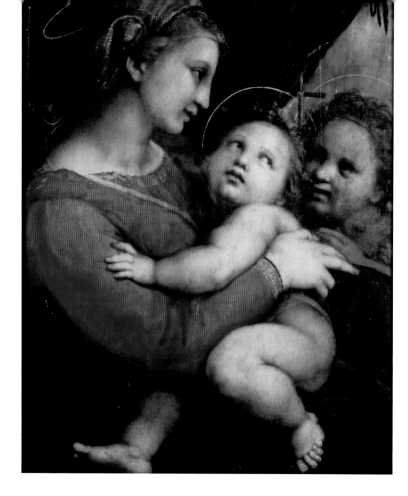

*Madonna della Tenda*, 1514, oil on wood, Alte Pinakothek, Bayerische Staatgemäldesammlungen, Munich, Germany, 65.8 x 51.2cm (26 x 20in)

Resembling Raphael's *Madonna of the Chair* from the same period, this work features one of Raphael's rare profile depictions of Mary. *Madonna della Tenda* (meaning 'of the tent' to describe the draped green curtain in the background) shows Mary sitting sideways on with Jesus on her lap. It is particularly intimate. Mary smiles at her baby, who turns toward Saint John.

*God the Father, the Seven Planets and the Fixed Stars*, 1516, mosaic, Chigi Chapel, Santa Maria del Popolo, Rome, Italy, dimensions unknown

In the domed ceiling of the Chigi Chapel, Raphael created a magnificent vision of the medieval idea of the world (all that was about to be changed by the theories of Copernicus). The dome mosaic of *God the Father in Benediction* in the centre shows him as the Creator of the World and was completed by a Venetian artist after cartoons by Raphael. The design blends pagan, Neoplatonic and Christian ideas.

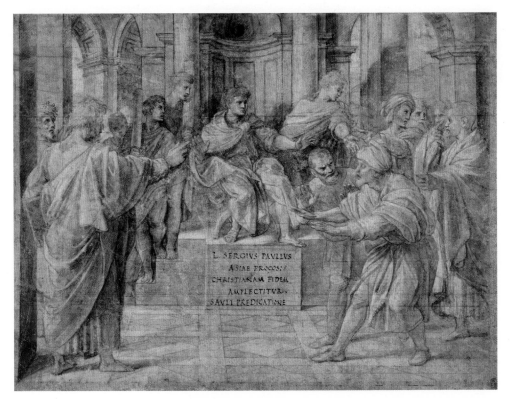

*The Conversion of the Proconsul, c.1514,* metalpoint, brown wash, white heightening and later pen and ink on pale buff paper, Royal Collection, England, UK, 26.9 x 35.4cm (11 x 14in)

When Leo X commissioned the set of tapestry designs in 1513, Raphael made many preparatory drawings. In this study for one of the cartoons, he depicted the Bible story of the magician Elymas trying to prevent the Roman proconsul Sergius Paulus from hearing the preaching of Paul and Barnabas. Paul temporarily struck Elymas blind and the proconsul was converted to Christianity.

*Christ's Charge to Peter, c.1514,* red chalk on paper, Royal Collection, England, UK, 25.7 x 37.5cm (10 x 15in)

A study for a tapestry cartoon to reinforce the Pope's role this illustrates the moment when Christ tells Peter to build his Church. It was made by laying a blank, slightly dampened sheet of paper over a chalk drawing and rubbing on top to produce a reversed impression. Called an offset, this process was often used during the preparatory stage, to check what a composition would look like in reverse, as would be the case in a tapestry.

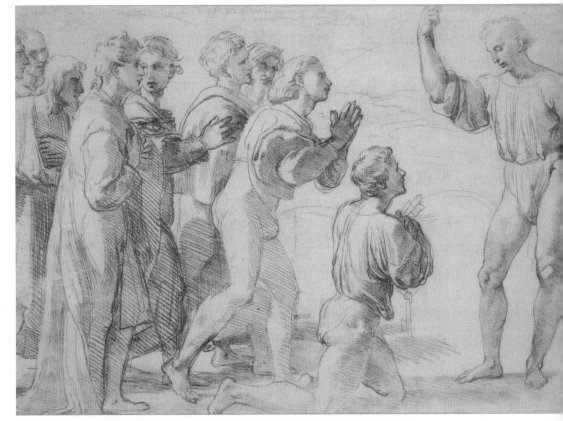

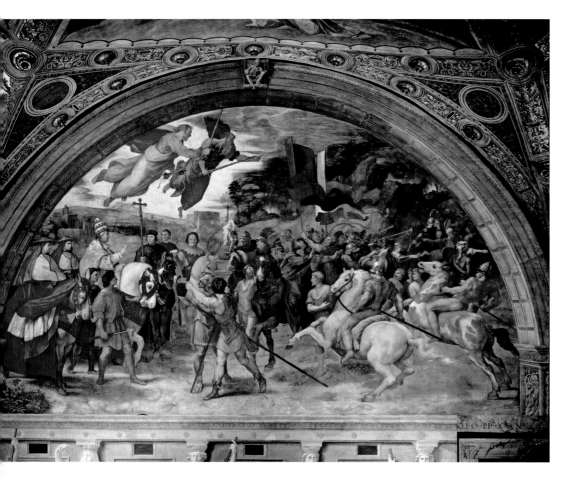

*The Repulse of Attila,* c.1513–14, fresco, Apostolic Palace, Vatican City, Rome, Italy, base width: 750cm (295in)

Raphael was in the midst of painting the frescoes in the Stanza d'Eliodoro when Julius II died. This work was one of the first he completed for Leo X. It represents an encounter between Pope Leo I and Attila in 452 and also draws parallels with the recent efforts of Julius II to drive the French from Italy. Leo X is depicted here as Pope Leo I.

Detail of *The Coronation of Charlemagne,* 1516–17, fresco, Apostolic Palace, Vatican City, Rome, Italy, width 670cm (260in)

In the Stanza dell'Incendio, *The Coronation of Charlemagne* records an event that took place in St Peter's basilica in the year 800 when Charlemagne was the first to be crowned as Emperor of the Romans by a Pope, in this case, Leo III. Designed by Raphael but probably largely painted by Giovan Francesco Penni, the ceremony takes place in the new St Peter's basilica. Leo III is a portrait of Leo X, and Charlemagne a portrait of Francis I.

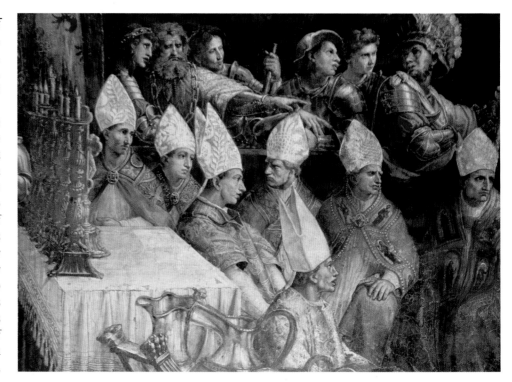

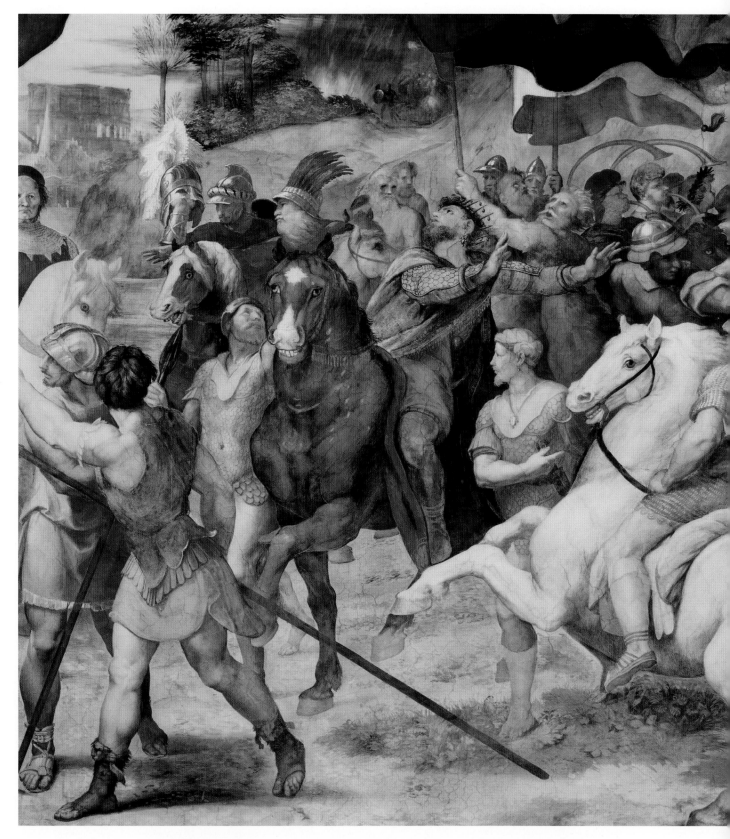

*The Repulse of Attila (detail of painting opposite).*

Groundbreaking in its use of light and in the lively composition, this fresco depicts a miracle when the unarmed Pope Leo I routed Attila and his heathen hordes. The Pope, on his white horse, raised a finger; Attila and his supporters fell into confusion and retreated.

*The Fire in the Borgo,*
*c*.1516–17, fresco, Apostolic
Palace, Vatican City,
Rome, Italy,
width 670cm (260in)

The Stanza dell'Incendio, the
third room in the Vatican
painted by Raphael, is named
after this painting, depicting a
miracle performed by Leo IV
in 847. The style of Raphael's
painting at this time, which
was a blend of classical and
theatrical, can be seen.
Innovatively, he painted the
scene from more than one
viewpoint and included
several classical buildings
as a backdrop.

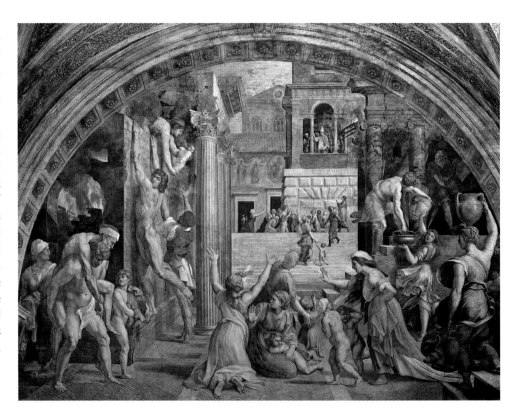

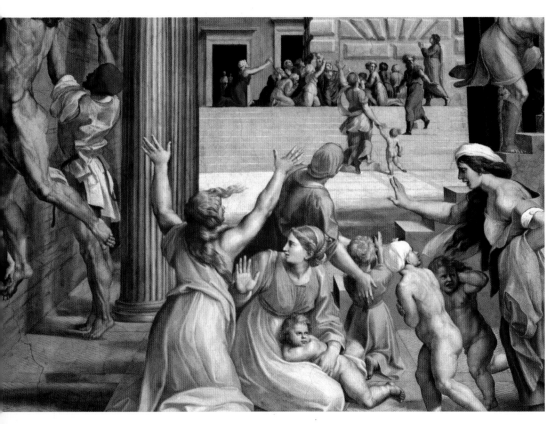

Detail of *The Fire in the
Borgo, c*.1516–17, fresco,
Apostolic Palace, Vatican
City, Rome, Italy,
width 670cm (260in)

The figures' poses here echo
many ideas from ancient art,
particularly where some are
taken from classical statuary.
Here the wailing woman
spectacularly embodies the
fear and disbelief of the
spreading fire and of the
Pope stopping it with a
simple sign. As he often did,
Raphael has included a
tender, human moment. In
the foreground a mother
hugs and reassures her child.

*The Creation of the Sun and Moon,* 1518–19, fresco, Apostolic Palace, Vatican City, Rome, Italy

Part of the Pope's loggia, this fresco comes from the first vault, in which Raphael illustrated the Creation of the World. This is *The Creation of the Sun and Moon,* described in the Old Testament book of Genesis as happening on the fourth day. Around the fresco is a lattice pattern featuring angels and within, Raphael poetically shows God creating the cosmos using his arms and body to divide light and dark amongst the clouds.

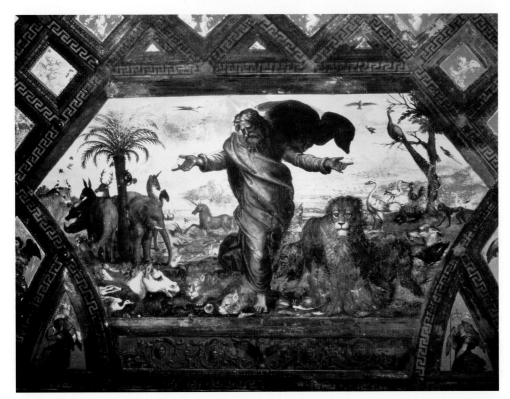

*The Creation of the Animals,* 1518–19, fresco, Apostolic Palace, Vatican City, Rome, Italy

The idea of God appearing as an old man with flowing beard and garments developed at the beginning of the Renaissance period. Here his powerful actions are vibrant and descriptive. Like the previous work, this fresco is in the first loggia. It shows an array of species emerging and populating the Earth. In homage to Leo X, the lion is the most prominent animal.

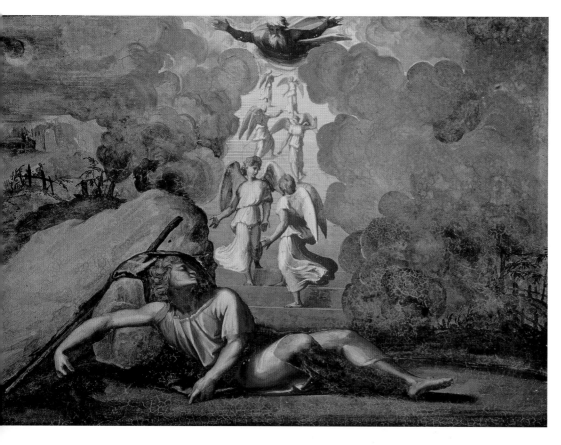

*Jacob's Dream*, 1518–19, fresco, Apostolic Palace, Vatican City, Rome, Italy Assisted by Alonso Berruguete (*c.*1488–1561),

Raphael painted this in the sixth vault of the Pope's loggia. From the book of Genesis, the story tells how Jacob escaped his brother's vengeance and fell asleep in the desert. In a dream he saw a ladder whose top reached the sky with angels climbing up and down. Jacob is prominently in the foreground, while God appears between clouds at the top of a pyramid of golden light.

*The Journey to Canaan*, 1518–19, fresco, Apostolic Palace, Vatican City, Rome, Italy

As described in the Old Testament, this is Jacob's journey back to Canaan where he hears that his brother Esau is coming to meet him with an army of 400 men. Assisted by Tommaso Vincidor, Raphael used soft warm colours, created solid-looking figures and a credible landscape background, although the animals do not appear to have been drawn from life!

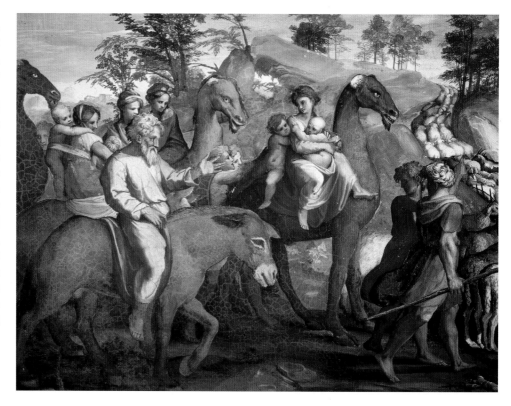

*The Battle of Ostia*, 1514–1515, fresco, Apostolic Palace, Vatican City, Rome, Italy base: 770cm (303in)

Largely painted by Raphael's workshop, this fresco is in the Stanza dell'Incendio where every theme was connected to previous popes who had taken the name of Leo. This portrays the victorious Leo IV who repulsed an invasion by the Saracens as they disembarked at the mouth of the River Tiber. The fortress of Ostia is in the background.

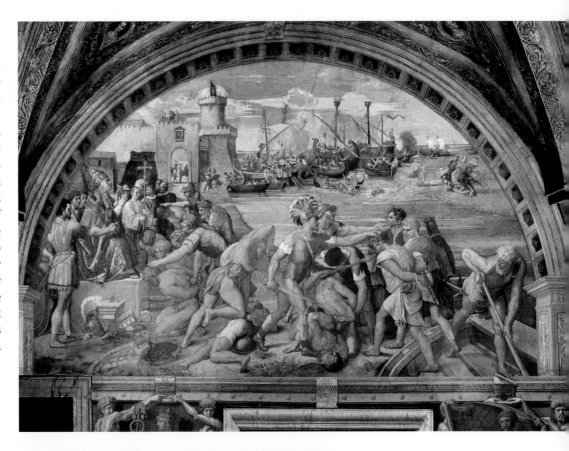

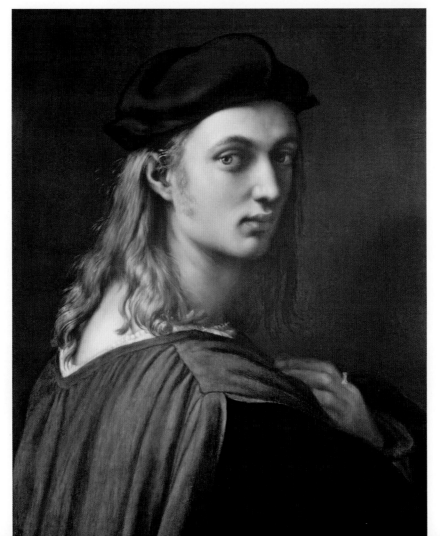

*Bindo Altoviti*, c.1515, oil on panel, National Gallery of Art, Washington DC, USA, 60 x 44cm (24 x 17in)

Bindo Altoviti (1491–1556) was a wealthy Florentine banker and friend of Raphael's in Rome. Known for his mesmerizing eyes, he turns dramatically to look over his shoulder. Holding his hand above his heart, a ring is prominent. Bindo and Fiammetta, the daughter of a prominent Florentine family, had married in 1511. The couple had six children, but Fiammetta remained in Florence while Bindo's business with the papal court required his presence in Rome.

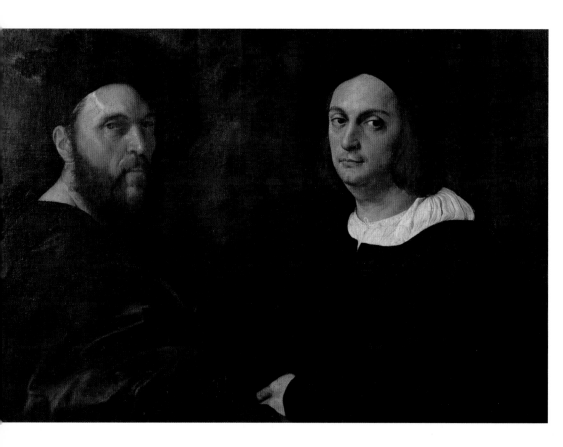

*Andrea Navagero and Agostino Beazzano,* 1516, oil on canvas, Galleria Doria Pamphilj, Rome, Italy, 76 x 107cm (30 x 42in)

These two Humanists from Venice were friends of Raphael's. It is believed that he painted this portrait of them speedily, resulting in a less formal portrait than his usual commissions. It was painted to be seen by only a few viewers. Posed almost as mirror-images, the subjects reveal nothing about themselves, just their friendly, relaxed expressions.

*Joseph Sold into Slavery,* 1518–19, fresco, Apostolic Palace, Vatican City, Rome, Italy

Completed mainly by Perin del Vaga and Polidoro da Caravaggio, this work maintained the unity of all the other paintings in the papal loggia. It illustrates the Old Testament story of Joseph, the 11th of Jacob's 12 sons and his wife Rachel's firstborn, being sold into slavery by his jealous brothers. Eventually Joseph rose to become the most powerful man in Egypt next to the Pharaoh.

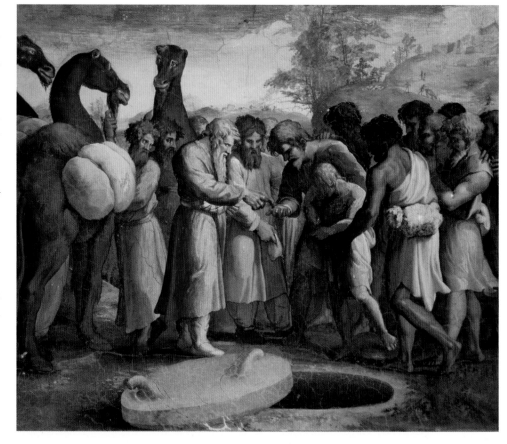

*Saint John the Baptist, c.1516,* oil on canvas transferred from wood, Musée du Louvre, Paris, France, 135 x 142cm (53 x 56in)

This vision of the young Saint John the Baptist in the wilderness was completed by Raphael's assistants, although he planned and drew the image and possibly painted the face and pointing hand. Michelangelo's influence can once again be detected. It is a skilful composition, conveying the vigour of the young man and also creating interest through the rich setting.

*David and Bathsheba,* 1518–19, fresco, Apostolic Palace, Vatican City, Rome, Italy

From the Pope's loggia, this depicts a moment in the Old Testament book of Samuel, when King David sees Bathsheba from his terrace as she takes her bath and becomes enamoured of her. In the fresco, they are separated by a parading army, alluding to David's sending of Bathsheba's husband to die in combat.

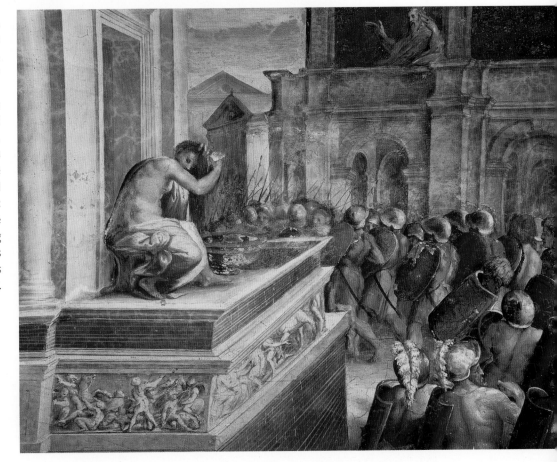

*Portrait of a Young Man,*
c.1518–19, oil on panel,
Thyssen-Bornemisza
Museum, Madrid, Spain,
43.8 x 29cm (17 x 11in)

Many believe that the subject
of this portrait is Alessandro
de' Medici, the future Duke
of Florence. Although it has
also been speculated that
Giulio Romano assisted
Raphael in the creation of
the work, the colour
harmonies and contrasts
created by the white shirt,
pale pink cloak and pale,
clear flesh tones resemble
the master's later methods of
portraiture. Also, as a close
friend of the Medici family, it
is likely that he completed at
least most
of this work.

*La Donna Velata,* c.1515–16,
oil on canvas, Pitti Palace,
Galleria Palatina,
Florence, Italy,
82 x 60.5cm (32 x 23.8in)

Vasari described 'a mistress
whom Raphael loved to the
day of his death. Of her he
made a very beautiful portrait,
wherein she seemed wholly
alive…' The idea became
established that this elegant
and elaborately dressed young
woman is a portrait of that
mistress – Margherita Luti,
known as La Fornarina. It has
never been verified, but the
beautiful young woman, with
wisps of hair escaping from her
white veil (velata) was clearly
someone whom Raphael
respected enormously.

*The Miraculous Draught of Fishes*, 1515–16, bodycolour over charcoal underdrawing on paper, mounted on canvas, on loan from HM Queen Elizabeth II, V&A Museum, London, England, UK, 319 x 399cm (126 x 157in)

One of Raphael's cartoons for the Sistine Chapel tapestries, this illustrates an important episode in the history of the Church. Leo X was keen to emphasize the legitimacy of papal succession amid the renewal of the splendours of Rome and Raphael followed his brief. Peter, a humble fisherman, was Christ's first apostle and along with Paul became one of the founders of the Roman church, so Raphael celebrated episodes in their lives in his tapestry designs.

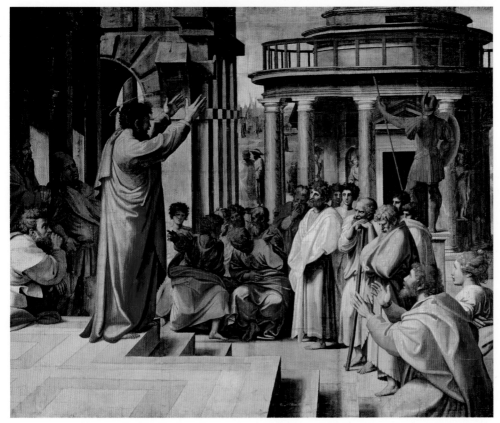

*Saint Paul Preaching at Athens*, 1515–16, bodycolour over charcoal underdrawing on paper, mounted on canvas, on loan from HM Queen Elizabeth II, V&A Museum, London, England, UK, 343 x 442cm (135 x 174in)

The Pope was interested in preaching and Paul was known as the 'Prince of Preachers.' Raphael depicted Paul preaching to a group of councillors at the judicial council in Athens. Behind him, are two figures: the bearded man is modelled on Janus Lascaris, the director of a new Greek academy in Rome and the plump, clean-shaven man was the Pope himself. Raphael's portrayal of the Pope listening intently to Paul implies that he was following Paul's greatness.

*The Blinding of Elymas* or *The Conversion of the Proconsul*, 1515–16, bodycolour over charcoal underdrawing on paper, mounted on canvas, on loan from HM Queen Elizabeth II, V&A Museum, London, England, UK, 342 x 446cm (135 x 176in)

This painting was created after the drawing on page 199: *The Conversion of the Proconsul*. Raphael experimented with the facial expressions of the witnesses and with the distribution of light and shade before deciding on this final composition. In this image, Paul has been invited to preach to the Roman proconsul, Sergius Paulus, but is interrupted by Elymas, a magician, who Paul miraculously causes to go temporarily blind, so converting the proconsul to Christianity.

*The Sacrifice at Lystra*, 1515–16, bodycolour over charcoal underdrawing on paper, mounted on canvas, on loan from HM Queen Elizabeth II, V&A Museum, London, England, UK, 347x 532cm (137 x 209in)

Raphael's cartoons created prototypes that influenced the European tradition of narrative history painting for centuries. Here, Paul and Barnabas have just cured a lame man in the city of Lystra. The Lystrians think they are the gods Jupiter and Mercury and try to offer them a sacrifice. Paul tears his garments in fury at this act of idolatry, while Barnabas pleads with the crowd to stop. A young man responds, leaning toward the executioner to prevent him from slaughtering an ox.

*The Death of Ananias*, 1515–16, bodycolour over charcoal underdrawing on paper, mounted on canvas, on loan from HM Queen Elizabeth II, V&A Museum, London, England, UK, 342 x 532cm (135 x 210in)

The Pope appointed Raphael Commissioner of Antiquities, allowing him close contact with Rome's past. Here, Peter condemns the Jews for disobedience, which was seen as punishment for embezzlement of religious funds. Ironically, Leo X was accused of improperly diverting Church money.

*Healing of the Lame Man,* 1515–16, bodycolour over charcoal underdrawing on paper, mounted on canvas, on loan from HM Queen Elizabeth II, V&A Museum, London, England, UK, 342 x 536cm (135 x 211in)

Peter, in blue and yellow, heals a lame man in a crowd at the gate of the Temple in Jerusalem. John the Evangelist (in salmon-coloured robe) watches. The act symbolizes Peter's spiritual healing. With *The Conversion of the Proconsul,* it illustrates the missions of Peter and Paul; Peter converts the Jews, while Paul converts the Gentiles.

Raphael based the twisted columns on examples in St Peter's Basilica in Rome. At the time, they were believed to have come from Solomon's Temple in Jerusalem.

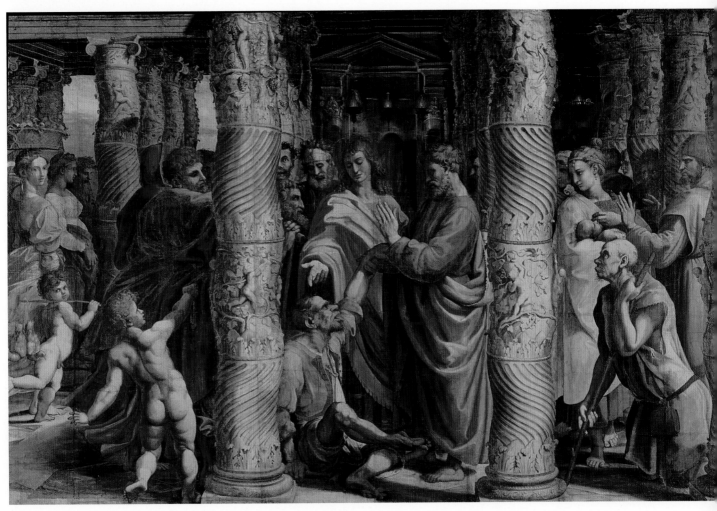

*Portrait of Cardinal Bibbiena,*
*c.1516,* oil on canvas,
Galleria Palatina, Pitti Palace,
Florence, Italy,
85 x 66.3cm (33 x 26in)

As the Pope's private
secretary, Cardinal Bibbiena
was one of the most
powerful men at the papal
court. Additionally, he was a
writer, humanist and a
passionate scholar of classical
antiquity. This portrait clearly
expresses his astute and
malevolent character as well
as his taste for beautiful
things and fine living.
Although more severe and
rigid than many of Raphael's
portraits, it may be a copy,
although the composition
and colouring imply that this
is Raphael's work.

*Portrait of Baldassare*
*Castiglione,* 1514–15, oil on
canvas, Musée du Louvre,
Paris, France,
82 x 67cm (32 x 26in)

Largely through his *Book of*
*the Courtier,* Castiglione had
become a powerful and
influential figure throughout
Europe. As an ambassador
from the court of Urbino,
he was in Rome during the
winter of 1514 to 1515.
Shared interests, equal
celebrity status and
compatible personalities
meant that he and Raphael
were good friends and spent
a substantial amount of time
together. In this portrait,
Raphael embodied the noble
and elegant courtier of the
subject's book.

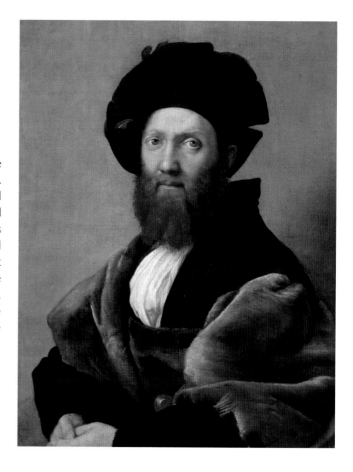

*The Raphael Loggias,* 1882,
engraving, Paul-Marie
Letarouilly

Paul-Marie Letarouilly
(1795–1855) was an
architect, cartographer and
engraver. In 1820 in Italy he
bought a book, *Buildings of*
*Modern Rome.* Influenced
heavily by this, on his return
to France, he produced his
own books illustrated with
engravings of Italian
Renaissance buildings.
Published between 1840
and 1855, these were called
*The Renaissance in Rome* and
*The Vatican and the Basilica*
*of Saint Peter's, Rome.*

*The Raphael Loggias, 1882, engraving, Paul-Marie Letarouilly*

The Vatican loggias began as a project by Bramante, but they were left unfinished at his death. In completing the first and second floors, Raphael created a cohesive range of architecture, sculpture, reliefs, frescoes and decorative motifs, with an emphasis on variety and graceful beauty. In this engraving in Letarouilly's book, the detail of one aspect of his decorations can be seen.

*The Raphael Loggias, 1882, engraving, Paul-Marie Letarouilly*

Another of Letarouilly's engravings from his book of 1882, this reveals Raphael's mix of classical and contemporary ideas, his original use of colour and his understanding of harmony and balance. Letarouilly's books became important reference point for many architects and designers of the late 19th century, bringing Raphael's original designs to a modern age.

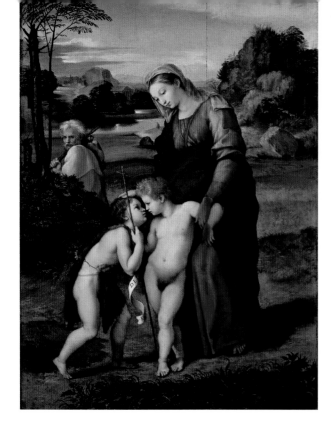

*The Madonna del Passeggio,* c.1516, oil and gold on panel, Scottish National Gallery, Edinburgh, Scotland, UK, 90 x 63.3cm (35 x 25in)

Meaning *Madonna of the Promenade,* the title for this work was inspired by the way Mary and Jesus appear to have met Saint John the Baptist while walking in the countryside. Joseph watches them from the middle distance. The scene refers to a story about Saint John's childhood, when he first met his cousin and aunt when the Holy Family was returning from Egypt.

*The Way to Calvary (Lo Spasimo),* 1517, oil on canvas, Museo del Prado, Madrid, Spain, 318 x 229cm (125 x 90in)

Signed RAPHAEL URBINAS on a stone in the foreground, this altarpiece was commissioned by the Olivetan monastery of Santa Maria dello Spasimo in Palermo (see pages 94–95). It became incredibly famous after an almost miraculous recovery from a shipwreck. Jesus has fallen on his way to Calvary and as Simon of Cyrene lifts the Cross, Christ looks to his mother behind him. Her palpable agony gave the painting its name – *The Torment.*

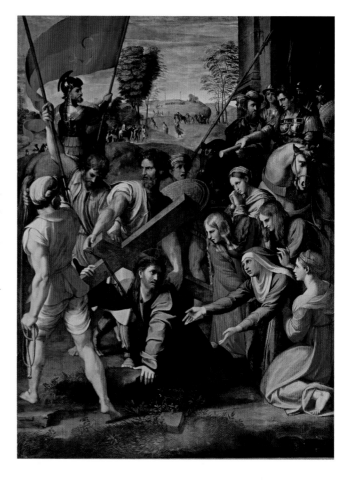

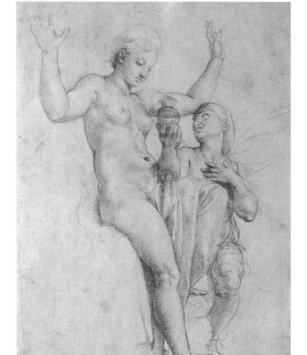

*Psyche presenting Venus with water from the Styx,* 1517, red chalk on paper, Musée du Louvre, Paris, France, 26.3 x 19.7cm (10 x 8in)

Full of action, this shows Raphael's skill with red chalk, a medium and colour he frequently used at this time with great sensitivity, building gradated tones, lively elements and smooth shapes. His chalk drawings were often copied by his admirers and rivals alike. This was a study for another fresco for a loggia – or garden room – for Chigi's Villa Farnesina in Rome.

*Walkway*, 1517–18, Villa Madama, Rome, Italy

With magnificent views of the River Tiber, the Villa Madama was built on a steep slope above Rome initially for Cardinal Giulio de' Medici, the future Pope Clement VII. Designed by Raphael in 1516–17, it was later altered by Antonio da Sangallo, but it remained unfinished. This is a view of a walkway leading to the gardens of the villa featuring a maze, all designed by Raphael.

*Walkway*, 1517–18, Villa Madama, Rome, Italy

This is another geometrically-designed and open walkway from the Villa Madama, situated on the slopes of Monte Mario, a few miles north of the Vatican. Even unfinished, with its loggia and segmental columned garden court, it was one of the most famous and imitated villas and terraced gardens of the time. Antonio da Sangallo created the final plans and supervised most of the construction, following original designs and plans by Raphael.

**The Garden Front,** detail of the entrance, 1517–18, Villa Madama, Rome, Italy

Cataloguing the Roman ruins stimulated Raphael's interest in architecture and during his final years, he was considered the greatest architect in Rome. Trained by Bramante, in 1516 Antonio da Sangallo was appointed second architect on St Peter's and the Villa Madama. This imposing curved entrance was quite unique. In 1527, the villa was looted by the troops of Charles V and lay neglected for some time.

*Psyche – also known as Venus seated on Clouds, pointing Downwards, c.1517,* red chalk on white paper, Chatsworth House, Derbyshire, UK, 33 x 24.6cm (13 x 10in)

This is a design for one of Raphael's unrealized lunettes for the vault of the Loggia of Psyche in the Villa Farnesina. The pose of the figure of Psyche and the putti demonstrates Raphael's inventiveness, although some of the execution seems a little clumsy for him and was probably undertaken by Giulio Romano.

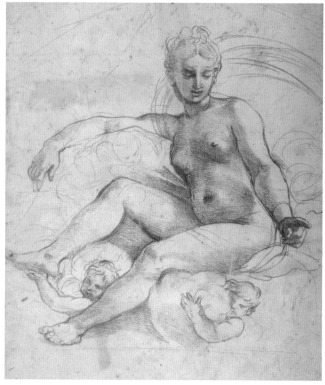

**The Façade,** 1517–18, Villa Madama, Rome, Italy

Raphael's designs for the Villa Madama were original and revolutionary and its construction helped to increase his fame even further. Giulio de' Medici was also interested in architecture and the two had many discussions about designs and requirements. Seeing to imitate the magnificence of buildings of classical antiquity and aiming to dazzle the eye with different materials and architectural styles, Raphael's plans for the villa were distinctive and innovative.

*Three Figures of the Horae,*
*c.*1517, red chalk on paper
with some bodycolour
white highlights,
Musée Condé,
Chantilly, France,
19.7 x 35cm (8 x 14in)

These three female figures
in draped half-length
sketches represent the
Horae – goddesses of the
seasons and of time
and also representing the
personifications of nature.
The three figures throwing
flowers are a lively study
for a fresco of the
*Banquet of the Gods* that
Raphael painted in the
Villa Farnesina, portraying
the sumptuous and sensual
wedding banquet of
Cupid and Psyche.

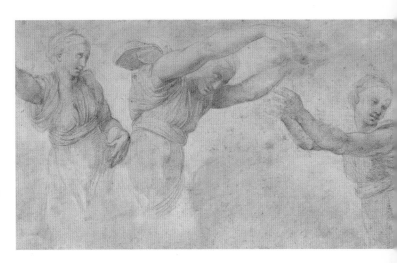

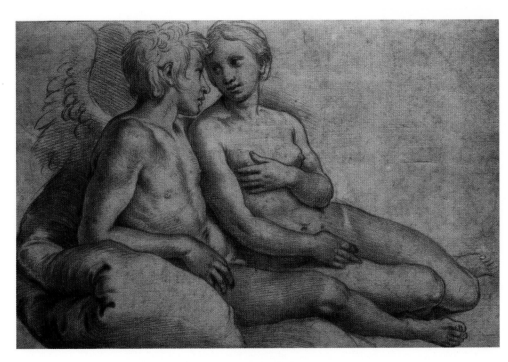

*Cupid and Psyche, c.*1516–17,
copy, red chalk on paper,
Collection Jan Krugier and
Marie-Anne Krugier-
Poniatowski,
17.6 x 25.2cm (7 x 10in)

Outside the papal court,
fascination with the graceful
and elegant style of Raphael's
later Stanze flourished. On
the ceiling of the ground
floor loggia of the Villa
Farnesina, Raphael depicted
episodes in *Metamorphosis* as
told by the ancient Roman
writer Apuleius. In this
study for the *Marriage of
Cupid and Psyche,* the
beautiful lovers relax.

*The Three Graces,*
*c.*1517–18, red chalk over
some stylus underdrawing
on paper, Windsor Castle,
the Royal Collection,
England, UK,
20.3 x 25.8cm (8 x 10in)

This is another red chalk
study for the vault of the
Loggia of Psyche in the Villa
Farnesina. The Three Graces
pour a libation over the
couple in the *Marriage of
Cupid and Psyche.* Raphael's
studies for the loggia were
extensively copied.

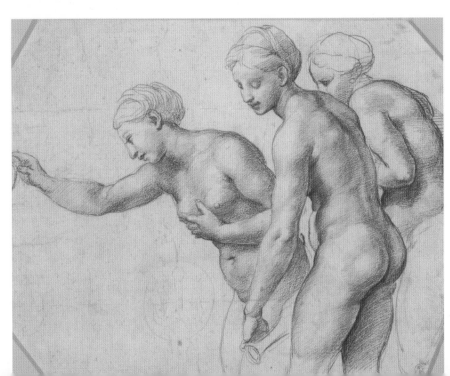

*The Loggia of Psyche,* 1518–19, Villa Farnesina, Rome, Italy

This ground-floor loggia of the Villa Farnesina faces out on to the garden. Chigi commissioned Raphael and his studio to paint an illusionistic arbour of a fruit- and flower-decorated trellis, through which a blue sky shines through, imitating a real garden bower. Along the length of the ceiling, Raphael painted two mythological scenes; of Cupid and Psyche's marriage and of Psyche being received at Mount Olympus.

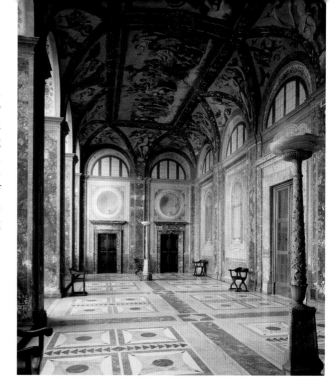

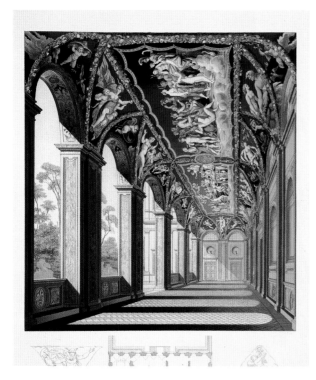

*The Loggia of Psyche,* 1518–19, Villa Farnesina, Rome, Italy

Raphael painted the ceiling of the loggia to create the illusion of two tapestries strung overhead. Around the two main frescoes, the verdant and alluring arbour is populated with nude figures of gods and goddesses painted in a cool, classic manner, as if they are part of a sculptural relief, reflecting Raphael's study of classical sculpture. Here can be seen the impression that his frescoes made on the airy room.

*The Three Graces,* 1518–19, fresco, The Loggia of Psyche, Villa Farnesina, Rome, Italy

On the spandrels between the garlands of fruit and flowers on the frieze beneath the ceiling of the Loggia of Psyche are divine episodes in Psyche's life. This is the resulting painting after Raphael's red chalk drawing on the previous page of the *Three Graces*. The beautiful goddesses, part girlish and part womanly, are less natural than the previous study and more rigid – to replicate the frescoes of antiquity.

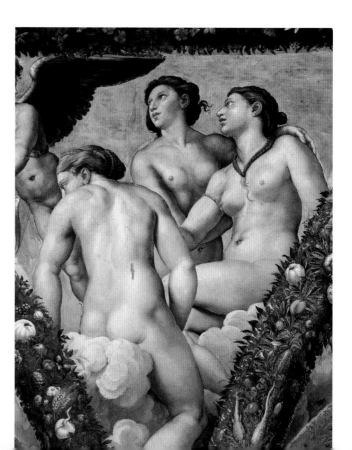

*Venus with Ceres and Juno,*
1518-19, fresco, The Loggia
of Psyche, Villa Farnesina,
Rome, Italy

One of the provocative
images of goddesses that
border the frescoes in the
Loggia, this bold and
seductive illustration helped
to create the impression of
recreation and pleasure that
Chigi wanted for his villa. In
painting such audacious
nudes, even giving them the
names of goddesses, Raphael
was being extremely
courageous and preceding a
trend of eroticism in art that
emerged in Venice later in
the century.

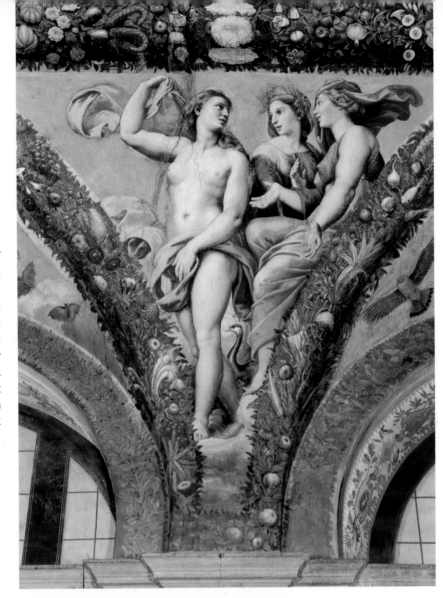

**Venus with Ceres and Juno
(detail of fresco above)**

In mythology, Ceres was the
goddess of agriculture, grain
crops, fertility and motherly
relationships. Juno, the sister
of the chief god Jupiter, was
the protector of Roman
women. So the mortal
Psyche ran to them for
advice about how to face
her furious mother-in-law the
goddess Venus. This flowing
and animated image in one
of the spandrels that
surrounds the frescoes in
the Loggia augmented the
subject of the room.

*Venus with Ceres and Juno* (detail of fresco on previous page)

Vasari maintained that Raphael was a great lover of women. This seems to be verified in his portrayals of female beauty. At the time he was working, eroticism was frowned upon in art, so any sensual images were restrained and camouflaged as mythological stories. The pretence of modesty was well known in Renaissance art, but Raphael, as groundbreaking as ever, changed all that – for instance in these bold nude representations.

*Venus in her Chariot*, 1518-19, fresco, The Loggia of Psyche, Villa Farnesina, Rome, Italy

Although all the designs for this loggia were completed by Raphael, a large part of the actual painting was undertaken by his assistants. Giovanni da Udine made a fundamental contribution, which explains the more detached appearance of many of the figures. Here is Venus, in her chariot, being pulled by white doves, looking as powerful as many of Michelangelo's female figures.

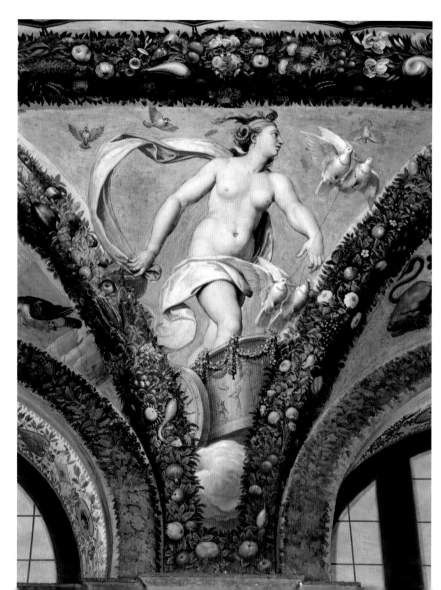

*Venus in her chariot* (detail of fresco opposite)

In mythology, white doves symbolize love and are sacred to the goddess Venus. In Ovid's Metamorphosis, white doves pulled the dainty celestial chariot of Venus across the sky. Here Raphael has depicted them attached to her chariot by a tiny gold harness. A small grey bird flies by. The patterned, agitated brush marks within the plaster can be seen clearly, creating a further sense of movement.

Detail of *Venus refusing the Vase of Sacred Love*, 1518–19, fresco, The Loggia of Psyche, Villa Farnesina, Rome, Italy

In ancient Roman mythology, Venus represented love and beauty and governed human romantic desire. In this episode, the figure on the right is holding the vase of divine or sacred love, which represents pure spiritual love and eternal happiness, but Venus throws up her arms, unimpressed and refusing to take it. She prefers passionate, earthly love, with all its accompanying emotions.

*Zeus and Cupid,* 1518–19, fresco, The Loggia of Psyche, Villa Farnesina, Rome, Italy

According to the myth of Cupid and Psyche, several goddesses were jealous of this mortal girl who stole the heart of a god. This included Cupid's mother Venus and his two sisters, but Zeus, the father of the gods, helped Psyche by giving her nectar and ambrosia, turning her immortal. Raphael represented the kindness and paternal care of the older god to the younger.

*Cupid and Psyche,* 1518–19, fresco, The Loggia of Psyche, Villa Farnesina, Rome, Italy

Situated at the end of the loggia, perpendicular to the ceiling fresco of the *Wedding Feast of Cupid and Psyche,* are the two protagonists sitting in a spandrel. As the loggia opened on to the garden, the design of animals, insects, fruits and vegetables extended the feeling of being out of doors. Renaissance viewers would have marvelled at representations of the recently discovered species of corn, courgettes, gourds and beans from the New World.

*Psyche carried to the heavens by Putti,* 1518–19, fresco, The Loggia of Psyche, Villa Farnesina, Rome, Italy

Raphael created an ancient Greek style of wall painting with these frescoes, which had the atmosphere of an ancient loggia, but the symbolism also carried Christian relevance. This echoes the Assumption and white doves represent the Holy Spirit.

*Loggia of Psyche* (detail of the fresco on page 218)

This detail of one of the festoons in the loggia was painted largely by Giovanni da Udine. Featuring a wealth of diverse and succulent fruits, vegetables and flowers, many of which were not readily available in Italy at the time, including a large gourd, grapes, acorns, tangerines, apples, pears and flowers, the overall impression is one of abundance. Many were grown in the villa's gardens and emphasized Chigi's wealth.

*The Young John the Baptist,* c.1517, oil on canvas, Galleria degli Uffizi, Florence, Italy, 165 x 147cm (65 x 58in)

Similar to the painting of the same subject in the Louvre (see page 207), this is believed also to have been completed by Raphael's assistants, although he appears to have painted some of the work, probably at least the face and pointing hand. The young Saint John the Baptist is once again featured in the wilderness as an older child, draped with his distinctive camel skin.

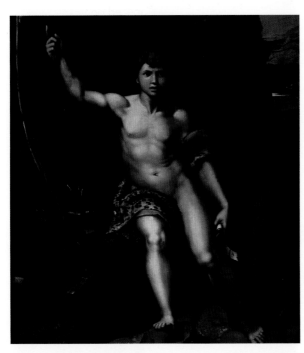

Study for the *Head of an Apostle,* c.1518-19, black chalk, partially pounced, on paper, Chatsworth House, Derbyshire, England, UK, 36.3 x 34.6cm (15 x 14in)

Several of the heads in Raphael's large painting of the *Transfiguration* can be compared with Leonardo's *Adoration* of 1481, with the strong chiaroscuro and faces thrown into atmospheric shadow. This study and several others Raphael produced for the final work were used as a reference tool during the painting and provided him with the ability to continue to refine his ideas. The studies also served as detailed guides for assistants to follow.

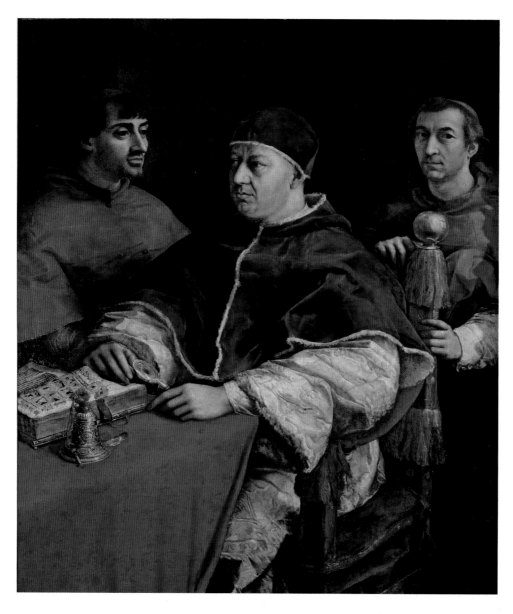

*Portrait of Leo X with Cardinals Giulio de' Medici and Luigi de' Rossi,* 1518, oil on panel, Galleria degli Uffizi, Florence, Italy, 154 x 118.9cm (61 x 47in)

Until the Protestant Reformation and Sack of Rome of 1527, Rome became known as the most progressive location of architectural and artistic production. In 1518, Raphael painted this portrait of members of the Medici family for the Pope, and with political and psychological insight, he conveyed Leo X as a scholar, Vicar of Christ and a worthy heir of his father, Lorenzo the Magnificent.

**Detail of *Portrait of Leo X with Cardinals Giulio de' Medici and Luigi de' Rossi,* 1518, oil on panel, Galleria degli Uffizi, Florence, Italy, 154 x 118.9cm (61 x 47in)**

This portrait was sent to Florence to be exhibited at the wedding of Lorenzo de' Medici, duke of Urbino. His mother wrote that the presence of such a powerful painting had created the impression that the Pope had attended his nephew's marriage. The Pope's impression of majesty and his costly clothes were intended to impress any who doubted the authority of the papacy.

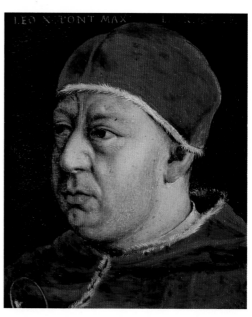

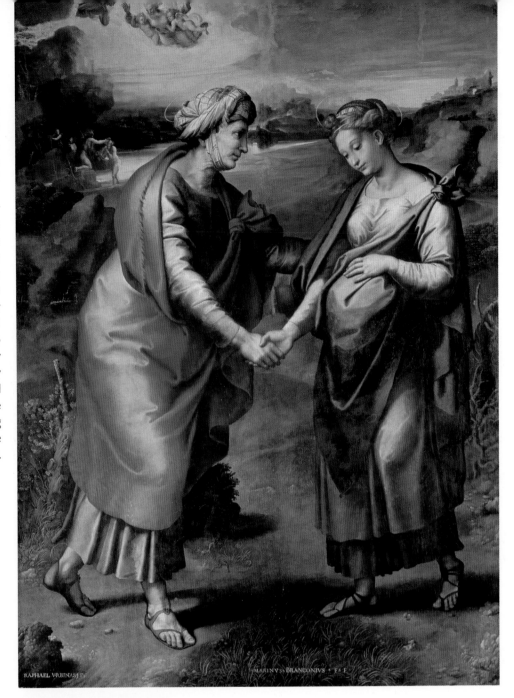

*The Visitation, c.1517*, oil on canvas, transferred from wood, Museo del Prado, Madrid, Spain, 200 x 145cm (79 x 57in)

Depicting Mary's visit to her cousin Saint Elizabeth soon after the Annunciation, when the elderly Elizabeth was miraculously in her sixth month of pregnancy, the work was commissioned by one of Raphael's influential friends, Giovanni Branconio (1473–1522) for his family chapel in a church in the city of Aquila. In the background is an event which took place years later: Jesus being baptized by Saint John in the River Jordan.

*Portrait of Leo X with Cardinals Giulio de' Medici and Luigi de' Rossi,* (detail of painting opposite)

The notion of the Pope as art patron reached a peak with Julius II and Leo X. Here, depicting Leo X as Pope, art lover and an intellectual, Raphael conveyed further messages as well. Under his elegant hands is a magnificent illuminated Bible, nearby is a chased silver bell and he holds a magnifying glass. This part of the painting emphasizes the Pope's appreciation of fine things.

*The Last Supper*, 1518–19, fresco, Apostolic Palace, Vatican City, Rome, Italy

This was one of four themes from the New Testament that Raphael painted in the Pope's loggias. Once again, the composition is unusual and dynamic. The individuals seated around the table are all moving and busy – showing their characters. One of Raphael's unique talents, obvious here, is that he could change his style completely to suit different commissions. These frescoes are nothing like anything else he designed, but they are perfectly suited to their requirements.

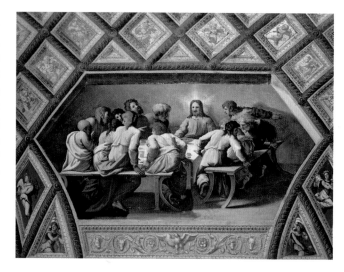

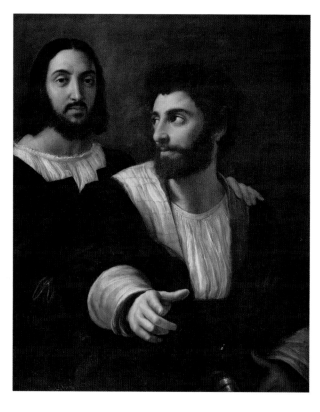

*Self-portrait with a friend*, 1518–19, oil on canvas, Musée du Louvre, Paris, France, 99 x 83cm (39 x 33in)

The bearded, 35-year-old Raphael has a fuller, more mature face than in his earlier self-portraits. The identity of his friend is unknown, but it is no longer believed to be Raphael's fencing master as it once was. Among the many names suggested are: Polidoro da Caravaggio, Giulio Romano, Perino del Vaga, Jacopo Pontormo, Baldassarre Peruzzi or Giovanni Battista Branconio, for whom Raphael had built Palazzo Branconio dell'Aquila, a palace next to St. Peter's Basilica, in 1518.

*The Building of the Ark*, 1518–19, fresco, Apostolic Palace, Rome, Italy

In June 1519, Castiglione wrote to Isabella d'Este that the Pope 'delights in architecture and is forever devising something new in this palace and now a loggia is complete, painted and fashioned in stucco in the ancient manner: a work by Raphael, as beautiful as can be…'. This fresco, like many of the others, is depicted with skilful chiaroscuro.

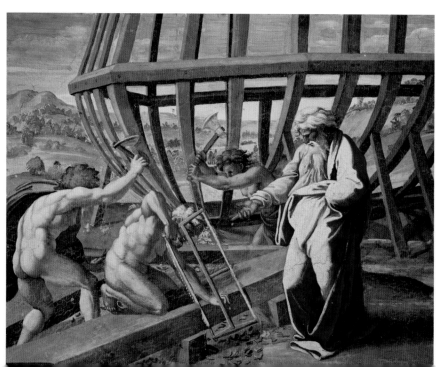

*The Holy Family of Francis I*,
1518, oil on canvas
transferred from wood,
Musée du Louvre,
Paris, France,
207 x 140cm (81 x 55in)

Designed by Raphael as a
gift to Claude, the Queen of
France, from Lorenzo de'
Medici and Leo X, this
painting is noted for its
strong chiaroscuro. Light falls
mainly on Jesus as Mary lifts
him from his cradle. As John
the Baptist leans forward, his
mother Elizabeth holds him,
while Joseph and two angels
look on. Appreciative of art,
particularly Italian, Francis I
amassed a large collection
of works by Raphael.

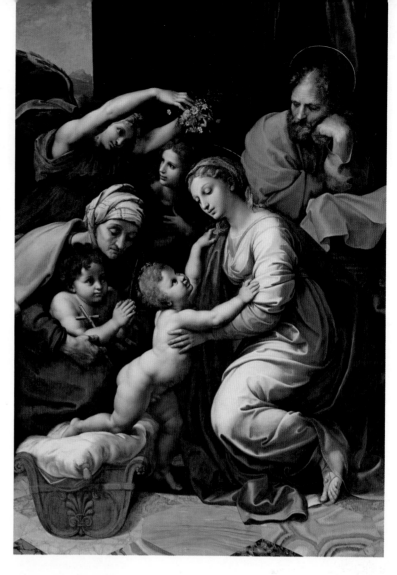

*The Little Holy Family*, c.1518,
oil on wood, Musée du
Louvre, Paris, France,
38.6 x 29.5cm (15 x 12in)

In an idyllic landscape setting,
a young and beautiful Mary,
draped in brilliant blue,
steadies her baby as he leans
across his mother's lap to
hold Saint John the Baptist's
face. Elizabeth also cradles
her son, kneeling by Mary.
The entire image emits
a relaxed and tender
atmosphere of particularly
close relatives who are
also divine figures. The
composition is an
asymmetrical pyramid, while
the gestures, positions and
glances convey a multitude
of messages.

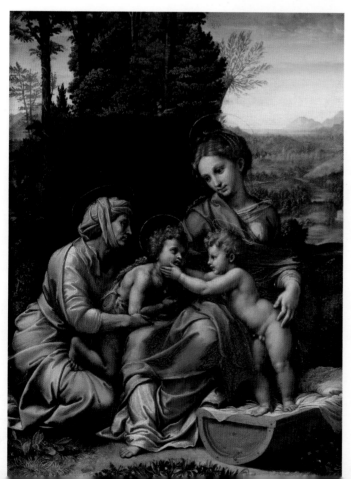

*Portrait of Dona Isabel de Resquesens,* 1518, oil on wood transferred to canvas, Musée du Louvre, Paris, France, 120 x 95cm (47 x 37in)

Formerly believed to be a portrait of Jeanne d'Aragon, it has been verified that this work is of Isabel de Requesens, the wife of the extremely powerful Viceroy of Naples. The portrait was commissioned by Cardinal Bibbiena, intended as a gift for Francis I of France, and was executed by both Raphael and one of his pupils, probably Giulio Romano.

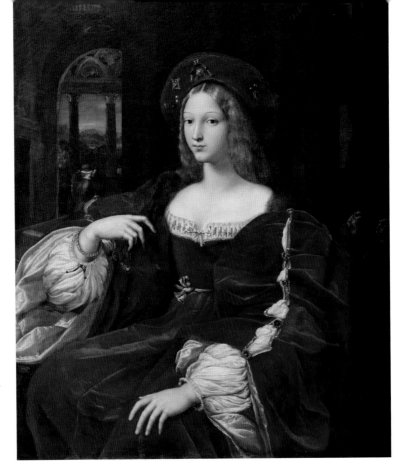

*The Virgin with a Rose,* 1518–20, oil on canvas, Museo del Prado, Madrid, Spain, 103 x 84cm (41 x 33in)

Also known as *The Holy Family with little Saint John,* this shows Mary holding Jesus on her lap as Saint John hands him a ribbon displaying the words *Agnus Dei,* meaning *Lamb of God* in Latin. As usual with Raphael's Holy Families, Joseph watches from the background. Named after the rose on the table, the main focus of the work is the message on the ribbon, referring to Christ's future sacrifice – lambs were sacrificed by the Jews.

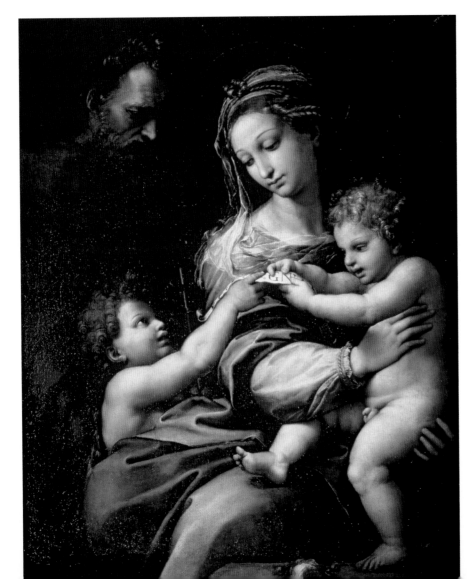

*The Virgin with a Rose,* (detail of the painting on page 228)

It is possible that Giulio Romano assisted Raphael with this work and that Raphael based the composition on a work by Leonardo – who continued to influence him throughout his life. The softness of the Virgin's face; the shadows around her lips and eyes and the inherent sadness reveals her understanding of what is to come, while her veil and elaborate hairstyle evoke the impression of a fashionable and bourgeois young woman.

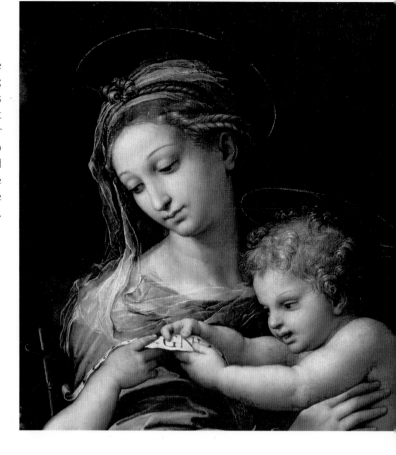

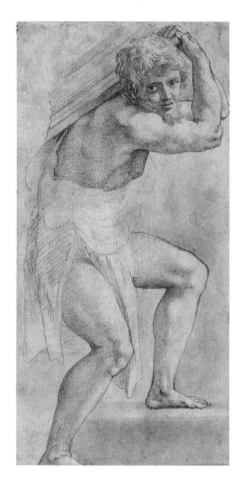

*A Man Bearing a Load,* 1514–17, red chalk on paper, Musée Condé, Chantilly, France, 32.2 x 16.2cm (13 x 6in)

This man is carrying a heavy load and climbing a step. He is a study for a figure in the left foreground of *The Coronation of Charlemagne* in the Stanza dell'Incendio. There is still some debate about whether or not Raphael drew this work or whether it was in fact drawn by one of his best assistants, either Giulio Romano or Giovan Francesco Penni.

*The Council of the Gods,* 1518–19, fresco, Loggia of Psyche, Villa Farnesina, Rome, Italy, 300 x 750cm (118 x 295in)

Raphael created this fresco on the ceiling of Chigi's villa next to the *Marriage of Cupid and Psyche.* Cupid stands in front of a Council of the Gods, asking Zeus to help him and his mortal love Psyche. Standing are several gods: Mercury with his winged helmet, Neptune, holding his trident, Bacchus, with grapevines in his hair and Venus, Cupid's mother, standing beside him.

*Marriage of Cupid and Psyche* (detail of the fresco below )

The animated composition, interactive gestures and poses and detailed elements are characteristic of Raphael's late style. This close-up detail of the wedding banquet of Cupid and Psyche shows Raphael's awareness of methods and approaches that would attract and hold viewers' attention as well as how to meet his patrons' needs – here he has created a sensual, classical and indulgent atmosphere.

*The Marriage of Cupid and Psyche,* 1518–19, fresco, Loggia of Psyche, Villa Farnesina, Rome, Italy

Also known as the *Banquet of the Gods,* this fresco, along with the *Council of the Gods* dominates the entire garden loggia of the Villa Farnesina. The year after it was completed; Chigi and his mistress Francesca Ordeasca were married with the Pope officiating. A lavish banquet was held and this reflected the revelry below.

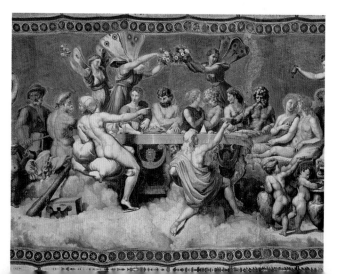

*The Marriage of Cupid and Psyche* (detail of the fresco above)

This is part of just one of the colourful and eventful scenes painted to look like a tapestry on the ceiling of the Loggia of Psyche. Several gods and heroes are sitting or standing on a cloud around a large gold table. This fresco sets the atmosphere of the loggia. It is full of detail – and also more sensuous and risqué than any other paintings in contemporary Rome.

**Inside the *Raphael Loggia* copy at the State Hermitage Museum, St Petersburg, Russia, *c.*1770–80**

The *Raphael Loggias* in the State Hermitage Museum are a copy of the Loggias in the Vatican Palace, designed by Bramante and painted by Raphael and his workshop. The State Hermitage Museum was created for Catherine the Great, the Empress of Russia (1729–96). Once built, several artists copied Raphael's original frescoes in tempera on canvas. Accurate in size and in nearly every detail, this shows the grandness and eloquence of Bramante's and Raphael's work.

**Saint Michael Overwhelming the Demon, 1518, oil on canvas transferred from wood, Musée du Louvre, Paris, France, 268 x 160cm (105 x 63in)**

Commissioned from Raphael by Lorenzo de' Medici as a gift to Francis I, it was a way of strengthening bonds between the Medici dynasty and the French royal family. A cartoon of this work was sent by Raphael to the Duke of Ferrara. Francis I was the Grand Master of the Order of Saint Michael and had accepted a commission to defend the Catholic Church. To symbolize this, the Saint Michael in the painting is defeating his enemy with ease.

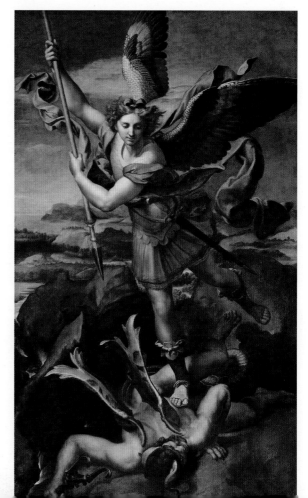

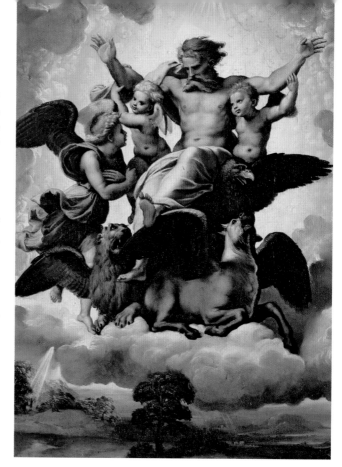

*The Vision of Ezekiel*, 1518, oil on panel, Pitti Palace, Florence, Italy, 40.7 x 30cm (16 x 12in)

With flowing hair and beard, God is depicted surrounded by angels, as described in the Old Testament book of Ezekiel: 'And behold, a whirlwind came out of the north, a great cloud and a fire infolding itself and a brightness was about it and out of the midst thereof came the likeness of four living creatures.' These creatures combined the features of lion, ox, man and eagle, believed in Raphael's time to represent the four Evangelists.

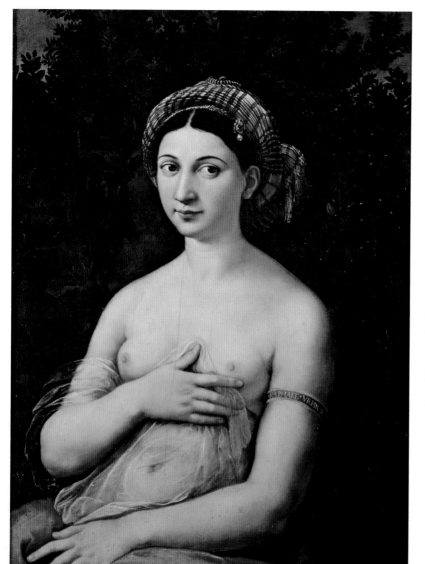

*La Fornarina*, 1518–19, oil on panel, Palazzo Barberini, Rome, Italy, 85 x 60cm (33 x 24in)

Generally accepted as a portrait of Raphael's lover, Margherita Luti, the baker's daughter, this unusual work breaks the boundaries of contemporary female portraits and contrasts with Raphael's normally chaste Madonnas. Bejewelled, but posing provocatively, holding a diaphanous veil up to her naked breasts this bold image reinforces the concept of the female as a sexualized being. There has been much debate over whether or not *La Fornarina* and *La Donna Velata* represent the same woman.

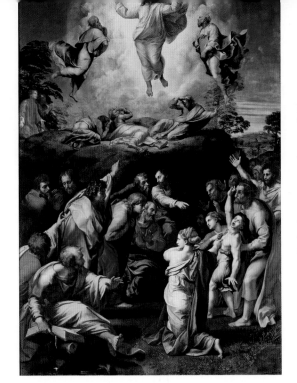

*The Transfiguration,* 1518–20, oil on panel, Pinacoteca Vaticana, Vatican City, Rome, Italy, 405 x 278cm (159 x 109in)

Despite his many other commitments, Raphael was responsible for all of the work on this painting. Vasari said that he 'resolved afterwards to execute by himself, without assistance from others, the panel picture of the Transfiguration of Christ that is in San Pietro a Montorio.' Commissioned by Cardinal Giulio de' Medici, the future Clement VII, this painting is Raphael's last major work.

*Study for the Transfiguration,* 1517, brown pen and ink and chalk on paper, Graphische Sammlung Albertina, Vienna, Austria, 53.5 x 37.7cm (21 x 15in)

In preparation for a majestic altarpiece depicting the Transfiguration of Jesus, Raphael drew this detailed and careful image. Every figure is naked and drawn from life – it was not until he painted the work that he added clothes. This study demonstrates his great attention to accuracy and detail. The complex composition combines two narratives told successively by the apostles Luke and Mark.

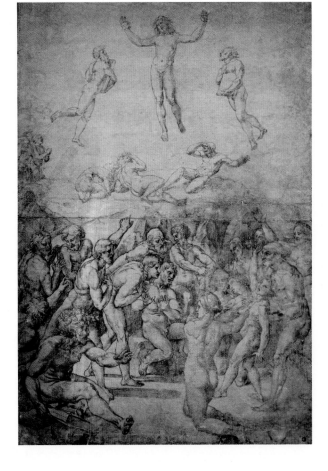

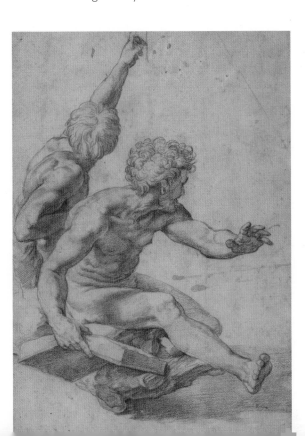

*Study of Two Apostles,* c.1518–20, red chalk over stylus indentation on cream paper, Chatsworth House, Derbyshire, England, UK, 32.8 x 23.2cm (13 x 9in)

The many preparatory studies that Raphael produced for his painting *The Transfiguration* are dynamic, detailed and assured. At the same time, he was also working as an architect, a conserver of Roman antiquities and a city planner, yet they never appear rushed. These two nude studies are for Saint Andrew and another apostle.

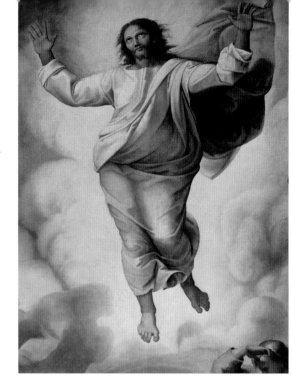

Detail of *The Transfiguration*, 1518–20, oil on panel, Pinacoteca Vaticana, Vatican City, Rome, Italy, 405 x 278cm (159 x 109in)

When Cardinal de' Medici commissioned this, he asked for it to be sent with Sebastiano del Piombo's *Resurrection of Lazarus* to the cathedral in Narbonne (see pages 94-95), but once he received it, he kept it. This animated image of Christ, with his arms up and a glowing light behind him was perceived as creating a connection between God and his people.

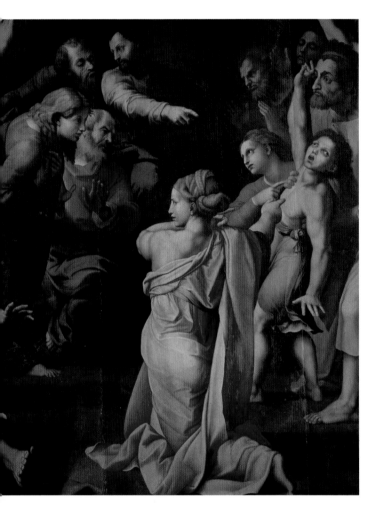

Detail of *The Transfiguration*, 1518–20, oil on panel, Pinacoteca Vaticana, Vatican City, Rome, Italy, 405 x 278cm (159 x 109in)

With theatrical gestures and expressions, Raphael managed to connect two contrasting events from the Gospel of Matthew: the mystery of the Transfiguration of Christ in the sky, with the apostles trying to free a boy of demonic possession on the ground. The recently transfigured Christ performs the miracle. The work is seen by some as anticipating Mannerism and Baroque painting.

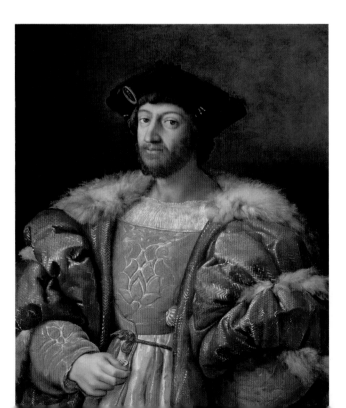

*Lorenzo de' Medici, Duke of Urbino*, c.1518, oil on canvas, Private Collection, 97 x 79cm (38 x 31in)

Lorenzo de' Medici (1492–1519) was the grandson of Lorenzo the Magnificent and son of the Pope's elder brother, Piero. This portrait of him was commissioned on his betrothal to the King of France's cousin, Madeleine de la Tour d'Auvergne. Before they met, Lorenzo and Madeleine exchanged portraits. Raphael was aware that this would be seen by Francis I, who loved Raphael's work and who had invited the ageing Leonardo to live with him.

*Holy Family of the Oak Tree,*
c.1518, oil on panel, Museo
del Prado, Madrid, Spain,
144 x 110cm (57 x 43in)

Sitting on Mary's lap, Jesus
looks back at his mother,
who is leaning on a classical
ruin. Joseph watches them.
Saint John the Baptist is
giving Christ a banner
inscribed with the words
*Ecce Agnus Dei,* meaning
*Lamb of God.* The work is
named after the oak tree in
the middle background,
which separates the group
of figures from the ruins of
the Caracalla Baths in the
distance. Although designed
and started by Raphael,
this was completed by
Giulio Romano.

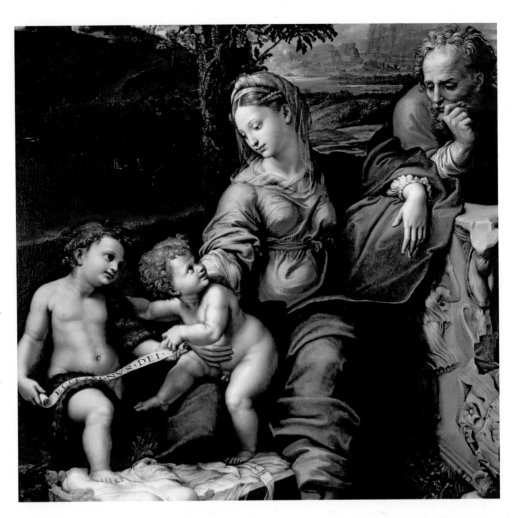

*Jousting Children on Boars,*
c.1518, black chalk and
stylus on paper, Musée
Condé, Chantilly, France,
53 x 125cm (21 x 49in)

Following the poet Giovanni
Boccaccio's *Uberto e
Filomena,* Raphael made this
detailed cartoon for an
unknown decorative

scheme. He based the boars
on those in Dürer's *Prodigal
Son* and created mischievous
and lively putti, using his
own perceptive ideas in

their representation. As
usual, he made the figures
interact with each other and
convey their individual
personalities to viewers.

Façade of the *Church of San Lorenzo, c.1515–16*, pen and ink on paper, copy of Raphael, Galleria degli Uffizi, Florence, Italy

In 1515, Raphael accompanied Leo X to Bologna to meet the King of France. It is believed that Leonardo and Michelangelo were also part of the entourage and that they all passed through Florence. Leo launched a competition to design the façade of the Church of San Lorenzo, inviting artists, including Raphael, Giuliano and Michelangelo to enter. In 1516 he awarded the work to Michelangelo. This is a copy of Raphael's proposed design.

*Floor plan for the Villa Madama, c.1517*, pen and ink on paper, Galleria degli Uffizi, Rome, Italy

In a letter of 1519 to Isabella d'Este in Mantua, Castiglione wrote that Raphael: 'is also engaged on a country house for Cardinal de' Medici, which will be a most excellent thing.' This plan for the Villa Madama was made by Raphael, who started the construction of the building in 1518, but put Antonio da Sangallo the Younger in charge after that. Sangallo produced the final plans and supervised most of the building of the villa.

Cupola of the *Loggia of the Villa Madama*, Rome, Italy, started in 1518

Following his interest in the antiquities of Rome, Raphael designed the Villa Madama in the style of a suburban Roman villa. As the first of its kind, it set a trend. Enclosed within an octagon with a blue background, Cardinal de' Medici's arms; a gold shield with a circle of one azure and five gold balls, is the central feature of the cupola in the middle.

Cupola of the *Loggia of the Villa Madama*, Rome, Italy

With its views of the River Tiber, when first built, the loggia of the Villa Madama was open to the terraced garden. It is now closed in. This view of the ceiling and cupola shows the airiness of the space, created originally by Raphael, with adjustments by Antonio da Sangallo the Younger. Based firmly on Raphael's ideas, it was built as a modern version of an ancient Roman villa; the first revival of its kind.

Cupola of the *Loggia of the Villa Madama*, Rome, Italy

Each of the three bays in the loggia had an arch leading to the garden. The cupola is in the central bay and its large proportions mean that the many colours and intricate ornamentation do not overpower, but impart a sense of rhythm. Cardinal de' Medici did not want religious themes in his home, so the walls are embellished with figures from Greek mythology. Although the decorations were completed after Raphael's death, his assistants Romano and Udine followed his designs.

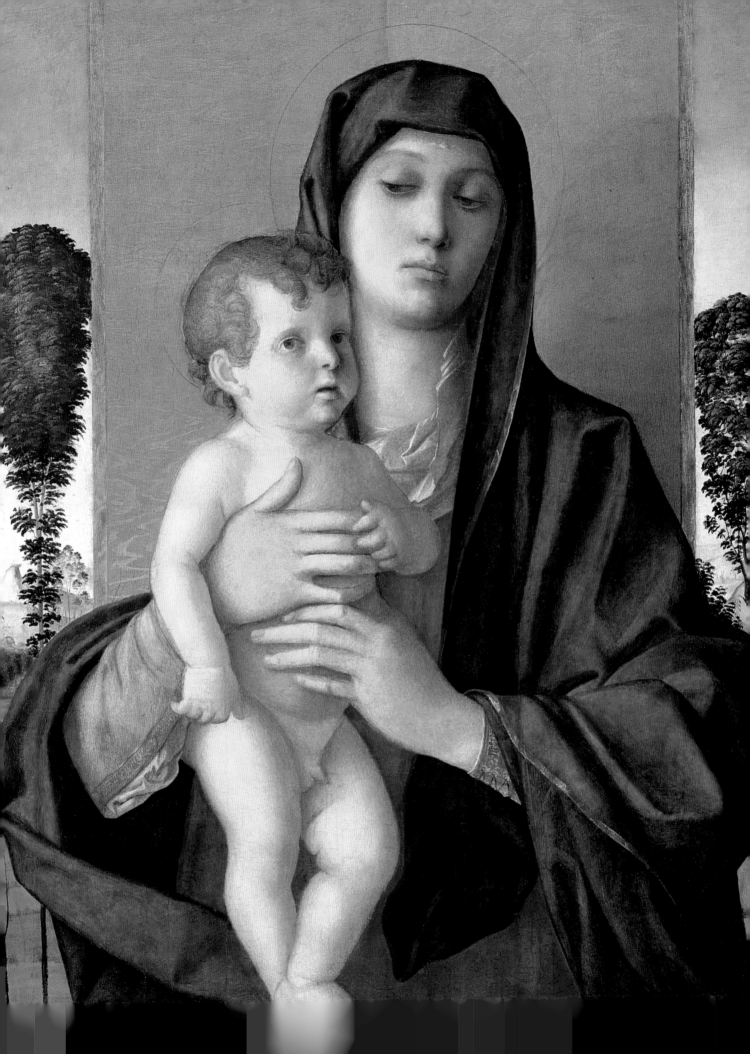

# INSPIRATION
# AND INFLUENCE

Few artists have been as admired and emulated as Raphael. His greatest
achievements emerged from his insight and ability to select and assimilate
ideas and advances made by others. After his death, for the next five
centuries, artists and academies all over the world used his art as a model.
The following images in this gallery focus on just some of the artists that
influenced him and some of the artists who were inspired by him.

*Above:* The Visitation, c.1630, Jacopo da Pontormo, oil on wood, Gemäldegalerie Alte Meister,
Dresden, Germany, 202 x 156cm (79 x 61in). Although Pontormo was just a few years younger
than Raphael, his work was particularly stylized.

*Left:* The Madonna of the Trees, 1487, by Giovanni Bellini, oil on panel, Galleria dell'Accademia,
Venice, Italy, 71 x 58cm (28 x 23in). Since his boyhood, Raphael had admired Bellini. This work by
the Venetian master shows his skill in painting pure light, brilliant colour and a new quality of
human emotion and realism.

*The Pantheon, Rome,*
*Bernardo Bellotto* (1720–80),
*c.*1742–45, oil on canvas,
Museum of Fine Arts,
Budapest, Hungary,
71 x 118cm (28 x 46in)

Raphael was buried in the
Pantheon, which had
originally been commissioned
by Marcus Agrippa as a
temple to the gods of
ancient Rome, rebuilt by
Hadrian in 126 and
consecrated as a Christian
church in 609. The painter,
Bellotto, was the nephew
and pupil of Canaletto. His
paintings of such scenes
were characterized by their
atmospheric light.

*The Pantheon, Rome, Giovanni*
*Paolo Panini (or Pannini)*
(1691–1765), 1732, oil on
canvas, Private Collection,
119 x 98.4cm (47 x 38in)

An interior view of the
Pantheon which houses
Raphael's sarcophagus, this is
looking north from the main
altar to the entrance and
the Piazza della Rotunda
beyond. The massive
Corinthian columns
emphasize the enormity of
the space. The golden light
indicates that this was
painted during an afternoon.

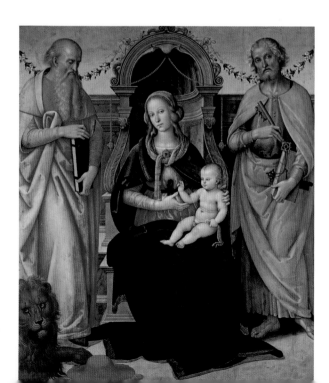

*The Virgin and Child between*
*Saint Jerome and Saint Peter,*
*c.*1490–95, Andrea d'Assisi,
tempera on panel, 1490–95,
Musée Condé, France
145 x 128cm (57 x 50in)

Andrea d'Assisi (also known
as Aloigi, Alovigi, Aloisi or
Aloysii) was born in Assisi.
Vasari wrote that as one of
Perugino's best pupils, he
worked closely with Raphael
during the early part
of their careers. He also
collaborated with
Pinturicchio in Perugia
along with Raphael.

*The Visitation of Saint Elizabeth to the Virgin Mary,* 1503, Mariotto Albertinelli (1474–1515), oil on panel, Galleria degli Uffizi, Florence, Italy, 232 x 146cm (91 x 57in)

Albertini's work was similar to Fra Bartolomeo's, but with the use of bright, enamel-like colours. He was working in Florence while Raphael was there. This shows his use of vibrant colour and his Peruginesque style. The composition is calm and imposing, an arch is formed by the two figures, echoed by the arch behind.

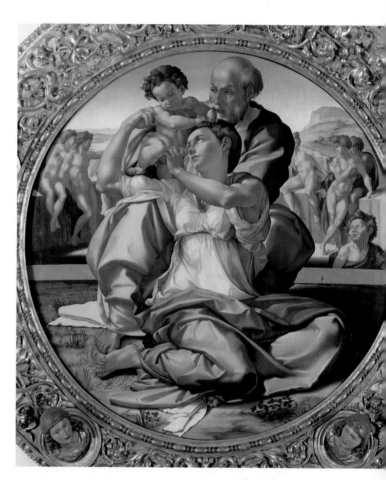

*Holy Family with Saint John (Doni Tondo)* 1504–05, Michelangelo, oil and tempera on panel, Galleria degli Uffizi, Florence, Italy, diameter: 120cm (47in)

Painted to commemorate the marriage of Angelo Doni with Maddalena Strozzi, this is a powerful sculptural composition in which the group of figures – Mary, Jesus and Saint Joseph – seems to be carved from a single block, with the Virgin as the most prominent figure. The nude figures in the background form a sort of wall beyond which a landscape is lightly outlined, so that viewers concentrate on the foreground.

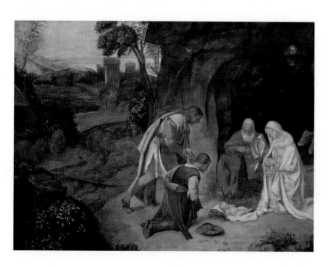

*Adoration of the Shepherds,* 1505–10, Giorgione, oil on panel, National Gallery of Art, Washington, 90.8 x 110.5cm (36 x 44in)

Although he died in his early 30s, Giorgione was one of the greatest artists of the Renaissance with a significant influence on ensuing generations. He initially studied with Giovanni Bellini, was influenced by Leonardo and taught Titian and Sebastiano del Piombo. Also known as the Allendale Nativity, this work inspired many. The composition is divided into a dark cave and a radiant Venetian landscape, while Joseph and Mary seem to glow in the darkness and contrast with the ragged shepherds.

*Madonna and Child,* Correggio, c.1512–14, oil on panel, Kunsthistorisches Museum, Vienna, Austria, 66 x 55cm (26 x 22in)

After his training in Bologna and Ferrara, Correggio (born Antonio Allegri) developed a style influenced by Leonardo and Venetian painting. His

painting was dynamic and expressive, often set in dramatic perspective. This flowing, delicate work epitomizes his graceful style that focused on colour and light over line. Elegant Madonna images like these became popular in Italy in the early 16th century and were perfected by Raphael.

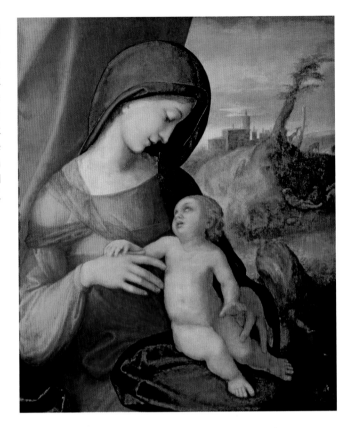

*The Holy Family after Raphael,* Marcantonio, c.1515, engraving, Private Collection, **dimensions unknown**

After seeing some of Dürer's engravings, Marcantonio Raimondi created his own versions and tricked the public into believing they were by Dürer. Dürer complained and

Marcantonio was forbidden to continue copying his work. Once he began working with Raphael, however, his pure lines and sensitive rendering of tone established his reputation and his exceptional design skills mutually benefited them both. He became acclaimed for his skill and Raphael's work became known across Europe.

*Massacre of the Innocents after Raphael,* Marcantonio, 1510–14, engraving, British Museum, London, England, UK, 28 x 42.6cm (11 x 17in)

Raphael drew the original version of this purely for reproduction in print. It depicts the Bible story of

King Herod's soldiers murdering all the baby boys in Bethlehem in an attempt to kill Jesus. The engraving corresponds almost exactly with Raphael's drawing. Through his prints, Raphael's fame and popularity increased with his income and prints of other artists' works began to be made.

*Madonna of the Cherries,*
Titian, c.1515, oil on panel,
Kunsthistorisches Museum,
Vienna, Austria,
81 x 100cm (32 x 39in)

With Saints Joseph,
Zacharias and John the
Baptist surrounding a radiant
Virgin and Child, this
luminous and sensitive work
shows why Titian was
regarded as the most
important Venetian painter
of the High Renaissance.
He imbued the classical
styles implemented by
Raphael and other successful
artists of the period with
vitality and vivid colour. After
Raphael's death, he became
renowned across Europe.

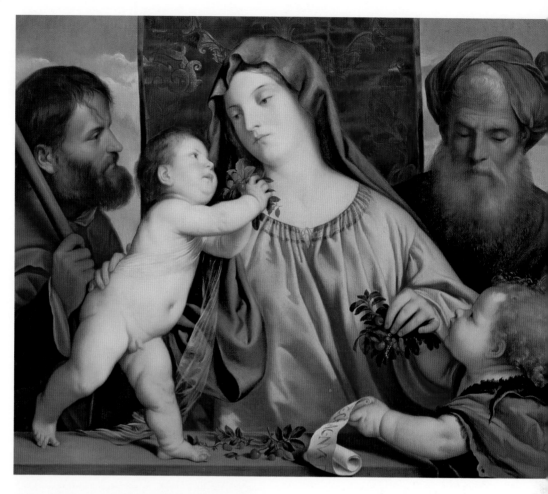

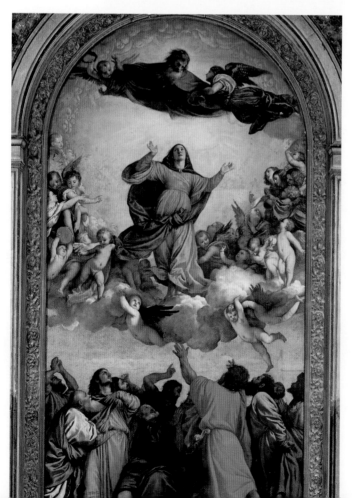

*Assumption of the Virgin,*
Titian, 1516–18, oil on
panel, Basilica of Santa
Maria Gloriosa dei Frari,
Venice, Italy,
690 x 360cm (270 x 140in)

In its elevated location on
the high altar in the Basilica
of Santa Maria Gloriosa dei
Frari in Venice, this painting
thrust Titian to the forefront
of Venetian art. Mary's
assumption into Heaven is
an important Catholic
doctrine and this was Titian's
first major commission in
Venice. With its daring scale,
dramatic colour and dynamic
gestures, the painting
attracted much attention and
Raphael's Transfiguration,
completed a couple of years
later, shows many similarities.

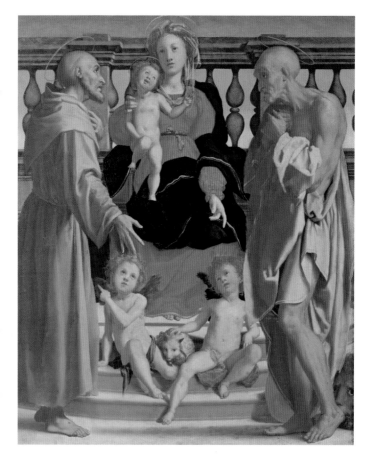

*Madonna and Child with Saints Jerome and Francis and Two Angels,* Pontormo, c.1517–18, oil on panel, Galleria degli Uffizi, Florence, Italy, 73 x 61cm (29 x 24in)

Pontormo was employed extensively by the Medici family through his career. His style became acclaimed, although he worked slowly. Many theories about the origins of Mannerism have been raised, including whether it developed as a result of artists rebelling against the styles of the High Renaissance or whether it was a development from the late styles of Leonardo, Michelangelo and Raphael.

*Madonna and Child in Glory with Angels,* Correggio, c.1520, oil on wood, Galleria degli Uffizi, Florence, Italy, 20 x 16.3cm (8 x 6in)

Correggio was renowned during his life for his dramatic style and was the first to portray light emanating from Christ, but he remained difficult to categorize. He responded to Raphael and to Leonardo's work, but his style could not be pinpointed and he was always enigmatic and eclectic. His illusionistic experiments have since been seen as precursors to Mannerism and the Baroque.

*The Triumph of Titus and Vespasian,* Giulio Romano, 1537, oil on wood, Musée du Louvre, Paris, France, 122 x 171cm (48 x 67in)

Painted for Federigo Gonzaga, Duke of Mantua, this was one of eleven panels that Romano created to decorate the Sala di Cesare at the Palazzo Ducale in Mantua, where they were placed beneath portraits of emperors by Titian. As Raphael's best pupil, Romano received many commissions on the strength of his close association with the master, but he never reached the same level of expertise.

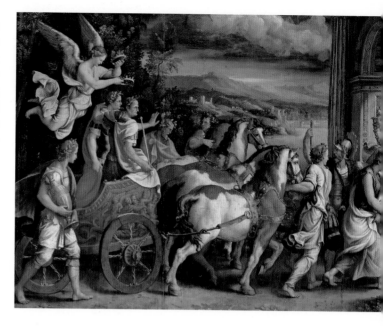

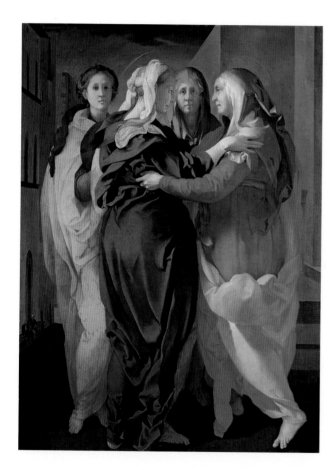

*The Visitation,* Jacopo da Pontormo (1494–1557), c.1530, oil on wood, Church of San Michele Pieve, Carmignano, Italy, 202 x 156cm (79 x 61in)

Like Raphael, Pontormo was orphaned at a young age and went to Florence, where he first studied with Leonardo and then with Andrea del Sarto (1486–1530). Although he was just a few years younger than Raphael, his work became particularly stylized and he was later considered to be one of the first Mannerists. He became known for his sinuous figures and indistinct perspective. Here, in glorious colour, Mary and Elizabeth greet each other with insightful looks.

*Portrait of a Woman inspired by Lucretia,* Lorenzo Lotto, c.1530–32, oil on canvas, The National Gallery, London, England, UK, 96.5 x 110.6cm (38 x 43in)

Lotto was one of the many artists vying to be commissioned by Pope Julius II when Raphael arrived in Rome. Like Raphael, he was influenced by Bellini, but he also became influenced by Raphael. With a dynamic pose and vigorous gesture, this portrait shows the unknown sitter pointing to a drawing of Lucretia of ancient Rome, who was about to stab herself after she had been raped by King Tarquin's son.

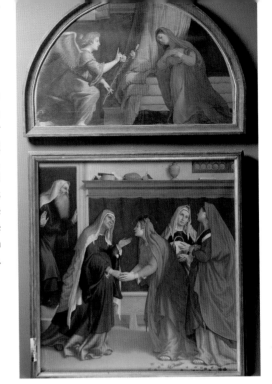

*The Annunciation and The Visitation*, Lotto, c.1530–35, oil on canvas, Pinacoteca Civica, Comune di Jesi, Venice, Italy, bottom section: 154 x 152cm (61 x 60in); top section: 103 x 152cm (40 x 60in)

This altarpiece shows the remarkable freshness and expressiveness that Lotto achieved. As a Venetian painter, his use of colour was vivid and clear, following the approaches of Titian, Giorgione and Bellini, and Raphael, his style was smooth and harmonious. He is often described as the transition from the High Renaissance to Mannerism.

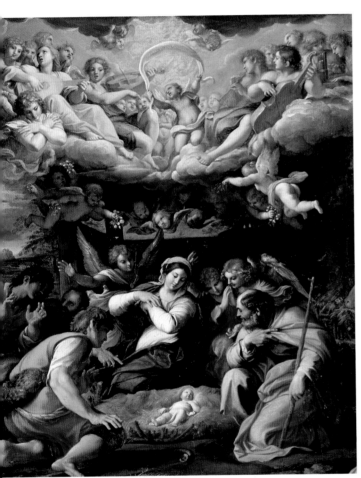

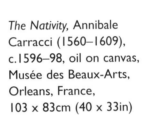

*The Nativity*, Annibale Carracci (1560–1609), c.1596–98, oil on canvas, Musée des Beaux-Arts, Orleans, France, 103 x 83cm (40 x 33in)

Annibale Carracci, his brother Agostino and his cousin Ludovico shared a painters' studio in Bologna. They closely followed Raphael's, Michelangelo's and del Sarto's styles, incorporating the glowing colours they admired in Venetian paintings. Carracci especially admired Raphael, as can be seen in the composition, gestures and features of this painting, but in turn his work inspired the Baroque styles that followed.

*The Descent from the Cross*, Tintoretto, c.1560–65, oil on canvas, Musée des Beaux-Arts, Caen, France, 135 x 102cm (53 x 40in)

Tintoretto is a nickname meaning 'little dyer'. His father was a dyer in Venice and as a child, Tintoretto used the dyes to colour his drawings. He grew up to work with outstanding energy and speed, with paintings that feature muscular figures, dramatic gestures and a bold use of perspective, this typifyies the Mannerist movement, although he also upheld the Venetian approach of using bright, intense colours and creating impressions of clear light.

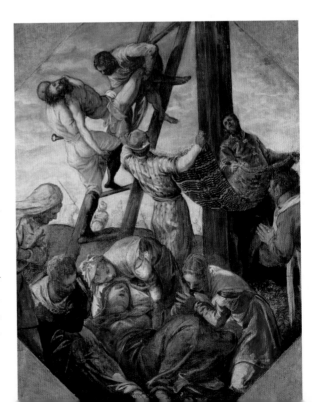

*The Mystic Marriage of Saint Catherine*, Veronese, 1547–48, oil on canvas, The State Hermitage Museum, Russia, 145.5 x 205cm (57 x 81in)

Although born and trained in Verona, Veronese soon moved to Venice and became one of the most renowned Venetian artists of the 16th century. Originally an altarpiece, this diagonal composition with its rich colours emphasizes harmony and splendour. In many ways, Veronese was a natural successor to Raphael, although Titian's colouring and Tintoretto's flowing style influenced him strongly. Like Raphael, he took ideas he admired and assimilated them into his own style.

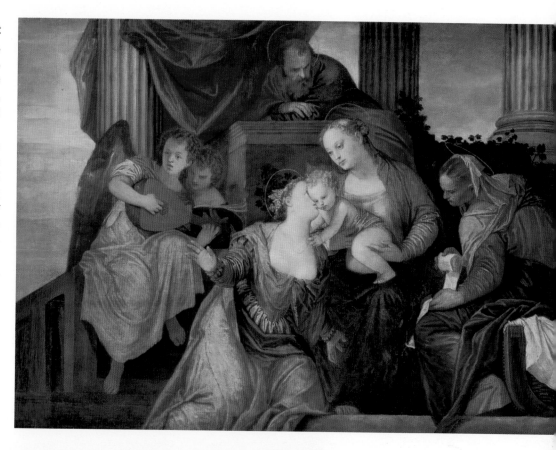

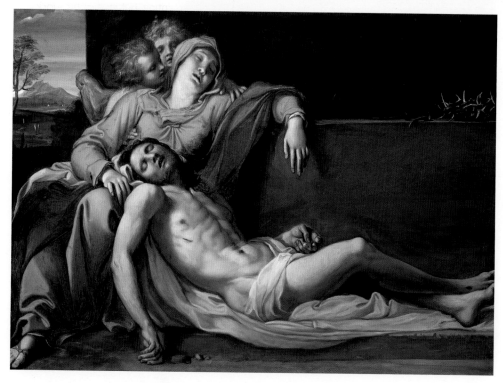

*Pietá*, Annibale Carracci, c.1603, oil on copper, Kunsthistorisches Museum, Vienna, Austria, 41 x 60cm (16 x 24in)

Annibale was the greatest of the Carracci family of painters and, like Raphael, after his move to Rome, he developed an almost 'pure' style that was seen by many as a move away from the excesses of Mannerism and the exaggerated chiaroscuro of those who tried to emulate Caravaggio. Influenced by Michelangelo, Raphael, Correggio and Veronese, Carracci had the ability to combine the styles he admired in an original way.

*The Artist's Wife, Elizabeth and their son Raphael,* Benjamin West (1738–1820), c.1773, oil on canvas, Yale Centre for British Art, Paul Mellon Collection, Connecticut, USA, 67.2 x 67.2cm (26 x 26in)

Many 18th century American artists were influenced by Raphael, including Benjamin West, John Singleton Copley (1738–1815) and John Vanderlyn (1775–1852). In naming his son after his icon, Benjamin West announced his reverence. In this portrait of his son and wife, with its tender poses, gestures and glances, West overtly followed Raphael's Madonna paintings.

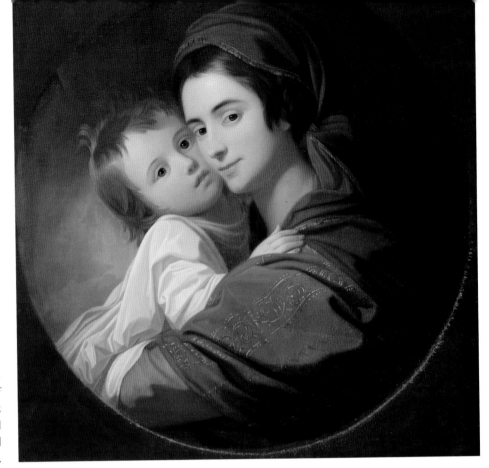

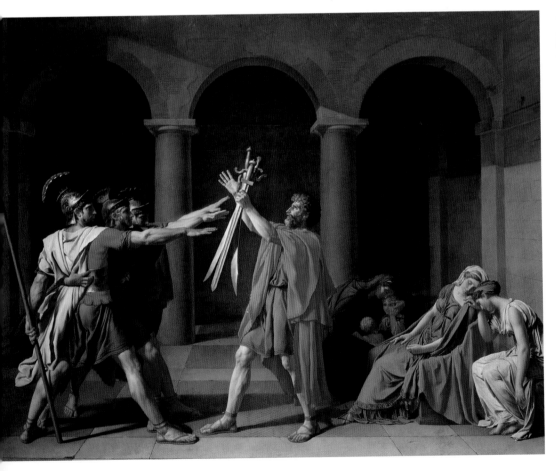

*The Oath of the Horatii,* Jacques Louis David (1748–1825), 1784, oil on canvas, Musée du Louvre, Paris, France, 330 x 427cm (130 x 168in)

Inspired by the balance and clarity of Raphael's art, David was one of the most successful neo-classical painters of the 18th and early 19th centuries. He chose an episode in ancient Roman history for his first royal commission in 1784, depicting the Horatii brothers of the 7th century BCE, swearing to defeat the Curiatii brothers. Because of links by marriage, the women of the family are distraught.

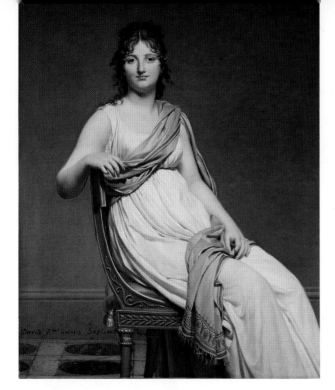

*Madame Raymond de Verninac,* David, 1798–99, oil on canvas, Musée du Louvre, Paris, France, 145.5 x 112cm (57 x 44in)

Born Henriette Delacroix, this young woman was the older sister of the painter Eugène Delacroix. In 1798 she married the ambassador Raymond de Saint-Maur Verninac. Raphael's renown as the 'Prince of Painters' continued and David learned his craft by studying the work of Raphael profusely. Because of this, great similarities in the purity of line, softness and delicacy of tones and colours and the classical style, are evident in all that he produced.

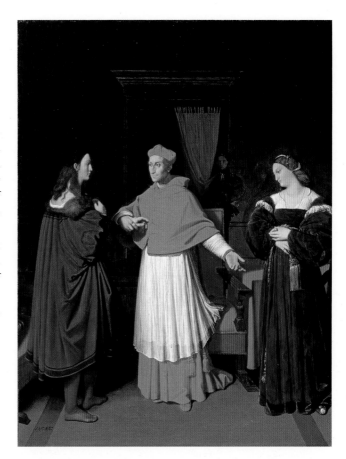

*The Betrothal of Raphael and the Niece of Cardinal Bibbiena,* Jean-Auguste-Dominique Ingres (1780–1867), 1813, oil on paper, mounted on canvas, Walters Art Museum, Baltimore, USA, 59.3 x 46.3cm (23 x 18in)

This intimate painting expresses Ingres's high regard for Raphael.

Following Raphael, Ingres painted Cardinal Bibbiena presenting his niece as a bride to Raphael. Interestingly Ingres' representation of Raphael is based on the portrait of Bindo Altoviti, which at the time was believed to be Raphael's self-portrait and the depiction of Maria Bibbiena was based on Raphael's portrait of his mistress, La Fornarina.

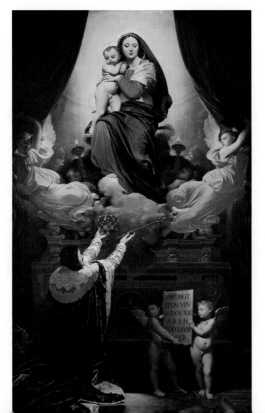

*The Vow of Louis XIII,* Ingres, 1824, oil on canvas, Cathedral of Notre-Dame, Montauban, France, 421 x 262cm (166 x 103in)

In 1820, Ingres moved to Florence and immediately obtained a commission to paint this work for the Cathedral in Montauban, representing an event that occurred in 1638. Recognizing this as an opportunity to establish himself as a painter of history, he spent four years working on the large canvas, taking it back to Paris in October 1824. Unashamedly emulating Raphael's Sistine Madonna and following other elements of *The School of Athens,* Ingres helped to establish Raphael's authority in academic art.

*Virgin and Child*, William Dyce (1806–64), c.1845, oil on plaster, Nottingham City Museums and Galleries, Nottingham, England, 78.7 x 60.3cm (31 x 24in)

When Dyce visited Italy in the late 1820s, he saw the art of a group of German painters known as the Nazarenes who were inspired by 15th century religious art. The Nazarenes aimed to produce art that had the same moral purpose, but worked for their own times. This picture, one of several modelled on Raphael's Madonna paintings, was unusual for 19th century English painting.

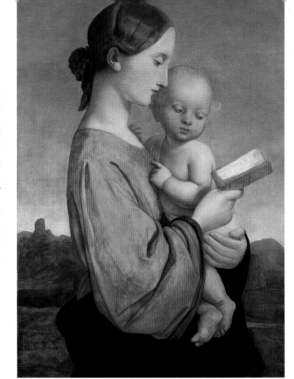

*Jesus among the Doctors*, Ingres, 1862, oil on canvas, Musée Ingres, Montauban, France, 265 x 320cm (104 x 126in)

Ingres moved to Rome in 1806 and to Florence in 1820. He returned to Paris in 1841 and 20 years later, painted this work in the style of Raphael.

It reveals a vibrantly coloured, purely painted and serene composition. Like Raphael, Ingres has represented Jesus as a natural-looking child rather than a remote and unapproachable figure. Inspired by Raphael, the Virgin at the side combines elegance and femininity with spirituality and purity.

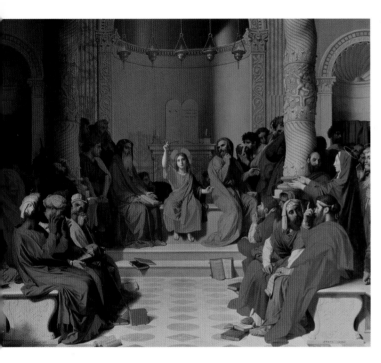

*The Judgement of Paris*, Marcantonio after Raphael, c.1510-20, engraving, The Metropolitan Museum of Art, New York, USA, 29.2 x 43.6cm (11 x 17in)

A demonstration of the successful collaboration between Raphael and Marcantonio, this print was made from a drawing Raphael created for Marcantonio to engrave. In his illustration of this ancient myth, Raphael drew inspiration from Roman reliefs and Marcantonio did not detract from Raphael's dynamic and detailed style.

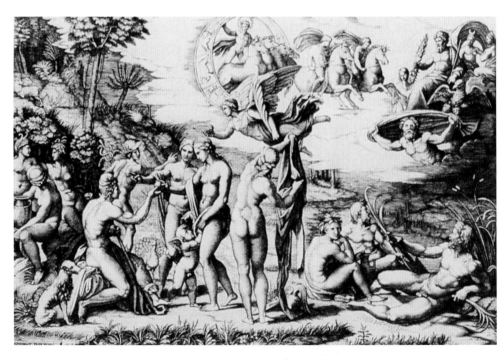

*Déjeuner sur l'Herbe,* Edouard Manet (1832–83), 1863, oil on canvas, Musée d'Orsay, Paris, France, 208 × 264cm (82 × 104in)

Taking his inspiration from the central group in Marcantonio's engraving after Raphael's *Judgement of Paris,* (left), Manet was derided when he exhibited this painting in Paris in 1863. His idea was to present, in a modern way, some of the notions of the greatest artists of the past. So the roughly painted style and photographic style of lighting was his way of paying homage to the masters of the past, but at the time it was received with contempt.

*All Happiness,* Alfred Stevens (1823–1906), *c.*1880, oil on canvas, Musée d'Orsay, Paris, France, 65.3 × 51.5cm (26 × 20in)

Born in Brussels, Alfred Stevens moved to Paris in the 1840s and socialized with Manet, Degas and others who became known as Impressionists. Despite their modern approach, Stevens maintained his admiration of Raphael's sensitive and tender approach. With the mother and child leaning toward each other and the father in the background, comparisons with many of Raphael's Holy Family compositions can be seen in this family group.

# INDEX

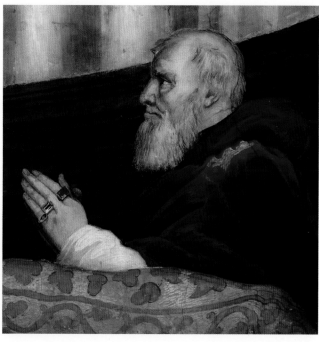

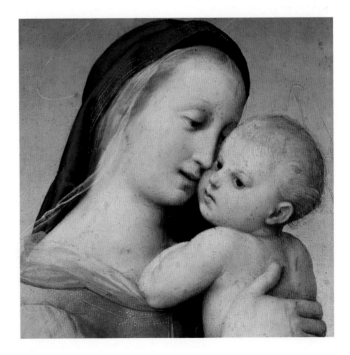

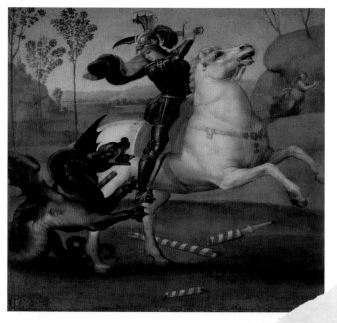